Chaucer's Pilgrims

The Allegory

Chaucer's Pilgrims:
THE ALLEGORY

Dolores L. Cullen

FITHIAN PRESS · SANTA BARBARA · 2000

Published by Fithian Press
A division of Daniel and Daniel, Publishers, Inc.
Post Office Box 1525
Santa Barbara, CA 93102

LIBRARY OF CONGRESS CATALOGING-IN-PUBLICATION DATA
Cullen, Dolores L., (date)
 Chaucer's pilgrims : the allegory / by Dolores Cullen.
 p. cm.
Includes bibliographical references.
 ISBN 1-56474-334-9 (alk. paper)
1. Chaucer, Geoffrey, d. 1400. Canterbury tales. 2. Allegory. e. Chaucer,
Geoffrey, d. 1400—Characters—Pilgrims. 4. Christian pilgrims and pilgrim-
ages in literature. 5. Chaucer, Geoffrey, d. 1400—Symbolism. 6. Tales, Medi-
eval—History and criticism. 7. Rhetoric, Medieval. I. Title.
 PR1875.A44 c85 2000
 821'.1—dc21 99-050529

In appreciation of

the Libraries of the Claremont Colleges—

my home away from home

The Chaucer we know is a creation of our own response to his works. For that he is no less the *real* Chaucer. This is true for a reason which, as exegetes, we sometimes set aside, but which as humanists we always assume: that for every man who creates great poems there is an infinte truth, of grandeur and terror, in the adage *style is the man himself*—that there must be in him, and in those who would read him, all of the human possibilities which can be realized in his works.

—Donald R. Howard, *Chaucer the Man*

CONTENTS

ACKNOWLEDGEMENTS

Many thanks are in order as this lengthy pilgrimage reaches its end: to the San Dimas Writers Group for their patience, opinions and many levels of assistance; to Victor and Ted for sharing their Latin expertise; to Sabrina for consultations on French; to John for advising on matters of astronomy; to family and friends for their enthusiasm and encouragement; to Margie for volunteering time and creativity; to Virginia for being Virginia.

CHAUCER'S PILGRIMS

THE ALLEGORY

*This feeling for allegorization, for double and triple levels of
meaning, is one of the features which distinguish the great
works of imagination in the Middle Ages from the mediocre....
Only in the hands of the great poets does this world become
a reflection of all things human and divine and then only
to the perceptive reader who observes, as the medieval
audience, at least in part, did, the different
levels of understanding.*

—*W. T. H. Jackson,* The Literature of the Middle Ages *(1960)*

I. Introduction

I'VE BEEN given the answer to a six-hundred-year-old riddle
that you've probably never heard—but it's time you did. Knowing
the answer won't make you rich. It won't make you irresistible to
men or women. But it does have the power to change the world—
at least a tiny segment of it. Here is how my quest began, and how
the answer came to me.

At the beginning, I was like any other English major reading
the *Canterbury Tales.* Then things just began to happen. As I read,
I was distracted by questions about the pilgrims. What made this
precise group necessary? Chaucer's reputation was too well known,
his skills too well recognized for me to think that the group was a
haphazard collection. Why was there one pair of brothers—not
from a religious order, but two men related by birth? Why not
three brothers or no brothers? Why was there a wife—but no hus-
band and wife? Why no children? Why so few women?

When I raised the question of the make-up of this assortment
of travelers, I was told, "That's just the way it was in the Middle
Ages." End of discussion. But that never satisfied me, nor did it
stop the never-ending tape loop that had begun playing in my
head. No matter what I was doing, in some little compartment of
my brain, the images of the pilgrims were always on screen. I knew

there *had* to be an answer to the selection of exactly this group, and my need for the answer was unrelenting. And then it happened.

Picture, if you will, that what's going on in your mind is projected on a TV screen, and at the bottom of the screen there is a narrow tape running—rather the way stock market numbers are displayed. (That's the best image I've come up with to illustrate what was in my head.) That tape at the bottom ran on and on with the pictures of the pilgrims. And then—without any warning—a second tape of images began running just above the pilgrim-tape, and, in a few moments, they meshed. They matched. The pilgrims were identified. The tapes stopped running, and I sat there overwhelmed, contemplating the matched identities. It was like checking your lottery ticket against the winning numbers printed in the newspaper—and realizing *they are the same.* Amazing! Chaucer presents the first group described in terms of the second group.

Before we meet Chaucer's characters, it would help to learn about typical quarters for pilgrims. One sentence from a booklet about Canterbury Cathedral gives a simple, class-conscious description of medieval hospitality.

> The poorer pilgrims lodged in [the] Norman hall; the next [step] up the scale went along a covered way…to the Cellarer's Hall near the south-west corner of the court; while the most important were lodged at Meister Omer's, a house east of the Cathedral.[1]

Each level of society had its own expectations and accommodations. Arrangements just detailed were the norm.

Now examine Chaucer's account of the arrival at the Tabard where all his pilgrims will spend the night before their departure for Canterbury. (All of Chaucer's poetry in Modern English is my own rendering, with no attempt to maintain a rhyme-scheme. The meaning alone is what is important.)

> At night was come into that hostelry
> Well nine-and-twenty in a company,
> Of sundry folk, by chance (or fate) come together[2]
> In fellowship, and pilgrims were they all,

> That toward Canterbury would ride.
> The chambers and stables were wide,
> And we were provided for most excellently.
>
> (A 23-29)

Chaucer's lines certainly don't create an atmosphere of class distinctions. His travelers behave more like old friends on tour together. In contrast, the statement from the cathedral booklet, the "poorer," "next step," and "important" pilgrims are hardly seen as *unified*. With them, it seemed like everyone kept themselves more than arm's length away from those who were not their equals. In Chaucer's group we find a prestigious knight, a humble plowman, a clever lawyer, a dishonest miller and a refined nun all in close association.

To look further into Chaucer's account of the arrival, he tells us it was late when the nine-and-twenty companions appeared.

> And shortly, *when the sun was at rest*,
> I had spoken with each of them
> And was of their fellowship immediately.
>
> (A 30-32)

Is it likely that Chaucer could *actually* have spoken with each of the twenty-nine and formed a close acquaintance with them by the time the sun had set? That seems to stretch the truth. If the truth is what we're after, let's consider the scene once more.

Picture how unlikely it would be, under any circumstances, for twenty-nine people all to arrive at their destination just as the sun sets. No matter the distance traveled, the quality of their means of transport, their personal stamina and ability to plan ahead—twenty-nine of them, from whatever direction, reach the hostelry during that brief period we call *sunset*.

And when they do arrive simultaneously, there are no details of confusion, congestion, rudeness, noise. We learn nothing of horses, belongings, physical necessities, selection of sleeping arrangements—nothing complicates the smooth transition from their entry on the scene to our poet's association with them in a friendly social atmosphere.

The impression is like the special effects in "Star Trek"—

"Beam them up, Scottie." Presto, the crowd begins to mingle and to chat with the poet/interviewer. Chaucer's fantasy-like scene becomes even more fantastic when he acquaints us with the individuals who had just arrived.

What I experienced with the pilgrims was so exciting that I will try to guide you along a path that will allow you to share that feeling of discovery. So, before I begin to point to the clues woven into the *Tales*, the clues to a hidden identity for each pilgrim, I'm going to indicate some sign posts. For centuries, indicators of distance-traveled from London to Canterbury have existed; a second level of indicators, strangely parallel, lead into another dimension.

Those of you who know Chaucer well will probably have more difficulty understanding the language of the signs than those with limited knowledge of the *Tales*. The cause for the difficulty is that prior knowledge of the pilgrims inhibits the range of vision, restricts possibilities. Chaucer's audience actually needs to enjoy "seeing double." It's a bit confusing at the outset—but quite fascinating once you accept the aberration.

Now let's turn our attention to the pilgrims. It is understood that the group will be journeying *together*. That fact and your own basic knowledge is all you need to negotiate the twists on the trail. Let me assure you that you all have at least a nodding acquaintance with the "characters" familiar to Chaucer. What we are dealing with is very much like pictures that have come on the market in recent years, the pictures that hold a clear image, but, with concentration, a second image can also be seen. That's what we are aiming for—to see that second, alternate image.

Before we look at who (or what) *is* there, let's understand a placard that relays restrictions in the course ahead.

There are *no children.*
There are *no married couples.*
The group is *almost all men* (only three women).
One pilgrim has *no physical description*, is identified only by a function—*purchasing agent.*

Next is a well-illumined sign detailing the most energetic personality, who has

broad shoulders
wide, black nostrils
and could knock a door off its hinges by running into it with
his head.

A little past the door-crasher, a marker points to

one pair of brothers.

Mention is also made of a slender journeyer who

is easily angered
has long, extremely thin legs
is as dreaded as death
and lives in the shadows on uncultivated land.

A modest sign directs us to a man who calls for *water*.

Another man is denoted as one who rides *very high on a horse*.

The directions I read, which lead to dual personalities for the pil-
grims, become prominent at sunset and remain so throughout the
night.

Associated with the characters already mentioned, two others
are symbolized with a more complex design. Chaucer portrays the
guide of the pilgrimage as having a solicitous attitude toward

a man dedicated to war
and a woman whose motto is "love conquers all."

They arrive as part of the group and remain for the night, of course.

Now it's time to give your imagination permission to experi-
ment, to be unorthodox as you try to interpret what Chaucer is
communicating. Are there pictures in your mind? Perhaps outland-
ish pictures? Can you see the door-destroying, broad-shouldered
character alongside the two brothers, alongside the man who calls
for water, alongside the dreaded, slender, long-legged character,
alongside the man who seems to be very high on a horse? Is there

an image of the important man dedicated to war and the special woman dedicated to love, who also arrive at sunset and come to stay for the night?

(There are many other personalities, for a total of twenty-nine. I've chosen only those easiest to visualize. This visualization was tried a number of times with small groups of friends in an effort to guide spontaneous recognition.)

If you simply want to continue the explanation, skip the hints below and go on. But, if you see yourself as something of a trail-blazer and want the personal accomplishment of interpreting the connection between the signs referred to, try reviewing the particulars. After you've read the hints, close the book and cogitate.

SMALL HINT: Think about the tape analogy. All the figures are, loosely speaking, an organized group that arrives at sunset and remains for the night. How many "groups" that come for the night existed for Chaucer and still exist today?

BIGGER HINT: Concentrate on forming a mental picture of the door-smasher. (Almost every successful interpretation began with this identification.) Then the relationships of the others quite readily fall into place.

❧

For the traditional reader, the explanation of Chaucer's second pathway follows. For the trail-blazer, here's your confirmation.

The essential key to alternate identities is concealed in the fact that—instead of arriving amid hustle and bustle—they all *appear* at sunset. When I realized the importance of this apparently trivial "detail," I was astonished. This redirects our concentration, our point of view. It lifts our eyes to recognize that there is an alternate path being traveled by stars and planets visible in the night sky. The poet's descriptives listed above introduce the constellations Taurus (the bull, the door-smasher), Gemini (the two brothers), Aquarius (the water-carrier), Scorpio (the slender, dreaded creature), and Sagittarius (the centaur, the torso of a man joined atop the body of a horse). The planets Mars and Venus are the other two characters. A pilgrim was also mentioned that Chaucer gave no physical description at all. That's Libra, the Scales, not a living creature.

It will be the purpose of this book to show how Chaucer, in the finest allegorical fashion, concealed the images of heavenly bodies behind/within the specific details associated with each pilgrim.

The poet had expertise regarding astronomy/astrology. (It was more or less one science when he lived.) He wrote a text book (left unfinished) about how to calculate time, geographic location, etc., by using measurements derived from observing stars and planets. Terms used to refer to these figures in the sky may have influenced his choice of a *pilgrimage.*

The word *pilgrim* (wanderer), for example, could refer to a *planet.* Planets were wandering stars—"wandering" because they always change position in relation to the fixed stars. In a broad sense, *planet* could even mean "heavenly bodies," in general. Then the night sky is truly "peopled" with many pilgrims all on a journey. The poet, in his seemingly boundless imagination, accompanies them. His becoming part of their "fellowship" so immediately (as he relates in the *General Prologue*) is no longer surprising. Because of his background in astronomy, he already knew each of them well—he'd just never met them in "person" before.[3]

Late in the pilgrimage, another character rides in, accompanies the group for a while, and then departs. Cosmic events of the 1990s—Hyakutake and Hale-Bopp—give us the insight to see him as a comet. Identity is confirmed by Chaucer's account of the "person" and "his actions."

The poet chose signs of the zodiac and planets (the ones known when he lived) as his traveling companions. By the time we have looked at the concealed clues and considered relationships described, we may have a firm idea about *why* he used this plan and *what* new information is revealed from the "double" identity of the pilgrims.

I almost forgot. Here is the old riddle: When are people on a journey the same as stars in the sky? You probably already have the answer: When they are *pilgrims.*

Now, let's begin. We will concentrate on one surface image at a time, as with those newfangled pictures, and assume that the "second, alternate image" will define itself as we examine the intricate outlines inscribed by Chaucer.

The Cook is larger and more interesting than the mormal on his shin—and upon this point depends our ability to read his performance in something like its full tonal range.

—*V. A. Kolve,* Chaucer and the Imagery of Narrative

II. Just a Taste:
The Cook (and the Five Guildsmen)

I WANT to begin immediately with the Pilgrim Cook because I know him so well and because his identity will demonstrate an important fact in the plan for the storytellers. This will be a preview of what's to come. "Nine-and-twenty" pilgrims will be heard from. We'll meet half a dozen of them now. That ought to ease the overcrowding in the waiting area. Jostling and almost tripping over one another, the six pilgrims make their way toward the audience.

The Cook is traveling with a group of five individuals who each have a special skill. It is curious to note that they hired a cook, although we're never told that he prepared any food for them. That isn't the only thing that's curious about the group.

The Cook's zodiac sign is Cancer, the crab. The story behind the constellation is simple: Juno was pleased when a crab bit the toe of mighty Hercules; the hero killed it; Juno rewarded its bravery by placing the crab in the heavens. That's it. It doesn't have much content to inspire the poet, so he concentrated on the stars of the constellation and characteristics of the animal to create the Cook's vignette.

Chaucer provides ample evidence to make the identification—but he provides a lot more and must have been amused as he worked. The introduction of the character is like a riddle. With "seemingly and interestingly irrelevant clues...the interpreter is

lured into a maze of information." But, where a riddle often tries "to lead the interpreter…off the track,"[4] Chaucer is actually leading his audience in several meaningful directions at the same time. And his final lines provide the information that gives the solution. (We could look at the introductions as riddles to be solved. These internal riddles, however, each have multiple answers.)

There are no descriptive specifics, and the narrator tells "nothing of the Cook's personality except…his knowledge of London ale."[5] We come to know him as a pilgrim who prepares food, *and* a crab who is part of that food, simultaneously. As clothing *makes* the man, and beef *makes* the stew, so this crab *makes* the recipes.

The Cook was there "for the nones" (for the occasion),

> To boille the chiknes with the marybones,
> And poudre-marchant [seafood] tart and galyngale.
> Wel koude he knowe a draughte of Londoun ale.
> He koude rooste, and sethe, and broille, and frye,
> Maken mortreux, and wel bake a [seafood] pye.[6]
>
> (A 380–84)

> (To boil chicken with marrowbones,
> To make a fish tart specially flavored with a spice like ginger.
> He was well acquainted with a draft of London ale.
> He could roast, and boil, and broil, and fry,
> Make thick fish soup, and well bake a seafood pie.)

Chaucer, at the very end of this miscellany, establishes a single fact about the Cook's bodily characteristics and, with it, clearly defines his role in the zodiac.

> But greet harm was it, as it thoughte me,
> That on his shyne a mormal hadde he.
>
> (A 385–86)

> (But great harm was it, as I thought,
> That on his shin a *mormal* had he.)

This *mormal* is a stinking sore, an "evil held to be incurable."[7]

(Wouldn't you think that his five employers could have found a healthier, less repulsive fellow to prepare food?) The Guildsmen must not have been concerned with his condition, and the narrator seems only to display sympathy. This startling situation, with its lack of reaction, was constructed by the poet in order to indicate the sign of Cancer. It was a "necessary" aspect. Designating this affliction is about as close as you can get to his identification without simply using the word *cancer*.

Just one more line follows, and it combines with and adds credibility to the reason for the mormal.

> For blankmanger, that made he with the beste.[8]
>
> (A 387)
>
> (Blankmanger he made with the best.)

Having been told about all the recipes he was familiar with, now, like an afterthought, we learn of the Cook's expertise at preparing another medieval favorite: Blankmanger.[9] One recipe typical of the dish calls for perch or lobster, boiled with almonds, rice and sugar.[10] The poet has coupled the announcement of the open sore to a recommendation of this fish pudding. Such close association seems poorly thought out. The combination is unappetizing to say the least. The unsavoriness is meant to be *noticed*.

The narrator has changed his point of view, expanded his point of view. He is still describing a preparer of food as well as a crab—except that now the crab is a constellation of stars! That's why the pudding wasn't catalogued with the other foods. Because it was meant to be both surprising and supportive evidence.

The final pair of lines has a separate and important job to do. If Cancer "is the most inconspicuous figure in the zodiac,"[11] how can it be made conspicuous? There is only one thing about it that is noteworthy—a cluster of stars called (in Latin) *Praesepe*. *Praesepe* can mean a *Beehive*, but for our present purposes the alternate translation is called for—a *Manger*.[12] The blank*manger* "made" by the Cook[13] refers to the white (blanc) manger that makes part of the sign of the Crab.

If these lines show the sign's identity, then who are the Guilds-

men and why are they necessary? I think they are "necessary" mainly because of Chaucer's wit. He chooses to draw upon an ancient tradition. In 1 Corinthians 12, we are told, "The body is one, and hath many members." The foot, the ear, the eye are not independent, but all members of the body. Aesop produced a similar didactic fable which the Middle Ages called, "The Belly and Its Members."[14] This is the picture Chaucer is bringing to life for his audience.

We see the Cook, the character whose way of life is centered on food, as the belly. But if we acquire a more medieval view, from Chaucer's contemporary John Gower, the belly (stomach) is the "cook" for the entire body—it boils meat for all.[15] With that snatch of fourteenth-century whimsy, we realize that from the beginning of the Cook's description the poet had in mind a *cook*, a *crab*, and a *belly*. Maintaining the outlines of such a multipurpose figure would preclude endowing it with the physical attributes of a *human being*; only the mormal is sufficiently adaptable.

Now, if the Cook is the belly, the five Guildsmen *must* be the members. A group of five is, again, a "necessity."[16] We note that Chaucer carries out the tradition of members of the body having diversified tasks, as he introduces the Guildsmen. Rather than having all five men associated with the same occupation, they are:

> An Haberdasshere and a Carpenter,
> A Webbe, a Dyere, and a Tapycer,—
> And they were clothed alle in o lyveree
> Of a solempne and a greet fraternitee.
>
> (A 361–64)

> (A haberdasher and a carpenter,
> A weaver, a dyer, and a tapestry maker,—
> And they were clothed all in one livery
> Of a solemn and a great fraternity.)

When we are told that these five men are clothed all in *one* livery, Chaucer, in this game he's playing, means exactly that. A footnote to many editions of the *Tales* will explain that the men all wear the same kind of suit, but the poet offers us five men inside *one* suit—

another line meant to get our attention. Visualizing what is proposed is not that hard if you work up to it.

Chances are you've seen two men in a "horse suit": one manages the front half, the other plays the part of the rear. Below the costume, we see only their legs. This is why five men are specified, are necessary—because (at two legs each) ten is the number of appendages (members) a crab has. When I could see the idea in my mind, I wondered if such a costume existed in the Middle Ages. I was delighted to find a variation of the horse suit documented as part of a celebration which took place 100 years after Chaucer lived. It was not described as anything new or strange; costumes like this may have been used for many years. Chaucer's creation is just more fanciful.[17]

We benefit from this fifteenth-century document because it features an inordinate amount of "detail and careful specification"[18] regarding the celebration of the arrival of Katharine of Aragon to marry Prince Arthur. One of the large, decorated wagons (called *pageants*) transported entertainers and was pulled by two great lions—one silver, one gold—a hart (a male deer) and an ibex (a wild goat with splendid horns), all of significance as royal symbols of either England or Aragon. The reviewer of the procession tells us that "within every one of the four beasts were two men—one in the fore part and another in the hind part—secretly hid and appareled, nothing seen but their legs."[19]

Chaucer's allusion to a "solemn and great fraternity" could be understood as a "brotherhood," as unified parts of one body, or, what seems more likely, the poet could be referring to the relationship between all Crustaceans.

Confident that I had found the proper clues and made the proper identification of the sign of Cancer *the crab*, I read through the remainder of the introduction of the Guildsmen. When I got to their "wives," however, I became confused.

> It is ful fair to been ycleped "madame,"
> And goon to vigilies al bifore,
> And have a mantel roialliche ybore.
>
> (A 376–78)

(It is very nice to be called "madame,"
And go to vigils ahead of the other attendees,
And have a cloak carried royally.)

Why does Chaucer depict women with their cloaks royally borne, garments trailing behind as they move? This is *not* the picture of a crab. Where did I go wrong? Reevaluation was called for. Still certain that the sign itself was correctly identified, I put the problem aside for the moment because I saw no immediate possibility of a solution. I was at a dead end.

Some time later, while looking at photos of cathedrals Chaucer could have seen (a regular pastime), the solution unexpectedly greeted me. The "answer" came from a picture of the Virgin Portal at Notre Dame in Paris. Around the door jamb are the twelve signs of the zodiac which were commonly illustrated as part of the numerous decorations (carvings, mosaics, etc.) of Gothic cathedrals. Heavenly bodies were accepted decor as part of the vast universe created and controlled by God. At Paris, Cancer is not the carving of a *crab* but of a *lobster*.[20] And a lobster is obviously a figure with a substantial part trailing behind. The two creatures, crabs and lobsters, were somehow interchangeable in the medieval mind. A likely explanation, of what may seem to us as peculiar, is that because knowledge of Latin was common among the educated—both *crab* and *lobster* are expressed in Latin by the word *cancer*.[21]

Now that we have recognized that the sign can be designated as a lobster, let's return to the first lines of the introduction of the Guildsmen and search for the bits of fun that the poet has concealed.

A haberdasher and a carpenter,
A weaver, a dyer, and a tapestry maker,—
And they were clothed all in one livery
Of a solemn and a great fraternity.

The medieval Haberdasher stocked various small articles: spurs, beads, points, etc. My feeling is that the poet selects this craft for the initial character to portray someone in charge of "various small parts," a clue to the many parts contained in *one* sign. The same

feeling comes from the Cook's "name" which is recorded only once, during the *Prologue to the Cook's Tale*. He is called "Hogge of Ware," which is generally read as "Roger, from the town of Ware." But his personal name and that of the town also function as ordinary words, so the phrase can be read as "a mixture (hogge) of things (ware)." The poet leads off by indicating that he is presenting a group of associated things which make up one entity. (The Cook's name is also a clue that *he* represents the collection of things.)

That same feeling comes from the line about livery. Chaucer's word *lyveree* appears to be a play on *lyvere*—a living being. As the poet says elsewhere "I never saw as virtuous a *lyvere* in my life as she" (B 1024–25). And "clothed" can mean *covered*, as when the poet speaks of a meadow clothed in new green; perhaps a closer analogy is incarnation expressed as "to *clothe* in flesh."[22] So the line can be understood to say "they were enveloped as one living being." We have a choice now of seeing the five characters in a costume, or in a single body—or, a third choice would be to see both simultaneously.

The second of the craftsmen is a Carpenter. If we think of him as a builder of homes, this is a poetic way of conveying the remarkable ability that lobsters have as they create new shells "built" to house themselves as they grow.

A Webbe is third and is defined as a *weaver* for the surface reading, but the word *web* also means a *net* which can be used to harvest many a lobster for the table.

A Dyer follows. He has to do with dyeing, with changing color. That's what the lobster does when immersed in boiling water.

Lastly, we have the Tapycer. Rather than accepting him as "a maker of tapestry,"[23] it seems more likely that there is a play on *tapister*, someone with the ability to pierce (*tap* a keg). He might even be visualized making a tapping sound as he walks.

The physical description of the "men" is undistinguished; one set of traits fits all.[24] It's more or less to be expected with lobsters, but quite unlikely if we're viewing five men.

> Ful fressh and newe hir geere apiked was:
> Hir knyves were chaped noght with bras
> But al with silver; wroght ful clene and weel

Hire girdles and hir pouches everydeel.

(A 365–68)

(Very fresh and new their apparel was adorned,
 [or armor was spiked]:
Their knives were not trimmed with brass
But with silver; wrought very clean and well
[Were] their girdles and their pouches completely.)

They look fresh and new, their most recent change of shell—or they are catch of the day. The words describing the apparel, their visible surface, give two quite different readings depending on whether you see a man or a Crustacean. "Piked," used to described these Guildsmen, is also a term for quills of hedgehogs, spines of fish, and claws of bears.[25] It's a word equally suitable to speak of the threatening claws of lobsters or crabs.

A negative statement that follows only *appears* to give information, one of Chaucer's standard ploys. We are told that their knives are not sheathed in brass. This tells us, if we choose to see it, that the cutting tools are not brass, but instead are silver—the color, not the metal. Aristotle pictures lobsters as dull white all over;[26] white and silver were often synonymous in the Middle Ages, as were red and gold. A last view is their sleek and well-defined body segments—the girdles (bands that encircle their bodies) and pouches.

In the next lines, the narrator's interest shifts from physical description to the excellence of lobster as food.

Wel semed ech of hem a fair burgeys
To sitten in a yeldehalle on a deys.

(A 369–70)

(They seemed each of them a handsome burgess
To sit in the guildhall on a dais.)

I am always suspicious when Chaucer uses *seemed*. It is a signal to take note of what is said. In this case these "burgesses" would be found at the head table *as part of the menu*. They were fit for a king—or at least for the local officials.

> Everich, for the wisdom that he kan,
> Was shaply for to been an alderman.
> For catel hadde they ynogh and rente,
> And eek hir wyves wolde it wel assente;
> And elles certeyn were they to blame.
>
> (A 371–75)

> (Every one of them, for the wisdom [instinct?] that he had,
> Was shapely enough to be a controlling agent.
> Of property they had enough and revenue,
> And also their wives would readily assent;
> Or else they were certain to blame.)

It really goes without saying that lobsters have all the "property" and "income" they need. But what is the point of telling us anything about the wives? They aren't on this pilgrimage. The point is that Chaucer knows his craft. For example, mention of the wives interjects "assent," a term used to indicate the rising of a constellation. The wives' tendency to "blame" also demonstrates the unpleasant influence of the sign, as well as spitefulness of feminine "*crabbed* eloquence," a charge made against women by both Chaucer (E 1203) and Lydgate. Crabbedness, it was said, "comes to women naturally."[27] Vigils (evening services noted earlier) attended by the wives could hold the indication of the feminine as well as nocturnal aspects of the sign of Cancer.

Introduction of these six pilgrims is now complete, but there is more entertainment to come as the poet plays with the double image created for the Crustacean/Cook.

In the *Prologue to the Cook's Tale*, the pilgrim good-naturedly "claws" a fellow pilgrim on the back (A 4325–26).[28] A few lines later we are told that many pilgrims curse the Cook because of his "percely" (parsley). Why choose to curse innocuous *parsley*? Because the Middle English spelling of *percen* (to pierce) allows a play on *pierce*. The poet often chooses words that seem odd at the surface, but are made to order for the covert storyline.[29]

I was further amused to find, in the *Manciple's Prologue*, a scene featuring the crab/lobster/Cook apparently included just for the sheer joy of poetic imagination. The narrator tells of playing with a

straw—an activity children might dare in teasing a crab or lobster. The Cook is pale (recalling Aristotle's description) and "nothing red." This is an uncooked lobster who is in poor condition and therefore "stinks." He is doubly angry; Chaucer uses two words— "wrooth" and "wraw"—that say the same thing. The sound of the second word, however, holds a play on *raw* (MED, *rau*). To add further complication, the raw and angry pilgrim has been un-horsed.[30] His fellow pilgrims have the awkward job, with "much care and woe," of righting the "unwieldy" pilgrim (H 44–55). The terms "pinched," "bring to lure," and "in a snare" are also part of the scene's vocabulary.

In addition, there are a couple of Chaucer's typical vagueries (that which is purposely vague). The Pilgrim Manciple says to the Cook, "Of me…thou shalt not be *glosed*" (H 34). *Glosed*, for the surface story, means *flattered*, but a second definition is *explain*, as in *gloss*ary. The Manciple's remark attests that the Cook's hidden content will not be *revealed* here. Then, having been helped by a good Samaritan, the Cook "thanked him in such way as he could" (H 93). Once more, a vaguery side-steps the poet's revealing the game he's playing. We understand that an expression of gratitude *from a crab* would not be communicated with typical words or human actions.

During the pilgrimage, the five men with the Cook never utter a word. They are never spoken to or about. The Cook and his five companions function as one. It is the *sign* that is meaningful, not the number of "members" involved. The Cook represents Cancer throughout the *Tales* and tells a story that also confirms the constellation: it is about a Beehive, the other meaning of *Praesepe*. (See Appendix.) The five men tell no tales because only one story is necessary to fulfill the participation of the zodiacal unit.

This is an important point. At the beginning of this chapter, I said Chaucer's "plan for the storytellers" would be demonstrated. The pilgrims who do not tell stories have been a matter of confusion. How do we deal with the *mum*mers? In actuality, only one story is necessary from these six "individuals" because Chaucer's traveling companions on the allegorical level are not people but the *signs* of the zodiac and other celestial bodies. The same idea—one sign illustrated by multiple figures—explains why the Gemini, the

two brothers, offer only *one* story. It is predictable that only one tale from the pair is necessary. In the following chapter you will find, among other things, the explanation for this principle of necessity, of predictability.

*The sky to Chaucer and his contemporary readers was still a pictured
scroll, whose once familiar symbols we no longer read.*

—*John Livingston Lowes*, Geoffrey Chaucer *(1934)*

III. The Plan

UNDERSTANDING ALLEGORY

What happens now you may consider a pre-performance presenta-
tion: information and program material to aid your enjoyment and
enhance your experience.

Angus Fletcher courageously wrote an entire book about alle-
gory when "everyone" had given up serious study of the genre. His
pursuit takes the reader from classical literature through the centu-
ries to the present day, demonstrating the continuity and purpose
served by the form. It's fascinating reading and a must for anyone
interested in medieval literature.

Allegory is much like an extended parable. Each tells a story to
demonstrate a second and deeper meaning. I've used the following
example elsewhere; I choose to use it here again because it is so
readily understood.

The parable of the sower and the seed—where some seed fell
on good ground and flourished; some fell in weeds and was choked
by the surroundings; some fell on rocky ground, sprang up, but
soon withered because the roots were weak—is ultimately speaking
of the development of faith; the seeds are only a visual image of a
spiritual process. Both allegory and parable tell a surface story
which can be understood and enjoyed, while, at a deeper level, the

second message is being delivered. An allegory, however, though similar, is generally longer and more complex than a parable, and it deliberately "tries to be obscure."[31]

Fletcher's statement of the purpose of allegory, which follows, can also apply to parable: "Allegorical stories exist, as it were, to put secondary meanings into orbit around them; the primary meaning is then valued for its satellites. Much of the time the secondary meanings are obscured, actually withheld from view."[32] That technique is clearly the basis of the sower and his seed. To overcome obscurity, the gospel gives the interpretation, the "orbital" meaning, following the story.

Allegorical literature, with its cultivated obscurity, was "popular from the thirteenth century on and is by far the most characteristic literary form during the later Middle Ages."[33] Its structure can "make you feel that two levels of being correspond to each other in detail and indeed that there is some underlying reality, which makes this happen.... But the effect of allegory is to keep the two levels of being very distinct in your mind though they interpenetrate each other in so many details."[34] A distinct but static example of this idea is sequestered in the double-image pictures mentioned in the introduction. But allegory is not static. It flows. Both "distinct" levels communicate with us, like the Cook who prepares recipes while being an ingredient of those recipes, or like my tape of the pilgrims that merged with the cosmic level while remaining distinct from it.

Some find allegory deadly dull in spite of its boundless possibilities. Part of the reputed dullness is that two kinds of allegorical methods are lumped together: interpretive and creative. Walter Ker clarifies:

> So when the Middle Ages are blamed for their allegorical tastes it may be well to distinguish between the frequently *mechanical* allegory which forces a moral out of any object, and the *imaginative* allegory which puts fresh pictures before the mind. The one process starts from a definite story or fact, and then destroys the story to get at something inside; the other makes a story and asks you to accept it and keep it along with its allegorical meaning.[35]

Fletcher asserts that "allegories are far less often the dull systems that they are reputed to be than they are symbolic power struggles."[36]

Moralists, unfortunately, were willing to go to great interpretive lengths to "discover" inner meaning. For example, an erotic episode of "the lover plucking his rosebud," in the *Romance of the Rose*, was moralized to signify "Joseph of Aramathea taking the body of Christ down from the cross."[37] Advocating such a distorted "inner meaning" is bound to prejudice the average reader (or critic) against allegory in general.

Distortion, however, has *nothing* to do with our reading of Chaucer. Chaucer is a creative, *imaginative* allegorist; he creates "fresh pictures"; he writes two storylines simultaneously so that, "in the simplest terms, [his] allegory says one thing and means another."[38] Or, we find him saying "one thing in order to mean something beyond that one thing."[39] What little we have said of the Cook and his companions performing on more than one level has demonstrated this skill.

I gained additional assistance for my search from John Gardner and his analysis of Old English poetry, literature written before Chaucer. It is Gardner's opinion that "*all* poetry tends toward allegory...it suggests more than it states."[40] It was his description of "principles governing poetic signaling" that made me aware of much of Chaucer's style. The principles, in brief, are:

1. Poetry tends to allegory.

 An image "implies something"; the reader is "teased toward a meaning beyond that which is stated"; the writer "shows what things are somehow significant and what things are not."

2. "Suggestion" is stylistic signaling.

 A word, "or in an extended sense, an image, scene, rhetorical flight, etc....by its nature stands out from its background...capturing attention...tell[ing] us there is something to be noticed or unlocked." (*Mormal*, as an example, surely caught our mind's eye.)

 Repetition "catches the reader's attention and prompts him to ask himself what the point is."

> *Structural implications* are signals when a "seeming mistake of juxtaposition or symmetry, an apparent *non sequitur*," invites notice.[41]

I find "signaling" to be the main characteristic of Chaucer's poetry. So many of his words demand special attention. Fletcher finds the term "conspicuous irrelevance" useful.[42] That is precisely what many of Chaucer's *signals, clues, ornaments* are—words that are outstanding because they seem out of place in some way.

Boccaccio, the famed fourteenth-century Italian writer, helps us understand the medieval attitude toward allegory:

> Surely no one can believe that poets invidiously veil the truth with fiction, either to deprive the reader of the hidden sense, or to appear the more clever; but rather to make truths which would otherwise cheapen by exposure the object of strong intellectual effort and various interpretation, that in the ultimate discovery they shall be the more precious.[43]

It was Augustine (d. 430) who shaped that thought.

Although most readers today admire clarity and ease of comprehension, Augustine held that "a truth, simply and directly presented, may have no effect on the mind; whereas the same truth, concealed in a difficult allegorical presentation, may move the mind through pleasure," and "the quality of the pleasure has a direct relation to the difficulty of the ambiguities to be resolved."[44]

It helps to enlist the aid of Augustine, who, at a distance of centuries, managed to pervade the philosophy and literature of Chaucer's day. Along with pleasure gained, Augustine believed that "the beauty of poetry rests in an absolutely functional relationship between external form and inner meaning. The external form should bristle with a challenge to find an inner meaning; it is a shell to be cracked for the rich kernel. The 'aesthetic moment' comes when the shell has been with difficulty opened to reveal the contents."[45]

The world of "allegory teems with cases where the particular meaning of the work is not immediately obvious, where the inten-

tion of the work is to shroud abstract ideas under a cover of dimly understandable imagery."[46] The fact that the *Canterbury Tales* has remained undeciphered for all these centuries makes it just such a case. (In truth, I have never tried to remove a "shroud" so thickly woven in order to bring light to such a substantial corpus.)

Fletcher helps by introducing the idea of "*riddling* allegories,"[47] a category recognizable, again, from our experience with the Cook's group. A desire to develop intellectual strength and versatility caused widespread interest in riddles during the Middle Ages. Jember, a specialist in old riddles, explains that they were not like the children's game of today. They were seriously pursued as a "word game which has something in common with both metaphor and allegory, since it implies a referent by suggesting some of its attributes and characteristics."[48]

The riddler may "introduce seemingly and interestingly irrelevant clues intended to mislead and to confuse; he may also make use of puns, either to suggest his intended solution or, again, to lead the interpreter even further off the track. Thus the interpreter is lured into a maze of information—some immediately relevant, some not; some literal, some metaphoric; some direct, some oblique."[49] I don't believe it was Chaucer's intention to mislead, misinform. Details may seem chaotic in the surface reading; details difficult to apply to the surface, however, are often intended as clues to the sentence, the underlying meaning. (Trying to explain five men in one suit is an example.) I believe Chaucer's intention is to make the solving of his "riddling allegory" difficult enough to bring great "pleasure."

Although a second (perhaps a third) level is present, the popularity of Chaucer's *Tales* attests that it is very satisfying to read only the surface meaning. The point of allegory is that it does not *need* to be read with interpretation. We will look at the *Tales* as "a structure...that becomes stronger when given a secondary meaning as well as a primary meaning."[50] Our aim, therefore, is not to detract from the *Tales*, but to reveal the inner strength of Chaucer's creation.

Jember advises a hopeful riddle-solver to "stand, as it were, outside of his own consciousness and history. He must be free enough to think in genuinely new and different ways, for this is

precisely what the riddles require."[51] At the surface level, we have no problem (well, a few problems) with the *literal* view of Chaucer's riddling poetry. It's Augustine's guiding voice, again, that claims "fact furnishes the only secure basis for allegory."[52] The factual, the literal, is important.

We find enjoyment in "the literal...Chaucer took great pains to preserve,"[53] but we may not recognize when the literal or factual can also be read symbolically. If the reader does not sense an allegory to be "strongly iconographic" (we might say *symbolic*), its "literal surface then becomes sufficient unto itself, and the reader senses his own freedom from iconographic control."[54] What is this talk about control? Isn't a reader *always* free, unrestricted by what is read? What/who can exert control, deprive us of freedom?

Northrup Frye, aware of allegorical control, explains that a critic is "often prejudiced against allegory without knowing the real reason, which is that continuous allegory prescribes the direction of his commentary, and so restricts its freedom."[55] Limiting of freedom is powerfully stated (in Fletcher) by Elder Olson, who observes how doctrine (yes, religious doctrine) *determines* the action in some allegories. I will substitute "astrology" for "doctrine" to illustrate how this determining factor influences the *Canterbury Tales*:

> The allegorical incident happens, not because it is necessary or probable in the light of other events, but because a certain *astrological* subject must have a certain *astrological* predicate; its order in the action is determined not by the action as action, but by action as *astrology*.[56]

This analysis can be applied to the *Canterbury Tales*. Once we recognize the figure of Cancer and the figure of Gemini, everything else *must* fill out the pattern. It is a *necessity*. It is also why there had to be *five* pairs of legs for the crab/lobster and why there had to be precisely *two* brothers—not brothers of a religious order but brothers *related by birth*.

We understand, now, the way in which necessity will help discover who these celestial pilgrims are as they begin their journey, a journey from London to Canterbury. I checked my atlas just to survey the relative positions of the cities; it was just routine. But as

I looked at the map, my heart skipped a beat. The pilgrims would be traveling *east*. But we see the stars (including the sun) move *west*. Chaucer has them going the wrong way! This looked as if it were an insurmountable obstacle.

It was much more serious than the "crab" with part of its body illogically trailing behind. There was an essential error in my thinking. (Or so I thought for a time.) Richard Altick's volume on literary research was (and is) my constant guide; it dictates unequivocally that if an hypothesis "becomes clearly untenable, it has to be dropped."[57]

My "hypothesis" seemed to be slipping out of my hands until common sense reinforced my grasp. Too many parts fit and worked together; there was something lacking in my understanding of the heavens. That *had* to be the problem—and it was.

UNDERSTANDING FOURTEENTH-CENTURY ASTRONOMY

I couldn't continue working until I understood why Chaucer's plan was the opposite of what we know by observation. I'll tell you briefly what I learned.

From ancient times down through the Middle Ages and beyond, it was generally believed that the Earth was the center of our universe. Not only were we at the center, but we were immovable, stationary while the rest of celestial creation revolved around us. In order to explain the different sorts of movements noted with various heavenly bodies, it was theorized that there were "eight concentric hollow spheres, each of which ha[d] its own independent motion." (Picture one planet on the surface of each of these spheres, and the hollow spheres in graduated sizes one inside the other. Each has its own distinct surface motion. Earth is enclosed at the very center of this imagined cosmic design.) The seven spheres closest to us each contained one of the "planets." Counting outward from Earth, their order was seen as the Moon, Mercury, Venus, the Sun, Mars, Jupiter and Saturn. Each was found to have a unique ("wandering") path. (*Planet* means "wandering star."[58]) The eighth sphere contained the "fixed stars." These are termed "fixed" because they do not change position in relationship to each other; while "planets" seem to meander as they please. The Moon, for example, traverses the sky passing many fixed constellations.

Planetary motion is "irregular," but each has its own regular pattern. Their direction *west to east* was thought to be "natural," and is referred to as "direct," whereas, their movement toward the west is termed "retrograde." The sun, observed each day positioned against the stars at sunrise, appears to progress *eastward* through the twelve signs. As we view the zodiac, a given constellation will rise four minutes earlier each day. This rising a bit earlier each day will, at the end of a year, *return all the figures to their starting positions* again.[59]

Through meticulous study of the heavens, the ancients (without telescopes) noted that the zodiac was lagging—slowly, very slowly, tending *west to east*.[60] Aries, the first sign of the year, was slightly east of its position noted a year before, ten times farther east than a decade before. West to east (London to Canterbury) was considered the stars' and planets' preferred direction of movement. Then, to justify the apparent daily motion of east to west, an explanation had to be formulated. A ninth sphere was proposed to surround the eight spheres already mentioned. It was said to contain no planets, no stars, but was the prime mover (the *primum mobile*). It was believed to make "a complete revolution from east to west in twenty-four hours," and "its motion [was] so powerful that it cause[d] all the other spheres to revolve with it,"[61] thereby thwarting their *natural eastward movement*.

Chaucer knew these theories of heavenly bodies that apparently progress westward, but actually slowly tend toward the east. He refers to it in the *Man of Law's Tale*:

> O firste moevyng, crueel firmament,
> With thy diurnal sweigh that crowdest ay
> And hurlest al from *est til occident*,
> That naturelly wolde holde another way.
>
> (B 295–298)

> (O first moving, cruel firmament,
> With thy diurnal sway that presses on
> And hurls all from east to west,
> That naturally would continue another way.)

The poet calls the firmament "cruel" because, as Manly explains, "its daily motion force[d] all the heavenly bodies to revolve round the earth in a direction contrary to their natural motions."

Making a leap from astronomy back to our medieval poem, we need to put ourselves into the allegorical mode to make a time adjustment. The pilgrims travel a "day" in the surface plot, but at the covert level, the journey takes one *year*.[62] This should not come as a complete surprise because we are dealing with all twelve signs of the zodiac. In a year, the zodiac circles through the heavens and returns to its original point of departure; the pilgrims will also come full circle by returning to the Tabard—*their point of departure* for Canterbury.[63]

Circles (and spheres) were associated for centuries with the idea of perfection. While the twentieth century is inclined to picture time linearly—from cavemen to Charlemagne to the twenty-first century and beyond—the Middle Ages had a sense of time as a circle. Much of life was thought of as cycles: seasons of the year, the high and low of the wheel of personal fortune, our own "dust to dust," and much more.

We know at the start that the pilgrims plan a round trip. As they travel, Chaucer refers now and then, in an offhand manner, to a time of day or a village en route, but time or locale rarely influence action or conversation.[64] Some of the narrator's statements, as far as "reality" is concerned, seem impossible to justify—five men in one suit, for example. Time, place, and "impossibilities" are all part of the signaling. We'll find a number of instances as the pilgrims pass in review.

While I was preparing to put this section together, an extraordinary thought fell into my head. It reflects several medieval conclusions—about time as a circle, the calendar, the end of the world and the Creation of the cosmos. (We'll take a quick look at each topic.) Commencement of the storytelling takes on a triple significance now. By Chaucer's design, it is the Knight who will begin.[65] That is as it should be—as it should be—as it should be.

[I'll digress for a moment to say I've read about the conventional levels of interpretation and the names given them (literal, allegorical, tropological and anagogical), but I've never been able to hang on to the distinctions. For example, I'm not sure what I'm

suppose to "see" tropologically regarding the Knight. Though I'm unable to identify which interpretive category corresponds to this new thought, the revelation gave me well-delineated evidence of another level of meaning.]

To tell the first tale would be proper for the Knight, the most prestigious individual on the journey.[66] We noted in the introduction that this man, described by the poet as dedicated to war, can be recognized by his attributes as Mars. From another point of view, or on a different level, for Mars to begin the proceedings might even be predictable because Mars' month, *March*, is the first month of the calendar used in Chaucer's day. (This old calendar holds the secret to why—with twelve months in a year—September, October, November, December are named for seven, eight, nine and ten. December being the tenth, there need to be two more months to make it twelve, so that we return to March and the beginning of another year.[67])

In addition to facts about the calendar, it's necessary to be aware of the late fourteenth-century anxiety regarding the End of the World. No doubt the several attacks of the Black Plague that swept across Europe intensified the anticipation. Many believed the end would come in 1400.[68] Domesday (Judgment Day) loomed large.[69]

Mindful of Domesday, in the introduction to the last of the *Tales*, Chaucer takes note of the sun declining.[70] Day is almost spent. The narrator draws attention to the fading light and to the ascending sign of Libra, the Scales, an image denoting Judgment.[71] The Host, the one who freely offered to guide and judge the pilgrims, exhorts the group that there is little time left. These indications of the end of this *day* impart a message of *Judgment Day* at another level.

With this knowledge of the ending of the *Tales*, the beginning takes on new meaning. *March* takes on greater import. An assumption in the Middle Ages was that Creation was accomplished in March. Chaucer alludes to this fact in one of the tales.

Whan that the monthe in which the world bigan,
That highte March, whan God first maked man.

(B 4377–78)

42

(When the month in which the world began,
That was called March, when God first made man.)

The progress of time, for medieval man, was a grand circle called the Great Year. This concept of time begins with Creation and ends with Judgment.[72] Setting out on the journey with Mars/March as the first representative and ending as the Scales are visible and darkness imminent holds a message beyond the cycle of a normal year.

Ancients had described how each and every celestial body, even those with "irregular" paths, would ultimately return to the exact place where it had been when time began. For the zodiac, moving *slightly* eastward each year, to achieve the end of its full circle, indicates more than the end of a *year*; this full circle denotes the end of the Great Year, that is, the end of time.[73] The Canterbury pilgrims, too, will return to their point of origin, which is signaled by a thought-catching impossibility. The whole group will return to the Tabard, with the directive that all twenty-nine be at "this place, sittynge by this post." Surely twenty-nine pilgrims can not *all* sit by one post; this is the poet's way of saying "return to the point of origin."

Aware, now, of the primary importance of March in the calendar as well as in Creation, let's take a final astronomical look at the Knight, the image of Mars, the patron of March. For the Knight, in the surface story, to be asked to tell the first tale out of respect for him as the pilgrim of highest social position is as it should be. For the Knight, as Mars (for whom the first month is named) to inaugurate the year's stories is as it should be. And now the additional intention for the Knight, as Mars (in whose month the first movement of the cosmos occurred), to begin the progress, which will conclude as time runs out, is also as it should be.

UNDERSTANDING THE ROLE OF PAGAN GODS
IN THE MIDDLE AGES

The modern way of looking at the stars and thinking about their cosmic activity is just that—modern. Ancient writers, such as Plato (d. 347 B.C.) and Ovid (d. ca 17 A.D.), both greatly respected in the Middle Ages, viewed the heavens as an orderly, *thinking* existence.

Plato's *Timaeus* tells of how the great Artificer put the universe together, made the planets (for example) as "animate creatures." They, the planets, "had learnt their appointed task." Each episode in Ovid's *Metamorphoses* conveys the same message about the universe: "The cosmos is alive."[74]

The Roman author Cicero (d. 43 B.C.) in his *On the Nature of the Gods* goes a step further to state that the stars themselves are to be reckoned as *gods*. They "move of their own free-will and because of their intelligence and divinity." Plato also speaks of "the gods, who are the stars of heaven...so many of them as are fixed stars."[75] Individual stars were recognized as having a particular appearance, sex and character which "their names alone suffice to evoke." Pictured as gods and goddesses who walked and talked in addition to having their celestial existence, the "fusion between astronomy and mythology is so complete [200 B.C.] that no further distinction is made between them." It was even felt that identifying the heavenly bodies as visible gods was an improvement because they are "superior in constancy of character to gods of mythology."[76] This absorption of the ancient gods into the stars assured the survival of pagan deities.

Pronouncements from antiquity were often incorporated poetically, allegorically into the writings of Chaucer, as well as those of his predecessors and contemporaries. Chaucer's awareness of cosmic absorption is noted in *The Parlement of Foules*. Bennett points out that, although it might seem that the following lines address a goddess, the narrator is actually speaking to a planet.[77]

> Cytherea, thow blysful lady swete,
> That with thy fyrbrond dauntest whom thee lest,
> And madest me this sweven for to mete,
> Be thow myn helpe in this, for thow mayst best!
> As wisly as I sey the north-north-west,
> Whan I began my sweven for to write,
> So yif me myght to ryme and ek t'endyte!
>
> (113–19)

(Cytherea [Venus], thou blissful lady sweet,
That with thy firebrand controls whom thou would,

44

And madest me this dream for to dream,
Be thou my help in this, for thou may best!
As surely as I see thee north-north-west,
When I began my dream for to write,
So give me might to rhyme and also to indite [compose]!)

The goddess *is* the planet.

Cicero's commentary adds difficulty to our attempt at understanding. He touches on a point often taken up later: one god could have "as many names as mankind has languages."[78] Cytherea-Venus is just a taste from an extensive international menu. And Augustine disparagingly refers to multiple names in a number of places; for example, Ceres is identified with Magna Mater and also with Juno. Or Libera is Ceres as well as Venus. Or, again, Tellus is equivalent to Juno, who is Ops, or Proserpina, or Vesta. Each cluster of names is associated with one "personality." As if that were not enough, a single "personality," such as Hercules, or Neptune, or Minerva could have several backgrounds, could be a different god to different cultures.

Along with these assimilations of stars to gods, and gods of many backgrounds signifying a single personality, a different sort of assimilation of pagan images also occurred. Augustine declared it proper, even advantageous, to use pagan treasures to help preach the gospel. Cicero's myths could, then, be read as history; gods were unusually gifted historic human beings. Or myths could illustrate the powers of the universe; gods were cosmic symbols. Or myths could be fables presenting philosophy or morals; gods acted out allegories. In the early sixth century, Boethius "rescued" stories from Aesop's beast fables and from Ovid's poetic—often racy—stories so they could be turned into "Christian moral discourse."[79]

Day-to-day life of Christianity met the pagan world face-to-face in efforts toward conversion. St. Gregory "the Great" (d. 604) and many of his successors advocated avoiding confrontations if possible, promoting "Christian alternatives" instead. Images, stories, celebrations "already familiar and revered" in a pagan culture were transfigured into "the service of Christian worship."[80] Outstanding transfiguration came about with the great feasts of Christmas and Easter as they superseded pagan festivals of winter and spring.

Christian writers "proposed that the pagan stories had to mean something, since they could not be what they seemed on the surface."[81] Cicero, as mentioned above, could have three edifying alternate readings. Ovid's *Metamorphoses*, rather than denoting revenge of gods upon humans or power struggles between gods who use humans as pawns to satisfy their whims, was given a "sacred meaning." In words much like Boccaccio's justification for this use of allegory, twelfth-century John of Salisbury demonstrates how a work like Ovid's found new life as a source of "sacred truth": "Not out of respect for false deities, but because under cover of words truths are hidden which may not be revealed to the vulgar."[82] Only those who were, in some way, worthy would understand.

Some interpreters worked out correspondences of ancient gods to Biblical characters. Another type of reciprocal correlation was Alexander Neckham's system where the seven planets stood for the seven gifts of the Holy Spirit. Hidden meaning was "found" in the Mars-Venus liaison: it "really" demonstrated lust dishonoring virtue. And, in that story, when the sun exposed the guilt of the two lovers, Venus took revenge upon the five daughters of the sun, who, newly interpreted, were man's five senses.[83] Christian interpretations were often "intricately theological analyses."[84] God overseeing such celestial adventures (are the participants gods or planets?) was addressed as "Chief Astronomer."[85]

Finding of pagan elements converted to Christianity makes for fascinating reading in the works of European researchers, including Erwin Panofsky, Fritz Saxl and Jean Seznec. (Their works are readily available in English.) We now understand how ancient gods influenced medieval thought processes and the visual arts. The calendar developed elaborate allegorical depictions. As early as the fourth century the months as well as the zodiac were "personified." There were no motifs more wide-spread and ingenious than those representing the zodiac.[86] With God as the Mighty Astronomer, the signs were twelve of His servants.

In absorbing classical figures to enhance Christian expression, God Himself could be "Jupiter Omnipotens." In Origen's third-century commentary on the *Song of Solomon*, Christ and the Church were portrayed in "Platonic reminiscences" as Eros and Psyche.[87] Illustration of Hercules in the twelfth century "hardly

differs from...St. Michael fighting the dragon."[88] But sometimes an image of Hercules represents not Michael, but Christ. Seznec, with an artist's understanding, explains that "as pagan ideas gradually became severed from expression in art, Christian ideas came forward to inhabit the forms thus abandoned."[89] There was no reason for craftsmen to give up a good model.

Gems are to be found with traditional carved pagan images of Cupid and Minerva. When adding identifying lettering, however, the mythical characters are "deliberately transformed" with inscriptions as the Angel of the Annunciation and the Virgin Mary, respectively.[90]

A different sort of medieval imagery also developed as pagan divinities became "indistinguishable in dress and attitude from the noble lords and ladies."[91] The famous astrologer Michael Scot created portraits of planetary figures not classical at all, but depictions of contemporary nobility. For example, Jupiter, in Michael's manuscript, is a distinguished gentleman holding gloves.

Though the zodiac had long decorated cathedrals, the planets were not given a like honor until the fourteenth century.[92] A Florentine stone carving of the period shows Jupiter as a monk holding a chalice and cross.[93]

Seznec sees the "crowning touch" of these developments as the early fourteenth-century moralized Ovid, recommended as edification for convents of nuns, in which "goddesses are represented as being nuns themselves. The gods are clergy." The depicted superior and her companions "are obviously [the goddesses] Pallas, virgin Diana, Juno, Venus, Vesta, Thetis." Mythical figures could also portray human qualities—strength, heroism, lust, deception, wisdom, etc.[94]

Chaucer had read the myths and had translated some of the works we've considered. He had opportunities to see or hear about many illustrated manuscripts and cathedrals. His treatise of instruction on the heavens leaves no doubt as to his acquaintance with celestial matters. He surely concurred with Cicero's admiration of the complete order of the heavens.[95] In these celestial movements a "strictly ordered system of mutually dependent relations...afford the perfect iconographic device." It is no surprise that celestial order would be used to "describe the orderly character of allegory itself."[96] Henry Peacham, in 1593, proclaimed,

> The use of an Allegorie serveth most aptly to ingrave the lively images of things, and to present them under deepe shadowes to the contemplation of the mind, wherein wit and judgement take pleasure, and the remembrance receiveth a long lasting impression, and there as a Metaphore may be compared to a starre in respect of beautie, brightnesse and direction: so may an Allegorie be truly likened to a figure compounded of many stars.[97]

Chaucer's life predated Peacham's by 200 years. Our poet could not have *read* this description, nevertheless his own training, observation, and imagination could have had a similar recognition of the perfect correlation of allegorical structure to the structural life of the heavens. In whatever manner the idea developed, combining allegory with the cosmos is what I see as a secondary meaning, a covert plan of the *Canterbury Tales*.

There is one more empowerment the stars possess, in addition to their personalities, but that must wait until later.

CHAUCER'S PROPOSAL IN THE GENERAL PROLOGUE

Some may insist that it isn't "Chaucer" who is making the proposals, but his narrator. I have explained elsewhere[98] that I see Chaucer in a pre-Freud, pre-Jung fashion, expressing himself in many ways: as author, as narrator, and as Pilgrim Chaucer traveling with a group of fictitious characters. I am pleased to accept his opinions, testimony, etc., as information the author wants us to have, information presented in the most entertaining way possible.

So what is it that he proposes to tell us about the nine-and-twenty pilgrims?

> whil I have tyme and space,
> Er that I ferther in this tale pace,
> Me thynketh it acordaunt to resoun
> To telle yow al the *condicioun*
> Of ech of hem, so as it semed me,
> And whiche they weren, and of what *degree*,
> And eek in what *array* that they were inne.
>
> (A 35–41)

(while I have time and space,
Before I get farther into the tale,
Methinks it is according to reason
To tell you just the condition
Of each of them, as it seemed to me,
And who they were, and of what degree,
And also in what array they were in.)

Words emphasized work nicely at two levels. The glossary and notes of the Baugh text of the *Canterbury Tales* assist us to understand *condition* as economic or social status, *degree* as rank, and *array* as clothing or adornments. These three words describe *people*, but they are used in association with *sky-watching*, as well. When the poet says "it *seemed* to me" (as he does here) I always assume "but not necessarily." He is imparting something beyond the obvious.

Finding a specific celestial parallel for the word *condition* is not difficult. Gower says the "condicion" of the planet Saturn causes malice and cruelty.[99] And Chaucer's *Treatise on the Astrolabe* instructs that if a planet is moving westward "in that *condition*, then he is retrograde" (Topic 35). The *Treatise* also gives specifics about the *condition* of the zodiac (Topic 14).

Degree needs no explanation as a term related to the location of celestial bodies.

Array as attire suits the surface reading, while *array* as an orderly arrangement of things readily captures the impression of the night sky. As one example, in speaking of the prime mover, Chaucer sees heaven "in such array" (B 299). And in *Troilus and Criseyde* the poet sees Venus well *arrayed* (that is, in an amiable position) in the seventh house of heaven (2.680–81). Ambiguity involved in the *array of Venus* projects a merged image of a beautifully clad goddess and a friendly planet. This two-fold possibility made it necessary for Bennett to specifically identify the recipient of a prayer as Venus the *planet*.

So while the regular storyline of the *General Prologue* presents a group of pilgrims in "one of the most perfect compositions in the English language,"[100] a remarkable, alternate storyline will acquaint us with heavenly characters as fascinating as their "real" counterparts.

For more than 650 lines (the center of the poem's universe) the pilgrims are introduced individually. The poet then composes a formal ending to these captivating vignettes.

> Now have I toold you shortly, in a *clause*,
> Th'*estaat*, th'*array*, the *nombre*, and eek the *cause*
> Why that *assembled* was this *compaignye*.
>
> (A 715–17)

> (Now have I told you briefly, in a clause
> The state, the array, the number, and also the cause
> Of why this company was assembled.)

Highlighted words lend a second level of understanding to this closure. *Clause*, aside from a grammatical unit, also hints at hidden meaning. An alternative to *clause*, in versions of the medieval *The Cloud of Unknowing*, is *sentence,* which has the connotation of an underlying message. *The Cloud* speaks of "some *clause* (or *sentence*) that was very hard…on the first or second reading." Lydgate also advises that "some clause" of a Chaucer poem ("An ABC") "will illumine" the reading of a work by Lydgate.[101] So in this lengthy *clause* he has told us of an *alternate meaning* involving the pilgrims.

Their *estate* (or *state*), aside from expressing (humanly speaking) stature, form, or position, can tell of the "aspect" of heavenly bodies, or "the phase of full illumination." A planet can stand "in good state"; the moon is seen "in clean state."[102]

Array we have already discussed because it was included in the list of special terms preceding the portraits.

Number signifies a group or collection of persons or things. It also alludes to order, as in Gower's statement, "the Sign which is *numbered* eight is Scorpio." Not surprisingly, there are numerous biblical references to God's *numbering* (and naming) the stars, and man's vain attempt to do the same.[103]

The word *cause* designates the stars as the source of "many wonders" and the planets as the "cause [of] influence" upon men.[104]

Middle English "assemblen" refers to gathering, bringing or putting things together. Gower alludes to astronomy and astrology

being "assembled." Boethius refers to the world being "assembled in one form" by the joining of "many diverse things."[105]

A strange implication of *company* is that it is a collective term for a group of *equals*.[106] On the surface, by their occupations or social status, the Canterbury-bound travelers surely are not equals. As an assembly of celestial figures, however, *company* functions as a proper descriptive.

Notice that, of the categories listed earlier, *array* is the only one also found at the conclusion. Chaucer has a real talent for clouding issues. Did he tell us about the pilgrims *condition, degree* and *array* as he said he intended before he began to talk about the pilgrims? Or has he presented their *estate, array, number* and *cause for assembly*, instead, as a covert message? Chances are he has done both.

Finished with his beginning and ending words that allude to heavenly actions as well as earthly qualities, we assume the poet is ready to take up the evening activities in the Tabard—but wait. With closure of descriptions at A 717, the poet, at A 743, inserts an apparent afterthought. Though it sounds like a trivial addition (if trivial, why bother?), it informs us that we will begin our task without a clear idea of how it will progress. The poet coyly, cunningly, casually remarks,

> Also I prey yow to foryeve it me,
> Al have I nat set folk in hir degree
> Heere in this tale, as that they shoulde stonde.
> <div align="right">(A 743–45)</div>
>
> (Also I pray you to forgive me,
> Although I have not set folk in their degree
> Here in this tale, as they should stand.)

The importance of the statement is, first of all, that the apology implies there *is* a proper order. Secondly, we must be prepared *not* to find the zodiac figures in order one after the other, nor the planets listed in their progressive distances from Earth. Our knowledge of astronomy will *not* be an automatic guide to recognition. So we will concentrate on the effect of the clues as we watch Chaucer, the creative allegorist, at work.

CHAUCER'S WORDS AND THE GAMES HE PLAYS

I can't stress enough that what Chaucer does with words is a treasure locked in Middle English. When the lines, the words, are modernized for ease of reading, something is lost. That "something" might very well be the life-blood, the vitality of Chaucer's art.

An example I love to use—because it is succinct and quick to grasp—will demonstrate just how much can be lost. An important character named "Sir Thopas" is described as weary from

> prikyng (pricking) on the softe gras.
>
> (B 1969)

Chaucer's line, reworked a few years ago, reads

> galloping over the tender grass.

The double-entendre in Chaucer's line has disappeared in the modern version—and so has the spice of the story. If you are thinking that the twentieth-century line has been expurgated for an innocent audience, on the contrary, it is clear later in the story that crudity is exploited.[107]

The idea of reading Middle English may put you off—even frighten you—but let me interject my own bit of encouragement, as well as that of John Livingston Lowes. For myself, I'm hoping the examples from Chaucer I've selected, coordinated with the modern words (my transliterations) that follow each tidbit, will help you recognize that Middle English (on the page) is *not* that different from our language as you know it. Whole lines (when you accept the variable spelling) are easily read. A word or two, in the space of several lines, may be a problem, but isn't that just as true, perhaps even more so, when reading Shakespeare, or a profession's jargon, or slang from a subculture?

Lowes, in his series of charming lectures as a lover of Chaucer, gives the following recommendation for the fourteenth-century language.

> The obstacle to instant understanding does exist, and I have no intention of belittling it. But I should like to say

with emphasis—and I am speaking not to the student of Chaucer but to the lover of books—that it seems more formidable than it is. A bare fraction of time which we spend in learning to read Homer or Virgil or Dante or Molière or Goethe will enable us to read Chaucer as he is meant to be read, to wit, with delight.... For it is in words and idioms...Chaucer's men and women speak—speak, at their best, with a raciness and point and flavour that have never been surpassed. Nor is it [essential]—and I think I know—to master all the complexities of Middle English in order to follow with intelligence.... It is, I suspect, the awe-inspiring [obstacle] of Chaucerian scholarship which has often scared the laymen for whom Chaucer wrote.[108]

So, fellow laymen, we are Chaucer's designated audience; put fear aside and give his English a fair trial.[109] It is not as forbidding as you think.

There have been countless valuable observations about the *Tales*. V. A. Kolve, for example, has grandly demonstrated that "Chaucer most characteristically sought to exercise the *visual* imagination of his audience."[110] His scenes and characters come alive.

Ralph Baldwin remarks on the poet's genius exhibited in the labels applied to the traveling companions. One word indicates their class, purpose, and personification; Chaucer's "name" for each "presents, denotes, and describes at once."[111] While literary personae were generally delineated with "either a measure of eulogy or of censure for the mediaeval writer," Chaucer, in contrast, introduces only "nonpareils." Whatever their calling, "each is the best of his kind."[112]

The reader finds that "discontinuity and incongruity of detail are Chaucer's stock in trade," and, yet, the "delirious garbling of detail...works."[113] It isn't that Chaucer is disorganized—it's that his statements are ambiguous, his topics complex, and the personalities he creates are earthbound and heaven-bound simultaneously. Both the pilgrims and their journey are multilayered.

Howard recounts trends of Chaucer criticism: It was felt that Chaucer drew directly from life. But a "counter-trend" held that

"nothing in Chaucer is what it seems." And then there is "the enthusiasm [of early scholars which] argues powerfully in favour of...everything is *exactly and only what it seems*, that every utterance is *exactly and only what it says*."[114] The word *seems* does not necessarily express *is*; to be exactly what a thing *seems* is cryptic, nebulous. And, again, to say "exactly" what one means may cluster several ideas in one expression, even in one word, when we deal with ambiguity. Baldwin provides a good example. He perceives that "lines [of the *General Prologue*] serve to give a semblance of movement" before the pilgrimage has begun.[115] If movement is "felt" without being stated, what happens to the idea of exactly what it *seems* or *says*?

Edith Rickert, a Chaucer scholar of the first half of this century, reported what F. N. Robinson says "may be one of the few cases of word-play in Chaucer."[116] That opinion is untenable today. Chaucer's innocent little words can catch us off guard. They seem always to be playing a game. Allegory certainly encourages such imagination and creativity.

A "searching" Bertrand Bronson finds that characters "not infrequently meet in startling juxtaposition."[117] He concludes—and I agree—that,

It is evident that this poet has few compunctions about transgressing the laws of natural probability. But there may be other laws in the world of imagination that he inhabits.[118]

It is in "the world of imagination" that he gathers, cultivates and regenerates what passes through his mind. So many traditions, disciplines, modes were available to the fourteenth century, and we get the impression that Chaucer knew them all.

He certainly knew Augustine as a philosopher who believed "all created things...had symbolic significance."[119] Because symbolism was omnipresent, the Christian "found oneness of pleasure and truth in discovering the underlying meaning of all he *saw* and *read*."[120] (This helps to explain the medieval fascination with riddles.)

Along with philosophy, Chaucer was surrounded by allegory. Its great popularity can be attributed, in some degree, to "the add-

ed advantage of being mysterious and requiring skill to be under-
stood." Allegorical technique can use "any fragmentary utterance
[which] takes on the appearance of a coded message needing to be
deciphered." Chaucer tantalizes with fragments. He breaks off in
the middle of a thought, suddenly takes leave of a topic with the
equivalent of "enough said." John Speirs recognizes that Chaucer's
"art is as much in what is left unsaid as in what is said."[121]

We must be aware of omissions, as well as fragments. Fletcher
tells us that "the silences in allegory mean as much as the filled-in
spaces, because by bridging the silent gaps between oddly unrelated
images we reach the sunken understructure of thought."[122] We feel
that gap, that understructure between the Cook's running sore and
his expertise in producing "blankmanger." This "gap" is an aperture
providing a glimpse into another world, another level of meaning.

In moments of "oddly unrelated images," Dorothy Everett
trusts the poet's skills, his purpose, feeling that "however apparent-
ly haphazard or even incongruous some things may appear to be, it
would be dangerous to assume that Chaucer introduced them
without good reason."[123] "Dangerous," though strong, is fitting.
The poet's mastery cannot be overestimated; a reader's gliding over
the eccentricities handicaps him in grasping the poet's colorful, in-
tricate textures.

Personification, another poetic gift, entertains us in "The
Complaynt of Chaucer to His Purse," a poem of twenty-six lines.
He speaks *to* his purse, flattering,

> Ye be my lyf, ye be myn hertes stere,
> Quene of comfort and of good companye.[124]
>
> \qquad (12–13)

> (You are my life, you are my heart's guiding star,[125]
> Queen of comfort and of good company.)

This poem serves a singular purpose: the closing stanza solicits as-
sistance from England's king to relieve this "dear lady's" plight.

When he isn't talking to his purse, he is selecting clever *names*
that began life as ordinary words. Both *herry* and *bailly*—the two
names given to the Host—are common words. The Cook's *hodge*

and *ware* were noted in the first chapter. The list goes on and on—eglantine, middle/burg, dart/mouth, goat/land, bath, and many more. We'll try to understand the part these words play as clues of association.

Another of his devices is the word *pilgrim*, which functions as a disguise. The poet's Troilus, in order to make a surreptitious visit to his beloved, will "lik a pilgrym to desgise" (5.1577). How natural to use the same ploy on a grander scale in the *Canterbury Tales*. It also carries on the old tradition that we are all pilgrims and life our pilgrimage—no matter how diversified our real identities may be.[126]

Pilgrims of the sky, stars and planets, were often creatively incorporated into medieval works. Chaucer, in his *Treatise on the Astrolabe*, informs us about images generated by the zodiac. It is "the cercle of the signes, or the cercle of the bestes (beasts)." "Zodia" in Greek, he tells us, corresponds to "beasts" in Latin.[127]

These "beasts" are part of the spectacle in his *House of Fame* as the narrator is being whisked through the air transported by an eagle. The bird, philosophizing about life, says,

> "Now turn upward," quod he, "thy face,
> And behold this large space,
> This eyr; but loke thou ne be
> Adrad of hem that thou shalt se;
> For in this region, certeyn,
> Duelleth many a citizeyn,
> Of which that speketh Daun Plato.
> These ben the eyryssh bestes, lo!"
>
> . . .
>
> "Now," quod he thoo, "cast up thyn yë.
> Se yonder, loo, the Galaxie..."
>
> (925–36)

> ("Now turn your face upward," he said,
> "And behold this large space
> This air; but look and be not
> Afraid of them that thou shalt see;
> For in this region, certainly,
> Many citizens (inhabitants) dwell

Of whom Plato speaks.
These are the airish beasts, lo!"

. . .

Then he said, "Now cast up thine eye.
See yonder, lo, the Milky Way...")

In another short poem, "Truth: Balade de Bon Conseyl (Good Counsel)," a similar scene uses both pilgrim (planet?) and beast. The lines draw attention to the insignificance of earthly things and recommend dedication to the spiritual (gostli). Chaucer presents the world as transitory; gazing upward, once again, one beholds man's true home.

> Here is non home, here nis but wyldernesse:
> Forth, pilgrym, forth! Forth, beste, out of thy stal!
> Know thy contree, look up, thank God of al;
> Hold the heye wey, and lat thy gost thee lede.
>
> (17–20)

(Here is not home, here is nothing but wilderness:
Forth, pilgrim, go forth! Forth, beast, out of thy stall!
Know thy country, look up, thank God of [for] all;
Hold the high way, and let thy spirit lead thee.)

The pilgrims and beasts here give an impression similar to the departure of the Canterbury journeyers. It is possible to perceive two levels of figures in the *pilgrims* and *beasts*: first as human pilgrims with horses; and then as (living) planets joined by signs of the zodiac.[128] Beasts (of the little poem) in *stalls* reflect the structure of spatial compartments inhabited by each sign.

Chaucer's narrator, in the *Parlement of Foules*, has a down-to-earth African guide.[129] The African, like his eagle counterpart, is a philosopher. He exhorts the poet to be aware of the comparative littleness of the earth, not to take delight in it, and adds a prophetic message.

> in certeyn yeres space
> That every sterre shulde come into his place

Ther it was first, and al shulde out of mynde
That in this world is don[130] of al mankynde.

(67–70)

(in the space of a certain number of years
When every star should come into its place
Where it was at first, and all should be forgotten
That which in this world is finished for all mankind.)

Chaucer speaks here of the world's end when every star returns to its point of origin. That concept, too, was in his mind as the *Tales* were formulated.

When Chaucer translated Boethius' *The Consolation of Philosophy*, he heard of a high way to be followed. Life was expressed as a struggle to win heaven. In cosmic terms "the erthe overcomen yeveth (giveth) the sterres." (Earth overcome achieves the stars. IV:m. 7)[131] This same roadway could be the one found in "Truth," and possibly the "way" traveled in the *Tales*.

Consider the elements we've noted in Chaucer's works. Boethius speaks of a high way that leads us; the stars are attained when earth is overcome. In *The House of Fame*, we're taken on a philosophical tour of the heavenly display. In "Truth," pilgrims and beasts are set in motion as the person addressed is told to raise his eyes and allow his spirit to guide him. In the *Parlement of Foules* we hear of each stellar ornament returning, once again, to its initial position at world's end. Stars related to heavenly reward, and both related to the pilgrimage of life, need not have been a sudden flash of inspiration for Chaucer. On the contrary, the idea may have gradually developed and become more solid and complex in his "world of imagination."

Stars moving in the heavens have always attracted speculators and poets. When we say *cosmos* today, our attention is on the universe. The term *kosmos*, however, was used by Aristotle (*The Poetics*) with two meanings—the universe and ornaments. Fletcher prepares us for Chaucer's anticipated performance by connecting cosmos as ornaments in poetic creation:

Obviously when a poet sets out to write allegory…he forc-

es the reader into an extreme consciousness of differences in status. As far as imagery is concerned then, the art of allegory will be the manipulation of a texture of "ornaments" so as to engage the reader in an interpretive activity.[132]

"Ornament" plays an important part on two levels. It expresses a characteristic of the heavens and of the earth with the same word, preparing us for the several-faceted heavenly/earthly pilgrims. Ornaments Chaucer attributes to them—quirks of garb, oddities of life-style, unique forms of address, extravagances of association—are the clues to each riddle.

Their "mounts," too, are integral, symbolic. This ploy has a long tradition. Ovid's *Fasti* represents the movement, progress or control of celestial figures as their horses. The sun takes a long year to pass through the zodiac signs that "the horses of the [moon] traverse in a single month" (129). Each starry component is coordinated to its mode: "steeds" of the moon are "snow-white" (217); the evening star's transport is "dusky" (81); Mars' horses are "swift" (119); the dawn is "saffron-robed...on her rosy steeds" (241). A three-day interval occurs as the sun god will "thrice yoke and thrice unyoke" his team (201).

Outside of classic myths, a horse serves Death, in the Apocalypse (6:8). The early Christian *Psychomachia* tells of horses ridden by Pride and Lust. Lydgate, too, presents personified sins on horseback. And, in a variation where the human is the horse, *Piers Plowman* finds Fee riding on a Sheriff, Fraud astride a Juryman, and others, each "equestrian pair" denoting a person's controlling vice.[133] By this same pretense, Chaucer will disclose ambiguous information about the pilgrims—as journeying humans *and* as travelers through the sky—when he speaks of their means of travel.

Celestial horses, Ovid tells us, are kept in "lofty stalls."[134] When an assembly of gods visited the palace of the Sun, radiant double folding-doors were flung wide to receive the luminous guests. That's a far cry from a medieval hostel with travelers segregated by class into separate stone buildings. How can earthbound fourteenth-century arrangements approximate the regions of space? They can't. Accommodating Chaucer's covert stars and planets

demands special arrangements. Instead of providing reality, Chaucer conjures up a fantasy.

> The chambres and the stables weren wyde,
> And wel we weren esed atte beste.
>
> (A 28–29)

> (The chambers and the stables were wide
> And we were well cared for at the very best.)

An inn patronized by the general population in the middle of crowded London would hardly have spacious stables and chambers. If we know that Chaucer's description differs greatly from actuality, what is he telling us? A vast cosmic intention waits at the covert level. Many heavenly images reside in words that also—but in less appropriate ways—demonstrate human actions and characteristics.

Regarding his pilgrims, there is a "commonplace" that implies "the portraits which appear in the General Prologue have a designed togetherness, that the portraits exist as parts of a unity." Demonstrating this "commonplace" is our purpose here. The unity, however, does not imply homogeneity. Each pilgrim exists as a microcosm; we never "go over the same ground twice—each…is a new beginning."[135] This has been precisely my experience; each pilgrim has led me in a different direction, challenged me in a new area.

An admiring John Tatlock points out that "Chaucer breathes the breath of life into a formula already existing."[136] Even though we don't understand everything Chaucer is doing, we know he is creating new ways to use old ideas and traditions. His new "laws," new rules transcend space, awakening, with oddities and "empty" phrases, a clearer, unified vision of the *Tales*.

A number of reviews of Chaucer's work go right to the edge of a new way of thinking without taking that "one more step."[137] An example of one of these pregnant statements is offered by Baldwin:

> It is the "world" that will be recreated in the *Tales*, and that "world," to be at all, must and will be a projected, Chaucerized *kosmos*.[138]

That is a capsule description of the entertainment to come. With-out Chaucer's using the word *cosmos*, the covert image of travelers through the universe can imprint in our minds. A different, but equally spontaneous, mental picture is experienced near the end of the *General Prologue*. The poet's great skill with mental imagery simply states that the Host *gathered all the pilgrims in a flock* to be-gin their journey. For a fleeting moment we see him as their *shep-herd* without the word being used. Though Baldwin alludes to the "Chaucerized *kosmos*," he does not step into the firmament. We will.

And, finally, in the following description of the "symbolic ac-tion" of an allegory, Fletcher is not speaking of the plan of the *Canterbury Tales*, but very well could be.

> All that is required for this to be a progress is that it have a constant forward motion, that it be unremittingly direct-ed toward a goal, that it attempt an undeviating movement in a given direction…[and] the term "progress" must have the most intellectualized meaning, since it is not the hero who moves (though the author's persona may do so, under the guise of discoverer who narrates the poem), but [it is] *the whole cosmos* that *moves toward completion*.[139]

It's just about time to meet that moving, personified cosmos face to face.

SUMMARY

I've presented what I hope will be all the background you will need to recognize details of the portraits. But if we find a gap in neces-sary information, we'll fill it in as it's discovered. Because of the length of this presentation—and because some of the topics are probably new—I'm going to summarize the major points.

Allegory

The first topic was the importance of allegory and how it is like a long parable. It says one thing but has an alternate meaning, as well. A hidden meaning is intended to be a "hard nut to crack." Effort and patience are called for, and the result deemed worth it.

A writer of allegories creates an interesting verbal texture. The structure of lines or selection of words makes the reader uneasy, wary. For instance, a word will call attention to itself, like *jane* (the name of a coin from Genoa), or *wonger* (an obsolete word from *Old* English). Chaucer uses both. Why go to such lengths when you are proficient in a perfectly good Middle English vocabulary?

And, in spite of that extended vocabulary, there can be passages where a single word will appear so often that it's almost irritating. (For example, *mirth* and *merry* appear eight times in forty-five lines, A 757–802.) Before a word becomes an "irritant," it should be viewed as "provocative" so as to provoke consideration of possible reasons for the repetition. Another allegorical maneuver is juxtaposing two things that would seem better off separated, like a cook's running sore adjoining his cooking expertise.

An important aspect of allegory is that its structure is determined. It's like telling a variation of *Romeo and Juliet*; the lovers *must* come to a sad end. Or, if *Cinderella* is the underlying structure, then there *has to be* a Prince Charming.

You could content yourself with the surface story and ignore any hidden meaning. Chaucer's surface story, for example, has been enjoyed for centuries—and will continue to be. But the poetry may nag you: "Why did he say *that*?" For example, we learn that only one of the Pilgrims wears spurs. No, not the Knight. It's one of the women. Such "conspicuous irrelevancies" will allow a parallel structure of the *Tales* to come into focus. Because of the covert content, both unity and greater depth will be added to the overall meaning.

Gods
Mythical gods will play a large part in the *Tales*. From ancient times these divine beings were identified with stars and planets as well as being understood to have lives which were recorded and commented upon by poets and philosophers. Because gods came from many cultures, a single deity (one personification) could have many names.

Over time these celestial figures were absorbed into Christian philosophy, literature and art. Their visual images resurfaced with Christian identities. Another school of illustration portrayed these same gods and goddesses in medieval garb. Without a label (or

other identification) the mythical figures looked just like the lord and lady next door. Such depictions reached the contemplative stratosphere when goddesses were shown dressed as nuns, and their originally risqué adventures were converted, interpreted to become edifying, religious meditations.

Both as myths and as human pilgrims, the Canterbury journeyers are touched by a tradition that utilizes their horses merely to represent the idea of movement or to confide an element of the personality of the "rider."

Stars and Planets

Stars and planets, we learned, "prefer to move from west to east" (as the pilgrims will travel west to east from London to Canterbury). The "one day" format of the pilgrimage needs to be expanded on the covert level to a *year* because all twelve signs are present. In addition, the pilgrims will return to their point of departure, which communicates the medieval picture of time as a great circle: when the zodiac and all the planets return to the place from which they set out, that will be the world's end. Time begins with Creation and ends on Judgment Day.

Authors

Chaucer read and translated a great deal. Several authors are an obvious influence. The philosopher Plato described with great authority the workings of the universe. His thinking, in a form called Neo-Platonism, was strong in the Middle Ages. Then there are Ovid's stories of the encounters of gods with men (and with women) which were very popular. Both Plato and Ovid regarded celestial phenomena as "alive."

St. Augustine, though critical of pagan religions, declared it advantageous and proper to use what was serviceable from paganism to advance the cause of Christianity. He believed that all things were symbolic, had a message concealed—the more labor in discovering, the more joy in success. St. Gregory recommended "Christian alternatives" to replace familiar pagan images and stories. Christian feast days took over the dates of pagan celebrations. Boethius lifted stories from the tradition of Aesop's beast fables and from Ovid's poetry to find Christian value in them. These

church writers were not showing respect for "false gods," but, by "interpretation," believed they had found hidden "truths"—hidden so as not to be understood by the unworthy.

Chaucer's Creativity

The *Canterbury Tales* is an acknowledged masterpiece. Not until Shakespeare is anything worthy of comparison. Each tale, each pilgrim, is unique. There are, of course, "problems." Parts left unfinished, for example, hinder comprehension.

Chaucer tells us, before the journey begins, that he had not placed the characters in their proper "degree." In other words, the zodiac will not be found in astrological order, nor will the planets be properly arranged. We will have only the poet's clues to rely on. His clues, his "signals," are the main characteristic I see in his writing. The signals, of course, are expressed in Middle English. He constructs a fantasy where objects are both abstract and concrete. Our mind's eye must develop sensitivity to the word-pictures he paints.

Personification is another of his skills. "Conversation" with his purse is one small example, but a matchless personification is the rooster Chaunticleer. This bird is unforgettable, as is his wife, who helpfully recommends that he could cure all his worries if he'd "taak som laxatyf" (B 4133).[140]

Leaving things unsaid is significant—a different sort of signal. At times the poet interrupts a line of thinking. Descriptions are less than detailed. Names are minimal. Ordinary words are consistently chosen to identify the pilgrims; their "names" double as everyday words. Disguising characters as pilgrims is a part of his game—the outer covering so completely cloaks their identity.

As the poet affixes the pilgrim ornaments he has created, relationships will be illuminated. We expect surprises. Wolfgang Clemen prompts us to an openness of mind: "We must work out quite new categories if we are to begin to understand how many medieval poems are constructed."[141] The exhibition we have been invited to amounts to the unveiling of a new work of art.

Pilgrimage

It is refreshing to know that the plan of pilgrimage is often seen, now, as purposefully paralleling life. The drama is likened to travel-

ing the road to salvation. This "new category" is a twentieth-century development in Chaucer scholarship.

Cosmos

We conclude with the idea of *cosmos*, the word that Aristotle used to indicate an "ornament" which sets an individual apart, demonstrates his status. Such ornaments hold the clues that Chaucer has encoded in order to identify his players. Cosmos is also "the universe," the total image of the poet's plan. The beauty and order of the heavens were directly related to the structure of "Allegorie." And the action, symbolic action, in allegory must be "constant …unremitting…undeviating" movement toward a goal which is often narrated by the author's persona. We couldn't ask for a more concise synopsis of the allegory of the *Canterbury Tales*. Symbolic action of the celestial pilgrims is "the whole cosmos [moving] toward completion." That is exactly what we expect to find.

What now? The poet has been kind enough to allow me to choose the sequence. Pilgrims will be introduced not in the order of the *General Prologue* but by the clues offered. Some are designated as "belonging" to each other in some way; belongers will not be separated. Pilgrims of independent status will be called upon by whim.

A first sequence will introduce the remaining eleven signs of the zodiac, beginning with Gemini. Special notice will be given the cluster of individuals (five of the signs) Chaucer associates with himself, the company he chooses to keep. After the zodiac is in position, the planets will arrive. When both groups have been set in their cosmic destinations, it will be evident that there are some "leftovers." Perhaps they have been added to make the search more difficult and, consequently, more rewarding. I doubt that added complication is the only reason, however, because they contribute a wealth of information even if they *appear* to be "afterthoughts."

Very shortly we will watch the universe come to life in a uniquely crafted construct designed by Chaucer himself. Our vantage point is the poet's mind. The circumference of this private theatre is draped in midnight-blue velvet. Individual, celestial units will be presented, receive their earthly personality and assume their predestined places in the velvet cosmos.

We are the first audience to experience the complexity of this fabled collection of pilgrims and tales. Correspondences will become evident. The poet's minimum of detail provides transparence, allowing sequestered images to be viewed both separately and simultaneously. Internal vitality that has gone unnoticed will manifest itself. Each part adds life and radiance to the whole. This model universe will embody the answer to the 600-year-old riddle. Chaucer-lovers who witness this gathering of the cosmos can expect a mind-changing experience.

When all the objects of his craft have been positioned, we will spend a little time enjoying the panorama and speculating on its significance.

Now, with a quote worth repeating, let's watch "the 'world' that will be recreated in the *Tales*, and that 'world,' to be at all, must and will be a projected, Chaucerized *kosmos*."

The ploughboy of Old England had the sun and stars for clock and calendar. There was then in every one such a consciousness and such a remembrance of the visible heavens over and under the motionless earth as he never has who merely reads statements of what astronomers infer from things which ploughboys can see. The study of Chaucer should prompt and help to recover this lost vision— to see the sky as he saw it.

—*Andrew Ingraham,* Geoffrey Chaucer's Prologue *(1902)*

IV. The First Dozen or So

THE PARSON AND THE PLOWMAN

From backstage two characters emerge. Their appearance and demeanor seem identical: their height, their simple clothing, their facial expression. When the more learned of the two comes to a halt, his companion takes a position somewhat in his shadow. The most prominent indication of their sign is that they are the only pair of brothers; they *must* be Gemini. Their myth has several variations. Gemini (the Twins) has many complexities.

The two figures—Castor and Pollux—were sons of Leda. (A bit of trivia: incomparably beautiful Helen of Troy was their sister.) Leda's husband, Tyndareus, was the father of Castor. The god Zeus (the Thunderer) fathered Pollux.[142] Having a god as his father meant immortality for Pollux, while Castor was a mere mortal.

The pair were inseparable; their mutual devotion is legendary. Human Castor became a trainer of horses, while the godly Pollux became a boxer. A proud, never-defeated pugilist king once challenged Pollux to a boxing match, assuming the Twin couldn't possibly defeat him. Not only was Pollux victorious, but, in the process, struck the king a fatal blow.

The Twins sailed with the Argonauts (seamen on a ship called *Argo*), in quest of a fabled sheepskin, the Golden Fleece. The two demonstrated dedication, bravery and fraternal devotion. The sea god, Poseidon (Neptune), awarded them power over wind and

waves, and so they were hailed as protectors of mariners.

The phenomenon we call St. Elmo's Fire was believed by early observers to demonstrate the presence of the Gemini. Today the "fire" is understood to be discharges of atmospheric electricity. The "electric" display, even with the explanation, can be dazzling. Pliny, commenting on nature in the first century, gives us his impression of such a manifestation.

> I have seen a radiance of star-like appearance clinging to the javelins of soldiers on sentry duty at night in front of the rampart; and on a voyage stars alight on the yards and other parts of the ship, with a sound resembling a voice, hopping from perch to perch in the manner of birds...they denote safety and portend a successful voyage...for this reason they are called Castor and Pollux, and people pray to them as gods for aid at sea. They also shine round men's heads at evening time; this is a great portent. All these things admit of no certain explanation; they are hidden away in the grandeur of nature.[143]

The Gemini, along with being the safeguard of mariners, were also all-around "helpers and saviors of men, rescuing them and protecting them against evil."[144] The Romans, who swore "by Gemini" ("by Jiminy"), were once aided in a major battle by the presence of the Twins.

Their final adventure together was a cattle drive. (Yes, a cattle drive.) They were joined in the enterprise by another pair of brothers, dishonest schemers. The Gemini, when tricked out of their fair share, fought the troublemakers. Castor was mortally wounded. Pollux stabbed and killed the man who had murdered his brother, and Zeus slew the second schemer with a thunderbolt.

The death of Castor was more than Pollux could bear so he asked Zeus to allow him to die, to renounce his immortality, in order to be with his brother. Zeus had a better idea. The brothers would alternate their existence: one day together with the souls of the dead, the next day with the celestial gods.

These inseparable brothers were placed in the night sky as a configuration of two rows of stars, which are almost straight, paral-

lel lines. Single stars that indicate the head of each are called, reasonably enough, Castor and Pollux. Pollux is the twelfth-brightest star in the sky and half again as bright as the light of Castor. The star Alhena marks the feet of Pollux and is yellow, golden, and almost as bright as that at the head of Castor. The ancient astronomer Ptolemy called Alhena "red," which Beyer's *Star Guide* suggests was probably just an exaggeration. As the Twins rise, Castor is seen first; Pollux is four degrees "southeast of Castor" and ascends ten minutes later.[145]

They were usually illustrated seated on horseback, with spear in hand, wearing a short, simple, sleeveless garment called a "chlamys."

This example of fraternal love was admired by the pre-Christian world and later blended with the idea of Christ's love for men. One Twin who sacrificed himself and suffered death in order to bring immortal life to his brother held a Christian message very near the surface. When Chaucer uses the Gemini, and the Parson, in particular, to give a spiritual message, it comes as no surprise. The *Parson's Tale* is the last one told by a pilgrim, and we will deal with it shortly.

From the two pilgrim brothers we hear only one story. The Plowman (like the Guildsmen) is never spoken to or about. He never utters a word, nor does he participate in any of the activities of the journey. His presence is only necessary to complete the image that identifies Gemini.

No physical description is given of these two travelers. Our scant visual guide is that one holds a staff, and the other wears a simple garment. We know nothing of age, height, health—nothing. This is Chaucer's "things left unsaid." The poet needn't deal with complications of coordinating physical details between the legend and the constellation if no description is given.

Their chosen titles—Parson and Plowman—announce their necessary identity and nothing more. But how imaginative! Chaucer indicates the difference between godly and human status by naming them a parson (a man of God) and a plowman (assuredly a man of the earth). The poet goes on to amuse himself by interweaving the mythical figures with the celestial configurations.

The expanse of the heavens is a backdrop, as we're told, of the Parson's home and how he serves his parish.

Wyd was his parisshe, and houses fer asonder,
But he ne lefte nat, for reyn ne thonder,
In siknesse nor in meschief to visite.

<div align="right">(A 491–93)</div>

(Wide was his parish, and houses far asunder,
But he never stayed home, because of rain or thunder
To visit in sickness or in trouble.)

His parish is *wide* like the stables at the Tabard. Rain and thunder do not deter him. Gods and stars are not plagued by these *mundane* problems. And thunder, of course, is his family heritage.

He'd visit

The ferreste in his parisshe, muche and lite,
Upon his feet, and in his hand a staf.

<div align="right">(A 494–95)</div>

(The farthest in his parish, much and "lite"
Upon his feet, and in his hand a staff.)

The staff in his hand resembles illustrations of Gemini holding a spear. "Much and *lite*, / Upon his feet," is a play on the word *lite*— light or little. Being on his feet "a lot or a *little*" is clear at the surface; to have a "*light* upon his feet" brings the bright Alhena of Pollux into view.

Said to be a poor man,

But riche he was of hooly thoght and werk.
He was also a lerned man, a clerk,
That Cristes gospel trewely wolde preche;
His parisshens devoutly wolde he teche.

<div align="right">(A 479–82)</div>

(But rich he was of holy thought and work.
He was also a learned man, a clerk,
That Christ's gospel truly would preach;
His parishioners devoutly would he teach.)

The above lines and several others tell of the Christian influence of this Gemini legend. If we have any doubt that his actions intend to instruct by *good example*, the poet states it and restates it. (Repetition signals something noteworthy.)

> This noble *ensample* to his sheep he yaf,
>
> . . .
>
> Wel oghte a preest *ensample* for to yive,
>
> . . .
>
> By good *ensample*, this was his bisynesse.
>
> . . .
>
> *He taughte*, but first he folwed it hymselve.
>
> (A 496–528)

> (This noble example to his sheep he gave,
>
> . . .
>
> Well ought a priest give example,
>
> . . .
>
> By good example, this was his business.
>
> . . .
>
> He taught, but first he followed it himself.)

He lived the wisdom of "do what you would have others do."

The poet's negative statements about the Parson impart non-information. We are advised to avoid what the Parson avoids.

> Ful looth were hym to cursen for his tithes.
>
> (A 486)
>
> He sette nat his benefice to hyre
> And leet his sheep encombred in the myre
> And ran to Londoun unto Seinte Poules
> To seken hym a chaunterie for soules.
>
> (A 507–10)

(He was loath to excommunicate those who didn't give tithes.)

(He set not his responsibility [his own parish] to hire
And left his sheep encumbered in the mire

71

> And ran to London to St. Paul's
> To find for himself a chantry for souls.
> [i.e., a good-paying position praying for souls.])

He was not unkind, not looking for the easy life, not "a mercenarie" (A 514). It's a way of saying none of these matters apply to Pollux. What difference would money make to a *god* or to a *constellation*? Nor did he disdain ordinary men (as Castor was).

> He was to synful men nat despitous,
> Ne of his speche daungerous ne digne.
>
> (A 516–17)

> (He was to sinful men not contemptuous,
> Nor of his speech haughty or dignified.)

The narrator claims

> A bettre preest I trowe that nowher noon ys.
>
> (A 524)

> (A better priest, I trust, is nowhere [to be found].)

The words do *not* say that he *is* a priest. It's like a statement I've heard many times among church people in speaking of an upstanding friend who has no church affiliation: "He's a better Christian than any of us."

The Parson's needs are small.

> He koude in litel thyng have suffisaunce.
>
> (A 490)

> (He knew how, with a little, to have sufficient.)

Stars in the sky, or gods on Mt. Olympus, have few earthly needs. A play on "light" being *sufficient* for him is also a possibility.

Now Chaucer interjects a different thought, an image unlike any other in the description.

...if gold ruste, what shal iren do?

(A 500)

(If gold rusts, what shall iron do?)

It's a way of alluding to the bright yellow star in Pollux, that was also seen as "red."
We learn that

He waited after no pompe and reverence.

(A 525)

(He waited for [sought] no pomp and reverence.)

Stars do not seek or *wait* for reverence—they are always on the move.

Nor did the Parson care whether a man was "of heigh or lough estat" (of high or low estate [A 522]). Proof is his deep love for the mortal who was his brother. But he could "snybben *sharply* for the nonys" (rebuke *sharply* for the occasion [A 523]) holds the image of Pollux *stabbing* the man who killed Castor.

A last consideration of the Parson finds the same consistently admirable person.

Benygne he was, and wonder diligent,
And in adversitee ful pacient,
And swich he was ypreved ofte sithes.

(A 483–85)

(Kind he was, and wonderfully diligent,
And in adversity very patient,
And such he was proved often times.)

Diligent and patient in adversity could apply to the Gemini gift of aid to those in storms or battles. But *proven many times* is more an allusion to his willingness to experience death every other day for the sake of his brother.

As we turn now to the description of the Plowman, the first

thing we encounter is a load of manure (A 530). How appropriate. Castor trained horses.

"God loved he best with al his hoole herte" (A 533) seems a statement of his devotion to his godly brother. His love was ongoing under all conditions.

> At alle tymes, thogh him gamed or smerte.
>
> (A 534)

(At all times, though he was active or was in pain.)

Activity and pain could refer to adventures during the quest for the Golden Fleece, fighting bravely in battles along with his companions (including his brother).

Farming terminology (threshing) serves as an allusion to battle, as well.

> He wolde *thresshe*, and therto *dyke* and *delve*.
>
> (A 536)

(He would thresh/thrash, and thereto dig and delve.)

If we connect these words to his final encounter, he did his best to thrash (to attack, to defeat), but was killed. *Thrashing* precedes the "dig and delve," a trivial phrase, easily assimilated with the overt intent. But as a clue, a thrashing resulted in Castor's death and "therto he was *dyke* [it also means to *bury* a corpse] and *delve* [this also means to *disinter* a corpse]."[146] It is Castor's story in one line. Though he died as a human, he was returned to life by his brother's loving self-sacrifice.

The next phrase, "if it lay in his myght" (A 538), is one of Chaucer's "vagueries." The narrator tells us that if the action was possible, he did it—but we aren't told whether or not it was possible. It makes a good "Christian" filler, however, because it has to do with tithes.

> His tithes payde he ful faire and wel,
> Bothe of his propre swynk and his catel.
>
> (A 539–40)

(His tithes paid he full fair and well,
Both of his proper work and his cattle.)

He was fair in his contributions of work and cattle. The last word, of course, contains a play on *catel* as "chattel," while being a recollection of the cattle drive.[147] Castor (the Plowman) was "full *fair*," but lack of fair play on the part of his enemies led to his death.

A final line holds the only hint of physical description of the Plowman. He wears poor man's clothing (a tabard) and rides a horse. I get a picture of a Gemini in a simple garment astride his horse.

The tale identified with the brothers is the last of the pilgrimage, the *Parson's Tale*. The last storyteller parallels in importance the first storyteller, the Knight. The Knight (Mars) initiated the cosmos; the Parson prepares for Judgment. This final narrative is a long, deeply religious closing to the Canterbury journey.

Though conscious of the setting sun, the Host takes time for a clue-laden interrogation with the idea that the Parson is a composite, a two-in-one sign. First the Host asks about the Parson's identity using two meaning-filled designations:

> "...artow a vicary?
> Or arte a person?..."

(X 22–23)

> ("...art thou a vicar?
> Or art a person/parson?")

Epithets are looked upon as ornamental, as *kosmoi*.[148] Vicary could mean *vicar* (a clergyman), but it could also mean *substitute* (vicarious). Therefore, when the Host asks if a vicar, a substitute, is before him, he is asking if he is conversing with a stand-in for Christ. In the words of John Wyclif, an influential (if controversial) preacher of the fourteenth century: "Eche preest shulde be *viker* of Crist...and so in a maner be Crist."[149] Wyclif is implying more than a vicar being a pastor. To him, a cleric must be a second Christ, a substitute for Christ Himself.

The Host's second question is generally explained with "person"

being another way of spelling "parson," but the fact is the word refers to an individual *person*, a human being, as well. The plowman image had long held meaning as a "symbolic figure" found "associated with a Christlike ideal" earlier than the role he filled in fourteenth-century literature.[150] The poet's efforts to make both the Parson and Plowman Christ-like is obvious.

Medieval churchmen saw in Castor and Pollux an image of Christ's love for man. As the two figures combine to represent both god and man, they—as a composite—can also be seen as an analogy of the union of divine and human natures of Christ.[151] Having asked two questions without getting (or waiting for) a reply, we can see the asking as merely an opportunity to impart a clue toward a deeper understanding of the potential of the twin image. Having received no replies, the Host cryptically closes the subject with, "Be what thou be" (X 24).

Finished with the pilgrim's occupation, a few lines later the Host coaxes the Parson to "Unbokele, and shewe us what is in thy male" (X 26). A *male* can indicate a pouch; that takes care of the surface view. But it doesn't take care of why such an intrusive request would be posed. The Host is asking to see what the Parson is carrying with him. Isn't it strange that he, out of all the travelers, is asked to open his belongings for everyone to see? What's the point, especially when the revelation is not insisted upon? The point is a play on *male*; then as now, *male* is also a *man*. The poet makes a completely unexpected move by asking the Parson to reveal his *personal* contents: "What do you contain as a man?" This oddity is a signal, a clue. There is more buckled up in him as a *person*; his presence is both of the Gemini.

When the Host concludes his banter, the pilgrim is ready to do his bidding "at once" (X 30). Mention of sowing seed, as in the gospel, gives the poet the opportunity to flash a hint of Pollux, the boxer, as the Parson describes scattering seed, not from his hand, as would be typical, but from his *fist* (X 35).

What he will provide to this company is

> Moralitee and vertuous mateere,
>
> . . .
>
> To shewe yow the wey, in this viage,

> Of thilke parfit glorious pilgrymage
> That highte Jerusalem celestial.
>
> (X 38–51)
>
> (Morality and virtuous matter,
>
> . . .
>
> To show you the way, in this journey,
> Of the same perfect glorious pilgrimage, destination
> That is called Celestial Jerusalem.)

It is the Parson's desire to lead the pilgrims to their heavenly home. His means of leading travelers "home" amounts to a sermon in two parts. The first is a section on Penance. That is followed by a "treatise on the Seven Deadly Sins." Understanding that "any pilgrimage is of its essence a rehearsal for death and judgment...[then the Parson and his] topic make a suitable mediaeval finish for the story."[152]

Baldwin, in his study of "unity," sees the Parson as performing a unifying task.

> Every one of the sins has its perpetrators among the pilgrims. It is against the blandishments and entanglements threatening their souls at that moment that the Parson assiduously, spiritually struggles.... In context the Parson is battling...against the weaknesses and sins which have been displayed *en route*, which call for correction and repentance....
>
> All of the pilgrims are tacitly reminded of their own trespasses; they know what they must do for the remission of these sins. And because what is happening here is happening on the level of characterization, it is another technical coup. The characters reflectively take on new depths.[153]

The Parson provides a potential "examination of conscience" for all the "Jerusalem-bound" travelers.

Fletcher's analysis of the closing of an allegory parallels Baldwin's estimate of the Parson's function. Medieval allegory often

ends with "a strong sense of 'closure'" by using a "summation scheme." The reader is guided to "look back" over the poem. Selecting two classic works (from Dante and Spenser), Fletcher describes how they "show this arbitrary closure more strongly than most allegories, because not only do they exhibit it along the way, by what I would call a 'segregation of parts'…but they both are intended to close with a final homecoming in an ideal world."[154] "Segregation" into parts and an idealized "final homecoming" describe the plan of Chaucer's work. The *Parson's Tale*, with its review of the sins that plague man (and these earthly pilgrims who are a cross-section of medieval mankind) provides another example of a *strong* allegorical closure.

In the midst of serious biblical allusions, for just three lines the Parson offers an aside about his personal literary prejudice.

> But trusteth wel, I am a Southren man,
> I kan nat geeste 'rum, ram, ruf,' by lettre,
> Ne, God woot, rym holde I but litel bettre.
>
> (X 42–44)

> (But trust well, I am a Southern man,
> I know not storytelling by letter 'rum, ram, ruf,'
> God knows, rhyme I hold as only a little better.)

He has little appreciation for poetry and even less for the alliterative kind. That's a definitive statement. It's preceded, however, by an "unnecessary" line, a line that again signals "What's the point?" True, the surface explanation offered in notes is that an alliterative revival was current *in the North*, but still the purpose of the Parson's (Chaucer's) "remark is not obvious."[155] This is one of those situations where the poet chooses a word because it is *adequate* on the surface, but its real importance is to be found in the covert intention. Allusion to his being a "Southern man" is a zodiac identification. As Gemini rises, Castor (our Plowman) is seen first; Pollux (our Parson) comes into view ten minutes later and, hence, is the "Southern man"—south of his brother.

For Christian example, the *Parson's Tale*, as the final message of the pilgrimage, is offered to aid all the participants in their

Judgment Day journey, the fulfillment of the journey for men and for the rotating cosmos. "Jerusalem celestial," the Parson's words, is the longed-for destination. It is the desire of the Parson for the pilgrims; it is the desire of Pollux for his brother; it is the desire, in serious medieval fashion, of Chaucer for his audience. We have done with the matter of Gemini, the Parson and his brother. Now let's find what Chaucer does with the fifth sign in the zodiac, the constellation Leo.

THE MONK

With a nod from the poet, a robust character, physically impressive, elegantly garbed, athletic in his stride, comes into view. Clues we will search for this time demonstrate that the Monk is the alternate image of the sign of Leo. Attention repeatedly drawn by scholars to the oddity of a Monk with a golden ornament under his chin points to the giveaway.

[What may seem an inconsistency, now, will actually be oddly consistent. From this point on, if brief Middle English quotes are quite readable, I'll insert them for you to enjoy. Just don't be inhibited about the spelling. Perhaps you can pretend it is like something your old Uncle Elwell would write. He holds seventeen automotive patents, but he quit school in fourth grade.]

The myth that tells how this lion became a group of stars begins with the Twelve Labors of Hercules (Heracles). His first task was to kill the "Nemean lion."[156] It had been ravaging the cattle in the valley of Nemea. So Hercules, who was very strong, was sent to solve the problem. He wasn't told, however, that the animal could not be killed by any weapon. After trying his arrows and his trusty club with no success, he grabbed the lion by the throat and strangled it. Hercules took its hide for a garment. (He is recognized in illustrations because he wears the lion's skin.)

Early myths claim that the animal came from the moon. It is not surprising, then, to find the lion returned to the sky and his slayer with him as the constellations Leo and Hercules.

There are a couple of medieval transformations, however, to the story of Leo's identity. He has been called the biblical Lion of Judah, or one of the lions that did no harm to Daniel while he was in the lion's den. Chaucer makes reference to the animal in *Troilus,*

calling it "Hercules lyoun" (IV:32).[157]

As earthly creatures, in very early times, lions roamed most of Europe and were admired for their fierceness and their bravery when threatened. Numerous crests of noble families display this "heraldic animal *par excellence*."[158] Lions pose on Flemish and British crests back to the 1100s. A red lion, as might be anticipated, was the insignia of the kingdom of Leon, in northwest Spain.

Depiction of a lion's jaws was a medieval impression of "hell mouth." Illustrations, carvings, and performances of plays showed the gaping jaws, and inside the mouth could be seen the "faces of dead sinners."[159] At the other extreme anatomically, the lion's tail, it is said, was used by him to erase his tracks as he moved. And Chaucer depicts the "gentil...lyoun" who, "whan a flye offendeth him or biteth, / He with his tayl awey the flye smyteth / Al esely" (*LGW*, F 391–95). He would give a gentle swish rather than harm the tiny creature.

As a stellar formation, Leo has a number of prominent features. It is one of the signs of summer. Fierceness of the lion is associated with the unrelenting heat of midsummer. In addition, one of its stars, Regulus (the modern name which replaced "the King's Star" or "the Royal Star"), is of the first magnitude in modern terminology. Its brightness was believed to contribute to the prevailing heat.[160] Regulus, sometimes called the "lion's heart," serves as a guide for navigation.

A second prominent star is Denebola (Arabic, "the Lion's Tail") which, as you might guess, marks the end of Leo's tail. A third star, Algieba, in the vicinity of Regulus but above it, is appropriately named "Brow of the Lion."[161] These three stars of considerable distinction can be seen on any cloudless night. And once a year, in mid-November, there is a meteor shower, the Leonids, that issues from the constellation. Records of the display go back almost to the birth of Christ.[162]

We have a description recorded Nov. 12, 1833, when hardy souls were especially delighted with the phenomena in eastern North America. Observers willing to be outdoors in the middle of that chill, wintry night help us picture the spectacle. That particular November was the peak of a cycle which runs about thirty

years. Conditions were good; skies, clear. Radiating from a point within Leo, "hundreds of thousands of shooting stars were observed in one night, some leaving persistent trains, but none reaching the earth." In 1966 it was Arizona that got that peak of the display: "over 100,000 meteors per hour were observed."[163] (Having a strong personal desire to experience the Leonids, several times I have set an alarm clock to wake me at 1 A.M. of the predicted night, only to find the sky overcast. Maybe next time.)

Much is said about the astrological influence of Leo and of its individual stars. Regulus, for example, was said by "early English astrologers" to bring "glory, riches, and power" to "all born under its influence." (Note the omission of a promise of *happiness*.) For 3000 years, until the 1600s, this Royal Star was believed to be the force that "ruled the affairs of the heavens." Denebola, in the tail, holds portents of "misfortune and disgrace."[164]

The ancient Manilius said Leo exhibited the personality of its animal counterpart—it was "a predator."[165] Ptolemy described various sections, from head to tail, as "hot and stifling" or "stifling and pestilential" or "wet and destructive" or "unstable and fiery."[166] Expect unmitigated disaster.

Chaucer tells of events associated with the sign of Leo. The "speaker" is the planet Saturn, who is a dire influence to begin with, and worse while "he" is in Leo.

> My course, that hath so wide for to turn,
> Hath more power than any man knows.
> Mine is the drowning in the despairing sea;
> Mine is the prison in the dark dungeon;
> Mine is the strangling and hanging by the throat,
> The murmur of the churls rebelling,
> The groaning, and the secret poisoning;
> I do vengeance and full punishment,
> While I dwell in the sign of the lion.
> Mine is the ruin of high halls,
> The falling of the towers and of the walls
> Upon miner or carpenter.
> I slew Samson shaking the pillar;
> And mine are the maladies cold,

The dark treasons, and the plots old;
My aspect is the father of pestilence.[167]

Don't think that all that horror and misery is really attributable to Saturn alone. In the area of astrological medicine (that is, doctors guided by the stars), Leo was thought to make curative baths harmful and prescribed medicines poisonous.[168]

We have many things to think about as we turn to meet Chaucer's Monk. The picture of a lion introduced as a clergyman may not be difficult to focus in your mind's eye. Start with the wolf in Red Riding Hood passing himself off as "Grandma" because he was wearing the old woman's nightgown and nightcap, and you're close. It was a common witticism among manuscript illustrators of the Middle Ages to show animals impersonating humans. Depictions of animals walking erect in procession and wearing liturgical vestments are common and amusing.

As the Host addresses the Pilgrim Monk and directs him to "telle a tale trewely" (B 3115), this guide interjects an exclamation about the next town. The interjection seems almost rude and certainly a distraction—at the surface. But we can see an occasion of underlying wordplay between "rocheter" and an allusion to "Rochester." *Rochet* is the name of a protective garment that medieval clergy wore over their clothes in public. A man, noticeable because of his rochet, would be a rocheter (as with trumpet, trumpeter; fiddle, fiddler).[169] When the Host first looks at Leo in the garb of a monk, he blurts out, "Rouchester stant heer faste by!" "Rochester" is standing nearby in the apparent storyline, but we can see also standing nearby a "rocheter"—leonine contours cloaked in clerical garb. (Animals in cleric's robes abound in marginalia.)

The Host is at a loss as to how to address the Monk. (Why doesn't he just ask his name? Because it's more fun for Chaucer to tease with speculating.) He asks if he should be called by a monastic title, "daun John, / Or daun Thomas, or elles daun Albon?" (B 3119–20). Some time later (after the Monk has told his story), the Host brings up the subject of his name again and settles on "sire Monk, or daun *Piers* by youre name" (B 3982). When the poet finally decides on "Piers" (Peter), after all the names speculated upon earlier, the multiplicity conceals the point; a play on *pierce*

could be overlooked. The Monk, as Peter, doesn't seem important, but the covert image of Leo connected to *pierce* is one of our clues.

His *General Prologue* introduction begins with shadows of a lion skulking within the lines

> A Monk ther was, a fair for the maistrie,
> An outridere, that lovede venerie,
> A manly man, to been an abbot able.
>
> (A 165–67)

> (A monk there was, the proper for the mastery,
> An outrider, that loved hunting,
> A manly man, to be an able abbot.)

Though Baugh's note explains A 165 to say he was "a fine example of a monk," the covert understanding is that he is preeminent at his craft, his mastery, which the next line says is *hunting*. This exercise in wit tells us that he loves to ride and hunt; and a lion would naturally have his way if he were in control of a monastery. Reference to "a manly man" seems an ordinary pleasantry—but undercover we perceive him as a "a lion of a man," a grand medieval compliment.

The poet continues creating similar reflections.

> The reule of seint Maure or of seint Beneit,
> By cause that it was old and somdel streit
> This ilke Monk leet olde thynges *pace*,
> And heeld after the newe world the *space*.
>
> (A 173–76)

> (The rule of Saint Maurus or of Saint Benedict,
> Because it was old and somewhat strict
> This monk left the path of old things,
> And looked toward the new world [of] space.)

Formal demands of religious life are not for him. This "monk" separated himself from the old path (pace) and has proceeded to look toward the new world of *space*—yes, space. The term was used then

to express the distance between the seven spheres of the heavens or the planets.[170] This sounds very much like leaving earth and now existing in the heavens.

Chaucer has not yet had his fill of constructing reasons for lions not to enjoy being men. The lion doesn't care "a pulled hen" (a plucked chicken) about a book that says "hunters been nat hooly men," and that a monk out of his monastery, one who is carefree ("recchelees"), is like a fish out of water (A 177–80). What does a lion care what a book says! The narrator agrees: "I seyde his opinioun was good" (A 181–83).

Still more lion games.

> What sholde he studie and make hymselven wood,
> Upon a book in cloystre alwey to poure,
> Or swynken with his handes, and laboure,
> As Austyn *bit*? How shal the world be served?
>
> (A 184–87)

> (What should he study and make himself crazy,
> Upon a book in a cloister always to pore,
> Or work with his hands and labor,
> As Augustine bade? How shall the world be served?)

To spend time in a cloister with books would drive the poor lion mad and so would working with his "hands" and laboring as Augustine instructed. Truly, how would the world be better off if he attempted these tasks? The poet tucks in just a glimpse of the lion hiding inside the words; instead of the usual spelling "bid" or "bidde," we find "Austin *bit*." Then, much like "render unto Caesar what is Caesar's," the poet concludes this train of thought with, "Lat Austyn have his swynk (work) to hym reserved!" (A 188). In other words, "Leave Augustine's work to Augustine."

The prologue to the Monk's story is complex. Chaucer touches upon many things, but we'll limit ourselves to dealings with the Monk.[171]

> Upon my feith, thou art som officer,
> Som worthy sexteyn, or som celerer,

> For by my fader soule, as to my doom,
> Thou art a *maister* whan thou art at hoom;
> No povre cloysterer, ne no novys,
> But a governour, *wily and wys*,
> And therwithal of brawnes and of bones,
> A wel farynge persone for the nones.
>
> <div align="right">(B 3125–32)</div>

> (Upon my faith, thou art some officer,
> Some worthy sextant, or some cellarer,
> For by my father's soul, as to my judgment,
> Thou art a master when thou art at home;
> No poor cloisterer, and no novice,
> But a governor, wily and wise,
> And there withal of muscles and of bones,
> A well faring person for the nonce.)

After stating that the Monk performs as someone of authority, the Host can only guess at his skills, but is certain that the monk is "maister whan thou art at hoom." Even in Chaucer's day the lion's preeminence was recognized with the title, "king of beasts." He continues with what the Monk is *not* and concludes that he *is* a "wily and wys" governor and a brawny "person for the nonce"— which can be understood, "a person for the time being," the poetic pretense again.

Another choice ambiguity reads well on at least two levels:

> I pray to God, yeve hym confusioun
> That first thee broghte unto religioun!
>
> <div align="right">(B 3133–34)</div>

> (I pray to God, give him confusion
> That first brought thee unto religion!)

How foolish anyone would be to introduce a *lion* into a monastery. How grim to recall the lions and the Christians.[172]

Chaucer laments that the lion's freedom is restricted, and may just be thinking of the constellation.

Haddestow as greet a leeve, as thou hast myght,
To parfourne al thy lust in engendrure,
Thou haddest bigeten many a *creature.*

(B 3136–38)

(If thou had as great a freedom as thou might,
To perform all you'd like in engendering,
Thou would beget many a creature.)

If the Monk were permitted, he'd beget "many a creature," which does not say *children, babies.* "Creature" suits the covert image of the lion; it doesn't do nearly as good a job at the surface. The Host ends his philosophizing by claiming truth can often be found in what appears to be a joke (B 3153–54). This could be taken to impart that a serious observation about celibate clergy is concealed.

Joined to these reflections on propagation is a line that has no purpose where it is found, rather like the noting of Rochester as the Monk is coming forward. Sandwiched between the Monk's begetting and how the Host would manage things if he were pope, he asks, "Why werestow so wyd a cope?" (B 3139). The question is pointless on the surface and a case of "conspicuous irrelevancy." What difference does it make how wide a monk's cowl or hood is? The point is that, for the lion lurking under the surface, the remark takes note of his splendid mane. (*Wide* has measured the vault of heaven. The possibility of *cope* used to express the dome of the sky inspires the outline of the constellation, as well.) A few lines earlier the elegance of this "man's" skin was remarked upon (B 3122). What an unusual observation to make regarding a man of religion whose skin is mainly concealed by his clothing. Ah, but beneath the surface, isn't this precisely what we think of when we see a lion. Hercules admired this lion's skin so much that he made it part of his identity.

Let's continue examining that "skin." During the *General Prologue* portrait, we learn that the Monk's sleeves are *trimmed* with fur, "the fyneste of [the] lond" (A 193–94). What is *not* disclosed is that the remainder of his "sleeves" are also made of that very fine fur. *Suppleness* of his boots, again, a tidy reference to his beautiful hide, is remarked upon (A 203). Recalling that details of a pilgrim's

horse disclose facts about the pilgrim himself, the Monk's horse is a case in point. Chaucer's phrase is particularly flexible and adaptable. This horse is of great "estaat." *As a horse* for a monk, it is exceptionally fine. *As the sign of Leo* the words imply an aspect that is ruling, or even perilous.[173] *As a lion* we find him in excellent condition.

The clincher for the portrait of his "mount" comes in the last line of the *General Prologue* introduction, as the narrator says,

> Now certeinly he was a fair prelaat;
>
> . . .
>
> His palfrey was as broun as is a berye.
>
> (A 204–07)
>
> (Now he certainly was a fair prelate;
>
> . . .
>
> His fine horse was as brown as a berry.)

The Monk is certainly a picture of authority as he "rides." His fine *brown* horse at the surface lightly conceals the lion silhouette.

The poet can't resist a final joke about the multilevel depiction when the Monk has ceased telling his story—a succession of tragedies halted by the Knight. The Host resumes his position as M.C., approving the Knight's action by declaring to the Monk, "Youre tale anoyeth al this compaignye" (B 3979). With stories of the lion's tail that swishes away his tracks and shoos flies that bother him, this is a play on his versatile tail/tale.

The lion image is captured in the venery (hunting) he loves so well. Called a "prikasour" (A 189), he is someone who pierces, punctures. His greyhounds move "as swift as fowel in flight" (A 190). What a clever way to tell of celestial dogs moving in the sky. The large and small dog (generally associated with Orion) would be appropriately seen as "grey" because stars were described as "grey" and it was "the colour of the fyrmamente."[174] When we learn of the quarry he pursues, there is no mention of big game. He loved to hunt *hare* (A 191) and his favorite roast was *swan* (A 206). Both are to be found as constellations, *Lepus* and *Cygnus*, respectively. (Unfortunately for Leo, there is no venison as a constellation in orbit.)

Multiple horses in his stable I take to be the many stars that make up the figure of Leo, the many elements which give him movement. Twice his voice is described as loud as a church bell (A 171–72; B 3971). Such intensity of sound would compare to the legendary *roar* of a lion.

With our eyes on the celestial regions now, we can marvel at Chaucer's creativity, at his placement of ornaments that are splendidly cosmic. First, let's look at a feature of the Monk's appearance that is *always* commented upon—that curious golden pin mentioned earlier (A 195–96). This *ornament* is conspicuous by its presence; it has *no* reason to be part of a monk's apparel. But this beautifully wrought clasp denotes the brilliant Regulus that marks the lion's heart. Next—and this is usually commented upon, too— is the "love-knotte in the gretter ende" (A 197). What, for a *monk*, is this "greater end?" Here is an instance where the words are just adequate at the surface, but—in the concealed constellation—it points to Denobola, at the other end, the Lion's Tail.

The poet scatters several lion clues (both earthly and celestial) through the next few lines. The Monk's head is described as smooth, bright, shining (A 198–99). He is "fat and in good poynt" (A 200). "In good point" needs interpretation for the surface, but unaided we see the glint of his teeth. The Monk's eyes are "stepe," *elevated* or *wide-open*. "Elevated" matches the constellation; "wide-open" is an allusion to the lion who was believed never to close his eyes, not even when he sleeps.[175] We are also told that his eyes are "rollynge in his heed (head)" and glowing (A 201–02)—hardly descriptive of a human. But here is the indication of Algieba, the star of the Lion's Brow.

We've accounted for Leo's three notable stars, but what about the Leonids? What an imagination! As the Monk rode "in a whistlynge wynd" (a hint of November) with everything clear, "men *myghte* his brydel heere gynglen" (A 169–70) or—translating this audible perception to a visual one—they *might* instead see the shower of Leonids.[176] With such a spectacular event to recall, it is not surprising to find these "bells" mentioned more than once. The "clynkyng of youre belles, / That on youre bridel hange on every syde" announces another moment of appreciation following the Monk's performance (B 3984–85).

A final astrological hint comes with another of the Host's un-answered questions, "Of what hous be ye...?" (B 3121). This is an inquiry as to which monastery is "home," but it also asks which is the House in astrology identified with Leo.

What is there to be said about the story he tells? It is not my intention to give a detailed analysis of each pilgrim's story. I will, however, indicate some of my thoughts, always remembering that the directive from the Host calls for adventures that actually oc-curred (A 795). The Monk is familiar with some aspect of these stories because of his lionhood. For example, it may be that we are peering at souls who have entered "hell's mouth."

His "tale" is actually a collection of small biographies, lives (and deaths) of prominent figures. This fits the idea of Leo (or Regulus) bringing power and riches to those under its influence and also misfortune and distress. There are seventeen stories; some are just a few lines. Each tells how the featured person had his life turned to ruin and death. Three persons were strong enough to kill lions with their bare hands—and it says they did. Two stories in-volve Daniel of "lion's den" fame. One tells of the retribution to a persecutor of the land of Judah (as in *lion* of Judah). The initial story tells of Lucifer, whose fall from grace changed him into the devil, who is "a roaring lion." Lucifer is followed by Adam, who lost paradise and, in Chaucer's words, went "to helle." There is also a King of Spain (of Castile), who may have had problems with the red lion of Leon.

I'm certain that a leonine connection can be made with each of the others—by heraldry in their family crests, by date of their death in the sign of Leo, by lion-like names that identified the in-dividuals. It's a challenge to figure where the secret is hidden. In any case, each of the seventeen is associated with a fall to unspeak-able distress—being crushed, poisoned, starved to death, hanged, and assorted suicides and murders. It's understandable that one of the pilgrims would call a halt to such a glut. And when that pil-grim is the powerful Mars (the Knight), there is cooperation.

And now, on to Sagittarius.

THE MERCHANT

With his shoes clicking, our next pilgrim strides forward. Of regal

stature, he is easily a head taller than anyone else we've seen. He stands now, frequently changing the position of his feet, his shoes tapping as he does.

If there is a configuration of bright stars and other visual attractions for reference, it makes deciphering easy once the first connection is made. A strong mythological story line is a big help, too. One unique feature (such as the pair of brothers) can point in the proper zodiac direction. We will not, however, always have these advantages. Even without these aids (Chaucer's basis for creativity), an extended introduction in the *General Prologue* may have enough details (ornaments) to put in place, touch our imagination, evoke pictures to which our mind can respond.

As we search for the right constellations, some are not distinctive and may even be difficult to find in the night sky. (We're talking *only* of the zodiac.) In some instances the myths may be minimal (as with Cancer) or confusing because of multiple identities (as with Hercules' lion or the Lion of Judah). With stars and their myths as givens, Chaucer delights in weaving a variety of possibilities together, picking and choosing when, where, and how the clues will be exhibited to put us on the proper trail.

Sagittarius, the Merchant, comes to us with a fairly small presentation from the poet. Where several portraits of pilgrims run to more than forty lines, we must make do with only fifteen for the Merchant. So, in the fifteen lines, what discloses the identity of Sagittarius, the Archer? Let's begin with the mythological basis. The traditional portrait is a centaur, with a beard and with shaggy hair, who is poised to release an arrow from his bow.[177]

Centaurs are said to be immortal beings descended from Ixion who, while visiting Mt. Olympus, tried to seduce Hera, the wife of Zeus. Zeus sent a cloud that looked like Hera (!) to the trysting place. The cooperative cloud bore the first centaurs, half-human/half-horse, and Ixion, for his part, was sent to Hades in torment.[178] Most centaurs were wild and savage, devoted to wine, women and war. While attending a wedding and imbibing liberally, they decided to abduct the bride and the other women attending the nuptials. The men objected (so did the women), and a grand battle ensued. Many centaurs were killed. Many others were driven out of Thessaly, their native region of Greece.

But we mustn't think all centaurs were bad. One, as a matter of fact, was good and kind and noble. Chiron was his name, and he is generally pictured with a beard and often with tousled hair. He lived in "an ancient rocky cave" on Mt. Pelion. Apollo and Diana educated him. Renowned for wisdom and justice, he was also skilled in many arts, including music and medicine. He was charged with the instruction of sons of the gods; many of them went on to become famous heroes such as Achilles and Aeschulapius. One day when Hercules was visiting Chiron, one of the visitor's poisoned arrows accidentally wounded the centaur. (There are several versions of the story, but the wound is common to all.) Immortal Chiron was in great and endless pain because there was no cure for the poison; so he asked that his immortality be transferred to Prometheus (that's another story) and that he, the centaur, be allowed to die. Zeus responded to the plea, and this strange but noble creature was placed among the stars. Ovid says that Achilles wept and after nine days "thou, most righteous Chiron, didst gird thy body with twice seven stars."[179]

A Christianized version of the figure has been called "Noah," perhaps because the area of the sky where Sagittarius was placed is called "the Sea." There are many water signs nearby: Aquarius, Capricorn, Delphinus (the dolphin), etc. The constellation, on occasion, is called "the Thessalian Sage."[180] Ptolemy describes the figure as ready to shoot an arrow. (*Sagitta* means arrow.) A billowing mantle can be seen above and behind his shoulders.

Star clusters, as well as bright and dark areas, are within its perimeter, but it has no outstandingly bright stars. The Milky Way adjoins Sagittarius. The *Alfonsine Tables*, a compilation of information of thirteenth-century astronomy, sponsored by Alfonso the Wise, King of Castile, associates this constellation with England. An initial connection was made between the sign and the kingdom because of an issue of coins struck by Stephen of Blois when he ascended the English throne in 1135. He arrived in England while the sun was in Sagittarius, so a figure of the Archer was depicted on one side of the coins. The depiction also became part of Stephen's coat-of-arms.[181]

Let's turn now to see how Chaucer uses the preceding information to create the portrait of his Merchant pilgrim. We'll review

the oddities that point to what Petrarch called "the dual shape of beast and man combined, from Thessaly."[182] Uniqueness is expressed in Chaucer's second line. No other pilgrim depiction says

…hye on horse he sat.

(A 271)

(…high on a horse he sat.)

If we "know" he is a member of the zodiac, we also know there is only one who fits *that* picture. See the torso of a man joined to the shoulder area of a horse. (Do you remember them from *Fantasia?*) We're directed toward attributes of the Merchant's head and then, with no intervening features, his feet. Nothing in between is mentioned—no sleeves, no shirt, no breeches, no hose, no money pouch, which would be natural in the apparel of a businessman. If the poet gives no intermediate details, it's because he'd give away the game he's playing, and our fun would be over. (If you stop to examine critically, you find that many of his pictures contain very few details.)

We look at his beard and a furry hat (A 270–72). This is Chiron's bearded image, and the fur hat replicates his tousled hair. He is in "mottelee" (A 271), which can mean a fabric woven of several colors, but more to our purpose, it also means a cover of more than one color. I see the light flesh of the man's figure "compounded with the body of a *tawny* horse," to use Ovid's perception.[183] Special notice is given his "boots," but they are not "supple" as the Monk's, the lion's. It is how they are "clasped" that draws attention, so "faire and fetisly" (A 273). "Fetisly" is *handsome*, and that's adequate for the surface image of the closures of a man's boots. But see them also as horse's hooves, and "fetisly" will say *ingeniously, neatly, cleverly* in describing a horse's leg in terms of a well-constructed boot.[184]

We learn that

His resons he spak ful solempnely.

(A 274)

(His reasons he spake full solemnly.)

It is a straightforward portrait of the honored and admired Chiron. The Merchant's voice is the last physical detail we are offered. Explication usually advises that

> Sownynge alwey th'encrees of his wynnyng
>
> (A 275)

intends that he is always proclaiming the increase of his profits. But it is more fun to find covert word-play with the often re-marked upon energy of equine vocal expression.

Sounding always the growing power of his *whinnying*.

Both Chaucer and Langland make poetic reference to the energy of a horse's audible display.[185]

Leaving his physical characteristics, the poet's lines become less clear. Sometimes, even with interpretation, the surface still seems pointless.

> He wolde the see were kept for any thyng
> Bitwixe Middelburgh and Orewelle.
>
> (A 276–77)

(He would that the sea were kept [looked after] for anything Betwixt Middelburgh and Orewelle.)

To keep the water, the sea for *anything* is mighty vague. (It could be a hint of the Christian "Noah" identity.) We are told that the area spoken of is found between an island off the coast of the Netherlands (Middelburgh), and a river in Suffolk (Orewell). What peculiar limitations. But, because names are ornaments to be examined, we can see why these were selected despite a seeming lack of purpose. They disguise their contents as simple words. Middelburgh, or "middle of the mountain," can refer to Chiron's cave in Thessaly. Orewelle—that is, "well of (metal) ore"—could be a cache of silver or gold. Precious metal is part of the line that fol-lows this "well."

Wel koude he in eschaunge sheeldes selle.

(A 278)

(Well could he [did he know how to] sell coins in an exchange.)

Gold coins were struck by Stephen when he came from France as heir to the English throne. There is a feeling here of the coins as a personification of Sagittarius. The *coins* would have a "personal" capability for buying, selling, exchanging other money. Chaucer's naming him the *merchant* communicates his specialty—the ability to purchase, one of the main "talents" of money.

The next four lines hold no surprising information.

This worthy man ful wel his wit bisette:
Ther wiste no wight that he was in dette,
So estatly was he of his governaunce
With his bargaynes and with his chevyssaunce.

(A 279–82)

(This worthy man full well his wits employed:
There was no man who knew him to be in debt,
So stately was he in his behavior
With his transactions and with his accomplishments.)

With no real limitations, no specific qualifications to contend with, the words can describe a man and his ethical business dealings. They can just as easily say a centaur (or a constellation) has no concern over debts and leads a well-governed existence. There is a hint of being applicable to the person of Sagittarius on the gold coins, as well—he who settles debts and closes bargains. It also seems likely, if we compare *chevaler* and *chevachour* as terms regarding horsemen, that there is a play on *chevyssaunce* as an allusion to his "horseness." (I am always fascinated by the number of mental images Chaucer's lines project.)

The final two lines of the portrait announce that the poet is leaving important information undisclosed.

For sothe he was a worthy man with-alle,

94

But, sooth to seyn, I noot how men hym calle.

(A 283–84)

(Forsooth he was a worthy man with all,
But, truth to say, I know not what men call him.)

Everything considered, the poet's subject is a worthy "man," but people have difficulty knowing what terms accurately portray him—man, beast, or man-beast. Ovid calls Chiron "semi-human."[186]
 Let's go on to Aries, the Ram.

THE FRIAR

As I check the program, I feel confident that after dealing with the Friar's clues, I will finally remember that Aries is the ram, not the goat. (I've never been able to keep them straight.) Proud, almost arrogant, the next pilgrim takes the stage, hardly waiting for the centaur to reach his assigned position in the velvet "sky." Chaucer is about to entertain us with animal pictures, bright stars and clever word-tricks.

 The myth tells of an evil stepmother who schemed to do away with the children of her predecessor. King Athamas had a son, Phrixus, and a daughter, Helle, by Nephele, and then she either died, or he got tired of her—depending on which version you read. His new wife, Ino, convinced the king by treachery that his son had to be sacrificed to appease the gods. The king was about to go along with the awful plan when Nephele (live or in the spirit) rescued Phrixus—and Helle, for good measure—and put them on the back of a marvelous ram that was a gift from Hermes (Mercury). One of the marvels of the ram was that it could travel through the air as it carried Phrixus and Helle to safety in the city of Colchis. Unfortunately, before they got there, Helle lost her hold and slipped off into the water and drowned. The area of water was named Hellespont after her. (Modern, *Dardanelles*.) Ovid tells us that Phrixus almost fell off trying to save his sister. "He wept at losing her...wotting not [knowing not] that she was wedded to the blue god."[187] When Phrixus reached Colchis safely, he was welcomed by the king, Aeetes. The young man was so grateful for his safe arrival that he sacrificed the ram (which hardly seems fair to

the beast), and it became the constellation Aries.

Phrixus removed the skin from the ram and gave it to King Aeetes. This was a really special gift because it had Golden Fleece and became the object of heroic Jason's quest. In the Middle Ages an attempt to change the ram's identity to the image of the Christian lamb was not successful.[188]

Aries has several distinctions, both historical and visual. Macrobius tells us that the earth was created when the sun was in Aries. Manilius addresses the Ram as "Prince of all the Signs."[189] Its stars once coincided with the vernal equinox—equal hours of day and night—and the beginning of a new year. The year began when spring returned; another winter had been survived. It was time, Chaucer tells us, for "the tendre croppes" when "the yonge sonne" was in the Ram (A 7–8).

It's a bit jarring to follow thoughts of spring with the news that Aries is "a dreaded sign indicating passionate temper and bodily hurt," characteristics of being the House of Mars. To locate the figure in the sky there are two features to look for. A triangle of stars, aptly called the constellation "Triangulum," sits above the Ram's head. This three-sided figure was sometimes seen as a harplike musical instrument. In addition, Hamal and Sheratan, at the head of the figure, are "a distinctive pair of stars that enables us to find the Ram with relative ease."[190]

(Allegories, with their multiple levels, can be complex to sort out. Astrology can be even more difficult. I want to mention that each sign of the zodiac has three "faces," which simply means each has three parts. I'm not prepared to analyze information about the signs to that extent, but it's good to know that Chaucer may have been working with a tri-level view in mind.)

Beyond myths and stars, there are ancient associations with horned animals and, at times, specifically with rams. The celestial figure of the Ram is a symbol of virility and violence as "an attribute of Mars."[191] In another vein, medieval dramas and illuminations often present shaggy, horned creatures with cloven hooves, features found in the Ram, but these medieval depictions are of the devil.[192]

Chaucer, who was certainly acquainted with all of the preceding information, gives it an unexpected twist with one of the word-tricks, but we'll save that for the end.

The poet leads off with a first impression of the Friar as a man both wanton and solemn.

> A Frere ther was, a wantowne and a merye,
> A *lymytour*, a ful solempne man.
>
> (A 208–09)

> (A Friar there was, wanton and merry,
> A "lymytour," a very solemn man.)

We get an immediate picture of a lascivious character who is officially *limited* (indicated by *lymytour*) in the area of his activity. A symbol of virility and sinfulness, restricted *to the sky*, conveys the intention of the lines; and so does an image of the devil in the environs of hell. We're going to concentrate on this devil image; the reason will be clear before we're finished. The Friar, as a devil, would be merry, a good-fellow as he tries to catch you, then solemn, all business, once you're caught.

The poet immediately interjects a misleading statement. (There's a bit of the devil in Chaucer, too.)

> In alle the ordres foure is noon that kan
> So muchel of *daliaunce* and fair langage.
>
> (A 210–11)

> (In all four orders is there none that knows
> So much of dalliance and fair language.)

Of the four orders (generally identified as Franciscan, Dominican, Carmelite, and Augustinian), no one knows as much as this Friar does of dalliance (which can be anything from polite conversation to coition). The lines, however, only appear to say that he belongs to one of these orders.

In the group where he does belong, he is very important.

> Unto his ordre he was a noble *post*.
>
> (A 214)

(Unto his order he was a noble pillar ["post"].)

Recall that there are also "orders" of angels, and the devil is a fallen angel. The "post" he is to his order may be a "pillar" on the surface, but "post" is also *power*, strength and authority. He is the power within the limits of his domain.

> Ful wel biloved and *famulier* was he
> With frankeleyns over al in his contree,
> And eek with worthy wommen of the toun.
>
> (A 215–17)

> (Very beloved and familiar was he
> With franklins all over his country,
> And also with worthy women of the town.)

Franklins (country gentlemen) are fond of him and he was "famulier" with them and with the women of the town. Though the medieval word *familiar*, as a noun, generally refers to a household servant, it can mean an "intimate associate." Quotations from the early 1400s speak of receiving help from a "familiar devil."[193]

The Friar's association with women does not surprise us.

> He hadde maad ful many a mariage
> Of yonge *wommen* at his owene cost.
>
> (A 212–13)

> (He had made many a marriage
> Of young women at his own cost.)

Because of him (the temptations of the devil?), many young women were married. Note that Chaucer does not refer to these brides as *maidens*. Besides conducting weddings, he also

> ...hadde power of confessioun,
> As seyde hymself, moore than a curat,
> For of his ordre he was *licenciat*.
>
> (A 218–20)

(...had power of confession,
As he said himself, more than a curate,
For of his order was he licensed.)

He claimed himself to be *more* than a curate. Taking charge of souls put him at odds with someone like the worthy Parson we've met. A license to preach and hear confessions is his claim.[194]

His next mention of women is a serious problem for the reader. The lines are filled with words that need to be questioned.

His *typet* was ay *farsed* ful of knyves
And *pynnes*, for to yeven faire wyves.

(A 233–34)

(His tippet was crammed full of knives
And pins, for to give fair wives.)

A typet is a long, narrow, ornamental strip of fabric that hangs freely, extending from a hood or sleeves. In these narrow extensions the Friar stuffed (farsed) knives and pins. (Though it seems impractical, Baugh's note suggests that there must be a pocket in this particular typet.[195]) Why didn't he carry these heavy, sharp instruments in a sturdy pouch? There is something wrong with this picture. These medieval "pins" were not the flimsy, temporary items of today, but could intend several kinds of sturdy implements. They can be ornaments for clothing, but can also be spikes and tools for stabbing, prods that a devil might use in hell (or in a stage production of hell).

Think of Satan's reputation as a liar as we read,

Ful swetely herde he confessioun,
And plesaunt was his absolucioun:
He was an esy man to yeve penaunce
Ther as he wiste to have a good *pitaunce*.

(A 221–24)

(Full sweetly he heard confession,
And pleasant was his absolution:

> He was an easy man to give penance
> So he knew he would get a good donation.)

When the devil hears your confession, he is *not* aiming to get you to heaven. He's easy; the penance imposed is trivial. This pittance (donation) that he hopes for contains (conceals?) the word *pit*—a dungeon, snare, underground chamber, and hell itself.

What results from these confessions?

> For unto a povre ordre for to yive
> Is signe that a man is wel yshryve;
> For if he yaf, he dorste make avaunt,
> He wiste that a man was repentaunt;
> For many a man so hard is of his herte,
> He may nat wepe, althogh hym soore smerte.
>
> (A 225–30)

> (For unto a poor order for to give
> Is a sign that a man is well absolved;
> For if he gave, he dared to boast,
> He knew that a man was repentant;
> For many a man is so hard of heart,
> That he may not weep, although he sorely smarts.)

Is giving money to a poor order a sign that you've made a good confession? Hardly. And here is another potential portrayal of hell—a man who is hard-hearted and in great pain. Aries, as a dreaded sign of "bodily hurt," comes through these mental pictures, as well; that's his astrological personality.

> Therfore in stede of wepynge and preyeres
> Men moote yeve silver to the povre freres.
>
> (A 231–32)

> (Therefore instead of weeping and prayers
> Men may give silver to the poor friars.)

This Friar recommends no prayers, no tears of contrition; just give

money. There is no concern about salvation.

> And certeinly he hadde a murye note;
> Wel koude he synge and *pleyen on a rote.*
>
> (A 235–36)

> (And certainly he had a merry note;
> Well could he sing and play on a "harp.")

Twice the voice of this ram is heard to stringed accompaniment, which keeps the triangular, harp-like figure above Aries in our mind's eye.

> Of *yeddynges* he baar outrely the *pris.*
>
> (A 237)

> (Of "yeddynges" he bore outwardly [utterly] the prize.)

There is deceit in the word *yeddynges,* which means songs. But it may also tell of lies, exaggerations.[196] An apt description of the devil is the one who takes the prize for lying outwardly, openly, utterly, unashamedly. In John 8:44 he is cited as "the father of lies." (*New American*)

> His nekke *whit* was as the flour-de-lys.
>
> (A 238)

> (His neck was as white as the fleur-de-lis.)

Why would his *neck* be noted as *white*? A good reason is that the rest of him is not. The devil is traditionally a *black* ram. (The specific white of a *lily* will be given special attention in a bit.)

> Therto he strong was as a champioun.
>
> (A 239)

> (In addition he was as strong as a champion.)

As a ram, he is surely strong, and so is the devil. Lines A 240–50 tell how he frequents taverns and is acquainted with tavernkeepers, innkeepers, and the rich—serving those eager for profits. It's also his usual practice to keep his distance from lepers and the poverty-stricken; they gain him no advantage. They do not enhance his reputation or turn him a profit (the devil's profit being souls gained for hell). It's probably easier to corrupt the haves than the have-nots.

His inclination to shy away from the poor is followed, almost immediately, by behavior that is the reverse of this declared practice. (Is this unpredictability on the part of the devil? on the part of the poet?)

> He was the beste beggere in his hous;
> For thogh a wydwe hadde noght a sho,
> So plesaunt was his "*In principio*,"
> Yet wolde he have a ferthyng, er he wente.
>
> <div align="right">(A 252–55)</div>

> (He was the best beggar in his house;
> For though a widow had not a shoe,
> So pleasant was his "*In principio*,"
> That he would have a farthing, e'er he went.)

I'm surprised to find him associating with a widow so poor she must go barefoot. Unfortunately for the woman, he has no sensitivity at all, and he doesn't leave until he gets a donation from her in spite of her poverty. A desperately poor person, such as this widow, whose prayers have not improved her lot, might try a different tactic—by asking the devil for help. Hearing his pleasant "*In principio*" ("in the beginning") may seem to her like the indication of a fresh start.

His being called a "beggar" made me uneasy. The narrator *knows* the Friar's activities. If this is a devil, *begging* is not his vocation. What's missing? I checked the medieval definitions of many words. (It always proves enlightening. You get a feel for how words that far removed are the same, and how different.) I didn't look for *beggar*, however, because everyone knows what it means. The word

continued to create a disturbance in my mind. And then, through the mental static, I got just an inkling of the soundtrack of a British film. Eventually it became loud enough to hear clearly as someone snarled: "The filthy beggar." I rushed to the MED (one of my favorite possessions) and there was the solution. Even in the Middle Ages, *beggere* also meant *rascal*. The story of the barefoot widow bears out, in this case, that *beggar* does equal *rascal*.

The next is a memorable line. It stands alone, a period before and after.

> His purchas was wel bettre than his rente.
>
> (A 256)

Its meaning is not obvious. Notes try to clarify, but admit "it is difficult to see what could be meant." This is an unusual case; I'm not going to try to give a meaning for the line, but a different evaluation can be made.

In the *Friar's Tale* a devil confides:

> I am a feend; my dwelling is in helle,
>
> . . .
>
> My purchas is th'effect of al my rente.
>
> (D 1448–51)

That's no explanation. We still don't understand what is said, but we know for certain that A 256 is a statement about diabolical activities because a devil at D 1451 expresses the same thought. Chaucer portrays the "feend" and the Friar in the same way, which helps to confirm the Friar's status as another fiend (devil).

Have you noticed little glimmers of the zodiac in Chaucer's carefully selected vocabulary? A "signe" is mentioned at line A 226, and the "*In principio*" (A 254) points to this pilgrim as Aries, the first, the *beginning* of the succession of signs. If we allow Chaucer's images to pass by unexamined, chances are, we will enjoy his stories anyway. But if we catch on to them and peer into them, it could be a lot more exciting.

Many of his lines, like the next one, stop my mind in its tracks.

And rage he koude, as it were right a whelpe.

(A 257)

(And rage he could, as if he were a whelp.)

What a totally unexpected picture! (Allegorically speaking, that makes it important.) Notes advise the reader to see a "puppy" in this "whelpe," but where is the sense in a puppy *raging*? Fourteenth-century *rage* can mean "carnal desire," but all the other medieval connotations are what today's word would intend—madness, wrath, fierceness, violence. How does a precious little whelp, a puppy, fit the picture? It doesn't. The poet's scheme is hidden in another definition. A whelp can also be "the offspring of a noxious creature," some kind of detestable being. That definition, however, has no value until you realize that our main subject is a devil. The OED has specific quotations telling of the "fiend's whelp" and "whelps of the devils."[197] Though Chaucer's image remains startling, it blends into the underlying framework he is constructing.

The Friar likes to get his fingers into all sorts of transactions.

In *love-dayes* ther koude he muchel helpe.

(A 258)

(In love-days could he help much.)

A love-day was rather like a moratorium on hostility between individual citizens. To find the devil influencing negotiations made between enemies in hoped-for reconciliations is easy to visualize. Each side wishes to appear agreeable before the public and the negotiator, but hopes to come away with an advantage, if possible. Concealed dishonesty would surely be the "help" given by the devil. (And, of course, if we read these "love days" as amorous arrangements, the devil would be pleased to assist there, too.)

What you will experience now is a kind of time warp. I had already finished this whole chapter but some of the words refused to cooperate; they wouldn't accept the order I'd worked out for them. The most stubborn was "farsed," followed closely by "typet" and

"pitaunce." No matter how strong an effort I made to insist they remain as assigned, as soon as I'd turn to something else, they'd start a rumpus, insisting I pay attention to them. They are demonstrative allegorical ornaments that refused to be ignored. What follows now (before we continue through the remainder of the Friar's *General Prologue* introduction) is the result of a delightful tussle to learn how the pieces fit *happily* together.

"Farsed" was the biggest nuisance until I discovered that, though the word in French means "stuffed," it is the source of the word *farce*. (There is no linguistic history of the transformation, so you're free to make up one that pleases you.) Farce is a direct connection to the devil in medieval plays; so we go back to where the devil comes onto the *General Prologue* scene. Functioning on stage, demons were always a comic element. Lucifer himself was considered a *fool*, his actions foolish, because he gave up heaven.

In the grand cycles of plays presented on church feast days "the Devil is continually being dragged in, even where he is not strictly required...purely for...merriment."[198] An actor could be quite creative. For example, a particular demon trying to stretch a length of parchment with his teeth (to have more area to record sins) is not a far cry from the Three Stooges: The belabored piece of parchment suddenly rips off and the demon cracks his head against a wall. Typically, devils are portrayed as fear-filled, and do a lot of sprawling and groveling. Their fear also inspires regularly announced occurrences of breaking wind.

Satan is provided, in his public image, with a spear or trident. On one occasion, when a demon decides to leave his post, Satan threatens to brain him. And when the battle scene (the defense of hell) is in full swing, a demon runs into the fray with the medieval equivalent of sparklers in his hands, ears and arse. Picture the comic exit signaled by the announcement "fast all hence," no doubt resulting in general pandemonium. Satan, the suave devil-in-charge, salutes the audience at his final exit with, "Have a good day! I go to hell!" But the ultimate for our imagination is a grand finale: an assembly of demons "drag" sinners to the pit of hell amid great noise, prodding and confusion.[199]

Lucifer, the fool, would be right at home during the Feast of Fools.[200] Chaucer's bedeviled lines also fit into the celebration

nicely, capitalizing on the elements of *fools*. The Feast was a brief period of a world upside-down: lowly clerics became men of importance; bishops reverted to lowly clerics. Church ceremonies were farcically imitated: pudding and sausage replaced incense; an ass was brought into church and ceremonial responses were brayed by the clergy.[201] This inversion could be reflected in that "licence," the permission, the Friar held. *Licentious* (from the same Latin root) also fits the occasion nicely.

After "farsed," our second unruly word is "typet." It actually has two parts. If we remove the "et" (the French diminutive ending) we have the English word "type"—a snare, a trap. A little trap is just what the devil would order. Now we don't have to try to picture that narrow strip of cloth "*stuffed* full of knives and pins." The line serves a devilishly different purpose altogether, a trap—such as hell—full of instruments that prod and puncture.

"Pit*aunce*," is our third word. Chaucer's playing a game with the word. The rules are like the ones that hold for remembr*ance*, hindr*ance*, deliver*ance*. The *-ance* functions as "caused someone to be" remembered, hindered, or delivered. In similar fashion, then, pitt*ance*, is "caused someone to be" pitted, where the *pit* is hell. "Hell pit" was a common term.

The scene is not what we originally thought. What *has changed*? At the surface of the reading, there are difficult words, difficult lines to deal with. At the covert level, it's a farce. The devil is imitating church ceremonies, performing weddings, hearing confessions, giving absolution. It's all pretense.

The typet becomes a little snare for this farcical performance where knives and pins represent assorted pointed instruments aimed at "worthy" women as they are herded into the pit. The pit entrance was called "hell mouth" and was a prominent feature of medieval staging. Dramatists reveled in portraying Doomsday where "devils rolled, shoved, pricked and tossed the damned into Hell Mouth unceremoniously." The object of the scene was to present the very wicked as a source of "rude laughter and humiliating action."[202] Fine women being herded by the devil was the "*pit*aunce" he'd hoped for. And that raging whelp becomes a demon giving his comic all. Our imagination sees him tremble, gesture, squeal, take pratfalls, do acrobatics and anything else that would get a laugh.

Back now to real time. We continue the Friar's depiction with one of my favorite parts. Features of the devil move to the background and the ram, as an animal, comes forward.

> For ther he was nat lyk a cloysterer
> With a thredbare cope, as is a povre scoler,
> But he was lyk a maister or a pope.
> Of *double worstede* was his semycope,
> That rounded as a *belle* out of the *presse.*
>
> (A 259–63)

> (For there he was not like a cloisterer
> With a threadbare cope, as is a poor scholar,
> But he was like a master or a pope.
> Of double worsted was his "semycope,"
> That is round as a bell out of the press.)

His "clothes" are not threadbare, of course not. He has clothing fit for a person of importance. Then, to get specific, he has a *short* cloak made of worsted (wool) and rounded as a "belle" (a kind of cloak or tunic) out of a "presse," which is a device to press and stretch cloth. In other words his woolen cloak—his fleece—fits him as if it were pressed and stretched just for him. What fun for the poet.

Let's take a second look at the "worsted." This is a fabric of "well-twisted yarn, long-staple wool." A handsome ram would have such a coat. But even better, the cope, the garment in question, is "double" worsted. "Double" holds a second connotation. Strangely enough, the word is also the name of a *gold* coin. (Think "doubloon.") Chaucer, in his international business dealings, would be familiar with a great variety of coins. *Double* worsted gives gold content to the wool of Aries which *is*, in fact, the *Golden* Fleece.

> Somwhat he lipsed, for his wantownesse.
> To make his *Englissh* sweete upon his tonge.
>
> (A 264–65)

(Somewhat he lisped, for his wantonness.
To make his English sweet upon his tongue.)

His lisping as a sign of wantonness seems no problem; making his *English* sweet is. The name of anything needs to be studied. The only implication that comes to me is that he also speaks another language if he needs to make an adjustment in his English. Perhaps this relates to the Ram's Greek origin.

And in his *harpyng*, whan that he hadde songe,
His eyen twynkled in his heed aryght,
As doon the sterres in the *frosty* nyght.

(A 266–68)

(And in his harping, when he had sung,
His eyes twinkled in his head aright,
As do the stars in the frosty night.)

These lines illuminate the celestial key. First we locate Triangulum as a harp. We've been told the triangle makes it easy to find the head of Aries, and that's where we move next. It's early spring. March nights can be chilly, frosty. We look up and there are the Friar's eyes, the "distinctive pair of stars," Hamal and Sheratan, that make it easy to locate Aries. They "twinkle in his head *exactly* as do stars in the frosty night." Chaucer must have loved writing those lines.

This seems like the right place to end the introduction, but the poet feels it needs one more line. We've already seen that last lines can be very significant, and names especially so. The pilgrim, as a final thought, is given a name, "Huberd." My best idea is that this has meaning regarding another "face" of the sign, probably an historical figure named Huberd or Hubert.[203]

The beginning of this chapter promised there would be a twist. Here it is. I keep saying that each pilgrim is called upon to tell a story that is part of his background. Aries is the Ram who let Helle slip into the water. The Friar, then, could tell a story about Helle—and he does. The twist is that h-e-l-l-e is the Middle English spelling of the devil's territory. The Friar tells a very enter-

taining story about "helle" and how the devil, who announces himself "a feend; my dwellyng is in helle," transacts his business to acquire souls (D 1448).

Let's think back to where we began with the story of Aries as told by Ovid. It may be that the Latin poet directly inspired Chaucer's duplicity. For Chaucer, a reader of Latin as well as Middle English, a double image would be evident when Ovid refers to Aries as "the ram of Helle."[204] One image is the animal that carried a girl named Helle, the second is an animal symbolic of the devil from "helle." Not a word need be changed; the images superimpose.

Next we'll visit Capricorn.

THE SHIPMAN

A sailor can have an unusual gait; it has something to do with all the time spent compensating for the rolling motion of a ship. As the poet hails the next participant, the pilgrim's advance is unusual to say the least—each step or two forward is punctuated by a wobble and a swish.

The *Shipman's* title can indicate a lowly sailor, someone skilled at navigating, a commander or owner of a ship, a helmsman—or a pirate. It's an eminently adaptable word. There is flexibility, as well, in the Capricorn image; we have two choices. Chaucer's words, despite a minimum of material from mythology and astronomy, will steer us in the direction of his choice of the depiction.

How did Capricorn become a constellation? What heroic deed was accomplished? Who rewarded a lowly animal with eternal, stellar recognition? We have no answers.

There are few facts to relate about the sign. At an early (ancient) time its image was a goat, simply a goat. At some later time (still ancient and probably in the Middle East) its front half remained a goat, but now it had a fish's tail instead of the goat's hind-quarters. This dual representation is sometimes called "the Sea-goat."[205]

A story is associated with the figure, and perhaps the story was Chaucer's guide in constructing the pilgrim introduction. Some details of Ovid's story correspond to details given by our poet, but at no point is anyone—or anything—placed in the heavens.

This, briefly, is the story. Acoetes, a shipman, brought his vessel to shore for the night. In the morning, the crewmen, who went ashore on various tasks, found a beautiful young man who appeared to be drunk. They wanted to take him aboard as a captive prize. Acoetes recognized the stranger as a deity and told his crew to forget the dastardly plan. They disregarded the order and the wisdom, and, amid Acoetes' protests, set sail with their prize. Continuing to object, this mythical shipman was about to be thrown overboard by the crew, when, suddenly, the young man (having come to his wits) took on his true celestial image. He, Bacchus (Dionysus), the god of wine, brought the ship to a halt. Ivy, out of the waters, rapidly grew up and over like ropes, holding the ship in place. The sight of "the god himself, with his brow garlanded with clustering berries…[and] around him…tigers…lynxes…fierce spotted panthers" caused the crew to jump overboard in fear. They were all changed to sea creatures which some writers refer to as dolphins: "Hands...can no longer be called hands at all, but fins." The crewmen swam with limbless bodies, tails like crescent moons, blowing water from their broad nostrils. When Acoetes recovered from the shock of the events he witnessed, he sailed on at the helm and delivered Bacchus to the god's chosen destination, Naxos. The sailor remained there and subsequently became one of the god's devotees.[206]

Bacchus is god of wine; wine is part of the plan to introduce the Pilgrim Shipman. Sailing and men overboard are also included by Chaucer. Those are the similarities, for what they are worth.

Goats were associated with Dionysus (Bacchus' other name) as one of the transformations he might adopt. The animal is also a preferred sacrifice to the god of wine. One more essential connection between wine and goats is that from biblical times the libation was kept in goatskins. A verse in the New Testament advises that you not fill old bottles, made of skin, with new wine.[207]

From the point of view of astronomy, Capricorn is an "inconspicuous sign."[208] Only one star is noted; the star is *Deneb Algedi*, Arabic for *Tail's End*. Relationship of stars that make up the image is apparently very ancient and was imported into European thinking.[209] We generally picture a constellation filling its allotted thirty degrees; Capricorn, however, does not. The sign originally marked

the winter solstice, when the sun is farthest south in its course. Af-
ter the solstice (which means "sun stands still"), the solar move-
ment appears to reverse as the sun climbs, again, northward toward
the highest dome of the sky. These winter days are the shortest.
(The sun's rising in this constellation coincided at one time with
the dates given to the sign, but the calendar is not perfect. The zo-
diacal divisions have shifted westward. Chaucer was aware of the
shift and the imperfection in the calendar.[210])

Astrologically, this is a feminine sign. It is also nocturnal, and
illustrations may combine the sea-goat with a crescent moon. Cap-
ricorn was thought to be a "harbinger of storms" and an influence
on creatures of the sea, as well as on sailing ships. Its name, "Gate
of Gods," indicates that souls of men rose through this sign to the
stars; the stars were believed to be the soul's ultimate destiny.[211]

With this introduction of another horned animal, the devil is
evident once again. I'm not going to claim each pilgrim from here
on to be partly devil. Tradition sees devils as the horned beast from
hell. Remembering the story of the wine god related earlier, in-
fluential Augustine claims that ceremonies of Bacchus "were insti-
tuted by foul demons."[212] It's no surprise, of course, if we find more
than *one* devil in the *Tales*. You're probably acquainted with at least
three: Satan, Mephisto, and Beelzebub. Chaucer names both Satan
and Belial, and includes the presence of demons and fiends in
general.

Let's see, now, what Chaucer says about the Pilgrim Shipman.

> A Shipman was ther, wonynge *fer by weste*;
> For aught I woot, he was of *Dertemouthe*.
>
> (A 388–89)

> (A Shipman was there, living far west;
> For all I know, he was from Dartmouth.)

He was living far to the west. This seems a simple hint of the
"precession" of the signs, the fact that they have shifted west from
where they "belong." The solstices, too, were no longer aligned, and
Capricorn—our Shipman—is the proper location of the winter
solstice. The "far west" statement may also indicate that this

formation does not fill thirty degrees, but occupies the western portion only. This is followed by one of those "informative" statements that gives no information (like the speculation about the Friar's order). This pilgrim, *for all the poet knows*, was from Dartmouth. Let's examine the name. This, again, is two words joined together: *dart* and *mouth*. Both have figurative allusions to the devil—as his weapon, and as the entrance to hell. The *Gesta Romanorum* warns that man "shall defend himself against the darts of the devil,"[213] and we've already talked about hell *mouth*.

Remembering that we said that the "horse" is part of the character, a goat would be equivalent to a small horse.

> He rood upon a *rouncy*, as he kouthe,
> In a gowne of *faldyng to the knee.*
>
> (A 390–91)

> (He rode upon a rouncy, as he knew how,
> In a gown of woolen cloth to the knee.)

"Rouncy" is actually the name of "a kind of small horse." His riding gown is made of "faldyng," and reaches his knee. Baugh notes the cloth as a *soft* woolen, although the MED identifies it as "coarse." The repetition—after the Friar—of another woolen garment on this character was a little disconcerting to me until I checked the *Britannica*. Sheep are not the only source of wool. Goats—angora and cashmere goats—are also sources of wool. The Angora, which most closely fits Chaucer's picture, is native to Britain. Angoras have short legs and long hair which covers most of the leg—"to the knee." Their fleece also produces mohair.[214]

He's equipped for defense—or attack.

> A daggere hangynge on a *laas* hadde he
> Aboute his nekke, under his arm adoun.
>
> (A 392–93)

> (A dagger hanging on a lace [a thong] had he
> About his neck, down under his arm.)

When approximating one thing in terms of another, some details are bound to be easier to correlate than others. But, if you're a poet determined in your analogy, you keep the lines flowing the best you can. The reason for this caveat now is that the dagger is peculiar. The often elegantly curved horns of a goat, however, are as potent a weapon as a dagger. And the "lace" (think shoelace), that follows the path around the Shipman's neck and down under his arm, was the term used to express a means of binding two things together. This potential connective may allude to the attaching of goat to fish.

> The hoote somer hadde maad his hewe al broun.
>
> (A 394)

(The hot summer had made his hue all brown.)

Reference to the summer in past tense is proper because Capricorn is a winter sign. A solid color (including brown) is what is expected with Angora goats.

A Shipman gave service for a price.

> And certeinly he was a good felawe;
> Ful many a draughte of wyn had he ydrawe
> Fro Burdeux-ward, whil that the chapman sleep.
>
> (A 395–97)

(And certainly he was a good fellow;
Full many a draught of wine had he drawn
From Bordeaux-ward, while the businessman slept.)

The lines, on the surface, give the impression that the Shipman is stealing the wine stores while the wine-dealer is asleep. It's amusing to watch the shift of the intention as we take the words to mean a goat instead. The animal is "certainly a good fellow" to allow his skin to be used for storing wine. In this way, the goat is capable of transporting quantities (draughts) of wine, while the wine-merchant is asleep—and while he is awake.

> Of *nyce conscience* took he no keep.
> If that he faught, and hadde the hyer hond,
> By water he sente hem hoom to every lond.
>
> (A 398–400)

> (He never kept a nice conscience.
> If he fought, and had the higher hand,
> By water he sent them home to every land.)

His *nice conscience* makes the subject seem unmistakably human, but the line is really only saying that this is a creature who does not live by *moral* guidance, which surely is true of a goat (or fish) or devil.

Then, if this Shipman overpowered "them," he sent them home by water to every land. This could refer to the "Gate of the Gods" aspect of the sign giving passage to souls of the dead. It makes for a possible recollection of Bacchus as the cause of the wicked sailors jumping overboard and turning into dolphins. It could also be identified as the power that Capricorn exerts upon creatures of the sea and sailing fleets. The sign is recognized as wet or destructive—or wet *and* destructive.

> But of his craft to rekene wel his *tydes*,
> His *stremes*, and his *daungers* hym bisides,
> His *herberwe*, and his *moone*, his *lodemenage*.
>
> (A 401–03)

> (But of his craft he could reckon well his tides,
> His streams, and his "daungers" besides,
> His harbors, and his moon, his navigation.)

Knowledge of tides, streams, harbors, etc., is what we expect of a good seaman. As Capricorn, we see his influence; each element named is identified as *belonging to him*. The poet does not say *the* tides, *the* harbors, not even *the* moon. Each of these is *his*. As a water sign, tides and streams and harbors would be familiar matters. And, it's notable that, elsewhere in the *Tales*, when a zodiac connection is at the surface, *herberwe* (harbor), in the explanatory note, is assumed to mean an astrological "house" (F 1035).

Parallel images are enclosed in these lines. At A 401, in addition to *tides* meaning movement of water, the word can refer to the devil's craft—his ability to reckon *events, seasons, spans of time*. (If this sort of *tide* is a problem, think Yule*tide*.) Streams, besides water, can be light emitted from a star, and also a legal term used in defining the extent, the area of one's freedom. "Daunger" often refers to power and control. Then, as a devil, A 402 speaks of *his* "domain," if you will, and power. A 403 is packed with covert implications. Harbors, in general, are places where one is welcome, not only areas involving ships. *His* moon can indicate Capricorn's association with the moon; as Ptolemy tells us, the moon governs Capricorn by night.[215] The governing moon goddess, Diana/Hecate, is the queen of Hades, the classical world's term equivalent to *hell*. His "lodemenage," besides meaning navigation on the water, can also be a course that is followed. A "lodesman" can be a guide—a job the devil would eagerly accept.

> Ther nas noon swich from *Hulle* to *Cartage*.
> <div align="right">(A 404)</div>

(There was none such from Hull to Carthage.)

There was no one quite like him—a fitting attitude encompassing the Pilgrim, the Sea-goat, and the devil. This observation is made regarding the area between two cities, two more names to be reckoned with. "Hull," in Yorkshire, is local, and, of course, can also mean the body of a ship; "Cartage" has been suggested to be Cartagena, Spain.[216] But, if we think Carthage instead, it's a much broader sweep of territory. The ancient Middle-East city also makes a connecting allusion to early astrology.

> Hardy he was and wys to *undertake*;
> With many a tempest hadde his *berd* been shake.
> <div align="right">(A 405–06)</div>

(Hardy he was and wise in his undertaking,
With many a tempest had his beard been shaken.)

"Wise in his undertaking" is appropriate for the surface. "Clever in his entrapments" is an alternate reading. And though "undertake" was not yet part of funeral terminology (undertaker), it did mean to *convey*. The line reminds me of scenes spoken of earlier regarding the Friar, where devils get souls into hell mouth, often by trickery. So the line expresses trapping, taking unawares and then conveying; as the pattern of getting souls ready for hell, the devil has had a lot of practice. We've said enough about storms, so there's no need to elaborate on the tempests. Just a word, however, about the beard that shakes; it is surely that of a billy goat.

Next we're entertained with the poet's ornaments of names, sure clues.

> He knew alle the *havenes*, as they were,
> Fro *Gootlond* to the cape of *Fynystere*.
>
> (A 407–08)

> (He knew all the havens, as they were,
> From Gotland to the Cape of Finisterre.)

Knowing *havens* is simple word-play on *heavens* (the vault of the sky) which was well known to Capricorn—and to the devil, as Lucifer, until his fall. In A 408 the poet gives us the clincher. Searching his world for the perfect names, he uses an island off the coast of Sweden and a promontory along the coast of Spain.[217] The sought-after names provide the sure identification of the Sea-goat with *goat-land* and *fin-star*. The one notable star in Capricorn, Deneb Algedi, indicates "End of the Tail," which is the proper location of a *fin* star, or a star at the *end* (*fine*).

We would say that the *goat* and *fin* were the ultimate touch. No more need be said. But in his Canterbury omniscience, the poet adds two more lines. The Shipman also knew

> every *cryke* in *Britaigne* and in *Spayne*.
> His *barge* ycleped was the *Maudelayne*.
>
> (A 409–10)

> (every creek in Britain/Brittany and in Spain.

His barge was called the Magdalene.)

These lines must hold a concealed confidence. We might pass over them because we think we've found all we need, but there is more than one idea hidden in these *General Prologue* vignettes, more than just the signs. The "cryke" may be a "creek," but the word also denotes a *trick*, a *stratagem*. Chaucer uses "cryke" elsewhere with that meaning (A 4051). The "Britaigne" is often interpreted here as Brittany (in northern France, geographically and culturally very close to England), but it *can* mean Britain itself. With our new definitions, we have a line that says he knew "every trick in Britain and in Spain." Royal intrigue? Political maneuvering? As a frequent emissary for his king, Chaucer would have been privy to many such matters.

Lastly, the pilgrim's ship is given a name. Could the poet be saying (as he does with the pilgrim's horses) that one aspect of this *Shipman* is actually named Maudelayne? It's worth mulling over. Or, does it simply point to the femininity of the sign?

This boat is designated as a *barge*, which is a sea-going vessel or a craft sometimes used for state occasions. "Boats" were also created for indoor spectacles, such as royal entertainments; a large vessel would be part of the pageantry.[218]

The Middle Ages knew a ship and a "shipman" to be an essential part of the Mary Magdalene (Maudelayne) story. Derived from the *Golden Legend* account of her miraculous adventures, the narrative formed a basis for dramatizations of her life. Because the wherewithal to carry "a large ship in procession" existed as early as 1313, chances are that such a "stage property" was part of outdoor performances even before the Digby plays (early 1500s) that make a prominent feature of the vessel. And, of course, we need not think a visual stimulus would be necessary for our poet to associate "maudelayne" with "Shipman." (Once we have deciphered the purpose for the names that play a part with each pilgrim, we may understand more of Chaucer's covert plan. A translator of the *Golden Legend*, working from a medival mind-set, makes this all-encompassing statement: "As with facts and dates and places, therefore, so also with names—*it is the hidden meaning which must be sought*, and the spiritual message which things convey.")[219]

As we conclude our review, we can see that though Chaucer

doesn't have a great deal to work with—no myth, no outstandingly bright stars—he uses what material he has to produce a brief but imaginative portrait.

Because this is such a good example, we should also note that the Shipman is given *no* physical characteristics aside from the color brown and the fact of a beard. This generally means the poet hopes we won't notice because he *can't* give us a clear picture or the game is up. A garment of wool and a dagger "complete" this portrait. Chaucer is famous for giving the impression of realistic detail—until you stop to scrutinize.

When the Shipman comes on the scene as the pilgrims are traveling, he is in character. The Host has just asked the Parson to tell the next tale. The seaman, however, rudely interrupts and absolutely refuses to allow the Parson to have his say. The hostile pilgrim fears that the humble Parson

> ...wolde sowen som difficulte,
> Or springen cokkel in our clene corn.
>
> (B 1182–83)

> (...would sow some difficulty,
> Or sprinkle cockle in our clean corn [seed].)

So like the devil. The trick he plays is that he, the devil, is the one who would scatter the cockle in the corn if he has the opportunity. The Shipman/Capricorn proposes,

> My *joly* body schal a tale telle.
>
> (B 1185)

> (My "joly" body shall tell a tale.)

Isn't it odd. He doesn't say *he* will narrate; he says his *body* shall. Something that odd always makes me suspicious. I decided to check words similar to "joly" to find a possible play on words. A clever possibility is *jollen*: to stagger. A dialect version has it: to roll to and fro in walking. This seems a reasonable picture of the Seagoat trying to take a stroll. Chaucer follows his odd statement with

And I schal *clynken* you so mery a *belle*,
That I schal waken al this compaignie.
(B 1186–87)

(And I shall clink you so merry a bell,
That I shall waken all this company.)

If we put the two ideas together it gives the feeling of rolling to and fro as he walks, combined with a goat's bell clinking noisily. A Sea-goat's ability to get about *would* be awkward as well as noisy. The Shipman continues, declaring we'll not hear of philosophy nor law nor *phislyas* from him. *Phislyas* has no actual meaning. (It's one of the mysteries of Chaucer's vocabulary.) The character study closes with

Ther is but litel Latyn in my mawe!
(B 1190)

(There is but little Latin in my maw!)

For a person to refer to his own mouth as a gaping maw sounds grotesque. But as an allusion from the devil, gaping hell-mouth is indicated, where Latin would be of little value.

So we have done with Capricorn, its goat image and its devil image. Our next project warrants a bit of explanation before the performance continues.

PILGRIM CHAUCER'S CLIQUE

Chaucer's allegory gets more complicated. More levels of meaning seem embedded. Our first consideration is that we will deal with a *group* and try to sort out why these specific individuals were joined together. Beyond that, the hidden images are more complex than those we've dealt with. (It may be true that the pilgrims we have met so far are also as complex as those ahead. If true, the earlier potential for complexity has eluded me.) The group the poet presents has Pilgrim Chaucer as one of its members. That is surely a signal for our attention.

The individual *General Prologue* portraits run on for several

pages (no matter which edition you're using) and then you come to this compound, overstuffed announcement.

> Ther was also a Reve, and a Millere,
> A Somnour, and a Pardoner also,
> A Maunciple, and myself—ther were namo.
>
> (A 542–44)

> (There was also a Reeve, and a Miller,
> A Summoner, and a Pardoner also,
> A Manciple, and myself—there were no more.)

Here's a hint of what these five occupations amounted to: a reeve kept a full account of what was produced on a manor, and what work was done; a miller needs no special explanation; a summoner was a petty clerical officer who cited people to appear before the ecclesiastical court; a pardoner was a minor churchman, who was understood to sell "little pardons" in lieu of other penances[220]; a manciple was an employee of an institution and functioned mainly in the purchasing of provisions.

At first the grouping appears to be a means to ending the *General Prologue* quickly, but it's not that at all. Immediately following the multiple introduction, each pilgrim named is singled out and given the same treatment as all the other pilgrims we've met. Then why set them in a group at all? It's surely not whimsy. It attracts attention, and, therefore, deserves special treatment. These characters have some sort of affinity for each other and some sort of relationship with the author/director/pilgrim. I explained earlier that I take Chaucer, in *all* aspects of his presence, as the writer himself communicating in various ways, on various levels. To encircle himself with these five pilgrims has a meaning.

As we deal with each of the five individually, we will try to identify what it is that gives each a meaningful connection to Chaucer's pilgrimage—his life. Our search will acquaint us with Scorpio, Aquarius, Pisces, Taurus, and Libra. We'll begin with Libra.

THE MANCIPLE
With an unexpected move, our poet disappears behind the curtain

for a brief interval. When he returns, there are five pilgrims with him. What begins as a close-order little marching detachment, within a few paces becomes a small disorderly contingent. One of the pilgrims is not "marching" with the others; they seem to be shoving him forward. (I wonder if it might be against his will.) Chaucer calls a halt. Four remain within view in the background, while Chaucer himself guides the non-marching pilgrim forward.

This first individual of Chaucer's special group is the sign/constellation of Libra. With that recognition, it's clear that this pilgrim would be in need of assistance to get into his present position; he is totally lacking the gifts of "personal" mobility.

Before I became interested in Chaucer, I assumed every zodiac symbol had a story behind it, but not so. It's strange but true, that, like Capricorn, Libra, the Scales has no myth to aid and inspire us. It became the twelfth zodiac character by the authority of Julius Caesar in 46 B.C. Before that it was seen as the claws of the figure Scorpio, the scorpion. Scales, however, are a timely image because Libra (sometimes called the Balance) appears at the autumnal equinox when night and day are equal.[221] The configuration may have originated in Egypt many centuries before Caesar. It is clear that two of the four stars that make up its distinctive diamond-shaped array were once considered part of Scorpio because their official names are Arabic for "North Claw" and "South Claw," Zubeneschamali and Zubenelgenubi, respectively.

Ptolemy, who used both the Claws and the Scales as interchangeable referents, declared the sign masculine, diurnal and the exaltation of Saturn.[222]

In looking at the twenty-three lines that introduced the previous pilgrim, the Shipman, we noted how little real information was given in order to "picture" the goat with a fish's tail. How much could be said, how many *details* given, and still keep the underlying identity *hidden*? The Manciple's twenty lines provide much less. Considering the visual limitations, it would be difficult to do otherwise. Manly has said that "of the thinly drawn figures the Manciple is perhaps, after the Second Nun, the thinnest." (The Second Nun's portrait is actually a void; we are only told she is traveling with a *first* Nun.) Brooks says of the Manciple that "of his appearance nothing whatever is said," and calls him an "odd man out."[223]

This choice of words reminds me again how much Chaucer's technique is discerned—without being understood. This truly is an "odd man" who is outside the norm. Weighing scales would be difficult to describe in terms of *a human being*.

So what does Chaucer do for an introduction? He distracts his audience by telling of the Manciple's capabilities, and hopes we won't notice the lack of physical attributes. We understand the pilgrim's "efficiency at his job—he is a skilled watcher of the market."[224]

I began to collect information for this pilgrim by searching for narratives of medieval business transactions which utilized primitive scales. Some details were available in chronicles or stories of travelers, but it was a lot of effort to gain a few facts. I gave it up and worked on another subject for a while.

Nevertheless, I was convinced that business transactions were what I had to understand because of the scales, and the title given him. A manciple is the servant who buys provisions. More simply said, he's "a purchasing agent." That was my comparative understanding: a scale *was* a purchasing agent; it made business possible. But Chaucer's scheme turns out to be much simpler than that.

When I returned to researching this pilgrim, I began from a different direction: the word *Libra*. It was one short step to the essentials. How can you make a purchasing agent out of *Libra*? The OED says that the Medieval Latin word "*libra*" was used to signify "pound" and that's why the British pound is symbolized as a fancy "L"—£, which stands for *libra*. With no effort at all this Manciple, as *Libra*, is *money*, the efficient agent of business transactions.

Chaucer gives his readers an extended "picture" of how well this character functions in market operations. At times money will clearly be the topic, at other times the weighing mechanism, just as with the goat/devil and other descriptions where one aspect moves to the foreground as the other recedes.

Libra's covert identity (as money or scales) is just beneath the surface. The Manciple is an exemplary transactor of purchases, who could outsmart learned men. He could also be a help under many circumstances to many people.

For a moment let's review Chaucer's extensive experience with both scales and money. He was, for many years along with other jobs, "Controller of Customs and Subsidy of Wools, Skins, and

Hides in the port of London."[225] This was not just a supervisory position; he was required to keep records in "his own hand," which meant he was responsible for accuracy and honesty. He must have given many hours to the job. (How did he find time to write?)

This pilgrim is introduced as

> A *gentil* Maunciple was ther of a *temple*,
> Of which *achatours* myghte take exemple.
>
> (A 567–68)

> (A genteel Manciple there was of a temple,
> Of which provisioners might take an example.)

"Achatours" are buyers of provisions, especially for a royal household. This "temple" is generally explained as an institution connected with the law schools, and that does fine on the surface. Because Chaucer uses "gentil" (or *gentile*) and "temple," these *achatours* bring a glimmer of other businessmen changing money in another Temple. The biblical moneychangers could take an example from this Manciple.

In managing purchases, he is outstanding.

> For wheither that he payde or took by *taille*,
> Algate he *wayted* so in his achaat
> That he was ay biforn and in *good staat*.
>
> (A 570–72)

> (For whether he paid or took on account,
> He always watched so in his buying
> That he was always beforehand in good state.)

Purchases were made by an on-the-spot-payment, or it was tallied (charged). With a play on *wayted* (watched) and *weighted*, the pilgrim always *wayted/weighted* regarding the purchase. In other words, always prior to the transaction he was in *good staat*, in "an unchanging physical state."[226] The scale was balanced and at rest before money changed hands. (*In good staat* also relates to an aspect of a heavenly body.)

A question follows.

> Now is nat that of God a ful fair grace
> That swich a lewed mannes wit shal pace
> The wisdom of an *heep* of *lerned men?*
>
> (A 573–75)

> (Now is that not from God a gift
> That such an uneducated man's wit shall surpass[227]
> The wisdom of a heap of learned men?)

I always mistrust Chaucer's questions. The words add interest, but they aren't *stating* what they say. It gives the poet a chance to talk about an uneducated man; that maintains the human pretense. And it's true that educated men might be put at a disadvantage by tradesmen with dishonest scales. (For just an instant, I also get a picture of the *heap* of learned men as images on coins.) Interestingly, *heap* is a term from the business of measuring and weighing (a glimmer of the Scales).

From another point of view, Chaucer would have known of at least two "learned men" concerned with weighing. One was the Chancellor of Oxford University (1327); the other, the Chancellor of Cambridge (1378). Scholars in the university system "were to cooperate with urban officials in enforcing the law."[228] It was the responsibility of the chancellors to keep up standards and check the actual heaviness of weights.

Who is in charge of the Manciple's activities?

> Of *maistres* hadde he mo than thries ten,
> That weren of *lawe expert* and *curious.*
>
> (A 576–77)

> (Of masters had he more than thrice ten,
> That were of the law expert and skillful.)

The idea of *law* involves many disciplines not connected to lawyers and courts. For example, nature performs according to a law—a consistent controlling principle.[229] More to the point, a whole world

of laws, along with enforcers of those laws, were part of England's world of trade and, necessarily, part of Chaucer's life. Standard weights (the King's weights) were kept and compared to those used in trade. Fraudulence was punished.

Masters, in the poem, could be associated with the craft of weighing. Early in the fourteenth century, London installed an official weighing machine which was overseen by a weigh*master*. As a group, Chaucer's masters come in a provocative number: more than thrice ten—reminiscent of a long month. The "long month" works if we are thinking "zodiac" or "time." But it could refer to the "corp of master measurers," in medieval England; there were probably "eight in number," and they had "twenty-four assistants." That totals "more than thrice ten," also. These administrators "specialized exclusively in performing one or more...functions."[230] Their knowledge of the laws of metrology had to be both *expert* (clearly demonstrated) and *curious* (skillful).

The poet continues regarding the masters,

> Of which ther were a *duszeyne* in that *hous*
> Worthy to been *stywardes* of rente and lond
> Of any lord that is in Engelond.
>
> (A 578–80)

> (Of which there were a dozen in that house
> Worthy to be stewards of income and land
> Of any lord that is in England.)

Again the number chosen attracts attention. Why twelve? Why not ten? or fourteen? Twelve is the number of months that lapsed between inspections of weights. At the same time each year, they were inspected and duly marked.[231] Twelve was also the number needed for a jury in trials of offenders; a juror could be seen performing as one of the worthy stewards spoken of. And twelve, of course, is also the number of divisions of the zodiac; signs could be regarded as masters over transactions. Celestial calculations were often made before dealings were entered into. The twelve are in a *house*, which may not seem noteworthy—unless you're looking for Chaucer's glimmers of evidence of the zodiac sign of the moment.

The poet recommends that the twelve are worthy to be in charge of revenue, income payments. Again the intent can relate to both money (£) as a commodity and to the zodiac; either can function as an influence or steward of "any lord in England."

This Manciple, this servant, is mighty assertive.

> To *make* hym (the nobleman) lyve by his *propre good.*
> (A 581)

(To make him live by his personal goods.)

How many "servants" have the power to enforce a way of life on "any lord of England?" The lord will be *made* to live by conducting his affairs using only his personal ("privately owned," *propre*) income and personal goods.

The lord would live

> In honour *dettelees* (but if he were *wood*).
> (A 582)

(In honor debtless [except if he were mad/wood].)

An honorable, debt-free life is the lord's if he would follow the directives of the Manciple (his money). But what is the intention of the parenthetic phrase? The surface meaning, about the lord going along with the plan unless he is out of his mind, is not what we're looking for. We need to find how the phrase relates to money. The line begins with a lord who would be without debt and ends "unless *he* were wood." This isolated "he" could be the Manciple—if something *wooden* enters the picture. A wooden object approaches.

Let's take a moment to think about the tally above (A 570). The line compares two situations: paying or incurring a tally. "Tallies" today are plastic, but in the 1300s they were "a scored wooden stick used for record keeping."[232] The stick would be appropriately notched to record a transaction and then split in half lengthwise. The tradesman kept one half; the debtor was given the other half. Thinking of the tally stick, the lord of the poem would be debtless,

unless money owed was recorded on *wood*. So the parenthetical phrase can be understood "except if money were owed."

"He" might choose to

> ...lyve as scarsly as hym list desire.
>
> (A 583)
>
> (...live as economically as he would desire.)

We're out of the parenthesis now. This "him" I take to be the lord, once again, who may live as frugally as pleases him. Economizing could be a way of removing present debts as well as refraining from incurring others.

We return to observations about capabilities of the Manciple.

> And able for to helpen al a *shire*
> In any *caas that myghte falle* or *happe*.
>
> (A 584–85)
>
> (And he was able to help all the county
> In any case that might befall or happen.)

The Manciple's helpfulness across a district reflects the plan for each shire's scales being overseen individually. Parliament ordered that standard weights be distributed to every shire. Each respective sheriff (from "shire reeve," an officer of the shire) was to ensure his territory's compliance to facilitate nationwide cooperation with London's mandate.[233] Proper trade practices would result from the scales, the balances.

The second line reads well at the surface: he helps "in any case that might befall or happen"—that is, in all cases, under all circumstances. Another *case* that might "fall" is a protective box for the weighing instrument. Though many beautifully made English cases from the 1500s exist, I found no earlier illustrations. Scales, however, were carried about in pockets, pouches, etc., which would necessitate a protective covering to maintain accuracy.[234] Line A 585, when intending a scale, says: In any case (scale-box) that might fall or have something happen.

If we choose, we can also understand the line as describing the movement *of* the scale pans, where one is weighted more than the other—or they bounce (hop) before reaching equilibrium. Such word-play (happe/hoppe) suits the poet's imagination.

We've arrived at the last line. The closing image often contributes a great deal to the game the poet is playing. This time, however, he makes up a new rule that no one completely understands.

> And yet this Manciple *sette hir aller cappe.*
>
> (A 586)

(And yet this Manciple set all their caps.)

The last phrase "is not known outside of Chaucer."[235] We have nothing to compare it to. Scholars have agreed to interpret it to say "made a fool of them all." Though the phrase deserves special treatment, there is no real comprehension.

As the pilgrimage progresses, the Manciple is called upon to tell his tale. The poet has another opportunity for fun with images of scales and money. Immediately the Host speaks of a little town that "stands" nearby (as Rochester/rocheter stood by the Monk). The significant name is "Bobbe-up-and-doun" (H 2), which brings the action of a scale to our mind's eye. This "town" is "under the Blee" (H 3), identified as the Blean forest—all well and good for the surface.[236] But I like to picture an alternate image: the Scales under the "blue" (also spelled "ble"), that is, beneath the vault of heaven. The name of the town and the forest are posed in a *question*. It gives the poet freedom to put these images in our minds—without making actual statements about them. The question never goes anywhere. We've seen that maneuver before.

Then the Host exclaims,

> "Sires, what! Dun is in the myre!"
>
> (H 5)

(Sirs, say what! Dun is in the mire!)

The allusion is to a competitive game of strength. This idea is nev-

er developed either, but the picture of a dark (dun) horse makes me think of the black horse of the Apocalypse, whose rider holds the scales. The end of the pilgrimage, after all, is Judgment. When the Manciple finishes his story, only one more will be told.[237]

Money matters are spoken of several times in his personal prologue: allusions to a man for *hire* (H 6), reckonings (H 74), and willingness to pay (H 78). Reckonings involve "pinching" and are tailored for the attributes of two pilgrims simultaneously. What is reckoned has to do with the Cook (Cancer, the crab) and the Manciple. The crab may be the expert at pinching, but misers as "*pinchpennies*" were recognized even in the fourteenth century.

The Manciple confides,

> Yet hadde I *levere payen* for the mare.
>
> (H 78)
>
> (Yet I had rather paid for the mare.)

Not only would he prefer to *pay*, but the words *levere* and *payen* seem a neat play on *lever* and *pan*, both of which are parts of a scale.

Lastly, in regards to money, the Manciple says,

> That that I spak, I seyde it in my bourde.
>
> (H 81)
>
> (What I spoke, I said in my board/joke.)

An obvious reading tells us that what he said was all a joke. The use of bourde (or *bord*), however, takes us back to the very first image of the pilgrim's introduction—the Temple and the moneychangers. "Bourde" can be a wooden tablet for making reckonings as well as a money-changer's table. As a medieval term, it biblically describes Christ's action in the temple as he turns the "bordis upsodoun."[238]

When the Manciple finishes his tale, only the narrator comments. Eight lines are given to the fact that it's getting late (X 2–9). This is followed by an "incorrect" disclosure about the influence of Libra (the Scales). Chaucer knew what was correct about Libra. A

mistake (an "obvious non-sequitur") is his way of getting the reader's attention. The Scales of Judgment resonate at the waning of day.

So what is the Manciple's function in Pilgrim Chaucer's tight circle? Late in his career, the poet wrote the little poem about his purse to remind a new king of the poet's need. Chaucer's purse, he says, is his life and the source of comfort and good company. If "it" continues to be in need, he laments, "I may die!" My guess is the Manciple, the purchasing agent, represents *money*, as a special concern of Chaucer's as he gets older.

That's all for the Manciple, the purchasing agent, the Scales, Libra. Now let's turn to that most recognizable sign of the zodiac, Taurus.

THE MILLER

As the next pilgrim makes ready to come forward, he addresses an aside to the little group waiting on stage; it begets a rowdy laugh from the companions. He turns, then, swaggering, flexing his powerful muscles. The poet, so as not to let the virile display get out of hand, takes control, ordering this second of his cohorts to restrict his actions, refrain from commentary and move his brawny frame to his mark on stage.

Part of the introduction to this book was a brief account of testing-sessions with small groups of friends (mainly people unfamiliar with the *Canterbury Tales*) to discover whether I could guide others to see what I see—not by explaining, but simply by presenting associations. One or two in a group generally "saw" the *bull*. (There may have been others who were hesitant, perhaps too shy, to admit a mental picture quite so outlandish.) Muscles of Taurus the bull, however, ripple just beneath the surface of the Miller's portrait.

Scholars, in examining the presentation of the Miller, have typically found him "a brute of vast strength," "robust [and] sanguine." Harold Brooks' comment is "on the verge," like those I've mentioned before. Brooks, noting the Miller's vulgarity and strength, calls attention to his being able to "perform the grotesque feat of breaking down doors by charging them with his head *like a great bull*."[239] Chaucer is a genius at capturing the essence. We just have to be "brave" enough to admit what we see in the poet's words.

To claim the Miller has an alternate identity as a *bull*, however, would need to be preceded by the understanding that this is an allegory. And then to go a step further and claim that the Miller is the counter-image of a bull to be identified as Taurus needs to be preceded by the understanding that we're dealing with the zodiac as allegory and, therefore, *must* find a bull and that bull *must* be Taurus. Allegories, once you recognize a few of their essentials, are necessarily predictable, as we said in the explanatory "Plan" for readers.

But let's go about this character's background in our usual fashion. The poet is well supplied this time. Myth, stars of distinction and a grand animal presence provide him with many fascinating "ornaments."

One version of the bull's identity is provided by Ovid's *Metamorphoses*. Jupiter (Zeus) was enamored of the beautiful Europa and so, having ulterior motives, took the form of an exceedingly attractive and gentle bull. Princess Europa and her attendants were picking flowers in a meadow when the animal approached them. "His colour was white as the untrodden snow...muscles stood rounded upon his neck...his horns were twisted, but perfect in shape...and more clear than pearls...his whole expression was peaceful." The princess looked at him "in wondering admiration... but...she was afraid at first to touch him." The bull frolicked about and then he laid "his snowy body down." The girls stroked his contours, and Europa went so far as to straddle him. That was what he was waiting for. He got up and walked slowly toward the nearby Mediterranean shore. Once at the water's edge he plunged in; the princess held on for dear life. He swam with her to Crete. When they came ashore, he assumed his godly form. Predictably, over a period of time, she bore him three children.[240] A second mythological personality for this bovine is the lovely Io, who was concealed by Jupiter in the body of a heifer in an attempt to avoid Juno's jealousy. Ovid acknowledges the conflicting possibilities of the two myths. Whether the figure "is a cow or a bull, it is not easy to know; the fore part is visible, the hinder part hid [by the waters of the Mediterranean]. But whether the sign be a bull or a cow, it enjoys this reward of love against the will of Juno." Either way, Jupiter's wife would be equally irritated. The foregoing confusion notwithstanding, there is no doubt which gender Chaucer is partial to.

As a constellation, Taurus has been recognized since ancient times. It has three bright stars: Alcyone and Aurigae are bright, but cannot compare to Aldebaran, which had the distinction of being yellow and the brightest star in the zodiac. Aldebaran is one of the Royal Stars, Guardians of the Sky. It is three times as bright as Sirius, the Pole Star, and has been called "the Torch." Aurigae serves as a member of both the outline of the bull and that of an adjoining non-zodiac figure, the Charioteer. A meteor shower, the Taurids, occurs in late November. These meteors are "slow and [have] fireballs occasionally."[241] Taurus borders the Milky Way and has two other notable attributes: the star clusters of the Pleiades and the Hyades.

The Pleiades have inspired writers for more than a thousand years. Their story begins with love-smitten Orion. He pursues seven lovely sisters for five years until Zeus takes pity on the young women, changes them into doves and places them among the stars.[242] Usually seen as located on the bull's shoulder, their visualized location can differ depending on how you imagine the animal. Pliny, who assumed it to be an entire bull, said the Pleiades marked "*cauda Tauri*," the tail of Taurus. Much poetic imagery has been inspired by this "circle of stars." In Sweden, for example, these seven sisters are called "Fur in Frost." Tennyson likens them to "a swarm of fireflies." They are a cluster of golden bees, or silken folds decked with gems.[243]

The other cluster has two different myths; both end with the Hyades being stellified. One story calls them "rain-stars," perhaps in commemoration of the copious tears they had shed. An early poet says they were sisters of Hyas who was killed by an animal while hunting. The women were so grief-stricken that they committed suicide. Their devotion was rewarded by placement as a star cluster. The other myth, with no resemblance whatever to the previous story, says the Hyads were nymphs who cared for the infant Dionysus. When that task was completed, Zeus restored their youthfulness and placed them in the heavens.

Hyads are generally considered a feature of the head of Taurus. As Ovid describes, "the head of the Bull sparkles radiant with seven flames...call[ed] Hyades after the word for rain (Hyein)."[244] Thunder and lightning are associated with them. The Moon is said

to wade "through Hyads bright, / Foretelling heavier rain." Early in
this millennium, Pliny complained of the cluster's responsibility for
continual rains and muddy roads.

That's the background. Now let's bring Chaucer's Miller to the
foreground. While physical detail for other pilgrim portraits is
sometimes a frugal repast, with this one, we have a feast. Fifteen
out of twenty-two lines tell of bodily characteristics.

> The Millere was a stout carl *for the nones*;
> Ful byg he was of brawn, and eek of bones.
> That proved wel, for over al ther he cam,
> At wrastlynge he wolde have alwey the *ram*.
> (A 545–48)

> (The Miller was a stout churl for the nonce;
> Very big he was of muscles, and of bones.
> That proved good, for he overcame all,
> At wrestling he would always have the ram.)

We are told immediately that he is a churl, a rascal. There will be
no delicacy from him and, instead, we can expect a good deal of
vulgarity. Chaucer's *for the nonce*—for the occasion—could be taken
as a private joke from the author: This character is a churl for the
nonce, *for the time being*; the Miller's external figure encompasses
more than one image. Great muscles and bones are a proper begin-
ning. If he were a wrestler, we would expect him to win. The
ram, on the surface, is assumed to be his *prize*. Speaking of the zo-
diac, however, it is Taurus who *would [overcome] always the ram* as
Aries, because it is dictated in the stars that Taurus always succeeds
Aries.

> He was short-sholdred, brood, a thikke *knarre*.
> (A 549)

> (He was short-shouldered, broad, thick as a "gnarled tree.")

The low, powerful outline comes into focus. The "knarre" is *a knot
in wood*, but it seems just right to see him here as a thick, gnarled

tree. "Knarre" also associates a bit of convoluted humor: Middle English *bole* means *bull*—the word also means *tree trunk*! The Miller's unusual capability is an alert.

> Ther was no dore that he nolde heve of harre,
> Or breke it at a rennyng with his heed.
>
> (A 550–51)

> (There was no door that he could not heave off its hinge,
> Or break it by running at it with his head.)

Can we *really* see a *man* persisting at running into doors, butting them with his head, wrecking them, and knocking them off their hinges? How often would he be invited to exhibit this talent? Might he have a capricious urge just to demonstrate his ability? If I try hard, I can picture a fullback lowering his *shoulder*, rushing at a door in an emergency and disintegrating the wood. But I can't believe a football professional would make a habit of giving even a shoulder such harsh treatment. Chaucer's words are supposed to startle us and add vigor to the animal image in our mind's eye.

The poet does himself proud with the outlines of the Miller's face. To "see" the face of a pilgrim is such a rarity.

> *His berd* as any sowe or fox *was reed,*
> And thereto *brood,* as though it were *a spade.*
>
> (A 552–53)

> (His beard was red as any sow or fox,
> And also broad, as though it were a spade.)

This red beard I see as the Hyades, in Ovid's estimation, radiant as "seven flames." And appropriately bull-like, his chin (where the beard is) is as wide as a spade.

> Upon the cop right of his nose he hade
> A werte, and theron stood a *toft of herys.*
>
> (A 554–55)

(On the very top of his nose he had
A wart, and on it stood a tuft of hairs.)

The tuft of hair, I imagine as the Pleiades, Chaucer's less than ethereal contribution to the collected visions of swarms of fireflies (Tennyson) or golden bees (Pliny).

His nosethirles blake were and wyde.

(A 557)

(His nostrils were black and wide.)

These *wide, black* nostrils ought to be a giveaway. A reader would have to skim past a lot of powerful animal features to remain oblivious to this prime bull-like attribute.

The next line is an unexpected problem because it sounds as if it's strictly about a human being.

A *swerd* and *bokeler* bar he by his syde.

(A 558)

(A sword and buckler he bore by his side.)

A sword and shield is unbefitting the impression of an animal— unless it is used figuratively. Aries (the ram) carried knives. Capricorn (the sea-goat) had a dagger. Horns of a ram or goat are substantial weapons—and so are the horns of a bull. I'm sure Chaucer and others saw animals use their horns as men use weapons and appropriated the idea. But it takes a stretch of the imagination to grant that horns would be spoken of as weapons to be used in hand combat.

I felt a little shaky in proposing the horns/sword analogy regarding the Miller, because of Chaucer's addition of a buckler (shield) to the equipment. A visit to the MED brought back my confidence. An entry made to order reads: "Out...come four-and-twenty oxen playing at the *sword and buckler*."[245] The four-and-twenty oxen are "equipped" just as the poet's bull is. I feel quite comfortable now in saying that, figuratively, each of Chaucer's

horned animals is "carrying" a weapon, and the bull's shield (buckler) is part of the poet's game.

Because this is a *horned* animal, we see the devil step forward.

> His mouth as greet was as a greet *forneys*.
>
> (A 559)

> (His mouth was as great as a great furnace.)

In medieval writings, one often encounters *furnace*, intending "fires of hell." Examples in the MED tell of a furnace of flames where sinners shall burn and of sinful souls cast into a furnace. Sermon literature refers to a mouth that is "the yawning chasm of hell-mouth." Chaucer's Parson is assigned to speak of the devil's *furnace* (X 545–50). He tells of kissing the mouth of a *furnace*, "that...is the mouth of hell" (X 855–60). To remark upon "the grossness of the speech that belches from [the Miller's] huge furnace of a mouth" puts Donaldson within grasping distance of the diabolism of the portrait.[246]

The Miller, in devil guise, continues relating to men.

> He was a janglere and a goliardeys,
> And that was moost of synne and harlotries.
>
> (A 560–61)

> (He was a teller of dirty stories and a glutton of words,
> And that was mostly of sin and obscene behavior.)

The words hold connotations of an apt assortment of devilish activities: backbiter (even literally), teller of dirty stories, a buffoon (the devil as a fool in medieval dramas), and glutton of words.[247] Much of his story revels in the enjoyment of sin, obscene behavior, and filth.

> Wel koude he stelen corn and tollen thries.
>
> (A 562)

> (Well could he steal corn and tax it thrice.)

He was a furtive thief, acting secretly, but later making excessive demands.[248]

> And yet he hadde a *thombe of gold*, pardee.
>
> (A 563)

(And he had a thumb of gold, pardee.)

Aldebaran! This thumb of gold must correspond to the Royal Star Aldebaran, just as the Royal Star Regulus was the wonderful gold pin that fastened the Monk's hood. The ignorable *pardee* (*par Dieu*, "by God") subtly asserts that the existence of Aldebaran is an act of God.

As the portrait draws to a close, the poet moves from the constellation to the myth.

> A whit cote and a blew hood wered he.
>
> (A 564)

(A white coat and a blue hood he wore.)

Chaucer, in *Troilus and Criseyde* (II:55), refers to the myth as he speaks of Taurus "the white Bole." Clothing the pilgrim with white coincides with the beautiful white bull of the myth. The blue hood I take to mean the firmament.

And, lastly, the devil returns.

> A baggepipe wel koude he blowe and sowne,
> And therwithal he broghte us out of towne.
>
> (A 565–66)

(A bagpipe well could he blow and sound,
And therewith he brought us out of town.)

Edward Block has identified the Miller's talent on "the humble bagpipe" as merely confirming the earlier lines which show the pilgrim to be a crude rustic. Block offers evidence from the visual arts—a tryptych by Hieronymus Bosch—which shows pipers playing flesh-colored bagpipes and inspiring dancers at a celebration. It

is suggested that the *instrument* is a symbol of gluttony and lechery.[249] (The two sins were closely associated in the Middle Ages.) That, however, does not get to the kernel of the intention.

Consider that *fiddlers* at dances in paintings, stories, and music have often been understood as the devil leading young people into sin; we need parallel thinking here. Instead of finding that "the *bagpipe* symbolized the perversions and snares of the flesh,"[250] it is necessary to attune to the Middle Ages and recognize that the medieval symbol encompasses *the piper playing the pipes*. It is the performing *piper* who is encouraging "perversions and snares of the flesh." Such snares are standard devices of a fiend from hell,[251] who would go to the end of the world for his prey, as declared by Chaucer's fiend in the *Friar's Tale* (D 1455).

As with numerous other specific references, there is no mention of the Miller or his bagpipe when the pilgrims actually begin their journey. Chaucer is inclined to serve an immediate purpose, project a momentary mental picture, which has no continuing effect. Names of towns and names of people also serve in this way.

As one of the select group associated with Pilgrim Chaucer, what is the significance of this Miller? I don't think it's too simple to say that he is "the devil"—as in "the world, the flesh, and the devil." Satan was recognized as man's enemy, the trickster who would get you to hell any way he could. Chaucer, as a creature of the fourteenth century, would have acknowledged the devil as a force in his life.

Our next subject is Scorpio.

THE REEVE

When the Miller/Taurus left the stage to take his "celestial-velvet" position, one of the remaining three pilgrims began to move forward, stiff-legged and stealthily. The other two pilgrims had kept their distance from him and seem relieved to see him move on. This third associate of Chaucer's is the Reeve. We will search for his hidden identity in Scorpio. The animal figure, its temperament (both live and celestial) are the nucleus of this portrait.

According to Hesiod, Orion (when he wasn't chasing the Pleiades) was a much too successful hunter. His accomplishments angered Earth, so she (Earth) sent a large scorpion to sting him.

When Orion died, Artemis (Diana), who held him as her favorite hunting companion, asked Zeus to commemorate him in the night sky. Zeus agreed, but, whatever the god's motivation, he also placed the monstrous scorpion in the heavens. Now, Orion perpetually escapes to the west as the scorpion rises in the east.[252]

Scorpio is "large and bright...a visual treat."[253] Some say it is the finest of the constellations. It contains three bright stars in the forehead; red Antares, the brightest in the whole figure (another Royal Star), located centrally; and along the body, several more blue-white stars on the joints and stinger. The greater part of the figure, especially the tail, is outside the ecliptic zone—the area paralleling the imaginary line in the sky traveled by the sun. Signs of the zodiac are located within a band approximately 8° above and 8° below that line. In northern latitudes this prominent array is found low in the evening sky as it travels southeast to southwest. Venus rules it during daylight hours; the moon, by night.

This sign is a calamitous influence. Ptolemy predicts thunder, fire, and earthquakes in Scorpio. Its fearful presence in the firmament caused the inexperienced Phaeton to allow the reins of the sun's chariot to slip from his hands. (Chaucer relates the tragedy in the *House of Fame*, 940–56.)[254] Twelfth-century Michael Scot, the "singularly gifted in science among men of learning," likens the sign to a live scorpion in its effect on men.[255] Similarly, he sees its month (October) as charming with its early warmth, only to end with piercing cold, which is seen as an analogy to the subtle movements of the animal's enticing claws followed by the deadly sting.

The fearsome aspect of the sign can be traced to scientific observation of the earliest times. Manilius (first century A.D.) describes the living creature as "predator and bane" of those that haunt "the thicket of the field." In the Middle Ages, Langland calls its venom the most deadly, and Lydgate advises caution in idyllic scenes for "under flowers rests the scorpion." Gower calls the sign "a felon." Michael Scot observes that it "gladly dwells in dirt and in obscure, filthy places such as the vicinity of latrines."[256] (With all these vile associations, the Middle Ages considered the scorpion a symbol of Judas or treachery—or woman.)

Chaucer gives an account of a number of scorpion-like qualities, *deception*, for example.

Fortune unstable!
Lyk to the scorpion so deceyvable,
That flaterest with thyn heed whan thou wolt stynge;
Thy tayl is deeth, thurgh thyn envenymynge.

(E 2057–60)

(Fortune unstable!
Like to the scorpion so deceivable,
That flatters with thine head when thou wilt sting;
Thy tail is death, through thine envenoming.)

A *traitor* has the "tonge of scorpioun" (H 271). An *evil-spirited* person is comparable (B 404). And the Parson warns that touching a *woman* is like touching a scorpion that stings and suddenly slays through its venom (X 850–55).

In physical structure, these "insects" have claw-like pincers and a long, upturned tail. Some are only half an inch long, but there are specimens as large as seven inches. Though we often think of them as living only in hot climates, they do have a wider distribution. Their chosen habitat is "under stones and bark, in crevices, under dead leaves and rubbish, in barns and deserted buildings, in thatched roofs, etc.... [They] prefer tight quarters."[257] Adaptable to weather, they can stand freezing for several weeks; they hide in the ground during dry spells, and surface again with the rain. What the scorpion kills, it shreds to draw the juices from the soft tissue.

Born alive, they molt seven or eight times as they grow. After only one molt, they have taken on the adult structure. It is their habit to avoid each other and live most of their lives alone. If confronted, scorpions fight to the death. Winner consumes loser. After copulation, the female often consumes the male. Caution should be used in handling any of the species. For a human, the venom may only cause symptoms that pass in a few hours—however, death, under some circumstances, can come as quickly as forty-five minutes. There is a fable about scorpions committing suicide when surrounded by fire, but the truth is that they are mainly immune to their own venom.

We have gathered information about the myth, the constellation, and the creature that inspired the myth and lent its personali-

ty to the zodiac sign. Let's see what bits and pieces Chaucer weaves together for the Reeve.

> The Reve was a *sclendre colerik* man.
> His *berd was shave* as ny as ever he kan;
> His heer was by his erys ful round *yshorn*;
> His *top was dokked* lyk a preest biforn.
> Ful longe were his *legges and ful lene*,
> Ylyk a staf; ther was *no calf* ysene.
>
> (A 587–92)

> (The Reeve was a slender choleric man.
> He shaved his beard as close as ever he can;
> His hair was by his ears completely shorn around;
> His top was docked like a priest before.
> Very long were his legs and very lean,
> Like a staff; there was no calf seen.)

Definition of a reeve is: an officer of the king, or the person on a manor who is in charge of accounts. (He can also be an agent or steward of God.) The authority figure served by this Pilgrim Reeve is nebulous (perhaps ambiguous), called only "his lord." This servant is slender and bad-tempered. His face is smooth, no evidence of a beard. We're told more than once (repetition is a signal) that his hair is well shorn. Of his slender body we learn that his legs are long and lean with no hint of muscle development. With unwitting insight, Harold Brooks remarks that this "thinness is positively abnormal...his legs, mere sticks."[258]

If we are trying to picture a man, Chaucer's words must simply be accepted. Knowing the poet's method from previous descriptions, however, we realize this peculiar image means to get our attention. His lack of hair is outstanding, as is his skeleton-like body. No more will be said about the physical characteristics of the Reeve—no eyes or nose, no hands to gesture, no indication of height, no sound of his voice. The poet's words are chosen to express what is needed on the covert level while they "perform merely adequately" on the surface. Human details that cannot maintain a dual function are avoided. This ill-tempered, hairless figure

whose legs are like sticks is a very serviceable portrait of a scorpi-on—both physically and temperamentally. Chaucer will dwell on this animal's existence for the most part, I imagine, because that's what he found most adaptable to his allegorical scheme.

> Wel koude he *kepe* a gerner and a *bynne*.
>
> (A 593)

(Well could he keep [protect] a garner and a bin.)

He "keeps"—occupies a place, keeps watch over—the storage ar-eas.[259] This is the scorpion's habit, to lie in wait, keep watch for prey.

> Ther was noon auditour koude on him wynne.
>
> (A 594)

(There was no auditor could get the better of him.)

To say no auditor was a match for him only *appears* to say that both he and the auditor are of the same species. If a human were challenged by a scorpion as he went about examining and verifying stored goods, the man might choose to make a strategic withdraw-al and allow the feared "overseer" to continue guarding the stores.

Instincts are part of his image.

> Wel wiste he by the *droghte* and by the *reyn*
> The *yeldynge of his seed* and of his greyn.
>
> (A 595–96)

(Well he knew by the drought and by the rain
The yield of his seed and of his grain.)

Attention is called to drought and rain, when the scorpion so clev-erly, but with seeming treachery, adapts to changes of environment. It would also be aware of the thickness of growth—yield of the seeds—in its surroundings.

The Reeve, as scorpion, seeks out areas where animals live.

His lordes sheep, his neet, his dayerye,
His swyn, his hors, his stoor, and his pultrye
Was hoolly in this Reves *governynge*.

(A 597–99)

(His lord's sheep, his cattle, his milk cows,
His swine, his horses, his livestock, and his poultry
Was wholly in this Reeve's governing.)

As Michael Scot said, they could be found "in dirt and...filthy places." His "governing" skills correspond to his "controlling events" and "exercising of personal control over others."[260]
A pact exists.

And by his covenant yaf the rekenynge,
Syn that his lord was twenty yeer of age.[261]

(A 600–01)

(And by his covenant gave the reckoning,
Since his lord was twenty years of age.)

A covenanted agreement has been made between this Reeve and "his lord." Lines A 594–600 hold terms found in bookkeeping. They may prove to be veiled descriptions of Judgment, as well.

Ther koude no man brynge hym *in arrerage*.

(A 602)

(There no man knew how to bring him in arrearage.)

Chaucer must have had fun with this line about being in *arrears*. It primarily says that no one *could* (or *knew how to*) catch the Reeve owing money. But it also conveys that no man could bring (carry) a scorpion by its rear section.

Ther nas baillif, ne hierde, nor oother hyne,
That he ne knew his sleighte and his covyne.

(A 603–04)

(There was no bailiff, nor herdsman, nor other farm worker,
Of whose tricks and frauds he was unaware.)

He seems to be able to catch anyone off guard. The poet parallels
many tricks and deceptions the Reeve/scorpion knows that men do
not.

> They were *adrad* of hym as of the *deeth*.
> (A 605)

(They were as afraid of him as of death [as of the plague].)

What a statement! This "human being" is dreaded as if he were
death itself (or the plague). It's an exaggeration at the surface, but
an accepted fact of the underlying image. One would dread the
swift, agonizing death that could result from meeting a scorpion.

> His *wonyng* was ful faire upon an *heeth*;
> With grene treës *shadwed* was *his place*.
> (A 606–07)

(His preferred dwelling was on a heath [on uncultivated land];
With green trees was his place shadowed.)

His dwelling (wonyng) on an area of uncultivated land is ambigu-
ous. *Dwelling*, means both a house and a location; *wonyng* works
the same way. The poet does not use the limiting form *he dwelt*
(*woned*) on the heath. The chosen word allows both interpreta-
tions: "a house to live in" as well as the general indication of exist-
ing, dwelling in a certain area. In A 607 "his place" is just as vague,
imprecise, one of Chaucer's many "vagueries." A "place" shadowed
by trees is perfect for a scorpion habitat. The description reminds
me of Manilius' locating the scorpion in "the thicket of the field."
My mind's eye also sees the twenty-third Psalm: a green area in the
valley of the *shadow* of death.

The Reeve/scorpion's tactics were more effective than the bar-
gaining of a human being.

He koude bettre than his lord purchace.

<div align="right">(A 608)</div>

(He could better make acquisitions than his lord.)

No wonder that he is better at acquisitions than his lord. There would be no quibbling, no dickering with a scorpion.

Ful riche he was *astored pryvely*:
His lord wel koude he plesen *subtilly*.

<div align="right">(A 609–10)</div>

(Rich were his private stores:
His lord he could well please subtly.)

He has rich stores accomplished privately as a Reeve, but a play on stored/starred (astored/isterred) is our first glimpse of the constellation. Scorpio is richly starred. Its existence was surely accomplished in some fashion *mystically* (*pryvely*).[262] The splendor of the figure would ingeniously, clearly (*subtilly*) please his lord—and any other observer.

To *yeve* and *lene* hym of his owene good,
And have a thank, and yet a *cote and hood*.

<div align="right">(A 611–12)</div>

(To give him and lend him of his own goods,
And have a thank you, and a coat and hood besides.)

In what reads like a deception, the property of his lord was *given* or *lent* by the Reeve to this same lord, and the Reeve was even thanked for his efforts. At the covert level, the Reeve, as Scorpio, would offer his only goods, his stars for view. Their splendor was appreciated, and the figure given a "coat and hood." (The Miller, in similar fashion, has a coat of white and a hood of blue.) We will soon find that the Reeve's coat is predictably *blue*, but a carefully chosen shade.

What skill recommends him?

> In *youthe* he hadde lerned a good myster;
> He was a wel good wrighte, a *carpenter*.
>
> (A 613–14)

> (In his youth he had learned a good craft;
> He was a very good craftsman, a carpenter.)

The skill has a special application to his existence because it was learned when he was *young*. One of the guild members in the figure of Cancer also is a carpenter. In this realm of imagination, carpentry seems to identify a creature's ability to construct a shelter—an exoskeleton. The crab, in order to grow, molts and needs larger quarters; so does the scorpion.

The Reeve has a strong means of transport.

> This Reve sat upon a ful good *stot*,
> That was al *pomely* grey and highte *Scot*.
>
> (A 615–16)

> (This Reeve sat upon a very good farm animal,
> That was dappled gray and called Scot.)

A "stot" is a solid farm animal and, therefore, is to be found in the fields once again. The "pomely" (dappled) coat is illustrated in the scorpion photo in the *Britannica* article. In addition the Reeve's "horse" is given a name. As in the past, the physical capability of the "horse," as well as its name, is taken to be part of this pilgrim. The name *Scot* is the same as the prominent medieval figure who has been mentioned a number of times. Michael Scot was a phenomenon. Much of medieval, scientific knowledge was made available through his translations from Arabic and Greek. Chaucer, no doubt, gained knowledge either directly or indirectly from Michael's work.

And here is that specially colored blue coat.

> A long surcote of *pers* upon he hade,
> And by his syde he baar a *rusty* blade.
>
> (A 617–18)

(A long surcoat of blue he had,
And by his side he bore a rusty blade.)

A long coat seems a proper garment for the extended figure of
Scorpio, the extra length alluding to the part of the constellation
which reaches beyond the usual zodiac area. The shade of blue ex-
pressed as "pers" contains an appropriate play on the scorpion's
ability to *pierce*. And the rusty blade, midway in the figure (why
would the blade be *rusty*?), locates *red* Antares.

What is the Reeve's origin?

Of *Northfolk* was this Reve of which I telle,
Biside a toun men clepen *Baldeswelle*.

(A 619–20)

(Of "Northfolk" was this Reeve of which I tell,
Beside a town men call "Baldeswelle.")

The name *North folk* (two words) is a clue to this Reeve. In the
Treatise on the Astrolabe, Chaucer says that the stars within the zo-
diac "ben clepid sterres of the north" (are called stars of the north).
The Reeve's grouping, therefore, is made up of stars *of the north*
and that, for me, makes him "of North folk."

Baldeswell, which sounds like it is good (well) to be bald,
stresses just how bald, how completely hairless, he is. The word
takes us back to the emphasis at the beginning of the portrait.

And what are the poet's final words? What gem does he con-
ceal for us?

Tukked he was as is a frere aboute,
And evere he rood the *hyndreste* of oure route.

(A 621–22)

(He was tucked about as is a friar,
And ever he rode the hindermost of our group.)

Tucked like a friar, cinctures about a robe, is a rather precise visual
representation of the well-defined segments of the scorpion's body.

To ride the most toward the rear ("hyndereste," hindermost) works as an allusion to how much of the scorpion's physical structure extends toward the rear. This completes his *General Prologue* portrait, but we'll return to his being *hindermost* in just a bit.

As the pilgrimage moves along, the next time we see this traveler, he is about to tell his story, the third offering of the *Canterbury Tales*. The Miller has just finished his tale to which the Reeve takes considerable exception. The churlish Miller has made fun of a carpenter, a fellow craftsman of the Reeve. In response, the Reeve calls on God to break the Miller's neck (A 3918). Animosity initially erupted between the two in the *Prologue to the Miller's Tale*. Their mutually hostile response is the first time I have found Chaucer so clearly indicating astrological "opposition." Scorpio and Taurus are 180° apart. The poet, as astronomer, notes their opposing positions in his *Treatise*. Ptolemy says such signs are "disharmonious." *Cosmographia* goes the limit: "Scorpio, troubling by the very depravity of his nature, rages with fierce glares against his opposite, the Bull."[263] The hostility, of course, serves a purpose. Kolve, referring to the Reeve's prologue, notes that this introduction "forces us in one final, comprehensive image to reconsider everything the Miller has invited us to enjoy—animal liveliness, bawdy laughter, youthful energy, aged gullibility—and see them as another thing."[264] The Reeve exhorts: We must think on *death*.

Matters for conjecture, here, are three names used by the Host: *Osewold*, *Depeford*, and *Grenewych*. Each can be seen as the joining of two simple words. First is the personal name of the Reeve, Osewold. Let's turn to Old English for a clue. Chaucer resorted to poetic use of these "obsolete" words a number of times. "Os," in the older language, gives us *the deity*. "Wold" can function as *would* or *wills*.[265] If we take this construction of his name to refer to what God (the deity) *would* do, or what God *wills*, we get a better feel for why this pilgrim is "dreaded as death." What God will do touches a level of fear far deeper than the sting of a scorpion.

Provocatively, with the Reeve designated as a keeper of records and possibly named for God's will, the pilgrim's horse, Scot, deserves a closer look. If this "Scot" superimposes *Michael* on the image of the Reeve, there are several things to consider.[266] First, Michael the Archangel is the angel of Judgment. Outspoken rival-

ry between the Miller and Reeve, then, functions covertly as that of the Devil (we have identified with the Miller) and Michael, the avenging angel. This would give a clear meaning to A 3912 where the Reeve advocates that force be met by force ("For leveful is with force force of-showve") as in the biblical account of Satan's expulsion from heaven (Apoc 12:7–9).

Secondly, Michael, in an oft-depicted scene, holds the scales of *Judgment*, as God makes the determination of each soul's eternal destiny. Many of the words of the Reeve *General Prologue* portrait have connotations of God's association with man: holy, governing, covenant, shepherd, sheep, bailiff, the seed and its development. There are also words connected specifically to Judgment: auditour, rekening, arearrage. Compilation constructs a chord of biblical resonance.

It would be most fitting (after the Miller's story of the joys of adultery and revenge) for the Reeve's—the pilgrim named as the *one dedicated to keep the accounts*—to express concern that the pilgrims consider the serious repercussions of their actions. "*Gras* tyme is doon," he says (A 3868), which gives a play upon "*Grace* time is done." There is no time left to gain God's grace. The fear of death, which Chaucer associates with the Reeve, is compounded with fear of Judgment.

When the Host, the guide of the pilgrimage, interrupts the Reeve's introductory message, the Host is said "to speke as lordly as a kyng" (A 3900). Their guide is suddenly vested with nobility. Then, to have the Reeve's words said to be "of hooly writ" is also quite unexpected (A 3902). But this new atmosphere, joined to seeing the Miller as the Devil, gives greater impact to the Host's next line: "The devel made a reve for to preche" (A 3903).

Numerous words and mental pictures cause me to see this Reeve, this account-keeper, as a personification of the Last Judgment. That's another reason to say he is hindermost, as is the Judgment. I believe this is one of the five elements (personified in the cluster of five pilgrims) that directly concerns Chaucer, and, therefore, he has made it one of the "characters" of his pilgrim circle. So far we have identified three: money, the devil, and Last Judgment.

Our next topic, Aquarius, provides a complex relationship with Pisces. We will get to know the Summoner's role before we deal with the complexity.

THE SUMMONER

As the Reeve/Scorpio exits the stage area, the poet gestures toward the pair of pilgrims remaining. They are so interested in conversing with each other that Chaucer's signal goes unnoticed. The two begin to sing in harmony together; the poet clears his throat to get their attention. That does the trick. It is time to meet the most visibly repulsive character in the pilgrimage.

During the introductory information, it was stated that once some of the zodiac signs are recognized, the other figures "*must* fill out the pattern." Identification might come down to a process of elimination: If there is only one sign unknown, then the one remaining figure is, necessarily, that constellation. That isn't quite where we are, but mythology and astrology give us little to go on regarding Aquarius, the Summoner's zodiac personality. There is only one clue for the zodiac figure. In this case, what guides our search for identity is his occupation.

Myths of many cultures recognize this water-bearer. (Roman mythology regards the person represented as Ganymede, the handsome young cup-bearer to Jupiter.[267]) If we scan celestial forms near Aquarius, we find many water-associated figures in this area of the sky: a whale, a dolphin, a ship. And, within the zodiac, on either side of this water-bearer are other aquatic characters, the sea-goat and the fish. This is the area of the heavens, noted earlier, called "the Sea." The reference was probably inspired by rain being frequent during January and February (the time of the Sun's passing through Aquarius) in the geographic regions of the cultures that developed the watery images.

Myth, as a source of information, is vague. The constellation, too, is vague. Although made up of many stars, none is brighter than the third magnitude. We find no special visual display. Our only identifying clue from Chaucer is a one-word game. The narrator says,

> [He] Kan clepen "Watte" as well as kan the pope.
> (A 643)

(He knows how to call for "*Watte*" as well as does the pope.)

This "Watte" is explained to say "Walter." The name properly spelled, however, would fit the line, so why alter the spelling? The best Chaucerian reason is word-play. With this spelling, "Watte" can function on two levels, as *Walter* and *water*.[268] Along with "water," there are two imprints of the zodiac in the description of the Summoner: one is a specific reference to a twelve-month period (A 651); the other is the Latin term, *Significavit* (A 662), which encompasses several ideas, including an allusion to *signs*, to *constellations*.[269]

We rely on the poet for additional aid, and it is forthcoming. Besides the call for "Watte," Chaucer incorporates two limitations to guide us, to keep us from going astray: one is the character's inclusion within the group of five rascals; another is a direct link with the Pardoner (the last of these scoundrels). First, if three of the five are recognized as signs of the zodiac, then it is reasonable to assume that the last two introductions of the cluster are intended as zodiacal signs, also, rather than other pilgrims of the night sky. The second bit of guidance is a firm connection between the Summoner and the Pardoner (which we will examine in detail when we meet the Pardoner, our next subject). This link is an important signal, a portentous disclosure.

The task-name of "summoner" emits awesome reverberations. So far, in the association of the five rogues, we have found *Money* (the Manciple), the *Devil* (the Miller), and *Judgment* (the Reeve). If we consider the Summoner as expressing something equally powerful, the most profound, most dreaded *summons* one could anticipate is Death.[270] I believe Death is personified in the *General Prologue* introduction of this Summoner.

This would not have been a flash of inspiration for Chaucer, as much as the utilizing of material at hand. Wickham, in *The Medieval Theatre*, tells us, "The spectre of Death summoning pope, emperor, merchant and peasant alike in the wake of plague and pestilence found its outward expression in art and literature." In the Coventry Cycle of plays, "'Dethe, goddys mesangere' personified, makes terrifying entry upon stage." In contrast, a most dramatic performance is given when Death, *unnoticed*, begins to mingle with a group of revelers. The sermons of at least three fourteenth-century English preachers record using Death personified, "a skulking, ghostly ty-

rant, who…spar[es] none…a dread visitor whose coming is sudden, privy and unannounced." The famous sermon of Thomas Wimbledon (about 1388), much quoted through the centuries, also speaks of death as a summoner. This was "a common medieval device."[271]

Chaucer, without doubt, had seen his share of death. He had borne arms (beginning as a teen-aged foot soldier) for twenty-seven years. He also witnessed the "greatest disaster in western European history"—the Black Plague, which swept across Europe, ravaging as it progressed, from 1347 until 1351.[272] London was hardest hit between February and May of 1349. Recent research confirms that the medieval estimate of 50,000 deaths in London, at that time, could be correct.[273] Chaucer was then nine years old. England probably lost one-fourth of its population.

This was not the only onslaught of the plague in Chaucer's lifetime—far from it. When he was twenty, it raged again. Across Europe 1000 villages were wiped out. When he was twenty-nine and traveled as the king's emissary across the Continent, the plague raged once again. He lived through epidemics when he was thirty-five, forty-three, forty-nine, and the year of his death when he was sixty. He was well acquainted with the dead and dying.

Famed Boccaccio records the destruction of life in the city of Florence where more than 100,000 human lives came to agonizing ends between March and July of 1348.[274] Many died in the streets; some were discovered only by stench emanating from buildings. Burials were so numerous that when all the churchyards were filled, great ditches were dug. Corpses were tossed into the ditch and a bit of dirt shoveled over them with little or no ceremony. (Gravediggers, understandably, touched the bodies as little as possible.) When the mass grave was heaped full, it was finally covered over.

There are three forms of the infection, the source being ultimately traced to fleas. The most well known is bubonic plague. Discoloration from bleeding under the skin around the "buboes" (lumps) gave the common name to the "Black Plague." This was an attack on the lymph system. Buboes would generally appear in the groin and armpits before the rest of the body was affected. Fever, headaches, seizures, and intense pain followed. It claimed its victim in about six days.

The pneumonic type was easily spread by afflicted persons, be-

cause it was associated with a cough. Contagion filled the air, penetrated clothing as well as bedclothes. A victim would typically die within three days.

Modern science concludes that the third form, septicemic, was the effect of a flea bite directly into the bloodstream. It was the most virulent, running its course within hours, and caused almost twenty percent of the fourteenth-century deaths. Boccaccio describes "valiant and comely young men" who were seen to "dine at morning with their Parents [and] Friends" but by evening "went to sup in another world."[275]

Those who survived the first plague may have had an immunity and were able to come through the next contagion—but the young were not immune, and a greater proportion of children died in subsequent attacks.[276] Notable persons were also struck down: King Alfonso XI of Castile, Queen Eleanor of Aragon, Philippa, wife of Edward III, two archbishops of Canterbury—and an English princess traveling to her wedding. The French chronicler, Froissart, claimed that one-third of the world had died; today's scholars agree with his estimate. The frequent and unpredictable return of the plague was an "ever-present threat" that instilled a "feeling of precariousness."[277] And why not? The population of Europe in 1400 was only half the number of those alive in 1300.

Chauliac, a figure of considerable authority as physician to the pope, records in his much-circulated treatise on medicine "the universal cause" of this plague. The epidemic was attributed to the celestial conjunction of Saturn, Jupiter, and Mars, which occurred in the 19° of *Aquarius*.[278] This zodiac figure and its association with the human devastation brings us back to Chaucer and his Pilgrim Summoner.

Using background we've acquired, let's look at Chaucer's sketch of the pilgrim.

> A Somonour was ther with us in that place,
> That hadde a *fyr-reed cherubynnes* face.
>
> (A 623–24)

> (A Summoner was there with us in that place,
> That had a fire-red cherub's face.)

Medieval cherubs were often illustrated as having faces painted red. (Perhaps it was their proximity to bright red Seraphs, who were thought to stand "amid flames," that gave them the rosy hue.) Thinking of this particular cherubic character, the famous Michael Scot declares that a philosopher who "dies in the Lord" will join the cherubim,[279] and this pilgrim was a philosopher of sorts (A 645).

Cherubim, members of the second order of angels, are also messengers of God. Functioning as a summoner means that this pilgrim is a messenger of a higher power. The title was often used figuratively for sickness, old age and death. Death might send "messengers to warn thee."[280] A man could take the opportunity to mend his ways before the arrival of Death. The warning, however, might not be taken seriously.

Chaucer's portrait dwells on limited attributes. Nowhere else are we introduced exclusively to the facial features of a character; other physical attributes of this pilgrim are never mentioned. His face must tell all we need to know.

> For *saucefleem* he was, with eyen narwe.
> As *hoot* he was and lecherous as a sparwe,
> With scalled browes blake and piled berd.
> Of his visage *children were aferd*.
> Ther nas quyksilver, lytarge, ne brymstoon,
> Boras, ceruce, ne oille of tartre noon,
> Ne oynement that wolde clense and byte,
> That hym myghte helpen of his whelkes white,
> Nor of the knobbes sittynge on his chekes.
>
> (A 625–33)

> (Afflicted with "saucefleem" he was, with eyes narrow.
> As hot he was and lecherous as a sparrow,
> With scaly black brows and thin beard.
> Of his visage children were afeared.
> There was no quicksilver, litharge, nor brimstone,
> Borax, ceruse, nor cream of tartar none,
> Nor ointment that would cleanse and bite,[281]
> That might help him with his whelks white,
> Nor with the knobs sitting on his cheeks.)

The red (inflamed) face is described with details that reflect, to put it mildly, an unsightly condition. "Saucefleem" was considered a form of leprosy caused by dietary excesses and lechery, as hinted in these lines. Red and black discolorations were part of the affliction as well as loss of hair. Such a man's face—or personification of serious illness and, ultimately, death—would naturally be feared by children. In spite of hideousness, his face is likened to an angel's. (That makes me uneasy.) "Hot" can communicate *fever* as one of the medieval "messengers of death."[282]

The length of the list of possible curatives dramatizes the fact that none of them will help his condition. This brings to mind, once again, the plague which Chaucer simply calls "the death" (A 605) and which Chauliac termed "the great death" (155). Corruption for which there is no *cure* is death itself. The Summoner's features could be the spectre of a body dead of the Plague or any corpse undiscovered for several days. I can't help wonder if there is a certain illustration—or traditional type—where death demonstrates these itemized particulars.

The next line,

> Wel loved he garleek, oynons, and eek lekes,
>
> (A 634)

> (Well loved he garlic, onions, and also leeks,)

is so specific, such an apparent signal, that there must be a close connection to death or plague, but I have not yet found it. A biblical connection exists, though, and could be what was in Chaucer's mind. In Numbers 11, God's displeasure sent fire to consume the Israelites at the edges of the encampment. Moses' prayer brought relief from this punishment, but the children of Israel complained about the Manna provided by God and longed for the "leeks, onions and garlic" they had eaten while in captivity. (Let's go on with that chapter of Numbers.) Subsequently, the Israelites longed for flesh to eat; the Lord answered the desires of these ingrates with an overabundance of quail, and then—"the Lord being provoked against the people, struck them with an exceeding great *plague*."[283] Does Chaucer use the onions and leeks to remind us

that an angry God has been known to send a "great plague"?

Chaucer makes a repulsive and grim association speaking of wine the color of *blood*.

> And for to drynken strong wyn, *reed as blood*;
> Thanne wolde he speke and crie as he were wood.
> And whan that he wel dronken hadde the wyn,
> Thanne wolde he speke no word but Latyn.
>
> (A 635–38)

> (And [he loved] to drink strong wine, red as blood;
> Then would he speak and cry as if he were mad.
> And when he had drunk enough wine,
> Then would he speak no words but Latin.)

I recalled another mention of wine as I traveled through California's wine country while working on this chapter. With mental pictures of the wine vats, a mind-grabbing description from the prologue to the *Reeve's Tale* confronted me. (We have not examined this prologue; there is not time or space enough to do everything here.) Chaucer's evocative lines present *Death* as tapster in charge of the wine that signifies *life*.

> As many a yeer as it is passed henne
> Syn that *my tappe* of lif *bigan to renne*.
> For sikerly, whan I was bore, anon
> Deeth drough the tappe of lyf and leet it gon;
> And ever sithe hath so the tappe yronne
> Til that almoost al empty is the tonne.
>
> (A 3889–94)

> (As many a year as it is past hence
> Since my tap of life began to run.
> For surely, when I was born, anon
> Death drew the tap of life and let it go;
> And ever since hath the tap so run
> Till that almost all empty is the tun.)

What a perception of one's life! There is no arguing with the statement that our birth is the beginning of our journey toward death. But Chaucer's illustration captures the inevitability of, and the inability to reverse, the process. His creativity brings ideas to life as we see wine freely pouring out of the cask. There is an urge to stop the stream, to catch the run-off and pour it back into the barrel. Our hands, however, are tied; the cask is unreachable; the loss, irretrievable. When the Summoner has drained the barrel (indicating the end of a life), words in Latin would naturally follow. We can understand these words as part of a ceremony for the dead, the Last Rites or the funeral.

In lines from the Reeve, once again,

> The streem of lyf now droppeth on the *chymbe*.
> The sely tonge may wel rynge and *chymbe*.[284]
>
> (A 3895–96)

> (The stream of life now droppeth on the rim [chymbe].
> The blessed tongue [of a bell] may well ring and chime.)

This speaks of the last drops of life falling on the rim (chymbe) of the barrel. And, in an attention-getting repeat, the poet rhymes with the same word (chymbe), but a different denotation. Now death is announced (as was the custom) by the ringing of a bell.

Returning to the Summoner,

> A fewe [Latyn] termes hadde he, two or thre,
> That he had lerned out of som decree;
> No wonder is—he herde it *al the day*.
>
> (A 639–41)

> (A few [Latin] terms had he, two or three,
> That he had learned out of some decree;
> It's no wonder—he heard it all the day.)

Again there is a projection of the dead (as in the plague), with numbers so large that the Latin terms (the ceremonies) were heard all day long. Earlier lines (A 636–37) portray him as if mad when

he had drunk a good deal of wine. The numbers of victims must have seemed that Death had gone mad: the more of the wine of life he consumed, the more he craved.

We have already looked at the call for "Watte," but now there is more to say.

> And eek ye knowen wel how that a *jay*
> Kan clepen "*Watte*" as wel as kan the pope.
> But whoso koude in oother thyng hym *grope.*
>
> (A 642–44)

> (And also you know well how a jay
> Can call "Watte" as well as can the pope.
> But who could other things grasp.)

The mental picture we're given is a bird, a jay, that could call for water *and* could grasp (*grope*).[285] An earlier reference noted the Romans identifying the figure as Ganymede, beloved servant of Jupiter. Although it may seem a bit peculiar, the ideas of a *jay* (a "J"), a call for water, and the ability to grasp something are basic features of Ganymede's abduction. Jupiter (starting with "J") literally carried off this young man by taking the form of a bird (an eagle), laying hold of Ganymede and carrying him to the celestial regions. If "J" standing for Jupiter seems too odd, initials had been used poetically before: There exists a medieval poem where "X" is Christ, and Mary, his mother, is "M" standing beneath the cross. There are other lettered examples as well.[286]

Chaucer gives a hint of the Summoner's Latin.

> Thanne hadde he spent al his philosophie;
> Ay "*Questio quid iuris*" wolde he crie.
>
> (A 645–46)

> (Then had he spent all his philosophy;
> Always "*Questio quid iuris*" would he cry.)

Drained of philosophy, he'd call out "the question to be judged."

We are now presented with a sudden change of direction, in

comparing the Summoner's personality to what has gone before. We're told that

> He was a *gentil harlot* and a *kynde*;
> A bettre felawe sholde men noght fynde.
>
> (A 647-48)

> (He was a noble harlot and "a kynde" [a natural];
> A better fellow should men not find.)

The Summoner, to our surprise, becomes a dear fellow. Our puzzlement vanishes as we look deeper into the words and think of circumstances where death would be welcomed as a "friend." A "gentil harlot" seems, at the surface, to be a contradiction; it could mean, for example, a *noble parasite*. But a "harlot" is many things. More fitting, regarding Death, is "a man of no fixed occupation" and surely "a vagabond." "How gentil" is an expression used by Reginald Pecock, a fifteenth-century spiritual writer, in describing the law of God. Combining these ideas, we find a "gentil harlot" to be a wanderer doing God's will. "Kynde" reinforces this mood. *Kynde* can mean *benevolent*, but a stronger connection is *natural, the essential character*. (We use this connotation when we ask, "What kind of a person is he?") Then this wanderer, Death, operating as God's law is natural. Bartholomaeus speaks of the death of old men as "kyndeliche," which can intend *kindly* as well as *natural*.[287] Our poet records a similar thought in the *Knight's Tale*.

> And we been pilgrymes, passynge to and fro.
> Deeth is an ende of every worldly soore.
>
> (A 2848–49)

> (And we are pilgrims, passing to and fro.
> Death is an end to every worldly suffering.)

Strangely enough, we have no more than adjusted to the perception of Death as a kind release, a friend to those whose lives are a burden, than another side of his personality emerges.

He wolde suffre for *a quart of wyn*
A good felawe to have his concubyn
A twelf-monthe, and excuse hym atte fulle.

(A 649-51)

(For a quart of wine he would allow
A good fellow to have his concubine
For twelve months, and excuse him completely.)

The Summoner is being tolerant, to say the least. His duties, in the surface story, involve summoning to the ecclesiastical court those accused "in moral offenses such as adultery and fornication."[288] Yet, he is willing to allow a fellow to enjoy having a mistress for a year, and the actions to be overlooked. The cost is *only* a quart of wine. Relating the flow of wine to the approach of death, this "good fellow" has given a portion of his life's blood and has not been summoned by Death within the year. The situation is *not* one of tolerance and understanding; the sinner's *time* has not yet come. His cask of wine has not yet run dry. He feels confidence, but it is false confidence. He has been tricked.

The poet confides of the Summoner,

Ful prively a *fynch eek koude he pulle.*

(A 652)

(Very privately he could "pull a finch.")

Though the line is sometimes interpreted as a sexual reference,[289] the covert sense conveys "to be cunning," "to pull a clever trick." Trickery is assumed of Death. The poet gives us the essential wisdom to anticipate "his" coming:

Me thynketh that it were necessarie
For to *be war* of swich an adversarie.
Beth redy for to meete hym everemoore.

(C 681–83)

(Methinks that it is necessary

> To beware of such an adversary.
> Be ready to meet him at every moment.)

Our modern world still has a sense of Death presenting his summons at inopportune, unanticipated moments—a life cut short on the brink of success, for example.

The idea of false confidence goes on.

> And if he foond owher a good felawe,
> He wolde techen hym to have noon awe.
> <div align="right">(A 653–54)</div>

> (If he found a good fellow anywhere,
> He would teach him to have no fear.)

Repetition of *curse* and *purse* in the next set of lines attracts attention, functions as a signal to be noticed.

> In swich caas of the ercedekenes *curs*,
> But if a mannes soule were in his *purs*;
> For in his *purs* he sholde ypunysshed be.
> "*Purs* is the ercedekenes helle," seyde he.
> But wel I woot *he lyed* right in dede.
> <div align="right">(A 655–59)</div>

> (In such a case as the archdeacon's *curse*,
> If a man's soul were in his *purse*;
> In his *purse* he should be punished.
> "*Purse* is the archdeacon's hell," said he.
> But well I know he lied in deed.)

The lines give the impression that a bribe is all that is necessary; however, the deception continues: "*but* I know he lied." Chaucer terms him "traytour Deeth" in the *Pardoner's Tale* (C 753). In that story, several young men set out to eliminate Death. But then, enthralled by the discovery of a cache of gold, they forget about Death entirely. He catches them off guard just when they think they have everything they could want.

The Summoner's geniality, or reassurance, is false! Now the truth is stated:

> Of *cursyng* oghte ech gilty man him drede,
> For *curs* wol slee right as assoillyng savith.
>
> (A 660–61)

> (Of cursing ought each guilty man be fearful,
> For the curse will slay right as absolving saves.)

A guilty man ought to dread such a curse for it will *slay* (implying spiritual *death*), while absolution will save the soul (give it eternal *life*).

The Latin word in the next line, we said earlier, can refer to constellations, signs.

> And also war hym of a *Significavit*.
>
> (A 662)

> (And also he should beware of what is signified [indicated].)

Beware of the sign! It is a way of relating what Chaucer calls "the *death*" (the plague) to the *sign* of Aquarius. Equally significant, it says to beware of illness, as a *sign* of approaching death.

Now Chaucer's expertise in creating allegory provides a bawdy surface which conceals grim reality.

> In *daunger* hadde he at his owene *gise*
> The yonge girles of the diocise,
> And knew hir conseil, and was al hir reed.
>
> (A 663–65)

> (In "daunger" had he his own "gise" [way with]
> The young girls of the diocese,
> And knew their secrets, and was their counsel.)

A sexual tone is usually given to these lines, but a dark message is veiled. Recall his loathsome appearance. Despite his looks, are we

to believe the young girls of the town interact with him? One con-
notation of his "daunger" is *the power of death.*[290] He had his own
way of doing things and his own (dis)guise. He was to these girls
their devastating intimate, their *ultimate* confidante. When he
seeks them out, young maidens find him irresistible. (In languages
where Death is a word of the masculine gender, seduction is a nat-
ural metaphor to express the demise of a young woman. Schubert's
"Death and the Maiden" is an example.[291])

The depiction nears its close with only one more detail regard-
ing the Summoner. We have been given no information about his
body, his clothing, his robustness or lack of it. Considering his por-
trayal as quite active within the community, we have a basic impos-
sibility regarding the initial lines that describe his state of health.
Presumably, the "man" is *very* ill, incurably ill according to visible
symptoms. The common medieval illustration of the ultimate sum-
moner is a skeleton. This could hardly be described with character-
istics of a man while maintaining the secret of a double meaning,
which is the point of allegory—the secret to be sought after. Chau-
cer's narrow field of description has a purpose. This last visual de-
tail observes the same limit: one more view of his face.

> A *gerland* hadde he set upon his heed
> As greet as it were for an alestake.
>
> (A 666–67)

(A garland had he set upon his head
As great as for an "alestake" [a post before a tavern].)

How preposterous an idea, this frighteningly grotesque man with a
wreath of flower (or leaves) atop his swollen face! This *garland* begs
investigation. I remembered pictures of lepers from the Middle
Ages. Their garb was regulated so that they were recognizable at a
distance. They wore broad-brimmed hats, and their heads, beneath
the hats, were swathed in fabric. Checking further into the defini-
tions of "garland," aside from floral examples, I found the answer:
The Summoner's garland can be a kerchief to bind the head of one
who is ill.[292]

Then the poet's closing lines perform as earlier examples have;

the last words are the finishing touch to the plan. Add to the garland/kerchief the very last line about a "cake," and we have two major clues.

A *bokeleer* hadde he maad hym of a *cake*.

(A 668)

(A buckler [shield] had he made for himself of a cake.)

George Renn has reviewed the reason for seeing this "cake" as a shield.[293] Renn's point of view (encompassing hypocrisy and magic) works for the surface; the hidden explanation, however, leads elsewhere and is spiritually powerful. *Cake* was used figuratively as the Eucharist, the Sacramental Wafer. Reception of this consecrated bread, when death is imminent, is called *Viaticum*, which communicates provisions for a journey. The sacrament provides a spiritual *shield* for the departing soul. So two thoughts of death bring this portrait to a close: the garland, a head-wrap as an indication of illness; and the cake, a shield for the transition to eternity.

As the fourth in this group of five villains (along with Money, the Devil, and Judgment), the poet portrays thoughts of Death close to himself. Other pilgrim introductions move back and forth between (or among) levels of identification from mythology, astrology, and sometimes biology. But stars and myth have little to contribute to Aquarius. We are invited, therefore, to concentrate almost exclusively on Death, the pilgrim Summoner's other personality. His repulsive facial features are those of disfiguring illness, illness with no cure. Fittingly, the plague is mentioned by the previous pilgrim, the Reeve. (It is also part of the story told by the Pardoner, the last of the group of five.) Victims (the dead) would look very much like this Summoner, Death personified. And his zodiacal identity marks the time when the "Great Death" first struck the continent of Europe.

As Aquarius and a dominant image of Death, the Summoner's close relationship with the Pardoner will have a surprising covert interpretation.

There are only two signs of the zodiac left to deal with: Virgo and Pisces. Virgo is a *woman* and, therefore, not part of the poet's

circle. By process of elimination, then, the last member of this fraternity must be Pisces. That is the first reason for the Summoner and Pardoner to share activities and interests: Aquarius and Pisces are *adjoining* signs. The Pardoner "of Rouncivale" is presented as the Summoner's "friend and comrade." They are said to be *colleagues*, but we will come to see them as *collaborators*. So now let's learn why Pisces completes the poet's little clique.

THE PARDONER

When our poet/director/producer dismisses the Summoner/ Aquarius, the pilgrim—instead of wending his way to his proper position in the velvet firmament encircling us—crosses the stage to his confrere once again. Sounding a note, they take up the two-part harmony that had been interrupted. Unprecedented! And un-appreciated by our director. Insisting that the Summoner/Aquarius take his leave, the poet draws the last pilgrim of his personal circle—the Pardoner—to front stage. Realizing that the audience is curious about this unusual behavior, a brief explanation will be incorporated into the Pardoner's introductory portrait.

His relationship to this friend, names that reverberate, the Pisces "animal" image and its symbolic implications are pregnant materials of the Pardoner's depiction. No lack of background to draw upon here, especially compared to the minimalist, Aquarius.

Pisces has a simple story, if you don't count the variations. A monster threatened Dione (or Venus or Aphrodite) as she was holding her little son at the edge of the Euphrates River. She called for help and two fishes responded. The goddess and her son rode on the backs of the fishes to safety, "wherefore they (the fish) now possess the stars."[294] That's the basic story, but another version says that, being deities, they changed themselves into fish and escaped. So much for the "history" of the starry figure.

There's a parallel story about a "southern fish" (located in the heavens just south of Capricorn and Aquarius) in that area called "the Sea." The fish is pictured drinking *all* the flow from Aquarius' water jar. Information on the zodiac written in 1488 calls *this* fish Pisces. Another legend says this southern fish begot the other two fish. A Christian legend commemorates it as a fish caught by St. Peter; a coin was in its mouth when it was hauled into the boat.

All the variations bring us to the fact that the fourth Royal Star, Fomalhaut (we've already seen the other three in other constellations), has long been called the Fish's Mouth. In spite of this, another authority places Fomalhaut in the generally accepted figure of Pisces (not in the Southern Fish).[295]

For my part, I consider the constellation we will deal with in reviewing the poet's ideas as "the sign of the fish" which contains Fomalhaut, a star of the first magnitude. The sign appears at the time of the vernal equinox. Manilius says that one half of Pisces "concludes winter, the other introduces spring."[296]

The camaraderie acted out between the Summoner (Aquarius/Death) and this Pardoner, has no comparable elaboration anywhere else in the *General Prologue*. Where the rest of the group is concerned, a friend of one of the travelers is merely said to be "in the company" of the other. In cases of pilgrims who are blood relatives—brothers, father and son—the poet only says "with him" was his son or his brother. The Summoner/Pardoner alliance is unique. Six lines of the Pardoner's introduction are taken up with the explanation of the interaction between these two characters.[297]

> With hym (the Summoner) ther rood a gentil Pardoner
> Of *Rouncivale*, his freend and his compeer,
> That streight was comen fro the court of Rome.
> Ful loude he soong *"Com hider, love, to me!"*
> This Somonour bar to hym a *stif burdoun*;
> Was never *trompe* of half so greet a soun.
>
> (A 669–74)

> (With him there rode a worthy Pardoner
> Of Roncevalles, his friend and his companion,
> That had come straight from the court of Rome.
> Full loud he sang "Come hither, love, to me!"
> The Summoner bore him a stiff burden;
> Was never a trumpet half so great a sound.)

The poet will sketch the image of a fish shortly. For now you'll need to trust that these lines are an account of the association of the Summoner/Pardoner, Aquarius/Pisces—Death/what? Ask

yourself, "What is historically recognized as the sign of the fish?" When I realized I was dealing with the Church—from earliest Christian times down to the present day—the sign of the fish, I shuddered. I was already aware that this pilgrim was anything but admirable. His characteristics, on the surface, are those of a less than perfect clergyman; the covert significance, however, is a devastating portrayal of the Church, the *source of pardon* come straight from Rome.[298]

To get back to these "friends," a major clue to the source of their closeness is Rouncivale (modern Roncesvalles, in northern Spain). Importance of the city's name goes back centuries to Charles the Great, Charlemagne, and to the memorable battle recounted in the *Song of Roland*. Chaucer refers, in the *Book of the Duchess*, to Roland of the "Song" and his friend Oliver, heroes who died together at Rouncivale (line 1122).

Written about the year 1100, the composition about Roland is filled with crusading. That is its background, although the action spoken of takes place in the 700s, predating the Crusades by centuries. Charlemagne is depicted as "a sort of priest-king."[299] Roland and the rest of a rear guard were caught in an ambush. The hero reflects, "We may be *martyred*" (stanza 143), a term one finds in stories of saints who gave their lives for their faith. Archbishop Turpin, who was also with the French forces, encouraged the knights who were about to do battle against the "pagans":

> Charles has left us here, lord barons.
> He is the king. It is our duty
> To die for him and Christianity.
> It's battle now for all you men;
> There they are, the Saracens!
> Confess your sins, and God's forgiveness
> Will be ensured for those I bless.
> If you die, you will be, as martyrs,
> High in Paradise hereafter.
>
> (stanza 89)

These men received pardon because of the circumstances of their death; they were designated as martyrs, pardoned of all sins, and

destined for an immediate place in heaven. The *Song* is a record of Pardon and Death collaborating at Rouncivale.

This form of general absolution was also a factor in the actual Crusades. Pope Eugene III (in 1145) declared, "those who devoutly undertake and accomplish [a crusade], or who die by the way, shall obtain absolution for all their sins...and receive from (God) the reward of eternal life."[300] It is a promise that a soul will forego the cleansing of purgatory, as well as be released from the threats of hell. There were "crusades, and plans for crusades," in the fourteenth and fifteenth centuries.[301] Chaucer knew of the close ties between death and pardon.

Returning to the two Canterbury pilgrims, we are introduced to them in conjunction with the reverberating locale of Rouncivale. Then (as their action on stage has demonstrated) they perform a song together. The Summoner's voice is more powerful than a trumpet blast, which (just for an instant) evokes heavenly trumpets proclaiming Judgment. Their duet says more than the words admit on first reading. The Summoner, with his great voice, is carrying a "stif burdoun" of a strong bass vocal line, but at another level there is the grim vision—the burden of a stiffened corpse being carried, the daily mission of this Summoner/Death. The lyric, "Come hither, love to me," when delivered *in unison* by the Church and Death, filled me with foreboding. I realized I knew of a song where Death and Pardon jointly express this sentiment; it is the *Song of Roland*, once again, especially the baptismal scene.

Even though it is a statement that characterizes that period, it is difficult to acknowledge that the lyric conveys "Become a Christian or die." One of the stanzas of Roland's *Song* recounts that Charlemagne and his forces have avenged the fallen French *martyrs*. A throng of defeated Saracens have been gathered together. Then,

> The bishops speak their holy words
> Over the water, and they lead
> The pagans to the baptistry:
> Any who opposes Charles's will
> Is hung or burnt or otherwise killed.
> A hundred thousand are baptised.
>
> (stanza 266)

It is a simple truth that many atrocities are committed in the name of religion. We'll hear no more of the Summoner and Pardoner functioning together. They go their separate literary ways now, now that their covert relationship has been established.

We will not forget the strong connection between the Church and Death even though we move on to the poet's introduction of Pisces in his biological existence. Chaucer must have had fun setting out these lines about a "man" while he pictured a fish.

> This Pardoner hadde heer as yelow as wex,
> But *smothe* it heeng as dooth a strike of flex;
> By *ounces* henge his lokkes that he hadde,
> And therwith he his shuldres overspradde;
> But thynne it lay, by *colpons oon and oon.*
>
> (A 675–79)

> (This Pardoner had hair as yellow as wax,
> And smooth it hung as does a bunch of flax;
> By "ounces" hung his locks that he had,
> And therewith his shoulders were overspread;
> But thin it lay, by "colpons" one and one
> [*or* on and on].)

A noteworthy aspect of this description is that the poet devotes five lines just to describe a man's hair. Gardner, whose work on Old English poetry has been a great assistance in understanding Chaucer's peculiarities, says of dwelling overly long on one idea:

> Whenever the poet dwells on some particular event, character or image...whenever he in any way calls special attention to something in his story, he is wittingly or unwittingly presenting a key detail.[302]

There is no doubt that this "hair" is a key. We learn nothing of other body parts—no hands, no legs, etc. Physical properties that don't approximate the characteristics of a *man* are avoided. We are directed to his wax-like yellow "hair" which spreads *very* smoothly over his shoulders. This "hair" is remarkably "thin." It's not hair

loss that's implied; the *hairs* themselves appear "thin." They hang "by ounces" (in very small quantities), by "colpons" (pieces or slices). What an imaginative analogy for color and thinness of the scales of a fish! The "one and one" gives a distinct impression of separate "hairs." But Middle English, with its flexible spelling, could just as easily convey "on and on"; that is, *indefinitely.* Perhaps both are intended. After five lines of cleverly worded particulars, we can see the orderly arrangement of the scales of a fish. "Hair" spreading out over the shoulders gives the proper fish contour and eliminates the need to mention a neck.

To the color and orderliness of the surface of a fish, Chaucer adds another visual characteristic.

> No berd hadde he, ne nevere sholde have;
> As smothe it was as it were late shave.
>
> (A 689–90)

> (No beard had he, nor ever should have;
> As smooth it was as if it were lately shaved.)

As a fish, absence of a beard is a foregone conclusion. The poet, however, doesn't stop there. He emphasizes the ultrasmooth surface, the sleekness of a fish.

Along with the bright color, orderly surface arrangement, and outstanding smoothness, we're given one more detail for this physical portrait. As fishes go, in addition to what has already been described, an obvious feature would be his "fish eyes." That's precisely what we're given.

> Swich glarynge eyen hadde he as an hare.
>
> (A 684)

> (Such glaring eyes had he as does a hare.)

Visualizing a man's eyes to be like those of a hare is grotesque. But to liken the eyes of a *fish* to those of a hare is quite observant. Neither fish nor hare look straight ahead, and the hare is born with eyes open; they never give the impression of helplessness as do

baby rabbits. Several lines separate depicting the smooth surface of the fish and the mention of these eyes. Interrupting the portrait would keep the covert image from being too obvious.

A strictly human quality is now introduced, but the poet doesn't make our job easy.

> Dischevelee, save his cappe, he rood al bare.
>
> <div align="right">(A 683)</div>

> (Disheveled, save his cap, he rode all bare.)

Two ideas come from "disheveled:" bare-headed or seeming in disarray. We already know of his very orderly appearance, so we have a contradiction. The alternative sense is that he must be bare-headed, but *he wears a cap*.[303] The line actually tells us that, aside from his cap, he rode all bare! A note is quick to explain that the words only mean that he's bare-headed. That seems to justify this convoluted description of a man's hair-style. On the other hand (other level), to say a fish is not wearing clothes is a bit of fun and only to be expected.

He comes minimally equipped.

> But hood, for *jolitee*, wered he noon,
> For it was trussed up in his walet.
> Hym thoughte he rood all of the newe jet;
>
> > . . .
>
> A *vernycle* hadde he sowed upon his cappe.
> His walet lay biforn hym in his lappe,
> Bretful of pardoun, comen from Rome al hoot.
>
> <div align="right">(A 680–87)</div>

> (But a hood, for jollity, wore he none,
> For it was trussed up in his pouch.
> He thought he rode all of a new fashion;
>
> > . . .
>
> A veronica had he sewed on his cap.
> His pouch lay before him in his lap,
> Brimful of pardon, come from Rome all hot.)

Jolitee caused him to put off his hood. Our *jollity* (fun) doesn't come near to what the Middle Ages might mean. How do you choose the proper connotation from: cheerfulness, merrymaking, vigor, impudence, insolence, agreeableness, elegance, pleasure, or attractiveness? It would depend on the nature of the person described. That's what makes the choice difficult. We have no sure way to decide—unless we use several meanings, one for each identity. This *vernycle* (veronica) that adorns his cap is a picture of Christ's face on a piece of cloth.

Pisces clues, for this generic fish, are concealed in the names of the towns selected.

> But of his craft, fro *Berwyk into Ware*,
> Ne was ther swich another pardoner.
>
> <div align="right">(A 692–93)</div>

> (Of his craft, from Burwick into Ware,
> Never was there such another pardoner.)

In the area of these towns, there is no Pardoner like him. He is one of a kind (as is each of the signs). The poet qualifies that *plying his craft*, practicing his expertise, in the area from "Berwyk into Ware" is what makes him exceptional. Locales chosen for other pilgrims took in great expanses of the known world. This pair of towns only claims "from one end of England to the other," which is not much of a boast for this Pardoner who travels the Continent. But homegrown words are all Chaucer needs for his alternate message.

Scrutinizing the towns as words, the most meaningful definition involves "Ware." It means *spring*.[304] Recall that Manilius wrote that one half of Pisces "concludes winter, the other introduces *spring*." Passing through Pisces should be the accomplishment of a metamorphosis. If Ware is spring, I suspect that Berwyk, in some creative way, must communicate *winter*. Searching for possibilities, *ber* as an alternate spelling of *bare* (without vegetation) gives the most promise.[305] Ber-wick, then, can say "an area of land that is bare." Transforming the bare land of winter into spring (Berwyk into Ware) is the given task of Pisces.

There is, however, a deeper, transcendent message in thoughts

of spring. The change of this particular season speaks of the renew-
al of life. A second look at *Ber* holds the image of a *bier*, another
transition from death to life. As far back as man recorded such
thoughts, he saw the winter world as dead and rejoiced with its re-
turn to life each spring.

If we repeat the associations we've made for Pisces, replacing
the zodiac identity with the Pardoner's parallel image—the
Church—what do we find? Again, there is no other Pardoner like
him (like the Church). He is unique. What is there to say about his
expertise involving the metamorphosis from death (Berwyk) to life
(Ware)? Theologically, death comes to the soul without the life-
giving waters (Aquarius) of baptism. (The *Song of Roland* drama-
tized this.) The poet's words also touch upon the death of sin and
the renewal of the life of the soul by the *pardon* of absolution. It
even touches upon pardon associated with physical *death* and entry
into eternal *life*, with the Church ministering to the needs of the
dying with guidance and sustenance (*viaticum*) for the journey into
eternal life. The depth and intricacy of the poet's many levels of
imagery is incomparable.

We have met one aspect of the pilgrim as a fish and identified
that fish as the zodiac sign of Pisces. He is commonly addressed,
however, as the Pardoner. What we learn about him from the nar-
rator is repulsive.

> For in his male he hadde a pilwe-beer,
> Which that he seyde was Oure Lady veyl:
> He seyde he hadde a gobet of the seyl
> That Seint Peter hadde, whan that he wente
> Upon the see, til Jhesu Crist hym hente.
> He hadde a croys of latoun ful of stones,
> And in a glas he hadde pigges bones.
> But with thise relikes, whan that he fond
> A povre person dwellynge upon lond,
> Upon a day he gat hym moore moneye
> Than that the person gat in monthes tweye;
> And thus, with feyned flaterye and japes,
> He made the person and the peple his apes.
>
> (A 694–706)

(For in his pouch he had a pillow-case,
Which he said was Our Lady's veil:
He said he had a piece of the sail
That Saint Peter had, when that he went
Upon the water, until Jesus Christ grabbed him.
He had a cross of brass full of stones,
And in a glass he had pig's bones.
But with these relics, when he found
A poor person dwelling upon the land,
In a day he got more money
Than the parson got in two months;
And thus, with feigned flattery and tricks,
He made the parson and the people his apes, monkeys.)

A fraud is being perpetrated on the unsuspecting, and, perhaps, even the impoverished, faithful. These disclosures may repel us, but when the Pardoner speaks for himself, as he does in the prologue to his *Tale*, he becomes even more hateful.

Here's a sample of his life-style from his own admissions: He has a collection of "relics" which he promotes and leads people to believe are authentic. Exaggerated promises are made about the power of the relics to cure animals, cure humans, assuage suspicious husbands. Trickery is admitted, but, he boasts, year by year it's a good living. There are one hundred false stories he tells. He preaches most effectively against avarice and is happily the beneficiary of the penitent's conversion. Admitting to a desire only for gain, he cares nothing about dealing with sin. Reputations are ruined when he spits his venom under cover of holiness. His sermons do not diminish his personal greed. Even the poorest give him money, wool and cheese, though their children are starving (C 347–451).

We are still reeling from his confidences, when he paradoxically reports:

> For though myself be a ful vicious man,
> A moral tale yet I yow telle kan.
>
> (C 459–60)

(For though I myself am a very vicious man,
A moral tale yet can I tell you.)

He proceeds to tell his *Tale,* in the opinion of many, one of the best of the Canterbury collection. When it's over, he moves right into his habitual preaching against avarice in hopes of getting valuables from his fellow-pilgrims.

In the midst of one of the most thought-provoking scenes in the *Tales,* he makes this disclosure:

> And Jhesu Crist, that is oure soules leche,
> So graunte yow his pardoun to receyve,
> For that is best; I wol yow nat deceyve.
>
> (C 916–18)

> (And Jesus Christ, that is our soul's salvation,
> So grant you his pardon to receive,
> For that is best; I will not deceive you.)

In the depth of his viciousness, he still admits devotion to Christ. (I think back to the line about the *vernycle* and wonder if Chaucer is illustrating the extent of this pilgrim's Christianity—just a token likeness temporarily applied to the surface.) The Pardoner has bared his soul, confessing his true nature, admitting his sinfulness. Is Chaucer hoping for the conversion of the Church?

The poet could never have conveyed these thoughts openly without reprisals—even death. How brilliant! How courageous to find a way to say what he must have felt needed to be said.[306]

Returning to the *General Prologue* portrait, the narrator admits respect for the Pardoner's capabilities.

> But trewely to tellen atte laste,
> He was in chirche a noble *ecclesiaste.*
> Wel koude he rede a lessoun or a storie.
>
> (A 707–09)

> (But truly to tell at last,
> He was in church a noble ecclesiast.

Well could he interpret a lesson or story.)

There is a trace of appreciation here despite what has been said before. The use of *ecclesiaste*, the only time Chaucer uses the term to indicate a person, presents a momentary response to the Latin word for *church*—a fleeting signal.[307]

We have come to the closing lines of the Pardoner's portrait.

> But alderbest he *song* an offertorie;
> For wel he wiste, whan that *song* was *songe*,
> He moste preche and wel affile his tonge
> To wynne silver, as he ful wel koude;
> Therefore he *song* the murierly and loude.
>
> (A 710–14)

> (But very best of all he sang an offertory;
> For well he knew, when that song was sung,
> He must preach and polish his tongue
> To win silver, as he very well could;
> Therefore he sang the louder and merrier.)

Connecting an image of his mouth to the winning of silver gives a glimpse of Pisces (and the star Fomalhaut), as the fish with the coin in its mouth.

We are directed, once again, to the Pardoner's vocalizing. Four times in five lines the poet refers to *song*. A point is being made. The Pardoner was best, and strove to be best, at delivering his song because the better his performance, the greater the amount of silver. His vocal intensity (loudness) communicates his dominating voice.[308]

The cheery lines, however, have a dark undersurface. He sang the offertory well; when the song was sung, he'd preach to win silver; *therefore*, he sang "murierly" and loud. This is the last bit of information we will be given about the Pardoner. If the poet is true to form, the words should hold a pregnant message. In order to inspire the most generous collection, he would be *loud* and—along with that emphasis—we can see a play on *Mary* (*murierly*). Preaching about Mary brought in a greater offering. Though I didn't expect to find this message, I believe it's there.

This interpretation is supported by the noted Catholic Marian scholar, Hilda Graef. She tells of the legends of Mary, during the Middle Ages, being collected and finding their way into many sermons. By the early 1400s claims were so exaggerated regarding the mother of Jesus that the stories sound "more like the legends of Jupiter than the mystery of the Incarnation...How could an illiterate congregation...still distinguish between the divine Father and the human Mother of God when they were told that Mary could do more than God?" Two aberrations in devotion to Mary came about in the eighth century and developed into "a commonplace in the Middle Ages." One claimed that God obeyed Mary because she was his mother; the other allowed that God wanted to destroy sinners, and they would be saved "only by the intercession of Mary." Graef continues, "No wonder that many of the less well instructed preachers and devotional writers of a later age, who read these sermons in Latin translations, stressed just these [two points above] which would appeal to the emotions of their public."[309] Chaucer, I'm sure, recognized these distortions and felt bound, in conscience, to point them out.

While scanning Graef's index, I came across the answer to a question I didn't know how to ask. A few words inserted into the chapter on the Friar indicated the discovery. Now is the proper time to give our full attention to the Friar's *neck*. The narrator, in an off-hand manner, observes:

> His nekke whit was as the flour-de-lys.
>
> (A 238)

This line is an intrusion amid the surrounding thoughts. After thirty lines of introduction, we're given a one-line glimpse of his physical appearance. Another twenty-two lines intervene before we *see* any more of the Friar. Considering content of the line itself, how odd to identify a man's neck as white, and white as a lily, no less. How odd to use a French form to name that lily. What's the point of this signal? Neither oddity compares to the oddness of finding "neck" as an entry in Graef's religion-based index. It is a fact that the lily as a fleur-de-lis (modern spelling) was symbolic of France. It is a fact that lily was also a metaphor for the Blessed

Virgin Mary. She was, and is, the white lily. What I retrieved from Graef sounds foreign to our thinking, but Hermann of Tournai (d. after 1147) "seems to have been the first to apply to Mary the metaphor of the *neck*, which was to play an important part in subsequent Mariology." During Chaucer's lifetime the idea was expressed that, as Christ is the Head and we (mankind) are the body, "no member of the body can receive the good things of the head except through this neck."[310] In France, again, the Chancellor of the University of Paris, John Gerson (d. 1429), also used "the metaphor of the neck, because Mary connects the members of the Church with Christ, their head."[311] Though functional, the metaphor is not felicitous.

In any case, this lily-white neck is a medieval symbol of Mary. I believe Chaucer's allusion to the *neck* is portraying a distortion in the analogy of the Mystical Body—Christ, the Head; mankind, His members. (The poet creatively provides the symbol of the true Mystical Body elsewhere in the *Tales*.[312]) We said the Friar was a devil personified. In that case, instead of presenting the mystical presence of Good, Chaucer constructs the mystical presence of Evil. Endowing the Friar with a lily-white neck seems to regard the exaggerated claims for the power of Mary as a function of the devil. Satan reaches people through this grossly malformed mother-image. Use of the French term and national symbol can also be seen to point to France as the source of the problem.

We'll review one more line of the Pardoner's *General Prologue* vignette. We avoided dealing with it in numeric order, but the underlying meaning is attuned to our thoughts of the moment. Announcing that the Pardoner would never have a beard, the narrator assumes,

I trowe he were a *geldyng* or a *mare*.

(A 691)

(I trust he were a gelding or a mare.)

The assumption deprives the Pardoner of virility, renders the Pardoner impotent, a *gelding*. Peering deeper, the Pardoner, as the Sign of the Fish, is declared impotent. This is heresy.[313] There is a

level here that goes beyond joking about an offensive personality. I believe Chaucer felt conscience-bound to communicate information he understood from what he read, heard, and saw on his travels. Communications of considerable depth are scattered through the *Tales* waiting to be found.

We've finished with the five rascals that surround Chaucer in his scheme of introductions: the Manciple/Money, the Miller/Devil, the Reeve/Judgment, the Summoner/Death and the Pardoner/the Church. The "Plan," at the beginning of this book, noted that the zodiac signs were said to have three faces; to identify three for each is beyond this project. These five cosmic journeyers, however, have three well-defined faces—including the zodiac identities—that almost leap out at you. They embrace essential considerations about life and weighty meditations on death. And, under cover of entertaining poetry, Chaucer imparts a deeper message for those ready to dig for it. His close circle of companions acquaints us with his close personal concerns.

It's time now to view the last zodiac pilgrim—Virgo, the virgin.

THE INCOMPARABLE WIFE

Chaucer nods toward those waiting off-stage. The last of the zodiac performers responds and makes her way toward the audience. With a cheery visage and boundless energy, the love-of-living-in-the-moment exudes from her presence.

Those familiar with the pilgrims may be thinking that the chapter heading is an error. How does the announced "Virgo, the virgin" fit this Wife, and a much-married wife, at that? Chaucer will show you in his inimitable fashion. The clues are what count. She has been termed "the consummate composite."[314] Though the intention of the phrase had to do with the merging of literary types, it applies here as a merging of classical figures.

The fact of Virgo's multiple representations, her identification in ancient times with many goddesses, is a commonplace. There is Erigone, "the Early Born," and Ashtoreth in the Book of Kings XI: 5, 33. Minerva is another. The Roman Proserpina as Virgo adjoins Pluto's Chariot (Libra); Pluto carried her off to Hades. Leo is on the other side of Virgo; so Cybele, who rides on lions, was added

to the collection. Venerable Bede claimed the virgin Astarte was the same personality as the Saxon goddess of spring, Eostre. (That's where we get the word Easter.) The last one we'll name is Isis, who spilled the grain that forms the phenomenon we call the Milky Way. We don't need any others because Isis is called "the thousand-named" goddess.[315] The facets of "Virgo" are beyond calculating.

This group of stars has been an inspiration since 3000 B.C., although it has only one outstanding feature: Spica, a blue star of the first magnitude. In Babylon the star signified the "Virgin's Belt." The word, however, refers to an ear of corn or a sheaf of barley or wheat. (That's where Isis got the grain she spilled.) The figure is sometimes referred to as "the corn maiden" because of the grain.[316]

With only one outstanding celestial feature to work with, the poet turns to mythology to make up the major elements of the Wife's allegorical presence. Some history and mythology will help us recognize candidates from the preceding roster, as Chaucer moves back and forth among the possibles. Cybele, the first candidate, started her existence in Asia. She enjoyed "perpetual din"; her followers would blast horns, play flutes, thump drums, crash cymbals and howl as they carried her statue through the streets. An identifying attribute is her crown, which resembles a defensive wall, a circle of towers; the design honors her as the one who gave towers to the first cities. Lions are generally present in her portrayals because "the wildness of the brute was tamed by her." A typical conception of Cybele is the figure of a woman seated on a lion or in a chariot drawn by lions.[317]

Augustine uses her title "virgin Caelestis" and tells of her love for young Attis. Attis, to his regret, made the mistake of dallying with a nymph. The jealous goddess destroyed the nymph, and Attis went mad. He wounded himself and died.[318]

In Rome, in 204 B.C., an oracle directed that the presence of this deity was necessary to gain a military advantage; so her image was brought to the Eternal City with great expectation. The Romans were victorious—and enjoyed a good harvest, as well. These events combined to encourage the ready acceptance of her cult.

The essential ceremony of Cybele's cult was the transporting of her image to a nearby river to be washed. While the washing may

seem a fairly ordinary idea, many other practices of her followers were quite *extra*ordinary. Her rituals included an annual celebration of five days, consisting of various ceremonies. Augustine, using the historian Varro as his source, explains that such offensive rituals were performed that Varro failed to record the details because "reason blushed and eloquence fell silent." We'll delve into the rituals when necessary. Augustine wrote of this offending goddess to argue against her worship. He also drew attention to her being confused with Juno and Ceres, as well as the Earth, each a nurturing figure or one dedicated to nature.[319]

A much different Virgo-likeness is Minerva (Athena), patron of artists, craftsmen, scholars and weavers. You may know the story of Arachne, who boasted that she was a better weaver than Athena. The goddess manifested herself to teach the mortal a lesson. The deity's demonstration-piece was matchless; Arachne's was superb, but her subject matter was disrespectful of the gods. So Athena destroyed the mortal's work and caused the woman to become the first Arachnid.[320] (Spiders didn't have a *family* name before that.)

Athena's action may seem cold, but perhaps we should attribute her deficiency to the fact that the goddess had never known the warmth of a mother's love. She had emerged, dressed in armor, from the head of Zeus. Augustine wondered that people believed the story of her emergence, and why, with such an auspicious origin, she wasn't ranked higher among goddesses.[321]

A significant event, often talked about regarding several of these Virgo-type deities, was the ceremonial bath. Ovid describes festivities of April first, in honor of Venus, saying "the goddess must be washed from top to toe." The statue of Cybele (the Mother of the gods) was carried in procession to a local stream and cleansed. Then there is the status-changing outcome from ritual bathing which occurred at "a spring called Kanathos"; it is there that Hera (Juno) "washes every year to renew her virginity."[322] Closer to home for Chaucer is Minerva's "bath." Her temple in Bath, England was at the Roman *Bath*, built in the first century to utilize the natural hot springs. (The town was named for the waters that flow at 114 degrees to 120 degrees Fahrenheit.) Part of Minerva's temple can still be seen in Bath.[323]

Now that we've gathered a few names identified with Virgo

and learned of their common ritual bath, let's try to understand what this represents. Each culture had a name for the reawakening of spring or renewal of the growing season. Often the names embraced more than one function, or one function embraced more than one name. Augustine had much to say about this as he worked against belief in the inconstant pagan gods. Apuleius (whose writing was known to Augustine) summarizes the problem in these words from a goddess in reply to a prayerful donkey:

> I, nature's mother, mistress of all the elements, the first-begotten offspring of the ages, of deities mightiest, queen of the dead, first of heaven's denizens, in whose aspect are blent the aspects of all gods and goddesses…The whole earth worships my godhead…by many diverse names…Phrygians …call me the mother of the gods…Athenians… know me as Cecropian Minerva…wave-beaten Cyprians style me Venus…the archer Cretans, Diana of the hunter's net; the Sicilians…Stygian Proserpine; the Eleusinians, the ancient goddess Ceres. Others call me Juno…Bellona…Hecate… but those on whom shine the first rays of the sungod as each day he springs to new birth…the Ethiopians, and the Egyptians mighty in ancient lore, honour me with my peculiar rites and call me by my true name, Isis the Queen.[324]

No matter whether she is called Isis or Cybele "all her kind are embodiments of the earth's fertility."[325]

Devotees of Cybele, the Mother of the gods, are much commented upon. During the wild processions with the howling, thumping drums and crashing cymbals, a state of such excitation was reached that they would follow the example set by the goddess' beloved, but unfaithful, Attis. Ovid tells of the young man's final act and its perpetuation:

> 'Perish the parts that were my ruin! Ah, let them perish,' still he said. He retrenched the burden of his groin, and of a sudden was bereft of every sign of manhood. His madness set an example, and still his unmanly ministers cut their vile members while they toss their hair.[326]

Augustine wonders at the "unhappy" castrated men: "They say that the mutilated Galli [pagan priests] serve this great goddess to indicate that those who lack seed should follow after the earth."[327] It is surprising that a religion with such gruesome demands would become popular, but popular it was. Once the goddess was accepted in Rome, her faithful could be found to the far reaches of Roman influence; her cult generally merged with a local fertility or earth goddess. In Britain, where portions of one of her temples have been unearthed, a marble tablet, which holds the following inscription, was discovered:

> The Virgin in her heavenly place rides upon the Lion; bearer of corn...by whose gifts it is man's good lot to know the gods: therefore she is the Mother of the Gods.... Syria has sent the constellation seen in the heavens to Libya to be worshipped: thence have we all learned.[328]

The constellation Virgo, the corn-maiden, the Mother of the gods was celebrated throughout the Roman world. What would be more exciting, more alive than the return of vegetation each spring and the promise it held? The ritual bath, it has been proposed, was equivalent to a rain-charm in hopes of a good harvest.[329] And if these multitudinous deities are all one, then Hera's regaining of virginity covers them all. That seems harmonious, proper. What a delightful picture of Spring—eternally a virgin.

And, now, let's welcome the Wife herself. We'll see the poet create his pattern from a mixture of mythical Virgos and provide a finishing touch with a glance at the heavens.

> A good *Wif* was ther of biside *Bathe*,
> But she was *somdel deef*, and that was *scathe*.
> Of *clooth-makyng* she hadde swich an haunt,
> She passed hem of Ypres and of Gaunt.
>
> (A 445–48)

> (A good Wife there was of beside Bath,
> But she was somewhat deaf, and that was "scathe."

Of cloth-making she had such skill,
She surpassed them of "Ypres" and "Gaunt.")

We've seen a *miller*, a *merchant*, a *cook*, and other crafts' representatives. The naming of this pilgrim, however, doesn't follow the craftsman pattern. The character-defining name for the others communicated their trade, their skill. Though we are told that the Wife is an outstanding cloth-maker, she is designated *Wife*. Her craft is a side issue. Her wifeness is her primary importance. We will find at A 460 that she has had five husbands. That's considerable evidence of her desirability as a wife.

Though she is always called "the Wife *of Bath*," Chaucer's line actually says "beside Bath." This changes our view just a bit. Her town's name has a dual function. *Bath* can be understood as both the name of the town *and* the procedure of bathing. Now we can see the pagan image at the river's edge as the ceremonial bath is accomplished.

Chaucer tells us immediately, before any visual or personality details, that she is somewhat deaf. *Scathe*, can mean *it's a pity*, but it also holds the impression that the deafness resulted from a punishment.[330] (The Wife will explain how it happened when she speaks to us in person.) She had an exceptional talent for "cloth-making." Her skill was greater than the finest weavers in the Low Countries—who were quite skillful. This projects the image of Minerva.

Minerva-like reaction can also be seen in the next lines.

> In al the parisshe wif ne was ther noon
> That to the *offrynge* bifore hire sholde goon;
> And if ther dide, certeyn so wrooth was she,
> That she was *out of alle charitee*.
>
> (A 449–52)

> (In all the parish, a wife was there none
> That to the offering before her should go;
> And if one did, certainly so wrathful was she,
> That she was out of all charity.)

Minerva's reaction to Arachne's pride might be recognized in these lines, but they are also typical of Juno's standard behavior: "Her [Juno's] rôle is very often that of a proud, sensitive, jealous character, quick to anger and revengeful."[331] At the surface, we have a woman "out of charity" if not given first place in the parish. On either level—surface or covert—no adequate reason is given for her to rate such a privilege. "Offerings" are found in both Christian services and pagan sacrificial ceremonies. And, if we think of this as the same parish the Parson serves, we're among the constellations.

The poet is taken with the lady's head covering.

> Hir coverchiefs ful fyne weren of *ground*;
> I dorste swere they weyeden *ten pound*
> That *on a Sonday* weren upon hir heed.
>
> (A 453–55)

> (Her coverchiefs full fine were of ground;
> I dare to swear they weighed ten pounds
> That on a Sunday were on her head.)

Ground, as a comment about the background of a patterned fabric, takes care of the surface view. Cybele's headdress of the towers of a city matches the definition of the *ground* as foundations of cities and towers.[332] The narrator dares to swear they weigh ten pounds, which, in the usual storyline, is explained as an exaggeration. But at the covert level *it's a fact*. She wears the headpiece on Sundays, of course, and, as a pagan idol, she wears it all the rest of the time too, continuously.

Chaucer so often has a strange and captivating way of telling us of "clothing." So it is with the Wife. We saw her head-covering. Now we'll see her legs and feet. Before this introduction is over, we'll learn about another head-covering. Then, while the Wife herself talks to us, we'll get a view of a cloak she enjoys.

> Hir *hosen* weren of fyn *scarlet* reed,
> Ful streite yteyd, and shoes ful *moyste* and newe.
>
> (A 456–57)

(Her hose were of fine scarlet red,
Tied very straight, and shoes very moist and new.)

The *hose* seem simple but Chaucer has played a trick with the word before.[333] Those who know Latin, as Chaucer did, would spontaneously see Latin equivalents for words used. A meaningful equivalent here for *hosen* is the *husk of grain*. Both are contained in this Latin word. Then I think of *scarlet*, and I know that her cloak, which she boasts is not troubled by moths, will also be scarlet. What I'm working up to is that during the Great Mother's festivities there was a "day of blood."

The goddess reveled in gore. A bull bedecked with flowers was stabbed and killed with a sacred spear. His blood flowed down through a grating to a chamber where worshippers eagerly awaited being covered with the fresh blood. They "emerged from the pit, drenched, dripping, and scarlet from head to foot." The Wife's foot coverings are said to be *moist*, an unusual descriptive for footwear. In Chaucer's translation of Boethius, Nero's blood-covered hands are also *moist*.[334] Visual imagery, one of the poet's greatest skills, details a woman covered with scarlet and wearing *moist* foot-coverings. We may cringe at these mental pictures, but, to Cybele's cult, it meant a day of rejoicing. Their deity was honored and pleased by bloody excesses. A way to express this is to depict her *enveloped* in the scarlet flow that gratified her; in a similar way, we might say a person was *rolling* in money. Another year of bountiful harvests was anticipated. (*Hosen*, as leg wear and as an ear of corn, can be seen alternately, simultaneously, now coated with blood.)

We're told next:

Boold was hir face, and fair, and *reed* of hewe.

(A 458)

(Bold was her face, and fair, and red of hue.)

Though the red of her face might also indicate blood, I'm inclined to think the bold redness is terra cotta; such figures of Cybele (and other deities) were common. The medium, used in the fourteenth century as well, did not produce a refined texture, and so her face

might naturally be considered bold because of the surface quality. Pliny and Plutarch both regarded terra cotta works with admiration. Such figures as an Aphrodite, with eastern qualities, in a statuette about seven inches tall were popular. Examples have been found in Britain as well as in France and Belgium.[335]

The Wife is straightforward and open about personal matters, as we will find.

> She was a worthy womman al hir lyve:
> *Housbondes* at chirche dore she hadde *fyve*.
> (A 459–60)

> (She was a worthy woman all her life:
> Husbands at church door she had five.)

"All her life." How old do you picture her? Fortyish? Fiftyish? To think older than that for the Middle Ages would be stretching it. Let's say she's forty-five. She's been married five times. Let's say the unions lasted five years each. That's twenty-five years of marriage. These speculations all reflect the surface story, of course. Then consider this:

> And thries hadde she been at Jerusalem;
> She hadde passed many a strange stream;
> At Rome she hadde been, and at Boloigne,
> In Galice at Seint-Jame, and at Coloigne.
> (A 463–66)

> (And thrice had she been at Jerusalem;
> She had passed many a strange stream;
> At Rome she had been, and at Bologna,
> In Galicia at Saint James, and at Cologne.)

Besides her five marriages, and all the leading up to and the withdrawing from—which takes time—she had managed three trips across the Continent, the Mediterranean and North Africa to Jerusalem. I wonder if anyone has figured how much time a trip like that would have taken (and how much the cost). Then there

are also trips to Rome, to Bologna, to Northern Spain and to Cologne. Seven lengthy trips and she seems none the worse for wear.

Instead of speculating about her five marriages now, we'll look at them as she tells us about her husbands. The travel aspect, however, is worth examining. Just estimating as the crow flies, if she begins and returns to England each time, the lady's travels total about 25,000 miles. Forget the cost. Just think of the hazards and hardship. How long was she away from her husbands on these seven excursions? And here she is, gone again, this time heading for Canterbury.

She appears more than equal to the miles traveled and to the number of spouses. There is nothing worn-down or depleted about her. The Reeve, the Cook or the Summoner would be no match for her stamina. Though she will admit being older, she exudes "elemental vitality."[336] What else would we expect from an Earth Mother?

As we look at the underlying meaning, foreign cities connected to this pilgrim are dedicated to perform differently from words that have an internal message of their own—such as *bath*. Jerusalem, Rome, Bologna, Spain (perhaps Compostella), and Cologne correspond to direct information about the Mother of the gods; they don't need further allegorical analysis. The earlier speech of Isis names Middle Eastern areas that are sources of her parallel identities; Jerusalem could surely be part of the itinerary from there to Rome. And, as the sought-after and accepted deity in Rome, her presence extended through the conquered territories. As Roman influence spread across the Continent, many temples to Cybele were constructed.

As the narrator recalls these destinations, it is not means of transport, not food, not weather or accommodations, not even persons difficult to deal with that are found worthy of mention. He focuses only on streams new to her. Cleansing of this Mother Goddess image was *essential*, and each new territory would offer a heretofore unknown stream, a strange stream. The phrase indicates the primary concern for her yearly ceremony.

We can marvel at how well she developed in spite of her disadvantaged "youth."

> Withouten oother compaignye in youthe,—
> But thereof nedeth nat to speke as nowthe.
>
> (A 461–62)

> (Without other company in her youth,—
> But thereof need not be spoken about just now.)

There is the vaguery that Chaucer uses so well. It's a signal to notice the subject he avoids. What needs to be avoided because she had no friends when she was young? Actually, the lack is even broader. It's not just *friends*; she lacked *companions*. Isn't that the situation of the Mother Goddess? Isis put it so well: She was "the first-begotten offspring of the ages...first of heaven's denizens." In the beginning there was no one to be a companion to the Mother Goddess. The line also contains an alternate interpretation: she didn't have any *youth* during which she needed company. The origin of two of our Virgo goddesses, Minerva and Venus, fits that scenario. Both began their existence fully grown. (Have you seen Botticelli's "The Birth of Venus"?)

The Wife was an adventurous sort.

> She koude muchel of *wandrynge* by the *weye*.
>
> (A 467)

> (She knew much of wandering by the way.)

These words perform curiously. They bring to mind I. A. Richards' thought where words exhibit instability and we find "not one meaning but a *movement* among meanings."[337] As a fourteenth-century woman, how did she get to know so much about *wandering*? Did she sometimes travel alone? without a destination in mind? Wasn't she concerned about risks? about losing her way? And by what *way* did she wander? It's difficult to find answers for this behavior in a *woman*. But, if we turn to the level of a constellation, *wandering* expresses stellar motion. And the *way* is something she knows well, the Milky Way ("Mylky Wey" in Chaucer's *House of Fame*, 937) created accidentally by one of her personalities.

Another quality of her face is revealed.

> *Gat-tothed* was she, soothly for to seye.
>
> (A 468)

(Gap-toothed was she, truly for to say.)

A peculiarity in her teeth and the color of her face will be the total of the poet's physical description of her. A note explains the gap in her teeth to indicate a person "vain, bold, lascivious, etc."[338] Chaucer had that personality in mind before he put the gap between her teeth.

Her mount is comfortable.

> Upon an amblere esily she sat.
>
> (A 469)

(Upon an ambler she sat with ease.)

This animal's gait is an easy pace, makes for a smooth ride. Can you see the Mother Goddess moving fluidly, luxuriously, without haste ("esily"[339]) as her lion strides majestically beneath her?

Two more lines tell of a second kind of head-covering. Chaucer is certainly concerned with how the Wife covered her head!

> *Ywympled* wel, and on hir heed an hat
> As brood as is a *bokeler* or a *targe*.
>
> (A 470–71)

(Well wimpled [covered], and on her head a hat
As broad as is a buckler or a protective shield.)

Why compare a woman's hat to a piece of armor? One reason would be to catch a hint of Minerva come forth in armor. And then there is the wimple. Though a wimple is usually thought of as a sort of veil, it can also be an over-all covering. This wimple (which can imply concealment) seems more than a mere head covering as the narrator also points to a hat.[340]

Her last garment noted must be a generous size.

A foot-mantel aboute *hir hipes large.*

(A 472)

(A foot-mantle about her hips large.)

The mantle reaches her feet and—in very ungentlemanly fashion—the narrator calls attention to the broadness of her hips. Besides ample-figured goddesses, this reports the size of Virgo's constellation. She is the widest of the twelve; with 30° supposedly allotted to each sign, she covers 45° (or more, depending on your authority).

Aside from possibilities in A 472, we've dealt exclusively with myths. Only one line, the next line, is needed to touch and confirm the zodiac sign.

And on hir feet a paire of *spores* sharpe.

(A 473)

(And on her feet a pair of spurs sharp.)

It is Chaucer's creative way of pointing to Spica. First, a woman wearing spurs is surely a signal. "Notice this!" (The Wife is the *only* pilgrim so equipped.) Why make them part of her attire? Are they attached to her *moist* shoes? Their presence has no connective; they never matter once they've been noted. Then why does she wear them? Because a spur is a *spike*,[341] about as close a clue to *Spica* as we could hope for. Then the Latin word, *spica*, gives a double clue, covert details pointing in two directions. The Latin continues to mean a *spike*, but it also means *an ear of corn*: spike for the star, ear of corn for the myth. (In my initial search for zodiac *necessities* among the pilgrims, the spurs were clearly Spica. It was a great surprise to understand I would have to search for "virgin" qualities in this woman who is a rollicking bawd.)

We see the Wife's outgoing personality.

In felaweshipe wel koude she laughe and *carpe.*

(A 474)

(In fellowship well could she laugh and chatter, etc.)

In a group she enjoyed herself. Her laughter can also hold a meaning for the Great Mother: One day of her festivities is called the "Festival of Joy (*Hilaria*)."[342]

Carpe is unusual—Chaucer's only use of the word. He must have had a good reason. (I do not subscribe to the idea that it was necessary for the rhyme with *sharpe*, because the poet also chose the word that needed the rhyme.) Latin, again, gives us something to think about. *Carpere* is "to select...and so to enjoy" (as in *carpe diem*). It also means "to proceed on a journey," which is what she is doing as a pilgrim. And it says "to pass over a place," her assignment as Virgo.

Here we are at the last two lines of the Wife's *General Prologue* introduction.

> Of remedies of love she knew *per chaunce,*
> For she koude of that art the *olde daunce.*
>
> (A 475–76)

> (Of remedies of love she knew per chance,
> For she knew about that art of the old dance.)

An explanatory note about the "remedies" generally mentions Ovid's *Remedia Amoris. Per chaunce,* however, is the first thing to catch my eye, because it overlays flexibility where we expect confidence in these remedies. The word can mean *perhaps, possibly,* or *as fate would have it.*[343] Each has a different flavor. Let's see how the line changes.

For the woman:
 Perhaps she knew about remedies of love.
 Perhaps she knew remedies of love, but remedies to gain love are more this woman's style.

For the woman or goddess:
 Possibly she knew *Remedia Amoris.*
 The goddess could *possibly* have been directly acquainted with Ovid's work.

For the goddess:

As fate would have it, she knew remedies of love. What Attis was fated to do to remedy his desire for love, she (Cybele) knew.

Continuing the last thought:

For she knew the art of the old dance.

The goddess knew the art of the old dance during which the "remedy" (castration) was self-administered.

Franz Cumont speaks of "the bloody *dances* of the *galli* of the Great Mother and the mutilations."[344]

The portrait is finished. For most of the pilgrims their *General Prologue* characterization tells all that is necessary to appreciate subsequent action. Again, the Wife is a non-conformist. Her introduction is just an appetizer. A splendid meal is about to be served.

Chaucer has a lot to say about her. If you've never met her personally, I'm excited for you because there is no literary character greater. The better you know her, the warmer, more vital, and energetic she becomes—the way the fertility force is inclined to perform. Chaucer assembles a pastiche of earth goddesses to create the Wife: *Bath* gives the initial clue, the ritual common to Virgo's mythical identities; *spurs* proclaim *Spica* as Virgo's celestial portrait. These set us firmly in the right direction.

Before the Wife launches into the prologue to her tale and we get swept along by the force of her opinions and her style, let's recall a couple of allegorical techniques. We need to be alert to the poet's "signaling," as we are "teased toward a meaning beyond that which is stated." *A word or image or scene* "by its nature *stands out from its background*" and demands attention, communicates "there is something to be noticed or unlocked." (Chaucer demonstrates this skill in presenting the notable stars that identify his pilgrims: the Cook's blankmanger, the Monk's curious pin, the Wife's spurs, and more.) *Repetition*, when the poet has a vast vocabulary—including several languages—at the tip of his mind, repetition nags to get our attention. *An apparent mistake* (five men in one suit) needs to be checked out as if it were *not* an error. If the statement is actually correct, what more does it say than we *expected?* The Wife's prologue is a tour de force, 828 lines—more than twice the length of her story. Comparing her to the other pilgrims, two of her com-

panions have no introduction; the remaining travelers begin their stories (usually after a bit of conversation with the Host, their guide) with introductions ranging from 8 to 165 lines. The Wife's protracted introduction conveys the poet's desire for us to really get to know this woman.

Lowes, in his series of Chaucer-loving lectures, says of the Wife's reputation among the pilgrims,

> It is the Wife of Bath who, as a figure, is the greatest of them all.... Her superb self-revelation, with its verve and its raciness and its serenely ceaseless flow, no more to be stopped...than the course of a planet; and above all...her 'profound, imperturbable naturalism.'[345]

It always amazes me how Chaucer captures the essence of personalities. The twentieth century, nevertheless, has been hesitant about making far-reaching connections, when staying close to the norm will do. Our "sign of the zodiac" is compared to a "planet"; both are unstoppable. Her function as a goddess of nature, of fertility, is well expressed as "profound, imperturbable naturalism." She is all that and more.

A good place to begin getting acquainted might be her thoughts on virginity, which she acknowledges is "great perfection" (D 105), but follows with "lordings, by your leave, that am not I" (D 112). If there were no seeds sown, she asks, where of would virginity grow? (D 71–72). And why, then, were "members of generation made?" (D 116). She assures, "Trust me, they weren't made for nothing" (D 118). Are they only to tell "a female from a male?" (D 122). Experience knows well that isn't so (D 124).

She reads in books that man shall yield to his wife her debt (D 130).

> Now wherwith sholde he make his paiement,
> If he ne used his *sely* instrument?
>
> (D 131–32)

> (Now wherewith should he make his payment,
> If he doesn't use his "sely" instrument?)

Sely is for you to interpret: brave, good for a purpose, efficacious, blessed, happy, pleasant, or an assortment of the above.[346] For her part, she'll use *her* "instrument as freely as my Maker hath sent it" (D 149–50).

She's good at her word.

> Myn housbonde shal it have bothe eve and morwe,
> Whan that hym list com forth and paye his dette.
>
> (D 152–53)

> (My husband shall have it both evening and morning,
> When that he wishes to come forth and pay his debt.)

Experience is the basis of her opinions.[347] After being schooled by five husbands, she is ready for a sixth, if he comes along (D 44f–45). Practice has come in diverse areas. For example, when she's been imbibing wine, she will think on Venus (the goddess of love), "For as sure as cold engenders hail, liquor in the mouth must have a lecherous tail" (D 464–66). She sighs, "Allas! allas! that evere love was synne!" (D 614). Franz Cumont, an authority on ancient religions, makes the same comment as the Wife, but not with her (Chaucer's) wistful sense of regret: "Nature worship was originally as 'amoral' as nature itself. But an ethereal spiritualism ideally transfigured the coarseness of those primitive customs."[348]

There are so many warm memories.

> I was a lusty oon,
> And faire, and riche, and yong, and wel *bigon*;
> And trewely, as myne housbondes tolde me,
> I hadde the beste *quoniam* myghte be.
>
> (D 605–08)

> (I was a lusty one,
> And fair, and rich, and young and well "bigon";
> And truly, as my husbands told me,
> I had the best "*quoniam*" as might be.)

Let's settle first that her *quoniam* is her "instrument." (According

to the MED, it may be a pun on the medieval French word for rabbit, *conin*.) In addition, she has all the other attributes a "housbonde" could hope for.

Wel bigon deserves some reflection. *Bigon* can mean *begun*, but this chosen word can perform in several ways. It can mean to engage in an activity or to be well endowed; both are her attributes. It is also seen as to be trimmed with jewels—a definite possibility. But another reading takes us directly to Cybele's cult ritual; it can mean "To cover (sth., as with blood)." An example says, "Al in blood he was begon."[349]

She has fond memories of her youth.

> It tikleth me about myn herte roote.
> Unto this day it dooth myn herte boote
> That I have had my world as in my tyme.
>
> <div align="right">(D 471–73)</div>

> (It tickles me about my heart's root.
> Unto this day it gives my heart a boot
> That I have had my world in my time.)

But that was then, and this is now.

> But age, allas! …
> Hath me biraft my beautee and my *pith*.
> Lat go, farewel! …
> The *flour* is goon, ther is namoore to telle;
> The bren, as I best kan, now moste I selle.
>
> <div align="right">(D 474–78)</div>

> (But age, alas! …
> Has bereft me of my beauty and my "pith."
> Let it go, farewell! …
> The flower/flour is gone, there is no more to tell;
> The bran, as best I can, now must I sell.)

That's a spunky older woman, a survivor. "Flour" doubles as the disappearance of both a flower (youth, virginity) and a baking in-

gredient (a glimmer of the faded goddess of the harvest). Her *pith* alludes to vigor or energy where a woman is concerned. But, for a goddess out of the past, it tells of the loss of her essence, her value or importance in the world.[350]

A message is addressed to "Ye wise wyves, that kan understonde" (D 225)—in spite of the fact that she is the only wife in the group. The lines, nevertheless, are not a waste. She lets "herself go with incomparable gusto and a frankness naked and unashamed, in an unexpurgated disclosure of her views upon marriage, and of her own successive marital adventures."[351] She confides that no man can swear and lie half so boldly as a woman can (D 227–28). It's a developed skill. If a husband is drunk, you make numerous accusations and get your friends to swear they're true (D 379–85). And even when the poor soul is so sick he can hardly stand, accuse him of wenching; it will assure him of your affection (D 393–96).

Chiding pays off. Never let a word go unanswered, no matter who is there to listen. He'll be glad to give in just to have a little rest (D 419–28).

If he's feeling romantic, refuse his advances until he pays "his ransom." When he has handed over what you wanted then "feign appetite" and allow him to "do his nicety" (D 407–17). All that said, she has some practical advice for men:

> And therfore every man this tale I telle,
> Wynne whoso may, for al is for to selle;
> With empty hand men may none haukes lure.
>
> <div align="right">(D 413–15)</div>

> (And therefore every man this tale I tell,
> Win whoever may, for all is for sale;
> With empty hand men may no hawks lure.)

She shares a secret.

> We wommen han, if that I shal nat lye,
> In this matere a *queynte* fantasye.
>
> <div align="right">(D 515–16)</div>

> (We women have, if I shall not lie,
> In this matter a "queynte" fantasy.)

With *queynte* as another referent for the lady's "instrument," her sexual fantasy involves craving that which is forbidden, and avoiding a lover who comes on too strong (D 517–20). Marketing a woman's wares demands skills: "This knoweth every womman that is wys" (D 524).

Now we'll change our endeavor to recognition of pagan embellishments, ornaments, signals. They are to be visualized much like pointillism. The idea is not to dwell on one point, but to stand back and register the total impression of her extended canvas.

Lines D 543–562 tell of an experience "in Lente." *Lent* is another word for spring. The Wife and friends would rejoice as they walked "in March, April, and May," from house to house. She tells us "I myself into the feeldes wente." She'd see and be seen by "*lusty* folk."[352] There were visitations, vigils, processions, and plays to watch. She wore that scarlet cloak we spoke of earlier—the one not bothered by moths.

The Wife/Earth Mother in Rome existed along with Isis, Juno, and Minerva in the early Christian era. She had time to get to know early Christians, this young sect, for a while before her husband died. As a matter of fact, she and the other ladies (other goddesses) and a fellow named Jankyn would go into the fields for all sorts of events and ceremonies. This is the proper setting to contemplate fertility. This is where one would expect to find fertility goddesses, and where one finds Christian blessing, as well.

We see the pattern as Ovid describes the goddess' celebrations as entertainment. Banquets were arranged, and the celebrants went "from house to house."[353] Augustine, in recollections of his erring youth, tells of the spectacles, games, musicians in which he took delight. Shows performed before the Mother of the gods used "obscene words and deeds...[that were a] shock to modesty."[354]

For the fourteenth century to have an interest in a fertility goddess is no surprise. Chaucer himself wrote a lengthy poem (*Parlement of Foules*) where "Nature" is a leading character. Ernst Curtius, in his study of medieval Latin literature, examines the subject of the "feminine component of the Godhead" (*mater gener-*

ationis) and says, "Here, then, as through an opened sluice, the fertility cult of the earliest ages flows once again into the speculation of the Christian West."[355] The fertility-cult idea did not originate with Chaucer; he was merely navigating the flow.

The Wife does not envy virgins. Let them be pure wheat seed, and let wives be "barly-breed" (D 143–44). A woman's favors our outspoken pilgrim sees as "who comes to the mill first, grinds first" (D 389). (She herself admits guilt, but, because she was the first to make accusations, their domestic "war" was cut short.) Though lines about barley-bread and grinding at a mill can be read as sexual double entendre of the day, the images evoke a glimpse of the goddess Ceres, as well. Then, as the Wife finishes her prologue, Chaucer indicates the name of a city which has just come into view. That carefully chosen name is Sittingbourne. It projects the mental image of the seated statue of Cybele carried (borne) in procession. As before, calling attention to a city makes little difference to the surface story, but enhances the underlying intention. Registering the name (the image) is all that comes of the city being noted.

Turning to Attis and the pine tree sacred to him, the tree where he wounded himself and died, wording reflects this.

> O Lord! the peyne I dide hem and the wo,
> ...by Goddes sweete *pyne*!
>
> <div align="right">(A 384–85)</div>

> (O Lord! the pain I did him and the woe,
> ...by God's sweet "pyne"!)

Such phrases tell of God's *pain*, but can also be read as God's *pine*.[356]

The Wife, as goddess, has a close association—both good and bad—with the animals of the pig family: sows are sacrificed to the Earth Mother. But, tragically, a youthful consort, Adonis, was killed by a boar. Because Attis and Adonis have parallel stories, a hint of both can be found when the Wife is told a proverb about a sow, and she laments:

> Who wolde wene, or who wolde suppose,
> The wo that in myn herte was, and *pyne?*
>
> (A 786–87)

> (Who would ween, or who would suppose,
> The woe that in my heart was, and "pyne"?)

There is a veritable menagerie ornamenting the Wife's dissertation: a goose, cow, etc. For example, a group of lines concentrates on cats (D 348–54). This might express thoughts from the viewpoint of Isis. (Chaucer would have known from Cicero that cats were sacred in Egypt.) It's a significant comparison. The Wife concludes if a cat is sleek, before dawn it would go out to show its skin (fur). Then she interprets:

> This is to seye, ...
> I wol renne out, my *borel* for to shewe.
>
> (A 355–56)

> (This is to say, ...
> I will run out, my "borel" to show.)

Borel is coarse woolen cloth or a garment of that cloth. Why would she be anxious to show that off? If we look a little deeper, a second meaning of borel is "a ray of light."[357] We can't forget the Wife has a zodiac identity; *borel* is a hint of the constellation. She's out of the house before dawn to show her light. Though the cat may have been an interesting bridge to the *borel*, it's the *light* that takes precedence over the animal image.

Cybele's lion shows up in the Wife's thoughts four times. A sheep also comes on the scene, as she addresses her husband so as to "ba" (kiss) his cheek (D 433). The Great Mother was partial to (male) sheep and accepted a parallel sacrifice to that of the *taurobolium* (slaughter of a bull) mentioned earlier. A *cribolium* was the ceremonial slaughter of a ram. Sacrifice of a "bull or a ram...became especially popular during the pagan revival near the end of the fourth century AD."[358] I'm sure there are other mythological animal connections, but we'll stop here. (Ovid's *Metamorphoses* and

Fasti would have a great supply of possibilities.)

Another area that attracts attention is the Wife's account of men who complain because they don't get to try the woman before the wedding. A comparison is made to the acquiring of basins, pitchers, spoons, stools, pots, and cloths, where the choice of objects doesn't seem of any interest to men (D 287–89). What they appear to be is housecleaning equipment. She continues with, "You pour always upon my face" (D 295) and "You make a feast on the day I was born, and make me fresh and gay" (D 297–98). The complete scene brings to my mind the *lavatio*, the ceremonial bath of the Mother Goddess.

The image central to an anecdote regularly exhibits more importance than does the plot. Another example is a story about a man called "Metellius" (D 460). The similarity to the name "Metellus" is notable. Ovid relates that Metellus built the temple to the Great Mother when her statue arrived in Rome.[359] That story would be too obvious, but, for those who would search for a hidden meaning, this almost identical name would indicate they were on track.

Skipping about in the Wife's narrative, we've never mentioned children. *She* makes no mention of children. This grand, lively figure, despite decades in the married state, never speaks of children. And when she refers to a niece (we'll talk a bit about her later), there is no sadness, no tone of regret that the niece is not a daughter. A related void in this frank discussion of things physical is no allusion to breasts or lactation. Chaucer's concentration of her purpose is that of *Wife*.

As the Mother Goddess, she has been connected with a number of different areas of the world through the centuries. I believe Chaucer presents the several husbands as her affiliations with various forms of fertility worship.

Let's hear about these husbands. She is thankful to have entered her wifely career at age twelve (D 4–5). This approximates being full-grown (as two of the goddesses were from the start) and it puts her at the beginning of the reproductive age. She is happy to have wedded so often. Then, she claims that she was told "not long ago" that Christ had only gone to one wedding and that he reproved the Samaritan woman who had married five times. The

Wife never heard tell in her "age" about a particular limit of spouses being defined (D 9–25). To claim that she heard New Testament stories *not long ago* is curious. Not long ago as compared to what? In her *age*, at the high point of her popularity, no marriage limits were declared. This sounds like quite a time had passed before the Christian era brought restrictions.

As for her spouses, "three of them were good and two were bad" (D 196). The first three are not distinguished one from the other. They were all good and rich and old, no doubt the source of her youthful wealth.

> Unnethe myghte they the *statut* holde
> In which that they were bounden unto me.
> Ye woot wel what I meene of this, pardee!
>
> (D 198–200)

> (Scarcely might they the statute/statue hold, keep
> In which were bound to me.
> You know well what I mean of this, indeed!)

Statute doubles as a *statue* they could scarcely hold. Not only can this be recognized as a simple play on the words, but a relationship between the words in Latin actually caused errors.[360] (Chaucer is taking advantage of the confusion.) As a young wife of an old husband, we can understand difficulty maintaining the statute of the marriage bond as a strenuous performance. The statue of a goddess carried in procession would also make strenuous demands. Her hesitation to be frank (D 200) is a signal; it's out of character. The lines, another of Chaucer's vagueries, point toward more to be understood than the obvious.

"Never let your husband get the upper hand" might be her motto.

> As help me God, I laughe whan I thynke
> How pitously a-nyght I made hem swynke!
> And, by my fey, I tolde of it no stoor.
> They had me yeven hir lond and hir tresoor;
> Me neded nat do lenger diligence

To wynne hir love, or doon hem reverence.

(D 201–06)

(So help me God, I laugh when I think
How pitifully anight I made them work!
And, by my faith, I took no stock of it.
They had given me their land and their treasure,
I needed no longer do diligence
To win their love, or do them reverence.)

Cult ceremonies are often said to have taken place at night and by
torch light.[361] All of the goddess' demands were met, even those
that were most difficult. She never treated the old "husbands" nice-
ly or respectfully. In spite of this, they allocated land and gave trea-
sures. We can see her ancient temples being constructed.

That was all true of her existence with early Eastern cultures.
But then she moved to the Western world and tried to establish
herself among existing rival cults. Because Chaucer has lumped
several old cultures together, there is no clear-cut picture of the
good "husband 1," "husband 2," or "husband 3." The poet will use a
different technique, however, for the *bad* husbands. They each have
a specific importance. What the Wife provides is an easy-going,
rambling narration. We'll hear about husband 4, a general com-
mentary will intervene, then she'll tell about husband 5, and then
back to husband 4, and so on. I'm sure the poet's method is meant
to keep the underlying meaning from manifesting itself with ef-
fortless clarity.

But before we become acquainted with husbands 4 and 5, let's
deal with the external interruption to the flow of her account. She
had just discussed the use of a man's "sely instrument" and wives
preferring to be "barley-bread." Continuing, she says she will be
generous with wifely favors both morning and night, and keep her
spouse enthralled. As this conjugal endorsement is being delivered,
one of the men bursts into her narrative. For a woman who is such
a handful, you'd think it would take a substantial man to slow her
down or halt her delivery. (This is the unstoppable "planet" situa-
tion.) But it's not the Merchant or the Shipman or the brash Mill-
er—it's the Pardoner, the one who is taken to be a gelding.

This is no mistake. He is the perfect choice. The Mother Goddess had castrated priests. The Pardoner is the most likely to be drawn to her ideas. He calls her a noble preacher and follows with,

> I was aboute to wedde a wyf; allas!
> What sholde I *bye*[362] it on my flessh so deere?
> Yet hadde I levere wedde no wyf to-yeere!
>
> (D 166–68)

> (I was about to wed a wife; alas!
> Why should I pay a penalty on my flesh so dear?
> Yet I would rather wed no wife this year!)

He is thinking of the penalty his flesh will pay.

She replies with references to drinking something that "smells worse than ale," to her being a "whip," and to his needing to decide whether he will sip from the cask she will "abroche" (D 170–77). Though "abroche" is taken to say she will "open," it actually means *to pierce* and, figuratively, *to shed blood*.[363] Considering the inflictive instrument first, carved representations of galli show a "whip for the castigation" hanging over one shoulder. It is a "terrible scourge of three lashes, fitted with rows of hard rings." This leather *flagellum* often had knucklebones attached "with which [the galli] belaboured their chests and upper arms."[364]

To better understand the Wife's allusions, here is Prudentius' eye-witness account of a taurobolium:

> [The flower-bedecked bull is brought in.]
> And with the sacred spear they penetrate its chest;
> The wound gapes wide and pours in mighty waves
> A stream of gushing blood over the wood [of a platform],
> An all-pervading odour spoils the air.
> Through [a] thousand fissures now the shower drips
> Of sordid fluid down the dismal pit
> And on his head the priest catches the drops
> With utmost care, his vestment soiled with blood
> And all his body dabbled with the gore,

Nay, bending backwards he presents his face,
His mouth and cheeks now to the scarlet flood;
His eyes he washes in the gory flow.
He moistens then his palate and his tongue
And sucks and sips and gulps the sombre blood.[365]

Images of eunuch priests who beat themselves with whips until their blood flows, and the bull that is the cask to be opened for the ritual libation are veiled in the Wife's words, but not invisible. Her reference to an offending smell is found in the mention of a pervading odor that "spoils the air." She cautions, "Be war of [the cask to be opened], er thou to ny approche" (D 178).

The Pardoner responds,

> Telle forth youre tale, spareth for no man,
> And teche us yonge men of youre praktike.
>
> (D 186–87)

> (Tell forth your tale, spareth no man,
> And teach us young men of your practices, customs.[366])

She brings an end to his urgent appeal with,

> Gladly...sith it may yow like.
>
> (D 188)

> (Gladly...since you may like it.)

The point of the interlude has been accomplished.

The Wife's prologue has only thirty lines less than the *General Prologue* of the entire collection of tales. Chaucer pulls out all the stops, uses every trick. Confusion, the uncertainty about time, so well done in the *General Prologue*, is present here, too. We might assume that she will take us in a straight line from a few preliminary thoughts to the story she plans to tell. On the contrary, her narrative becomes a seemingly endless maze of informative and often cryptic distractions. As she introduces her fourth husband, the confusion continues.

> Now wol I speken of my fourthe housbonde.
> My fourthe housbonde was a revelour;
> This is to seyn, he hadde a paramour.
>
> (D 452–54)

> (Now will I speak of my fourth husband.
> My fourth husband was a reveler;
> That is to say, he had a paramour.)

That is all we get, and it's off on another tangent. After a while she'll begin again: "Now wol I tellen of my fourthe housbonde" (D 480). He will be dead and buried by D 595, but Chaucer mingles details about him with information about the fifth husband, as well as the Wife's lively opinions on various subjects.

The goddess thrived in the environments of Asia Minor, which I assume to be the area of her first three marriages. With this fourth husband, however, she moved into the Western world. The clue indicating this is "in his owene *grece* I made hym frye" (D 487). Why is that a clue? Because it's a strong visual image that jumps out at you.

And then who is his paramour? A Greek goddess (or more than one) whose identity merged with the Great Mother's. The Wife's claim, "By God! in erthe I was his purgatorie," makes Persephone, goddess of the underworld, an appropriate figure (D 489).

She follows with,

> Ther was no wight, save God and he, that wiste,
> In many wise, how soore I hym *twiste*.
>
> (D 493–94)

> (There was no person, save God and he, that knew,
> In many ways, how sorely I twisted him.)

Twisted makes sense as a reference to Hephaestus (Vulcan) who was born lame. Hera (Juno), his mother, was so ashamed of him that she threw him out of Olympus. (He's a god; he survived the fall.) Another version of the story says he was grabbed by the foot.

In addition, a characteristic that fits the image of Hephaestus is the mention of his face being "very red and hot" (D 540); he was a smithy and the inventor of fire.

In spite of husband 4's faithlessness, the Wife has pleasant recollections after noting his paramour.

> How koude I daunce to an harpe smale,
> And synge, ywis, as any nyghtyngale,
> Whan I had dronke a draughte of sweete wyn!
>
> (D 457–59)

> (How I could dance to a small harp,
> And sing, surely, as any nightingale,
> When I had drunk a draught of sweet wine!)

These ideas coincide with the fact that the cult of Dionysus (god of wine) and that of Cybele had in common both music and frenzied dancing. (Euripedes described these resemblances.) Where Demeter protected the grain and Dionysus, the vines, the Great Mother was the protective goddess of all of Nature.[367]

The Wife indicates her fourth husband is buried under a "rood beam" (D 496), that is, beneath a large cross within a church. Why would a pagan be found buried in a Christian church? A simple explanation, and a common occurrence, is that a church was built over a pagan temple, or an existing structure was rededicated to a Christian purpose.

Although husband 4 is dead and buried, the Wife goes on talking about her fourth marriage. (It is routine for Chaucer to present events chronologically backwards.) The funeral takes place almost 100 lines later, at D 587–94. In the line just preceding this, she reminds herself—"A ha! by God, I have my tale again"—and finally tells her audience of the funeral. Between the reference to his tomb and the belated account of the funeral, there is a segment where shared confidences are the topic.

The Wife has a "gossib" (lady-friend).

> hir name was Alisoun.
> She knew myn herte, and eek my privetee,

> Bet than oure parisshe preest, so moot I thee!
> To hire biwreyed I my conseil al.
>
> (D 530–33)

> (her name was Alisoun.
> She knew my heart, and also my private matters,
> Better than our parish priest, so may I thrive!
> To her I revealed all my counsel.)

They couldn't know each other better. And we learn,

> To hire, and to another worthy wyf,
> And to my nece, which that I loved weel,
> I wolde han toold his conseil every deel.
>
> (D 536–38)

> (To her, and to another wife,
> And to my niece, whom I loved well,
> I would have told all his counsel, every bit.)

The women have secrets among themselves. Secrets are essential to the Great Mother. Ancient Eastern religions are often termed mystery cults. The Cult of Demeter, with which the Great Mother merged in Greece (the home of husband 4), had secrets kept so faithfully that we know almost nothing about the ceremonies or doctrine. All the worshippers vowed not to divulge the privileged knowledge. The secrets so carefully guarded are called the Eleusinian Mysteries. Demeter's alternate name is Eleusine, woman from Eleusis. I'm about to make a connection to something that bothered me for a long time. Finding this other name for Demeter cleared it up.

We call the Wife "the Wife," but during her prologue she refers to herself as "dame Alys" (D 320). What began to bother me is the fact that—with all the women's names the poet could choose from—the Wife's gossib is also "dame Alys" (D 548). There's an additional level of peculiarity. At another point we are told the gossib's name is Alisoun (D 530)—and finally, that the Wife's name is Alisoun (D 804). Now that attracts attention. That's a sig-

nal. It seems to me that Chaucer is doing what the ancients did—making multiple personalities with one name. The name, Alisoun, is a play on Eleusine, the fertility goddess, Demeter, the one whose secrets were so well kept.

The Wife has survived her fourth husband. She "wepte but smal" (D 592) and, completely in character, could hardly take her eyes off Jankyn, the clerk. He was irresistible and physically attractive.

> As help me God! whan that I saugh hym go
> After the beere, me thoughte he hadde a paire
> Of legges and of feet so clene and faire
> That al myn herte I yaf unto his hoold.
> (D 596–99)
>
> (So help me God! when I saw him go
> After the bier, I thought he had a pair
> Of legs and of feet so clean and fair
> That all my heart I gave into his keeping.)

Her appreciation of attractive legs and feet has all the indications of the Greek goddess Aphrodite rejoicing at no longer being bound to *lame* Hephaestus. The Greek civilization, for this Mother of the gods, is now a thing of the past.

She is finally ready to introduce husband 5. "Now of my fifthe housbonde wol I telle" (D 503). True to form, after we learn how she met him, we drop that thread of the story and return to husband 4. But husband 5 pops up regularly (as she seduces him) until she is free to marry.

Husband 5 is a different breed in many ways. Trivial though it may seem, he has a name—Jankyn. Where in the past, she has gained wealth from each marriage, to Jankyn she freely gives it all. And last, but not least—because it's the source of the problem that develops—he talks. He talks a lot and has many books on which to base a running commentary. Cumont, historian of early Roman religion, may be sympathizing with the Wife as he recounts that "the only cults still alive [ca. 400 A.D.] were those of the Orient, and against them were directed the efforts of the Christian polemics, who grew more and more bitter in speaking of them."[368]

He had been a "sometime" clerk at Oxford (D 527), but left school and boarded with the Wife's gossib. (We assume that's how the Wife met him.) Though he proved to be less than gentle, she loved him best of all.

> That feele I on my ribbes al by rewe,
> And evere shal unto myn endyng day.
>
> . . .
>
> That though he hadde me bete on every bon,
> He koude wynne agayn my love anon.
> I trowe I loved hym best, for that he
> Was of his love daungerous[369] to me.
>
> (D 506–14)

> (That I feel my ribs all in a row
> And ever shall unto my ending day.
>
> . . .
>
> That though he had beaten me on every bone,
> He could win again my love immediately.
> I trust I loved him best, because he
> Was of his love domineering, critical to me.)

Her attraction to Jankyn began while her fourth husband was still alive. (Remember she said women crave what they can't have.) When the husband was in London she arranged to spend time with Jankyn—often with her niece, gossib, etc., in attendance. During the festive springtime she wore that scarlet cloak (scarlet *gytes*, D 559) mentioned in the *General Prologue*. The word *gyte*, in addition to *cloak*, can signify an *outpouring*. The MED examples given are "of blood" and "of tears." A scarlet outpouring is not surprising as a gory covert detail.

An account of her time spent with Jankyn is open, uninhibited.

> Now wol I tellen forth what happed me.
> I seye that in the feeldes walked we,
> Til trewely we hadde swich daliance,
> This clerk and I, that of my purveiance

I spak to hym and seyde hym how that he,
If I were wydwe, sholde wedde me.

(D 563–68)

(Now will I tell forth what happened to me.
I say that in the fields we walked,
Until truly we had such dalliance,
This clerk and I, that of my purveyance
I spoke to him and said to him how he,
If I were a widow, should wed me.)

She tells him she dreamed of a night of blood; he had killed her. Her story wasn't true; she was just following her "dame's" *lore* (*guidance* or *custom*) (D 576–84).[370] Chaucer uses two prominent vagueries (in addition to the Wife's admitted lies) within thirteen lines. She thinks of marriage "and other things also" (D 571). As a goddess, this covers a wide range. Then, she discloses she followed her "dames loore, As wel of this as of othere thynges moore" (D 583–84). That could mean absolutely anything. The importance is that Chaucer announces he's holding something back.

The Wife's seductive technique worked.

What sholde I seye? but, at the monthes ende,
This joly clerk, Jankyn, that was so hende,[371]
Hath wedded me with greet solempnytee;
And to hym yaf I al the lond and fee[372]
That evere was me yeven therbifoore.

(D 627–31)

(What should I say? but, at month's end,
This vigorous [or lusty] clerk, Jankyn, that was so skilled
 [or close by],
Hath wedded me with great solemnity;
And to him gave I all the land and wealth [or tributes]
That ever was given me before.)

This is the last spouse we will meet. For the next (almost) 200 lines we learn about their relationship. Again, the number of lines attests

that the poet makes a special effort so that what happens between the two of them will be understood.

Her deafness plays a prominent role—an example of repetition. In the *General Prologue*, it was her first quality noted. As she speaks of Jankyn, husband 5, deafness is referred to twice more—at D 636 and D 668—with distractions in between, of course. Interestingly, the rhyme is the same in both cases: *leef* and *deef*. But let's not get ahead of ourselves.

Twice after the funeral of husband 4, the Wife contemplates things celestial, the influence of both the stars and planets. Virgo, which *we* see from April through July, is believed to have coincided with the vernal equinox in times past. That may be the reason that her legends often tell of spring.[373] This coincides with the Wife's allusions to celebrations she and her companions attended in March, April and May.

The topic of astrology sparkles with hints of Virgo, from D 609 to D 620, as the Wife declares,

> I folwed ay myn inclinacioun
> By vertu of my constellacioun.
>
> (D 615–16)

> (I followed always my inclination
> By virtue of my constellation.)

No constellation would be judged more *virtuous* than Virgo.

> For certes, I am al Venerien
> In feelynge, and myn herte is Marcien.
> Venus me yaf my lust, my likerousnesse,
> And Mars yaf me my sturdy hardynesse;
> Myn ascendent was Taur, and Mars therinne.
>
> (D 609–13)

> (For certainly, I am all Venusian
> In feeling, and my heart is Martian.
> Venus gave me my liking, my lecherousness,
> And Mars gave me my willful [or aggressive] hardiness;

My ascendant was Taurus, and Mars therein.)

Her observations seem to reflect Ptolemy speaking of Virgo, and the effect of the brilliant Spica, which is "like that of [the planet] *Venus* and, in a lesser degree, that of *Mars*."[374] Chaucer's inclusion of Taurus compounds our mental image with the victim of Cybele's taurobolium. The celestially influenced vocabulary concludes with the Wife's admission about men. It didn't matter "how poor he was, nor of what *degree*" (D 623–26).

Following these reflections, she announces that she and Jankyn were married. With a change of mate comes a change in atmosphere in celestial components. Venus and Mars shift to Venus and Mercury; Taurus is deleted. This second astrological cluster has a different tone. Her notable "mark of Mars" (D 619) is a thing of the past. Now she's concerned with "the mark of Adam" (D 696). ("Eve" puts in an appearance, too, at D 715.)

> Mercurie loveth wysdam and science,
> And Venus loveth ryot and dispence.
>
> (D 699–700)

(Mercury loveth wisdom and book-learning
 [or the power of knowledge],
And Venus loveth riotous living and the spending of money.)

As she speaks of planets, we learn that Venus (one of our goddesses) is in exaltation in Pisces, the sign of the Fish. In contrast, wise Mercury is exalted where Venus declines; the statement avoids directly informing us that studious Mercury's exaltation is *Virgo*. Thinking and reasoning take a higher position than with her past husbands; voluptuousness is less valued. This is the horoscope of the Wife's fifth marriage.

Now let's look in on the newlyweds. Spoken of earlier, Jankyn could "glose" (flatter) when he would have her "*bele chose*" (French for her "instrument"). After the announcement of their wedding, the term appropriately is expressed in Latin, *quoniam*. It's a clue of the goddess' presence as a Roman. Though mystery cults were restricted, persecuted, and often suppressed, the Great Mother

managed to gain official approval. (After the goddess's sought-for arrival in Rome, she was considered a national diety with a temple built on the Palatine and coins struck with her image.) Her cult spread throughout Roman-influenced Europe. Chaucer officially indicates Roman culture by specifically including references to "an old *Roman*" named Gallus (galli?) who left his wife (D 642–46) and "*another Roman*," who forsook his wife when she went to summer games (D 647–49). The allusion is apparently to the feast of another goddess.

Jankyn delights in telling stories to her of problem wives. He quotes one Latin author after another, but just to cloud the issue, the Wife says, "he read me, *if I shall not lie*" (D 724) and fills in a few non-Roman stories. Because she prides herself on her ability to lie, we can assume he *didn't* tell Greek and Trojan stories. (The poet presents a few false turns on the path.)

This husband-clerk continues to read from Latin authors and the Bible. If a myth gets into the verbal stream, there's a good chance it had a scriptural interpretation. Many fourteenth-century writers, following Augustine's lead, believed that "the pagan myths tell the same things as Holy Scripture, only in a mysterious manner."[375] Chaucer's lines are charged with meaning, with allegorical "mystery."

When the Wife gave her heart to Jankyn, she tells us,

> He was, I trowe, a twenty wynter oold,
> And I was fourty, if I shal seye sooth.
>
> (D 600–601)

> (He was, I trust, twenty winters old,
> And I was forty, if I shall say the truth.)

Truth is surely not what she's telling. But this ancient goddess claims she's twice as old as this bookish Roman clerk. (Considering her "real" age, it's no wonder she heard about the New Testament "not long ago.") Mention of "Ecclesiaste" presents a fleeting image of *Ecclesia*, the Church. *Glose* as *flatter* is what he did so skillfully toward her human presence. *Glose* as *interpret, explain* is what he did so skillfully in relation to her pagan deity presence. Paganism

could be usefully interpreted; Augustine would approve.

She hated his finding fault with her. She defends herself with "God knows I'm not the only one with faults" (D 659–63). She had given him everything, and regrets it because he allowed her nothing she desired (D 633).

In the deafness episode, the husband smote her ear, but Chaucer doesn't use the word *ear*. Instead, he calls upon *lyst*, a word of many meanings (including *ear*), to be the center of the thought he constructs. Why, when *hear* and *ear* are so simple to rhyme, does he opt for complexity? And, strangely, *lyst* (*ear*) also rhymes with the previous line where *list* is her *desire*. This makes a double statement: He struck her ear; he struck at her pleasures, her desires, also.

> By God! he smoot me ones on the *lyst*,
> For that I rente out of his book a leef,
> That of the strook myn ere wax al deef.
>
> (D 634–36)

> (By God! he smote me once on the ear,
> Because I tore a leaf out of his book,
> And of that stroke my ear became all deaf.)

But she was stubborn as a *lioness* (D 637), a predictable image. She insisted on going from house to house as she had before (D 639–40). This caused him to preach almost continuously from D 641 to D 785!

He read to her from Theophrastus, St. Jerome, Jovinian, Tertullian, Latin poets, the Bible and on and on. Each author portrayed women as detrimental. No longer able to stand it, she ripped a page from his book (according to the surface understanding). She describes this action three times—Repetition: It's important. At the third telling, we finally get the whole story. It's a great scene. You couldn't want a more captivating climax.

The progress to the climax builds little by little. This is where, "if she isn't lying," she interjects the stories of non-Roman wives (Clytemnestra, Eryphile) who murder or betray their husbands. And there is poor Lucia, who unfortunately killed her husband

with what she thought was a love-potion. Numerous brief examples are followed by a more detailed story; it covers eight lines and includes conversation between two characters (D 757–64). (That's unusual. That's a signal.) Here's the basic story: One man says to another, "There's a tree in my garden and three of my wives have hanged themselves on it." The other man replies, "Give me part of that tree so I can plant it in *my* garden." This tender anecdote is followed immediately with more wives' stories, Bible quotations (how difficult it is to live with an angry or scolding wife), and proverbs.[376] The final straw comes when a beautiful woman who is not chaste is compared to a gold ring in a sow's nose. The Wife's heart is filled with woe and "pine" (noted earlier).

When she saw there would be no end to her misery, she ripped the book.

> And with his fest he smoot me on the heed,
> That in the floor I lay as I were deed.
>
> (D 795–96)

> (With his fist he smote me on the head,
> So that on the floor I lay as if I were dead.)

He was "agast" at what he had done. After a bit, however, she regained consciousness.

> "O! hastow slayn me, false theef?" I seyde,
> "And for my land thus hastow mordred me?
> Er I be deed, yet wol I kisse thee."
>
> (D 800–802)

> ("O! hast thou slain me, false thief?" I said,
> "And for my land thus hast thou murdered me?
> E'er I be dead, yet will I kiss thee.")

Jankyn came near and knelt down.

> And seyde, "Deere suster Alisoun,
> As help me God! I shal thee nevere smyte.

> That I have doon, it is thyself to wyte.
> Foryeve it me, and that I thee biseke!"
>
> (D 804–07)

> (And said, "Dear sister Alisoun,
> So help me God! I shall thee never smite.
> What I have done, is thyself to blame.
> Forgive it me, and that I thee beseech!")

As he knelt there, she hit him in the face.

> And seyde, "Theef, thus muchel am I wreke;
> Now wol I dye, I may no lenger speke."
>
> (D 809–810)

> (And said, "Thief, that much am I revenged,
> Now will I die, I may no longer speak.")

Don't be concerned. She didn't die.

> But atte laste, with muchel care and wo,
> We fille acorded by us selven two.
>
> (D 811–12)

> (But at last, with much care and woe,
> We fell into accord just the two of us.)

He gave her control of house and land, of his tongue and of his hand. And she made him burn the book. "Soveraynetee" was hers (D 818).

> And that he seyde, "Myn owene trewe wyf,
> Do as thee lust the terme of al thy lyf;
> Keep thyn honour, and keep eek myn estaat"—
> After that day we hadden never debaat.
>
> (D 819–22)

> (And he said, "My own true wife,

> Do as you please the rest of thy life;
> Keep thine honor, and keep also my estate"—
> After that day we had never a controversy.)

She recalls,

> God helpe me so, I was to hym as kynde
> As any wyf from Denmark unto Ynde,
> And also trewe, and so was he to me.
>
> (D 823–25)

> (So help me God, I was kind to him
> As any wife from Denmark to India,
> And also true, and so was he to me.)

Finally, after this overextended prelude, she is ready to tell an actual story, her Canterbury tale. It would be difficult for Chaucer to top this prologue performance. He doesn't try. She tells a story having to do with the cycle of a year, and an old woman rejuvenated to a lovely bride—a completely suitable tale from a fertility goddess.

I didn't want to interrupt Chaucer's (the Wife's) grand style of storytelling. But now that it's over, we will go back for a second look and a second meaning.

I have said elsewhere that I recognize in Chaucer a dedicated Christian, and a man of serious conscience.[377] He has proven that to me in the past. Allegory, it was said earlier (p. 38), does not *need* to be read with interpretation. But we will find that this narration has an allegorical "structure that lends itself to a secondary reading...one that becomes stronger when given a secondary meaning as well as a primary meaning."

How do we demonstrate this underlying intent? Chaucer helps. He wants to make it difficult, as Augustine and Boccaccio have explained, but not impossible. He integrates cleverly designed clues.

If we accept the Wife as the essence of a fertility goddess reflected in Virgo, the virgin—which is where we began—that's a foundation.

Let's return, then, to the story of the tree and the three dead wives. The two men conversing are Latumyus and Arrius. The first name is a strong play on *Latium*, which, then and now, is the area surrounding Rome. Arius (d. 336) was a Greek Christian theologian. What all-important event finds Arius in conversation with Latium—with Rome? The Council of Nicaea (325 A.D.). The Council's major accomplishment was the Nicene Creed. A simple definition gets to the heart of what Chaucer is showing us. The Council of Nicaea produced "a formal statement of the tenets of Christian faith, and chiefly of the doctrine of the Trinity" (*American Heritage*).[378] Add to that the clue of the *tree*; the cross of Christ's crucifixion was often called a tree. I kept asking myself how all those *dead* wives fit into the scheme. It's a ruse. The wives actually hide the solution. The important element is the number *three*.

Arius' theology was a serious heresy. He asserted that what Christ experienced was experienced by the Trinity because they were inseparable. He reasoned that the *Trinity* experienced the crucifixion. So, if Latumyus (Latium) had a tree where *three* persons died, Arius' having part of that tree might gain a means to his end. (Matters of the Trinity will return.)

Now we move to the Wife's deafness and how it came about. Once in the *General Prologue* and twice in her own narration we're told she was "somdel deef," she "wax al deef," she "was deef." Deafness is, of course, the inability to hear. If we consider her as this Earth Mother, however, who enjoyed "perpetual din," when the din stopped, she'd feel as if she had gone deaf. Or, if she was a goddess responding to suppliants, when prayers were no longer directed to her, there would be nothing left to hear.[379] An action on the part of Rome resulted in the Great Mother no longer hearing anything. This is what the scene with Jankyn and the Wife demonstrates: Rome kept preaching and preaching, dealt the fertility cult a severe blow—but (by ingrained strength) the cult survived. We are speaking, after all, of the life force; we instinctively celebrate the return of spring every year whether we give it a religious connection or not.

After the conflict between the husband and wife, they resolve their differences and coexist happily; that is, once she had been

given complete sovereignty. She laments, "I may no longer speak," but she was given control of all Jankyn's possessions and *his tongue*. Her ideas are now delivered through him. When she asserts that she was as good a wife as any *from Denmark to India*, the area indicated just about covers the lands dedicated to Cybele, the Mother of the gods.

What brought about this complete change in their relationship? Her destruction of part of his book. That's another repeated action. As I calmly scrutinized the poet's words, I was alerted by finding that they are not always the same.

I must digress. This will seem far afield, but it has a purpose. Chances are you are familiar with St. Patrick. (Young Chaucer was a page in the royal household of the Irish Countess of Ulster, wife of one of the sons of King Edward II. What I'm going to say, however, was probably well known beyond the Irish culture.) Many people know two stories about Patrick. The most familiar is the belief that the saint drove the snakes out of Ireland. The other affects the Wife's story: St. Patrick's explanation of the Trinity illustrated by three leaves of the shamrock on one stem. Now we're equipped to pursue the Wife's strategy to gain authority.

The first time she describes her action it is:

I rente out of his book a leef.

(D 635)

(I tore out of his book a leaf.)

She tore out a *leaf*. The Wife's second allusion is the same as the first, "I rente out of his book a leef" (D667). But her final description of her action says,

Al sodeynly thre leves have I plyght
Out of his book...

(D 790–91)

(All of a sudden three leaves have I *plucked*
Out of his book...)

Baugh explains *plyght* as "plucked, torn." *Torn* works for the surface meaning. But as this pilgrim and her husband come to blows right before our eyes, Chaucer specifies, she "*plucked* three leaves." The "three leaves" are now in her control. When Jankyn realizes what she has done, he retaliates. The eventual resolution finds them at peace, the Wife in control. Understanding this as another commentary on the Trinity, this goddess, this image of Virgo has—through brashness, perseverance, and physical appeal—asserted her dominance.

Then references to all those preached-about women, those less than proper wives, exhibit another point of view. The Wife's achievement brings new clarity. These women took charge of *their* destiny (including one who consorted with a bull). The preaching did not deter this Wife/goddess from doing the same; as a matter of fact, the stories may have been an inspiration.

How has Chaucer managed such an intricate scenario? A brief look at the role of husband 4 shows that his being in *London* during Lent can represent that the Roman influence had reached to England while Cybele was in Rome. (*London* also confuses the searcher.) Her husband at a distance provides time for the Earth Mother to become acquainted with Christian ways. In listing vigils and processions and plays, such events were common to both pagan celebrations and in Christian communities long before Chaucer lived.

The Greco-Roman pantheon, which we can identify with husband 4 because of his "grece," existed separately from Cybele for a time. When she merged with the Roman culture, it was the beginning of the end of the imported Greek gods. The Wife's "pilgrimages" facilitates Cybele's arrival in Europe under cover of a journey from Jerusalem.[380]

As we have progressed through centuries of the career of this Mother Goddess, we should allow that later events in the memoir must bring us near to Chaucer's day.

To revisit the poor Wife, lying on the floor, and finally regaining consciousness, the factor that brought her to this condition is the early Christian Church, with the assistance of Roman Emperors (Constantine, Theodius, etc.), striking at paganism. As far as this Earth Goddess is concerned, it was not a death blow. The

"young" Christian sect was poor, reflected in Jankyn, whom she married "for love, and no richesse" (D 526). With Constantine's conversion, the land and treasures of the pagan temples were confiscated. (*The Golden Legend* tells of the conversion of the pagan structure which is, today, *Sancta Maria Rotunda*.) Following this, "the church so grew in wealth and numbers that its position could not be shaken."[381] The marriage of Jankyn and the Wife proved mutually advantageous.

How does the figure of the Wife conceal the medieval cult of the Virgin? Skillfully. A pair of twentieth-century scholars have valuable comments about the Wife. First, Donald Howard is understandably enthralled with Chaucer's portrait of the woman. "What we don't know is what is interesting and important here." He sees Chaucer's technique calling forth the appropriate "frame of mind" in the reader. "It is not a 'strategy', for strategy by definition manipulates. It is rather a stance which invites and permits."[382] That is a warm welcome, a true invitation to get to know the Wife as intimately as possible. And, once again, we find essence expressed so perfectly—even though it may only be a scholar's creative solution to finding the proper word: "The Wife is an *heresiarch* after her own...fashion." Even with listing the Wife's heretical declarations, G. L. Kittredge subsequently instructs that "she is not to be taken too seriously."[383] Without recognizing her attitudes as clues to an allegorical identity, the complexity of her nature remains unacknowledged.

Now, noting Chaucer's way with time, if we take the Wife's prologue to be delivered in the "present," everything in her account has already taken place before she tells about it. Her narration is on one time level. Then what she said in the midst of the prologue can be an observation about something in the comparative past which has not yet been disclosed. Let's return to the point where she tells us she knows she's older and says farewell to her "good old days." The flower/flour is gone, she confides.

> The bren, as I best kan, now moste I selle;
> But yet to be *right myrie* wol I *fonde*.
>
> (D 478–79)

(The bran, as best I can, now must I sell;
But yet to be *right merry* will I *strive*.)

Where *fonde* is read as *strive* or *endeavor*, and *myrie* is a play on *Mary*, she tells her audience that now she'll just do her best "to be Mary." *Right* is an intensifier; she'll try to be *completely* Mary.

Does she learn how "to be Mary?" Yes and no. The fourteenth-century image of Mary has grown beyond the limits of the lovely young Jewish girl who bore Jesus, and even beyond an older maternal image. In many ways the aberration of the Marian persona is much like a fertility goddess. The Catholic scholar, Hilda Graef, directs attention to how Mary differs "strikingly from the portrait of the humble, retiring Virgin...of Luke's Gospel...; [traits] seem to fit the goddess Isis, the mother of Horus, rather than the wholly human Mother of Jesus."[384] I believe that is what Chaucer is saying: "This powerful force of nature has taken over the image of the simple woman of the Bible. Don't you see how distorted, how all-powerful Mary has become?"

It may have been the Wife's purpose to be Mary, but her personality got the better of her. She was so enamored of Jankyn/the Christian sect that she set her cap for him as next in line while husband 4 was still alive. Good planning on her part.

The climax is the fisticuffs between Jankyn and the Wife. Though cause and effect were spoken of and the reference repeated—as one might involuntarily repeat a reference to a distressing incident—no visual details were included until the final run-through. Previous repetition could also function as a signal to pay close attention to the final version. And here it is:

I with my *fest* so took hym on the cheke
· · ·
And with his *fest* he smoot me on the heed.

(D 792–95)

It's simple. Each of them used a fist. But here is where the Middle English holds the concealed clue—and Modern English is one-dimensional. Using our everyday words, we would say,

I with my fist so took him on the cheek

· · ·

And with his fist he smote me on the head.

Transcribing an alternate medieval connotation for *fest*, the covert intent is a *feast* pitted against another *feast*—instead of an exchange of blows, an exchange of rituals.

I will suggest an appropriate feast—certainly not a *random* choice. (Some other feast might work just as well, but this one uses the wifely image.) If we look at their wedding, which took place "with gre[a]t solempnytee" (D 629), things fall into place. First, the ceremony is a signal; this is the only *wedding* she's mentioned. Second, there was a pagan festival of Diana in mid-August.[385] What became a major Christian feast, the Assumption of the Blessed Virgin, was and is celebrated in mid-August. This is very close to "one feast against the other." It becomes particularly fitting if we look at the entry for the Feast of the Assumption in the *Golden Legend*, a work well known in the Middle Ages. Her Assumption, the Virgin Mary's entrance into heaven, is expressed as a wedding. It would be the opportune event for the Wife-Goddess to make her move, to conceal herself behind the veil. Who would notice?

In a work called *Ecclesiale*, produced about 1200, the calendar for August tells of Mary's desire to see her Son once again and the "solemn feast" commemorating the day when "the Holy Mother of Christ is taken up *to the stars*." Her Son "made manifest the day and hour. Hence He took her up." I was intrigued by a glossed reference that follows Mary's being taken up: it hails, "The welcoming Virgin [i.e., the zodiacal sign]."[386] Mary and Virgo (the eternal virgin) were in a close relationship.

It is not difficult to establish that Chaucer was aware of the popular distortions regarding the persona of the mother of Christ. It is the Marian milieu of France. There was no need to be familiar with documents, with scholastic theology. This greater-than-life-size Virgin permeated the literature, the liturgical dramas and works of art. Plays produced in fourteenth-century France (*Miracles de Nostre Dame*), for example, had "no counterpart" in England. And Temko, biographer of Notre Dame of Paris, simply states, "In

the three hundred years since the Norman invasions [the Virgin] had become the most powerful deity of the Occident."[387]

Graef, the Marian scholar quoted earlier, tells of a thirteenth-century commentary where an entire chapter is devoted to "The Omnipotence of Mary." "She can do all things." Graef explains that New Testament statements regarding Christ were given an "undiscriminating application" to Mary. Another aberration was "the idea that God wants to destroy the sinner, who is saved only by the intercession of Mary—in flat contradiction to [John's Gospel]."[388] Historians have discovered the changes and commented upon them; Chaucer lived them. It took courage to speak out, to use the name of Arius, for example, and to direct attention to a three-leafed image, while praying that God would protect him from reprisals. The Wife's lies and detours did a good job of covering Chaucer's tracks. He was treading on dangerous ground.

As pointed out, France, with its many Notre Dames, was particularly devoted to this image. The Wife claims she can no longer speak but is given "governance" of Jankyn's tongue. Temko's observation about medieval France seems to iterate this thought:

> The Virgin spoke through her priests and governed through her earthly seigneurs, but it was she alone, in the twelfth and thirteenth centuries, who dominated French society.[389]

Chaucer's knowledge of Latin had served him many times before. An instance that comes to mind now is the Latin term for the French people: *galli*. This is the same word that is used to refer to Cybele's priests. What were Chaucer's thoughts about pagan-like devotion of the French? The poet had made the connection between France and the Virgin regarding the Friar; we noted this earlier (pp. 177–78). He saw the splendid cathedrals, saw the images of Mary take on a position superior to those of her Son.

Temko describes an instance which may still be seen today at Notre Dame in Paris: the queenly mother-image of Mary crowned and enthroned above the St. Anne Portal:

> The Virgin bears the scepter and rules. The commands of

the little prince Jesus, who does not yet wear a crown, may be taken no more seriously than his boy's haircut or his tiny book.[390]

The poet heard sermons, read devotional commentaries and saw that Mary was being extolled as equal and at times even superior to God, superior to the Trinity. This overbearing position is dramatized in the Wife's action: holding the three leaves puts her in control of the Trinity.

I'm sure the poet found the life force of the Wife a delight. That was not his complaint. It was the force of Nature passing herself off as the Mother of Jesus. Instead of the Wife *becoming* Mary, she *replaced* Mary. When denied the freedom to continue all her old ways, she adapted what she could. By the end of the seventh century, there were four major feasts to celebrate Mary.[391] I'm sure the Wife enjoyed them all in the same way she enjoys the renewal of spring and the fulfillment of harvest-time today.[392]

The Clerk, a pilgrim who has not yet been introduced, remarks,

> ...for the Wyves love of Bathe—
> Whos lyf and al hire *secte* God mayntene
> In heigh maistrie, and elles were it scathe—
>
> (E 1170–72)

> (...for the love of the Wife of Bath—
> Whose life and all her "secte" God maintain
> In high mastery, or else it would be a misfortune—)

A note recommends that *secte* be read as *sex*. If we read the word unchanged as "an organized system of religious belief and practice, esp. a non-Christian faith" (MED), this is our fertility goddess, our image of spring. It would surely be a misfortune if God did not maintain her and her powers.

And, finally, let's not forget Virgo. Virgo, sometimes pictured in ancient times as Isis holding Horus, her child, in her arms, "reappeared in the Middle Ages as the Virgin Mary with the child Jesus." Shakespeare refers to that image as the "Good Boy in

Virgo's lap." Some even said that the symbol for the constellation of Virgo (♍) was "M" and "V" joined to indicate "Mary Virgin."[393]

This concludes the assembling of Chaucer's zodiac. What can we say about him as an allegorist? Could the hidden message be more intriguing? I never tire of his performance. I never tire of searching to identify the sequestered vitality in the clues, the ornaments, illumined before us. The signs, in their predetermined places, now encircle us—a display of brilliant personalities against the velvet sky. There is no intermission. We just have time for a brief comment to those in adjoining seats and then we settle back once more for the second part of this cosmic event—the planets.

This regularity…this exact punctuality throughout all eternity notwithstanding the great variety of their courses, is to me incomprehensible without rational intelligence and purpose. And if we observe these attributes in the planets, we cannot fail to enrol even them among the number of the gods.

—*Cicero,* On the Nature of the Gods *(d. 43 B.C.)*

V. Almost Everyone Else

AS THE performance continues, it will be both the same and different. It will be the same because the next participants are also celestial figures. What has gone before, however, was an orderly succession of identities all following a prescribed path, the ecliptic, the path of the sun. They were lively characters, to be sure, but their existence has a "decreed" limitation. The next group behaves independently; they wander as they please, each in his or her own fashion. They are, after all, *gods.*

When we look up at the sky, how do we know which of those points of light is a planet and which a star? The only reasonable answer seems to be by comparative observation. If a "star" in a constellation tonight has changed its position next time we observe the formation, the changeable one is a planet. That's why they are called *wanderers* (that is, *planets, pilgrims,* p. 21). All the planets—except Mercury and Venus—are "usually visible at some time of the night." Brilliant morning and evening "stars" are frequently planets. Another noticeable feature is that stars twinkle; planets do not.

We said earlier that the universe was imagined as a group of concentric spheres—earth, at the central point, was thought to be stationary. The recognized "planets," one to each sphere, were the Moon, Mercury, Venus, the Sun, Mars, Jupiter and Saturn. They each have a unique way of moving and each travels at its own pace.

Observed to move east (direct) for a period of time, they appear to "stop," and then move westward (retrograde).[394] Their courses also take them outside the zodiac and into other constellations (Ophiuchus, Cetus, Orion, etc.).

Until the twelfth century, very limited astrological information was available. From the twelfth to the fourteenth century, a great deal of scientific learning was circulated, some due to the work of Michael Scot, mentioned earlier. Ptolemy and Aristotle, as well as Arabic sources, became known. New Arabic knowledge, partly attributable to the Crusades, promoted an "extraordinary increase in the prestige of astrology, which between the twelfth and fourteenth centuries enjoyed greater favor than ever before."[395]

Many qualities were associated with planets. For example, ancients believed that each one emitted a musical tone. The sun, as the most powerful, was ruler of the sky.[396] When more than one planet was observed in a particular sign (termed a *conjunction*), the power of the planets was expected to intensify—in a "water" sign, large amounts of rain would be anticipated; in a "fiery" sign, drought and famine. Each of the planets was identified with a particular skill: music, logic, rhetoric, etc. Each also had a special characteristic: joy, melancholy, disaster, etc. In the Middle Ages an attempt was made to replace these classic, pagan characteristics with Christian qualities. For example, the seven planets were set to correspond to the seven gifts of the Holy Spirit: wisdom, piety, and so on.

Astrologically, each of the seven planets was assigned to a designated hour of the day (following in succession) and to a designated day of the week. Each was allied with a color, a metal, a part of the human body, a person's age or development—and much more. Chaucer's contemporaries held that planets influenced events and lives on earth.[397]

The poet was well-acquainted with skills regarding things celestial. With the line of thinking we've been pursuing from the start, it is interesting to consider opinions about one of Chaucer's short poems called "The Complaint of Mars." F. N. Robinson's notes identify the speaker (narrator) as the Roman deity himself and *not* as the poet:

The simple incident of the separation of Mars and Venus

by the coming of Phebus is told with various complications of detail which have been shown to refer, not properly to the gods, but to the positions and movements of the corresponding planets. So the whole poem may be regarded as a treatment, in personal or human terms, of a conjunction of Mars and Venus.[398]

These "complications of detail" corresponding to movements of the three named planets is a small-scale, practice piece for what the poet is doing in the *Tales*. Planets are also recognized as "motivating forces" in the *Knight's Tale*, where "ancient mythological machinery" has been "discarded," replaced by "destiny and the *planetary influences of medieval astrology*."[399] Let's repeat the important quote used in the "Plan," the section on allegory, where "astrology" was substituted for "doctrine" to illustrate how this determining factor influences the *Canterbury Tales*:

> The allegorical incident happens, not because it is necessary or probable in the light of other events, but because a certain *astrological* subject must have a certain *astrological* predicate; its order in the action is determined not by the action as action, but by action as *astrology*.

That formula fits the commentary on "The Complaint of Mars" and the *Knight's Tale*. The *Canterbury Tales*, then, go the limit. To adapt F. N. Robinson's thought, Chaucer's "whole [of the *Canterbury Tales*] may be regarded as a treatment, in personal or human terms" of celestial movement detailing the progress of all celestial activity from the beginning of time to the end.

Remembering that the orderliness and beauty of the stars was compared to allegory (pp. 47–48 above), Bernard Huppé's insightful comment, at the closing of his reading of the *Tales*, could apply to the poet's performance we are enjoying.

> [The *Canterbury Tales*] is a poem full of God's plenty, but the vision of God's order illumines and organizes this plenty.

Now let's continue with Chaucer's organized luminaries.

THE FRANKLIN

Though the Knight is the first storyteller on the pilgrimage, he won't be the first planet introduced. We'll meet four others individually who take up less space at center stage. If truth be known, the four are also more accessible, easier to get to know.

The first of the individuals, a rather grand specimen, brightens the atmosphere as he comes from behind the curtain. His title, the Franklin, tells of his social position more than of a craft, a skill. We will scrutinize the introduction for indications of Jupiter, whose name derives from "the helping father." (*Zeus* is his Greek name; *Jove*, according to the OED, is merely a "poetical equivalent.") Numerous stories are told of the adventures of Jupiter, but Chaucer's allusions, in the portrait ahead, are of this god's personality or gifts to mankind. The many affairs and challenges are avoided. Ovid addresses him as the god of hospitality and the bringer of the seasons. The deity is always pictured with a magnificent beard and flowing hair. A festival of wine, Vinalia, is dedicated to him and Ovid tells that he "loves to be present at his own feast."[400] Many references associate *white* with Jupiter: his disguise as the bull "white as the untrodden snow," the heifer that was Io, white altars, white-garbed "priests," even milk as a ceremonial libation. His reputation is one of beneficence and bounty, and "laws" of hospitality were a prime concern.

As a planet, only one was known to be more distant (Saturn). Pliny calculated Jupiter's orbit as 12 years, which is quite accurate, the circular motion taking 11.86 years. Its total eastward progress, however, is only thirty degrees a year.[401] Its apparent direction varies, as we said of planets. It sometimes appears to move west or even to stand still. Because Jupiter is between the fiery Mars and the cold Saturn, it is considered the temperate force between Mars and Saturn and, in contrast to their influences, exhibits moderation. Pliny proposed that thunderbolts (which are the weapons of Jupiter the god) are really "heavenly fire" from the planet. On a moonless night, skywatchers in areas free of light-pollution may find that Jupiter can be bright enough to cast shadows.[402]

Ptolemy tells of many benefits attributed to Jupiter; "in general he is the cause of happiness" and provides the earth with an abundance of useful animals.[403]

The Middle Ages maintained the benevolent picture of Jupiter. "The entire region shines with light from the star of Jupiter and rejoices in the happiness of unending Spring...[and]...tidings of safety to the world." After noting the silvery-white of its pleasing presence, Bartholomeus announces that the planet is "the cause of wealth."[404] Michael Scot's "new" illustration of this god with the sanguine complexion elicits commentary because his Jupiter is a nobleman, or a jurist "seated before a lavishly spread table." The god's medieval attire is a fur coat, gloves, and purse. *Cosmographia* describes, "seated in his council chamber, Jove shone in regal majesty." He is often seen equipped with a scale to keep the world's affairs balanced—some happy events and some sad.[405]

Jupiter's image has a long history of Christian correspondences. He was identified with "the ruling principle of a Christian universe" in Fulgentius (sixth century A.D.). In the writings of Aldhelm (d. 709), who studied at Canterbury, "Olympus stands frequently for Heaven...God is frequently called the King of Olympus." Scot, too, called this god "the sign of true believers and Christians." An unusual bas-relief on a medieval bell tower in Florence portrays Jupiter garbed as a monk with cross and chalice.[406]

Classical mythological transfer persisted. An early fifteenth-century Carmelite preacher refers to God as "Jupiter Omnipotens." And Neo-Platonic interpretation in Luther's day would explain, "When I say Jupiter, understand me to mean Christ and the true God." (One hundred years after Chaucer it was still considered appropriate for ideas to be "hidden in silence...sacred things must needs be wrapped in fable and enigma."[407] The layman was not to delve into such precious matters.)

Chaucer had extensive knowledge about Jupiter from Ovid's poetry, from Augustine's protests and who knows how many more sources. Of the poet's many references to Jupiter or Jove (there are none to Zeus) in the *Canterbury Tales*, two are affirmations. The *Knight's Tale* records "Jupiter the king, / ...is prince and cause of all things" (A 3035–36). And Cecilia, a persecuted Christian (in the *Second Nun's Tale*), is advised to acquiesce and make a sacrificial offering to Jupiter (G 410–13).

Now let's meet Chaucer's Franklin and search for the Jupiter clues in his contours.

A *Frankeleyn* was in his compaignye.
Whit was his berd as is the dayesye;
Of his complexioun he was sangwyn.

<div align="right">(A 331–33)</div>

(A Franklin was in his company.
White was his beard as is the daisy;
Of complexion[408] he was sanguine.)

His appellation indicates he is a landowner and he ranks in prestige just below the nobility, a reasonable portrayal of a pagan deity whose image is honored just below that of the monotheistic God. At the outset we find one of his trademarks, the remarkable white beard of his classic image.

A rosy complexion is one of Jupiter's influences on others, and probably a personal influence because of his fondness for wine.

Wel loved he by the morwe a *sop in wyn*;
To lyven in delit was evere his wone,
For he was *Epicurus* owene sone,
That heeld opinioun that pleyn *delit*
Was verray felicitee parfit.

<div align="right">(A 334–38)</div>

(In the morning he loved bread or cake dipped in wine;
To live in delight was ever his habit,
For he was Epicurus' own son,
Who held the opinion that full delight
Was true and perfect felicity, happiness.)

If you're inclined to start the day with wine, that will perpetuate the rosy cheeks. Mention of Epicurus is a glimpse of his Greco-Roman "heritage." Living surrounded by all things that *delight* is a picture of perfection, or Olympus. (Gower, as well as Chaucer, when depicting a Jovian scene, fills it with sensory pleasure.[409])

> An housholdere, and that a greet, was he;
> *Seint Julian* he was *in his contree.*
>
> (A 339–40)

> (A householder, a great one, was he;
> St. Julian he was in his country.)

St. Julian is the perfect Christian parallel. Both he and Jupiter fill the role of "the patron saint of hospitality." Julian served England; the Franklin/Jupiter served "in his country," an indication of an area other than England.

And what is found for refreshment?

> His *breed*, his ale, was alweys after oon;
> A bettre *envyned* man was nowher noon.
>
> (A 341–42)

> (His bread, his ale, was always the same;
> A better envined man was nowhere known.)

A story in Ovid's *Fasti* recounts Jupiter's providence and beneficence. He aided besieged Romans on the verge of starvation by providing loaves of bread for them. (Like many myths, the story has an odd twist.) In appreciation Roman citizens set up an altar for their provident god—a *white* altar, of course.[410]

Envyned has just one MED definition, "stocked with wine," but the entry is limited only to this Chaucer phrase as an example. It seems that *involved* with *vines* is also a possibility as an allusion to Jupiter's "Vinalia," a major festival celebrating the grape harvest and *vines* that were productive.

The Franklin's daily menu is outstanding.

> Withoute bake mete was nevere his hous,
> Of fissh and flessh, and that so plentevous,
> It *snewed* in his hous of mete and drynke,
> Of all deyntees that men koude thynke.
>
> (A 343–46)

> (His house was never without meat pies,
> Of fish and flesh, and that so plentiful,
> It snowed in his house of meat and drink,
> Of all dainties that men could think.)

Exaggeration upon exaggeration: *never* without fish and meat; it *snowed* delicacies; *anything* you could think of to enjoy. This is no gentleman's home. This is the ultimate dream of abundance—heaven, or if you will, Olympus. The "snow," in particular, jumps off the page—a "conspicuous irrelevance"—and is, therefore, a signal. Although it seems puzzling, it may simply be an allusion to Jupiter's *house*, Sagittarius, being the "part of the zodiac [that] sends us hail, rain and *snow*."[411]

Another version of his "hous" might be the heavens themselves.

> After the sondry sesons of the yeer,
> So chaunged he his mete and his soper.
> Ful many a fat partrich hadde he in muwe,
> And many a *breem* and many a *luce* in *stuwe*.
>
> (A 347–50)

> (According to the sundry seasons of the year,
> So changed he his early and late meals.
> Full many a fat partridge had he in a safe place
> And many a bream and many a pike in a pot.)

The menu varied with the seasons of the year, the seasons being an idea of Jupiter's. Part of his beneficence lay in the provision of an abundance of "useful animals" such as those that provide food. Baugh recommends that "stuwe" be read as *fishpond*, but a closer connection to food ready-and-waiting is a "cooking pot." (MED, "steue.") It is not essential to picture food for future use once you know that it is Jupiter who is the source of the provisions.

Luce and *breem*, names of fish, also have a second connotation relating to light—bright, shining, brilliant light. And a "stuwe" can be a small chamber. This hints at the brilliance of the planet's reflected beams.

Cooperation on the part of his staff was, of course, expected.

> *Wo was his cook* but if his sauce were
> Poynaunt and sharp, and redy al his geere.
> His *table dormant* in his halle alway
> Stood redy covered al the longe day.
>
> (A 351–54)

> (Woe to his cook unless his sauce were
> Piquant and sharp, and his utensils were ready.
> His table dormant in this hall always
> Stood ready, covered all day long.)

Extravagant declarations continue. All the foodstuffs had to be tasty and ready all day long, without benefit of steam tables. The phrase might be read figuratively, as well, to communicate that *everything* had to be to the Franklin's/Jupiter's liking. The poet has covered fourteen lines with images of food and drink always being available. That's a different way of describing a character. Of course, if hospitality is one of the Franklin's primary functions, the lines capture his essence. The dormant table simply means it remains ready for use, rather than being dismantled. Medieval tables were generally boards laid across trestles; they were removed at the conclusion of a meal. In the Franklin's household, in other words, it was always mealtime. (Recall that Michael Scot's Jupiter had a lavishly spread table.)

And what does he do when not involved with food?

> At sessiouns ther was he lord and sire;
> Ful ofte tyme he was knyght of the shire.
>
> (A 355–56)

> (There at sessions he was lord and master;
> Often times he was the knight of the region.)

We could identify this with *Cosmographia's* portrayal of Jove sitting in his council chamber in regal majesty. Judicial gatherings on Olympus were overseen by Jupiter; his was the last word.

Now we find just a hint of his physical appearance. Except for his beard, it has seemed of no importance before this.

> An *anlaas* and a *gipser* al of silk
> Heeng at his girdel, *whit* as morne *milk.*
>
> (A 357–58)

> (A two-edged dagger and pouch of silk
> Hung at his girdle, white as morning milk.)

The added details are certainly minimal, and leave me wondering at this hospitable fellow equipped with a dagger as part of his usual attire. It could, of course, be the likeness of a thunderbolt, his personal weapon. These lines produce Richards' *movement among meanings.* They approximate Michael Scot's picture of Jupiter with staff (anlaas) and money pouch (gipser) in the appropriate *white.* But an allusion to *milk* brings a bovine image: the "beautiful white bull" with piercing instrument and pouch that hung down as constituting its male equipment. It would round out the figure of Jupiter to include a reference to his promiscuous creativity. Independently, milk is also a connection to the beverage at Jupiter's predominantly white rituals.

We have reached the last two lines. Will we find something especially significant?

> A *shirreve* hadde he been, and a *contour.*
> Was nowher swich a worthy *vavasour.*
>
> (A 359–60)

> (A sheriff had he been, and an accountant.
> There was nowhere such a worthy landholder.)

He had been an accountant (a counter). *Cosmographia's* description of Jupiter has him holding a scale, a device used in business transactions of the period. The *shirreve* is an appointed official who represents a higher authority. Jupiter could surely be interpreted as serving God Himself. Then as a vavasour, a noble landholder, he is a prime force in the "nobility" whose landholdings include Olym-

pus. Once more, a statement is so subtle it can almost be over-looked. But, the claim is that there *was nowhere* such a person. It places the Franklin out of this world, in the celestial abode of Jupiter.

For all the interest the poet stimulates in this very worthy personage, we hardly notice that, as a grand householder, no house is described—only a table. For all the hospitality, there are no guests, no family, and no food is served or eaten. For all his liveliness and activity, we're only told of his beard, rosy face (no other bodily features), his weapon and silken pouch. Carefully chosen details maintain an ambiguous image.

The pilgrim tells us a bit more of himself in the *Prologue to the Franklin's Tale*, a short monologue.

> But sires, by cause I am a *burel* man,
> At my bigynnyng first I yow biseche,
> Have me excused of my rude speche.
>
> (F 716–18)

> (But sirs, because I am a burel man,
> At my beginning first I beseech you,
> Hold me excused for my rude speech.)

What a surprising change of character! I did not expect an *ordinary* man, after the *General Prologue* description of his way of life. Protesting his rude speech is hardly a fitting portrait of this man in charge, the knight of sessions. What point is Chaucer making? Inserting this apology allows a play on *burel*. The word's main connotation is *coarse woolen cloth*, and consequently, identifying a person as one who wears garments of such cloth. This is surely not true of the Franklin's wardrobe. Considering the alternate meaning, *a ray of light*, brings us the Franklin's covert persona—Jupiter, a "man" identified with a ray of light. (Chaucer uses the same word game with the Wife of Bath.)

The plainness he protests also provides the opportunity to say,

> I sleep nevere on the Mount of Pernaso.
>
> (F 721)

(I never sleep on Mt. Parnassus, [sacred to Apollo].)

A negative statement informs without informing. It gives the poet the opportunity to interject "Mount." This brings a flicker of another Mount (Olympus) where he *does* sleep.

> Ne lerned Marcus Tullius Scithero.
>
> (F 722)

(Nor have I learned Cicero.)

His lack of knowledge of Cicero is to be expected. Cicero, a mere mortal, came into being long after the Franklin/Jupiter took charge.

Another opportunity from the apology is a chance to introduce colors—the merging of two different uses of colors.

> *Colours* ne knowe I none, withouten drede,
> But swiche colours as growen in the mede,
> Or elles swiche as men dye or peynte.
> Colours of rethoryk been me to queynte.
>
> (F 723–26)

> (Colors know I none, without doubt,
> But such colors as grow in the meadow,
> Or else such as men dye or paint.
> Colors of rhetoric to me are strange.)

Cicero leads to rhetoric; rhetoric leads to colors—Chaucer's destination. Referring to colors in nature is a distraction. Picking up the same word (colors) and using it in a different sense *is* rhetoric. The Franklin/Jupiter is claiming no knowledge of rhetorical skill, no talent with figures of speech—but his arrangement of words and thoughts demonstrate possession of the skill. A claim of lack of verbal facility challenges earlier evidence. As a "man" in charge of sessions, he cannot be completely devoid of rhetoric. Understanding the Franklin's protestation comes with granting that he never *studied* Cicero. *Analysis* of modes of speech is relatively modern

compared to this pilgrim's using them. It's the same notion as when the Wife just recently heard about *New Testament* ideas.[412]

With limitations of a planetary image—a human figure approximating a lighted sphere in the (night) sky—it may be that godly responsibilities will contain the clues. It is a place to begin as we turn our attention to Mercury.

THE MAN OF LAW

At the poet's gesture, the Sergeant of Law whooshes into view. He has this exceptional ability because hidden in his description is the image of winged Mercury. Chaucer will indicate the many-faceted activities of this character, instead of a *visual* description. (We'll watch for the pattern used in portraying the Franklin.)

As soon as the Man of Law comes to rest, I have a question. Why, if we always refer to him as the "Man of Law" and Chaucer's headings for his *Prologue* and *Tale* address him as a "Man of Law," does his original *General Prologue* introduction begin "A *Sergeant* of the Law"? Not many of the titles given the pilgrims have that pattern; it's similar to the *Wife* of *Bath* where each word has an individual task to perform. Instead of seeing this pilgrim as an elite lawyer, his surface appearance, there is an abstract quality to being a servant (sergeant) of the Law. In some way he enhances the existence or activity of the Law. With Mercury designated as the god of eloquence, that is a splendid attribute for a start.

Mercury (Hermes) was the first astronomer and had a reputation for intellectual creativity. He was the first musician, as well.[413] Ignoring his academic and cultural side, Augustine rounds out his personality by marking him as a thief.[414] Also recognized as the patron of businessmen, an entertaining story of a merchant's devotion to Mercury is told by Ovid. This devotee ceremoniously drew water from a source dedicated to Mercury. He cut a laurel branch to use for sprinkling the water on his merchandise and on himself. Then he prayed:

> Wash away the perjuries of past time...wash away my glozing words of the past day. Whether I have called thee to witness, or have falsely invoked the great divinity of Jupiter, in the expectation that he would not hear...let the

swift south winds carry away the wicked words, and may to-morrow open the door for me to fresh perjuries, and may the gods above not care if I shall utter any! Only grant me profits, grant me the joy of profit made, and see to it that I enjoy cheating the buyer![415]

Ovid explains that such a prayer would be an amusement for the god as Mercury remembers his own thievery.

Mercury, as messenger of the gods and an aid to commerce, is in charge of the faculty of speech. Augustine goes so far as to say, "Perhaps speech itself is called 'Mercury.'"[416] A popular poem of the Middle Ages describes the wedding of Mercury to Philology— "love of words," or "love of learning." It's a fanciful way of saying "the two are one." Speech and eloquence are both talented servants of the Law and an effective background for commerce, as well.

As an efficient messenger, when sent on an assignment, Mercury would return "sooner than he was looked for."[417] This is the "human" expression of his planetary motion.

The planet makes its appearance in the half-light very near the sun, so that when the sun rises, its light overcomes Mercury. The planet's closeness to the sun removes it from view soon after sunset. This proximity makes observation difficult. More than that, this eccentric planet changes location very rapidly; "by a system of widely varying movements, [it] passes back and forth across the path of the Sun." It is a fact that the planet "moves so quickly that…it is not possible to indicate its path with respect to the stars." Evidence of how difficult observation was for conscientious ancients, the planet's orbit was estimated by Pliny to be a little more than 348 days. Using today's technical advantages, Mercury's orbit has now been established as only 88 days.[418]

Astrologically, Ptolemy claims the planet has powers for both good and evil; he makes the good or evil more so. Mercury has been called a "benevolent sorcerer," assuring (as Ovid's prayer would have us believe) "success in business and swindling." Along with the many duties and interests already mentioned, the god is patron of accountants and students of science. He brings skills to both business and thievery, along with wit and wisdom.[419] (He's the perfect con man.)

Impressions of Mercury during the Middle Ages continue the earlier image with a few adaptations. Martianus tells of the god's role as "trickster god" of marketplaces, and laments that Hermes (the matching Greek deity), who was a gracious poet, had been "reduced to a bag of tricks—rhetorical arts." With contrasting motivation, Christian thinking gave some of Mercury's duties to the Archangel Michael.[420]

Michael Scot's illustration makes an ecclesiastical adaptation for this eloquent personality and portrays him as a bishop carrying a book. Fourteenth-century Italy (visited a number of times by Chaucer) is inclined to the academic aspect of the god, and, as a result, has sculptures of Mercury as a teacher and as a scribe. *Cosmographia* depicts the god with "a slender wand in his hand, and his feet were winged, lightly shod and bound, as befitted one who performed the office of interpreter and messenger of the gods."[421]

An entry in the MED makes a statement that stirs up confusion: "Wednysday is named aftir Mercury." The French for Wednesday is *mercredi*, easily seen as related to *Mercury*. Confusion about the English claim is resolved with the explanation that the name in France is different from our Germanic "Woden's day" because Mercury in early times was identified with Germanic Woden.[422] They were both eloquent and fleet of foot.

Let's meet the pilgrim.

> A Sergeant of the Lawe, war and wys,
> That often hadde been at the *Parvys*,
> Ther was also, ful riche of excellence.
>
> (A 309–11)

> (A Servant of the Law, aware and wise,
> That often had been at the "Parvys,"
> [He] was also, very rich and excellent.)

Surface details tell of an accomplished lawyer, one who (scholars assume) would be a claimant of his own special area of the porch (parvis) at St. Paul's—at least that was the custom for lawyers in Shakespeare's day. There is, however, another prominent fourteenth-century parvis, that at the front of Notre Dame of Paris. It

may be that a scholastic connection is to be made between this figure and France. The Parisian parvis is so prominent that it is noted as one of only two examples of the word in the MED. In addition, Temko explains that *parvis* is derived from the medieval French *paradise*, thereby adding a celestial aura to where he "had often been." Chaucer surely knew St. Paul's and Notre Dame in Paris; he also knew Norman-French and could have intended all these links.

It's important to acknowledge the fact of many kinds of *law*—laws of nature, moral law, a "consistent principle controlling the action of material things," etc. The obvious storyline is understood to be of a court of criminal/civil law, and of a man who is involved in such cases. We will set that aside intact and look more deeply for Mercury's figure.

> Discreet he was and of greet reverence—
> He semed swich, his wordes weren so wise,
> Justice he was ful often in *assise*,
> By *patente* and by pleyn *commissioun*.
>
> (A 312–15)

> (Discerning he was and of great reverence—
> He seemed so, his words were so wise,
> He was often a justice in a judgment,
> By authority granted and by being delegated.)

Line A 312 recommends this servant's discretion and reverence, but is followed by "he *seemed* so." For me, this makes the original recommendation a pretense. As the image of Mercury, he is expected to be less than trustworthy—pretense is his forte. In the fourteenth century, actions of the *assise* (comparable to a county court) could be used figuratively to depict God's Judgment. A *pagan* god's deliberation would work as well. Mercury's role in the pantheon would be directed by *patent* (a granting of permission) or by *commission* (official orders or instructions). "Duties commissioned" is a more-than-adequate picture of the activities of the Olympian messenger of high regard.

A reputation for clear thinking brings successes.

For his *science* and for his heigh renoun,
Of fees and robes hadde he many oon.

<div align="right">(A 316–17)</div>

(For his proficiency of knowledge and his high renown,
Of fees and robes had he many a one.)

His "science" can be "knowledge and book learning." It can also allude to cleverness, craftiness because Mercury has a reputation for both intellectual ability—and deceit. Fees and robes could come from many sources, many schemes. Robes (indicating a profession or multiple professions, for example) could allude to his new medieval associations as bishop and scribe.

So greet a *purchasour* was nowher noon:
Al was *fee symple* to hym in effect;
His *purchasyng* myghte nat been *infect*.

<div align="right">(A 318–20)</div>

(As great a purchaser was none nowhere:
All was fee simple to him in effect;
His purchasing, or transactions, would not be disadvantaged.)

Editors usually explain the intention of *purchaser* as involving land transactions, "but no example of the word used in this sense is known." As the patron of merchants and the god whose name is identified with com*merc*e, it is natural to associate *purchaser* and *purchasing* with him. (Fr. *merc*ier [trader], *merc*antile, and many other terms are "derived from a root related to merchandizing.")[423] In the same way that Augustine saw him as "speech" itself, Mercury might also be termed com*merc*e or *merc*handising itself. *Purchase*, then, in the broader medieval definition is acquisition, gain, something earned, booty, goods obtained by robbery, alms received, and more. Being a *great* purchaser reflects his patronage over many types of transactions.

Fee simple is complicated to understand in connection with ownership or sale of property. I read through the definitions of *fee* (fe) and *simple* (in the MED) on several occasions and tried to ab-

sorb the intentions and have it come clear. Returning once again to *fee*, I noticed that my concentration was on "n. (2)." What did "n. (1)" have to say? There was the answer. (There's a bit of Mercury the trickster in Chaucer.) "Fe n. (1)" is "livestock; a herd of live-stock." Strange as it may seem, that's our Mercury clue.

If purchase (in A 318 and A 320) is not concerned with property transactions, why should property be the subject of A 319? With *fee* (*livestock*) and *simple* (*easily understood* or *innocence*), we see Mercury's infancy—the glimpse of a "baby picture."

There are several versions to the story, but here is a brief version of the basic story: "A few hours after birth [Mercury] left his cradle and...stole some of Apollo's cattle with their hooves bound with branches so as to leave no tracks.... Apollo ran down the thief and took him before Zeus for judgment. So amused was Zeus by the infant's cunning and pleas of baby innocence that he let him off with only an order to restore the cattle."[424]

The *fee simple*, from little Mercury's point of view, tells of his precociousness in managing the livestock. From Zeus' perspective it was livestock stolen innocently.

Add to the mythological content some celestial considerations. *Infect* is an astrological term (in addition to standard associations). To negate *infect* allows A 320 to affirm that the dealings of Mercury/the Man of Law will *not* be astrologically disadvantaged. This is followed by the incorporation of physical properties of his planet identity and more.

> Nowher so bisy a man as he ther nas,
> And yet he semed bisier than he was.
>
> (A 321–22)

> (There was nowhere a man as busy as he,
> And yet he seemed busier than he was.)

What a clever way of expressing the reputation of Mercury, (a) as messenger, (b) as the movement of the eccentric planet and, perhaps, even (c) the action, the quickness of *liquid* mercury. A second meaning for A 321 communicates that there was no *man* as busy as the pilgrim, putting him outside the human family.

Claims of knowledge over a great period of time need scrutiny.

> In *termes* hadde he *caas* and *doomes* alle
> That from the tyme of kyng William were *falle*.
>
> (A 323–24)

> (In terms had he cases and judgments all
> That came down from the time of King William.)

Baugh recommends that "Chaucer is indulging in poetic exaggeration" with the claim of possessing information [of trials] dating back to "William, the Conqueror." Chaucer's outlandish idea is a signal. Words of the overblown statement have, again, more definitions than those limited to courts of law.[425] *Terms* and *fall* and *doom* can all reflect astrology. *Case* can be an event, deed, or question influenced by astrological aspect.[426] Possessing knowledge that dates back to William is a clue to a pilgrim outside the realm of *human* existence. The astrological associations could simply demonstrate Mercury's personal recollections.

The creativity exhibited earlier (as an infant) continues to be demonstrated.

> Therto he koude *endite*, and *make a thyng*,
> Ther koude no wight pynche at his *writyng*;
> And every statut koude he *pleyn* by *rote*.
>
> (A 325–27)

> (Thereto he could "endite" and make a thing,
> There could no one pinch at his writing;
> And every statute could he "pleyn" by rote.)

Of the events alluded to (of the time since William), this pilgrim knew how to *endite*; that is, to compose, tell a story, sing, or chant. He could "*make* a *thing*," a phrase that provokes two considerations. First, it recalls Chaucer's *Retraction* in which, as author, he calls himself "the *makere* of this book." Secondly, with one of his vagueries, the poet refuses to give a name to what is endited or made. "Pinch" holds a negative comment about his writing.[427] At last, he

has clearly said the word. The subject of the lines is *writing*. Mercury, in his historical identity, invented writing and his medieval image is a scribe. Musical composition may also play a part, from his being the first musician.

Musical thoughts, then, put a different light on A 327. This servant Pilgrim is equipped to *pleyn by rote*, play from memory, *or* play a *rote*, a harp-like instrument. Picture a medieval *scop*, a minstrel who chants, performs, and entertains with old romances, epic poetry and more. Ovid's variation on the image acclaims Mercury, "O thou inventor of the curved lyre."[428] The *statute* that is proclaimed musically recounts the rules (laws), for example, of love, or Nature. This interpretation suits the musical side of Mercury.

Here we are at the last three lines. What do they tell us about this servant of the "law"?

> He *rood* but *hoomly* in a *medlee cote*,
> Girt with a ceint of *silk*, with *barres* smale;
> Of his array telle I no lenger tale.
>
> (A 328–30)

> (He rode simply, or secretly, in a gray garment,
> Girt with a cincture of silk, with bars small;
> Of his array tell I no more of a tale.)

It is important to consider the diversified existences of "Mercury": the celestial messenger and god (inventor of writing, music and astronomy); a god as prankster and cheat (patron of merchants); a "god" identified as speech and, therefore, eloquence (a proper gift for scholars and men of law); a planet in astronomy (unique and fast-moving); a planet in astrology (with powers of good and evil); a metal of unique properties for both medicine and alchemy. Is any other pilgrim as diverse?

The fact noted is "he rode," but no animal characteristics are provided to give vitality to the picture. Just one word describes how movement was accomplished: *hoomly*. This is variously understood as "in a familiar manner," "privately, secretly."[429] This could be an announcement of concealment.

Next we are shown his coat. *Medlee*, that is, *gray*, is the color of

quicksilver. But with *medlee cote* another idea surfaces. *Medlee* is also "mixed," "composed by compounding," as in a chemical (or alchemical) procedure. Consider that the "action" of quicksilver gave the substance its name, that is, "silver that is *alive*" (*argentum vivum*).[430] It was "mortified"—killed—by immersing it in a compound with other elements. The pilgrim's *medlee cote* (coat) can be a complex picture: the liquid metal concealed (coated, compounded) by the material with which it was merged, blended.

When A 329 speaks of *silk* and *bars*, it is explained as the description of a silken sash and the bars as a means "to keep the silk spread."[431] Using the terms with a view to the planets brings a whole new world into focus, a world that would certainly please the Man of Law/Mercury. He would gladly serve the laws of astronomy; they were his invention.

Astronomy took on great importance beginning in the twelfth century when Arabic manuscripts, previously unavailable, were translated. The fourteenth century received "a flood" of new ideas and modes of calculating. Arabic numerals, for example (replacing Roman numerals), came into standard use in the European scientific community by 1320, allowing more readily constructed and interpreted tables, as well as greater ease of calculation.[432] A new scientific instrument called an "Equatorie of the Planetis" is described in a fourteenth-century work of the same name. (It is debated whether Chaucer wrote this treatise.) All the preceding details involving the planetary calculations and Chaucer's interest in the heavens may be concealed in A 329. This Equatory mechanism incorporated both *silk* threads (the cincture?) and metal *bars* to determine the position and movement of Mercury and the other planets.[433] We'll return to this in a moment.

Looking at the significant last line, the last chance to make a disclosure, the words hold a refusal to elaborate on the attire of the Man of Law/Mercury. The refusal must have a special meaning. (This avoidance maneuver was used with the centaur; the narrator's final "clue" was that he didn't know what men would call him.) What have we been told of this pilgrim's physical appearance? At most, we've learned of a coat and possibly a "sash" made of silk—a puzzling pair of items, hardly coordinated as an ensemble. What is the point of this odd combination? The point is the poet didn't want

to provide give-away details. He could hardly describe Mercury's winged cap or winged sandals, nor could he tell about the snake-wound staff he carries. The significance of the last line of introduction is that it announces it contains no *significant* information.

We could stop there, but let's take one more look at the last two lines. Taken together, they hold an auxiliary message. Once we are willing to see the *silk* and *bars* as a reference to a mechanism for making calculations about planets, then the last line becomes a refusal to indicate which formation (array) of the zodiac is involved in Mercury's location; we discovered, with this planet's closeness to the sun and eccentricity, it is seldom possible to locate him with any assurance.[434] In addition, *array* is the only functional word in the line, and it is capable of being directed toward both fashions and the firmament.

Apparently, the poet will provide minimal physical description about the planets, but will depend, instead, on their astrological responsibilities for their ambiguous depictions. Mercury is an extreme case because his name brings so many possibilities to our mind's eye, thereby giving the poet many opportunities to exercise his creativity. Chaucer was familiar with all of the correspondences and does his best to scatter clues for each representation as we get to know the Sergeant of the Law/Mercury.

Taking a quick (closing) glance at the vocabulary of the *Prologue to the Man of Law's Tale* finds more echoes of Mercury: stealing, gambling, winnings, rich merchants, and the fact that it's better to be rich than poor. Appropriately, this overseer of merchandising announces that he'll tell a story taught to him by a *merchant* many years before (B 131–33).

Now we feel a sudden chill spread through the atmosphere as we anticipate Saturn.

THE DOCTOR OF PHYSIC

There is a lag in the performance. It's not encouraged by the poet/director. It's simply unavoidable. The next pilgrim, a Doctor of Physic, is the counterpart of slow, lumbering Saturn, who is identified with lead and has the greatest and most distant orbit.

While we wait for his arrival, it might be well to remember that an allegory, as it says two things at the same time, can actually

deliver messages of opposite mood or content.[435] The Doctor/Saturn introduction is an exercise in just such divergence.

We're ready to begin now with Saturn's mythology. It's truly schizophrenic. When Saturn ruled, everything was idyllic—eternal spring, abundance of food without toil, everyone living in peace. The Romans looked upon Saturn as the origin of their civilization. As time passed, his reign was likened to an "Age of Gold."

Cicero explains that the Greek name for Saturn is Kronos, "which is the same as *chronos*, a space of time."[436] He, Kronos-Saturn, keeps time on course.

Sad to say, while the world enjoyed a pagan paradise, things were not going well at home for Saturn. An oracle had prophesied, "Thou best of kings, thou shalt be ousted of thy sceptre by thy son." What was a father to do? Ovid tells what Saturn did: "In fear, the god devoured his offspring as fast as they were born, and he kept them sunk in his bowels."[437] The Middle Ages elaborates on the problem and Saturn's change of personality:

[He was] an old man, everywhere condemned, savagely inclined to harsh and bloody acts of unfeeling and detestable malice. Whenever his most fertile wife had borne him sons, he had cut them off at the first budding of life, devouring them newly born.... One evil passion obsessed the old man, and he indulged in one form of savagery: he was still vigorous, and with a strength not yet impaired, and whenever there was no one whom he might devour, he would mow down with a blow of his sickle whatever was beautiful, whatever was flourishing.... By the spectacle he presented he prefigured the hostility with which he was to menace the race of men to come by the poisonous and deadly propensities of his planet.[438]

His wife formed a plan to outwit her husband; she was frustrated with being repeatedly pregnant without being allowed the joys of motherhood. So, when Zeus was born, she duped her husband by surrendering a stone wrapped as a baby, which Saturn promptly, unwittingly, swallowed. The prediction, of course, came true. Zeus overthrew his father and gelded him for good measure.

We can imagine that this violent mythology we've sampled might be a way of explaining (justifying?) the grim reality of human sacrifices, especially of children, which were dedicated to Saturn.[439] We'll say more about that later.

His revered beginnings changed dramatically. Once he was driven from authority, the Golden Age ended. (With Zeus came "The Silver Age.") Saturn's astrological force was recognized as malevolent. Old Saturn, cold and impotent, was the bringer of maladies. (Gustav Holst, in his fascination with the planets, calls this musical portrait "The Bringer of Old Age." That's fairly synonymous with the arrival of *maladies*.)

Modern astronomy has improved only somewhat on ancient, unassisted observations of this distant planet's orbit. Pliny declared it to be thirty years. It is now calculated at twenty-nine-and-one-half years for one trip around the sun, moving eastward a mere 12° each year. For all its slowness, its visual display is outstanding. At opposition (that is, directly opposite the sun), it is brighter than a star of the first magnitude. Recall that this is the planet with the rings. It can appear three times brighter when our view sees the rings spread out (instead of turned on edge).[440] Of course, the fourteenth century knew nothing of the rings; they just appreciated the changing visual display. Once you locate this bright planet, it will not be difficult to find again, because of its slow progress across the sky.

In Italian monuments and elsewhere, Saturn's figure holds a spade and sickle representing his introduction of civilization. Perhaps it's the old god's bloody penchant that inspired Michael Scot to illustrate him as a warrior. Gower, from fourteenth-century England, regards Saturn as the source of malice and cruelty. Petrarch depicts, "with faltering stride...reverend with years, comes rustic Saturn, holding in his clutch mattock and pruning fork...portrayed devouring his own progeny."[441]

Chauncey Wood's *Chaucer and the Country of the Stars* gives an analysis of Chaucer's images of the heavens, noting a scene where Saturn "speaks like a god, but describes himself as a planet."[442] This is attuned to the previous observation about "The Complaint of Mars." All of our pilgrims are celestial figures but do not declare it openly; the presence of their covert identities, however, answers many quirks and cruxes in the words employed by the poet.

Chaucer himself, in his astrological treatise, calls Saturn a "wicked planete," and goes on to prove it with the fictions he constructs. In the *Knight's Tale*, confinement to prison is accepted by one of a pair of knights, who says, "Some wicked aspect or disposition of Saturn...hath given us this" (A 1087–89). In the *Legend of Good Women*, the narrator is sorry for Hypermnestra, one of the good women, because "aspects hath she of Saturn / That made her to die in prison" (2597–98). Elsewhere, the poet confides the planet's dreadful "assist" in answer to a request: "Saturne anon.../.../ ...gan remedie fynde" (A 2450–52). His *remedy* was to have a victorious knight develop an infection in a wound and die.[443]

Now, after a thumbnail sketch that captures the essentials of this Doctor of Physic, we will be ready to turn our complete attention to the performer. This Doctor, Brooks tells us, is learned, a professional, experienced in technical knowledge including astronomy. He's not inclined to religion, and his fondness for gold is exhibited even during the "affliction of the Plague" (29–31). There are glints of Saturn in those ideas.

Finally, the Doctor assumes the spotlight.

> With us ther was a Doctour of *Phisik*.
>
> (A 411)

> (With us there was a Doctor of "Phisik.")

Though his being a physician is taken for granted, his professional title is actually ambiguous. The field of medicine is only one possibility. For example, Chaucer's introduction to the *Astrolabe* says, "after the statutes of our doctors...thou mayest learn a great part of the general rules of theory in astrology" (20–25). The MED allows that a doctor (doctour) is understood to be an authority or expert in any field of knowledge. Then the term *physik*, although it can identify concerns for the human body, also relates to natural sciences, as in Aristotle's *Physics*. The Doctor's portrait will be found to have two distinct faces. Again, we'll grant the traditional understanding as serviceable at the primary layer, but we'll turn it inside-out to discover a face of a darker aspect peering at us.

Chaucer calls upon a riddle tactic as a beginning.

In al this world ne was ther noon hym lik,
To speke of phisik and of surgerye,
For he was grounded in astronomye.

(A 412–14)

(In all this world there was none like him,
To speak of "phisik" and surgery,
For he was grounded in astronomy.)

The poet doesn't say there is *no one else* like him in the world; the claim is that no one like him is *in this world*. A subtle, but effective clue to an extraterrestrial. This pilgrim could speak of medical matters (they so often went wrong) from his basis in astronomy. He was a powerful influence of an unfortunate outcome. The third line captures the fact that astronomy is his foundation.

The Doctor's description is filled with divergent impressions.

He *kepte* his pacient a ful greet *deel*
In houres by his *magyk natureel*.

(A 415–16)

(He kept his patient a full great "deel"
In hours by his natural magic.)

Words play different roles—the force at the covert level is *not* for good but for evil. To *keep* sounds protective, concerned, but it also intends *to force to remain, to take possession by force*. The patient (person who is afflicted) is being kept in distress. This great *deel* has connotations of putting an end to one's life, distinguishing the *evil* hours to administer medications (rather than *beneficial* hours) and to *deal* somebody his fate. *Natural magic* constitutes the pilgrim's knowledge of "hidden forces," "stellar influences" in dealing with disease. Chaucer warns, in the *House of Fame*, that those who know "magik natureel" understand how to "make a man be whole or *sick*" (1270).[444] The know-how can be used both ways.

> Wel koude he *fortunen* the ascendent
> Of his *ymages* for his pacient.
>
> (A 417–18)

> (Well could he foretell the power of the ascendant
> Of his images for his patient.)

At the level we are pursuing the *fortunen* corresponds to the *control of someone's destiny*, deciding someone's fate, again. There is, after all, good fortune and bad. Properly foretelling the ascendant was considered important before an undertaking. Next, checking the MED for various uses of *image*, the *House of Fame* quote (seen above) appears again, but in a slightly different form. The emphasis is changed and is even more applicable to our Doctor/Saturn. In "certain ascendants [one can use] images through which magic makes a man be whole or *sick*." This doctor had the fate of patients in his hands as he used images and his skill with magic to make them sick—Saturn's role beneath a physician's exterior.

He was knowledgeable, but to what end?

> He knew the *cause* of everich maladye,
> Were it of hoot, or coold, or moyste, or drye,
> And where engendered, and of what humour.
>
> (A 419–21)

> (He knew the cause of every malady,
> Whether it was hot, or cold, or moist, or dry,
> And where engendered, and of what humor.)

His skill was knowing "the *cause* of every malady"—not the cure. He knew symptom, source and effect.

> He was a verray, parfit *praktisour*:
> The cause yknowe, and of his harm the roote,
> Anon he yaf the sike man his *boote*.
>
> (A 422–24)

> (He was a very, perfect practicer:

Knew the cause, and of harm the root, the origin,
Immediately he gave the sick man his remedy/his boot.)

Practice means to apply knowledge, rather than to theorize.[445]
Chaucer (in the *Astrolabe*) refers to the *practice* of aforesaid conclu-
sions (p. 546). A most outstanding "praktisour" is the Wife of
Bath, who was urged "teach us your practice" (D 187). The Pilgrim
Doctor/Saturn is simply proficient at doing what he knows and
following it through. And what does he know? He knows the
cause, the root, of each ailment and how to make the condition
worse.

In A 424, "his" has a dual function. If we think this is a helpful
medical man, then *he* (the Doctor) gave the sick man *his* (the sick
man's) remedy (*boote*). But, from the cruel and malevolent Saturn
personality, we expect the Doctor to give this man an application of
the Doctor's boot (*boote*) to add to his misery. From Saturn's point of
view, making things enjoyable is *not* making them better, but worse.

> Ful redy hadde he his apothecaries
> To sende hym drogges and his letuaries,
> For ech of hem made oother for to wynne—
> Hir frendshipe nas nat newe to bigynne.
>
> <div align="right">(A 425–28)</div>

> (Always ready were his apothecaries
> To send him drugs and his medicines,
> For each of them made the other a profit—
> Their friendship was not something new.)

The apothecaries were on good terms with the Doctor/Saturn.
Their drugs and medicines and potions were ready and waiting.
This Doctor and the druggists benefited each other. It was a rela-
tionship of long standing. I can just hear the apothecary's prayer to
Saturn—a variation on the merchant's prayer to Mercury—"Please
send plenty of maladies to others so that I can get rich." Saturn en-
joys and druggists revel in a "wynne/wynne" outcome.

Next, we're greeted by an historic role call of physicians. With
Saturn's penchant for maladies, calamities, it's no wonder he's ac-

quainted with a long list of medical men.

> Wel knew he the olde Esculapius,
> And Deyscorides, and eek Rufus,
> Olde Ypocras, Haly, and Galyen,
> Serapion, Razis, and Avycen,
> Averrois, Damascien, and Constantyn,
> Bernard, and Gatesden, and Gilbertyn.
> <div align="right">(A 429–34)</div>

> (Well he knew the old Aesculapius,
> And Dioscorides, and also Rufus,
> Old Hippocrates, Ali Ben el-Abbas, and Galen,
> Serapion, Razis, and Avicenna,
> Averroës, Damascien, Constantinus,
> Bernard, and Gaddesden, and Gilbertus.)

I know these are all doctors because the notes to the lines identify them.[446] Chaucer's poetry demands, and has received, a lot of scholarly analysis which we benefit from today. (For decades, perhaps centuries, his lines have been judged worth the effort.) When the notes explain that these medical men produced *writings* known to the Pilgrim Doctor, I agree and then smile because his Saturn counterpart knew the *men*, those authors, when they lived. The poet doesn't mention medical treatises; they are just a reasonable human assumption for the surface plot.

The Doctor's/Saturn's diet plays a part.

> Of his *diete mesurable* was he,
> For it was of no superfluitee,
> But of greet *norissyng* and digestible.
> <div align="right">(A 435–37)</div>

> (Of his diet "mesurable" was he,
> For it was of no superfluity,
> But of great "norissyng" and digestible.)

It's no wonder that the poet gets around to talking about eating-habits. Saturn is fairly unique in this area. (I say only "fairly" be-

cause mythology is inclined to solve problems with a "family" meal.) If we take *diet* to be a "customary way of eating" and *mesurable* as "appropriate to the nature of the problem," we have Saturn's method of trying to prevent a filial coup. Babies take a while in gestation so there was no overabundance of this foodstuff. Line A 437 is peculiar because it is easily understood as meaning *nourishing* and digestible, but there is also a "movement among meanings." *Norissyng* can have to do with "the act of bringing forth young"[447]; they immediately served as part of Saturn's diet.

Non-reading habits provide reverse information.

> His studie was but litel on the Bible.
>
> <div align="right">(A 438)</div>

(His study was but little on the Bible.)

Here's another of those lines that place a pilgrim outside and pre-dating the Judaeo-Christian world.[448]

Two lines of trivia regarding colors and fabrics constitute the entire "physical" detail of this portrait.

> In *sangwyn* and in *pers* he clad was al,
> *Lyned* with taffata and with *sendal*;
> And yet he was but esy of dispence.
>
> <div align="right">(A 439–41)</div>

(In sanguine and in "pers" he was all clad,
Lined with taffeta and with "sendal";
And yet he was hesitant to dispense.)

Though sanguine is explained as the color *red*, it also refers to a humor (an aspect of his personality, his nature), but, even more significant, it echoes the Latin term for *blood*. To picture him covered (clad) with blood brings forth the earlier description of Saturn, "savagely inclined to harsh and bloody acts." That's the personality we are dealing with. *Pers* is a shade of blue, perhaps purplish or blue-gray. My mind's eye responds with an image of what might be Saturn's favorite enveloping: a body blue-gray, discolored

and bloody.[449]

At A 440, we have a problem. *Taffata* and *sendal* are fabrics, and this is the only time Chaucer uses these words and the only time he refers to a lined garment—if he means a garment. Baugh says they are both silk fabric, but the MED disagrees about *sendal*. Sendal is a cloth used for cleansing, which would be an unlikely use for silk. It is noted as the fabric of a winding sheet, a shroud.[450] That Saturn connection is strong.

We learn, at A 441, that, although the yardage just mentioned is expensive, the pilgrim, by nature, is hesitant with "dispence." The assumption, on the part of the reader, helps conceal a second intention of the poet. But because "money" is not specified—an amount or type of coin—the statement about "dispensing" has ambiguous possibilities.

> He *kepte* that he *wan* in pestilence.
>
> (A 442)

> (He kept what he "wan" in pestilence.)

In the primary reading, *wan* sounds like the Doctor *won*, made a profit, during the plague. But wait, a very dark side underlies the words. With all the negative connotations of *kept*—take possession, take by force, force to remain, remain in a certain condition—there is little evidence that the Pilgrim Doctor was concerned with *aiding recovery*.

Wan makes matters worse for the patient. The verb means to become dark-colored, livid. It is a term applied to lead or things leaden-colored. (Lead is Saturn's designated metal, a proper poetic connection. Another Canterbury traveler complains that his own coloring is "wan and of leden hewe" [G 728].) Distressing connotations for "wan" abound, such as gloomy, ominous, sickly, unwholesome, discolored by bruising, and the color associated with signs of death.[451] Our Pilgrim Doctor/Saturn has control over those whose color turned unhealthy, whose fate worsened in the pestilence.

The final lines recall the "good old days."

For gold in phisik is a cordial;
Therefore he lovede gold in special.

(A 443–44)

(For gold in physic is a cordial;
Therefore he loved gold especially.)

Gold, as a cordial, lifts his heart, his spirits, recalling the time of the Golden Age, when he was revered.

Once again we have met a pilgrim that is a planet, and no bodily description is offered aside from a mention of colors and fabric. It's the easy way to avoid complications of creating a multi-level portrait.

There is no prologue to the story the Pilgrim Doctor tells, but let's take a brief look at the story itself. It has been said that "its assignment to the Physician is not especially appropriate."[452] We'll reserve judgment on that.

Chaucer adapts a bit of Roman history and augments the story with two additions. The added material has been called an "unskillful inclusion of extraneous material" which exhibits "faulty motivation."[453] Without these additions, however, the original tale would only have been about 150 lines. Saturn, it would seem, deserved a lengthier narrative. The result is a monologue quite openly characterizing his reputation, and the underlying sense is suited to Saturn's interests.

A section of eighty-five lines advocates proper care of children. Children, it says, can become "too ripe and bold" too soon, which is perilous as it was long ago (C 67–69). This can allude to the Golden Age, and the problems that developed in Saturn's family life. With a similar tone, *fathers* are addressed first, "and mothers too," with a warning to keep children under "surveillance" and not to neglect "chastising" (C 93–98).

Chaucer's second addition is a conversation between the father, the story's main character, Virginius, and his daughter, Virginia. (Why duplicate names?) Returning home from an appearance before a judge, he regrets to inform his daughter that she must choose between "death and shame." A judgment handed down is

forcing the father to turn over the daughter to a lecher who has lied to sway the judge's decision. It's lechery or death. The girl chooses death. (When Saturn first took the stage, "human sacrifice, especially of children" was mentioned as a topic to return to later [p. 251]. Later is now.) When the girl swooned, her father, heart filled with sorrow, "smote off her head" (C 255). That's a horror story. That's a child sacrifice. That's Saturn's kind of entertainment. What Chaucer adds develops the story he wants to tell. It is actually "especially appropriate" for this Doctor/Saturn to tell.

While old Saturn retreats to the most distant area of our theatre, we can feel a contrasting warmth as the Sun makes ready for his appearance.

THE HOST

The guide of all the pilgrims is striding toward the audience. A vibrant glow precedes the journeyer's entrance. With his arrival on stage, the other pilgrims become relatively invisible, their light overcome by his presence. Chaucer, however, has the genius to set this Sun, the Host, in his place while allowing the pilgrims we have already met to become visible again. (It's only a matter of adjusting the stage lighting. The poet, remember, is running the show.)

The sun, from earliest times among many peoples, was considered the Supreme Being. Pliny describes the sun as the soul and mind of the world, who lights the stars, regulates the seasons and brings each year to birth. The *Iliad* describes the sun as all-seeing and all-hearing. All the stars, and the sun in particular, were reckoned unconquerable: as often as they sank, they rose again. In Roman paganism, this star of the day was called *deus aeturnus* and *invictus*, that is, eternal and victorious.[454]

The sun's orbit, a line called the ecliptic, was divided into 360 parts, one for each day. Five intercalary (between calendars) days were added to get back to the celestial starting point; one extra day added every fourth year was also part of the plan. (Our February 29 is an intercalary day.) That worked for quite a while. It was a good approximation. But over the centuries, the signs and months drifted away from their coordination. (It has to do with the precession of the equinoxes mentioned in the introductory "Plan," p. 40). We'll talk about that later.

Cicero explained the name *sol*, for the sun, to mean *solus*, alone. *Sol* was either alone because no other heavenly body of that magnitude existed, or because when the sun rises, it's the only star you can see. It must have caused quite a stir when, during a solar eclipse, early astronomers discovered that the stars shine even during the day. We're prevented from seeing them only because of the sun's intense brightness.

Cosmographia provides a medieval astrological opinion of the sun. Speaking of his "Helian highway" (Helios is Greek for the personified sun), he governs "the universe...is preeminent in brilliance, foremost in power, supreme in majesty...spark of perception in creatures, source of power of heavenly bodies and eye of the universe" penetrating creation with radiance and warmth.[455]

He is "the middle among the planets" in order, which brings "harmony and accord" to the heavens. In reviewing the pantheon, Macrobius affirms that, "Even Jupiter himself, king of the gods, does not, it seems, rank higher than the sun."[456]

It was an easy step in early Christian thought from the sun to the identity of Christ, of God. Chaucer's *Boethius* openly states that this same God, who alone sees all things, "thou mayest say that he is the very (the true) sun" (V:m. 2).

Christ's nativity, celebrated at the time of the winter solstice, is Augustine's topic as he exhorts, "Let us keep this day as a festival; not, like the unbelievers, because of that sun up there in the sky, but because of the one who made the sun."[457] Devotion is to be directed toward him "who was called the Sun of Righteousness." This "lord of planets, beauty and perfection of all the stars" is also "moderator of the firmament"[458]—precisely the role the Host/Sun plays on the Canterbury pilgrimage as he moderates the progress of the celestial pilgrims.

With the approach of the vernal equinox, the sun plays an essential part at Easter, as well. It is the feast of the "dispersal of the darkness by '*Christus Sol*,'" Christ, the sun, in the spring of the year."[459] *Cursor Mundi*, referring to Christ, rejoices, "The sun uprose to glad us all" (18654). We hear an echo of that line in Chaucer's description of the Host: "when the day began to spring, / Up rose our Host" (A 822–23). It is he who volunteers to guide the journey. He sustains the travelers and governs them.[460] At the co-

vert level, we can understand now his stellar dimension. He is the "moderator"; our pilgrims, the firmament.

The sun sustains them by providing his light to the travelers and inscribing his path in the celestial spheres; he governs the heavens. As Lord of the Universe, the Host's/Sun's "way" is the line of the ecliptic, through the zodiac, the path the signs follow. This parallels the role of the Host with the "human" pilgrims—sustainer and guide—as they "goon by the weye" (A 771), as they "riden by the weye" (A 780). And, though the planets appear to have "freewill" in their movements, they never stray more than a few degrees outside this ecliptic path.[461]

The Host tells no story, but his magnificent presence, his unique relationship with each journeyer, creates an entire world for the pilgrimage. (His Christic identity is subtly delineated and has been dealt with elsewhere.[462]) Let's take a giant leap now to the end of the pilgrimage.

We join the travelers as they are drawing near to (but will never reach) Canterbury. It is late in the day as the Host recommends:

> But hasteth yow, the sonne wole adoun;
> Beth fructuous, and that in litel space,
> And to do wel God sende yow his grace!
>
> (X 70–72)

> (But haste thou, the sun will go down;
> Be fruitful, and that within a little time,
> And to do well, God send you his grace!)

Lines alluding to being fruitful before the sun is down seem inspired by Christ's exhortation in John 9:4–5.

> We must do the deeds of him who
> sent me
> while it is day.
> The night comes on
> when no one can work.
> While I am in the world
> I am the light of the world.

(New American)

As Chaucer positions the Sun and adjusts the intensity of his beams, a commotion can be heard as a group makes ready to come on stage. Prepare for the entry of Mars.

THE KNIGHT

The poet bows low and then stands at attention as a colorful group makes its way from backstage. A Knight and his small entourage have joined us—the Knight, still in soiled battle garb; his son, in elegant and stylish array; a servant, well-equipped, his arrows peacock-fletched.

The Knight, we said in the beginning, is the image of the planet Mars, the red planet. Its main characteristic is its red tinge. Over centuries it has commonly been referred to as "fiery." Because it changes position slowly, it should be easy to locate a second time within a reasonable interlude. At times, depending on the comparative position of the sun, Mars is the fourth brightest object in the sky. Pliny was able to estimate Mars' orbit at about two years.[463]

Ancients considered Mars' influence on earth strong. *Cosmographia*, a twelfth-century study of the universe, said Mars, "visits war upon proud cities, and his red glare often works strangely upon kings." Elsewhere, the same author, Bernardus Silvestris, describes the "emboldened" planet aroused by its position in a hostile sign seeking "a way of breaking out of his orbit...transformed to a comet, he might appear, blood-red and terrifying, with a starry mane."[464]

Myths about Mars are numerous. He is said to have sired Romulus and Remus (who were suckled by a wolf, as memorialized in the famous sculpture). Romulus went on to found the city of Rome. Another well-known story tells of Mars' tryst with Venus which was interrupted by the arrival of the sun, causing laughter among the gods at Mars' embarrassment. (This is recounted in Chaucer's "Complaint of Mars.") He is recognized as the god of war, of course, and may have been addressed as the god of bountiful, good crops and healthy, fecund farm animals, too. In October a Martian celebration (on the 15th) featured a chariot race "in the Field of Mars." In gratitude for victory, the right-hand horse of the winning team was stabbed with a spear as a sacrifice to Mars.[465]

Ovid records that the god was also honored and commemorated by Romulus: "We name the beginning of the Roman year after thee; the first month shall be called by my father's name."[466]

There was no greater protestor about things pagan than Augustine. He concludes, of Mars, that if there were "perpetual peace," the god would have nothing to do. And, "if war itself is called Mars…it is clear that he is no god." Petrarch's *Africa* finds the god vital and "bloodstained."[467] (We'll return to another Christian thought as we conclude the introduction of the Knight's group.)

Mars, as a character often used by Chaucer, is fierce—"Mars the red," god of battle, god of arms, and likened to iron. In *Troilus and Criseyde*, Mars' image is addressed as "Mars with thy bloody cope"; Troilus, wanting to be prepared for approaching death, reminds his confidante, Pandarus, "offer Mars my steed." And in the "Complaint of Mars," the worthy Mars is seen as the "welle" (the source) of knighthood. In his stellar identity, when things have gone poorly for the god, he is said to be feeble because he passed only one star in two days! In the Knight's story there is a lengthy, grisly, detailed picture of the temple of Mars and, in reply to prayer offered there, the armor of the sculpted deity begins to "ring"; the word "Victory" is heard by the suppliant.[468] (That isn't the last word in the plot, however.)

The Pilgrim Knight is the first of the journeyers presented by the narrator. I wonder if Chaucer was feeling his way along, not completely sure where this journey (as a story and as an endeavor) would take him.

And so he begins:

> A Knyght ther was, and that a worthy man,
> That fro the tyme that he first bigan
> To riden out…
>
> (A 43–45)

> (A knight there was, and that a worthy man,
> Who from the time he first began
> To ride out…)

As very worthy Mars, a reference to time and to him as "first began to ride out" seems a simple reference to Mars as first mover when time began.

> Ful worthy was he in his lordes werre,
> And therto hadde he riden, no man ferre.
>
> (A 47–48)

> (Full worthy was he in his lord's war,
> And thereto had he ridden, no man farther.)

It is speculated that this dedication to his "lord's war"—according to those who studied the historic battles about to be listed—gives the impression that this "lord" must be God Himself. The extended time covered by the battles named discourages seeing the Knight patterned after a particular historical personage, a pursuit enjoyed by scholars concerned with the pilgrims in general. When we learn of his battle experience, it seems out of character that none of the conflicts are concerned with the Hundred Years' War,[469] a campaign that continued throughout Chaucer's life. The Knight, of sufficient prestige to be one of those at the head table, is noted (A 52). Then the poet lists Alisaundre, Pruce, Lettow, Ruce, Grenade, Algezir, Belmarye, Lyeys, Satalye, Tramyssene, Palatye, Turkye and "in the Grete See" (A 51–66). (That is, Alexandria, Prussia, Lithuania, Russia, Grenada, Algeciras, Benmarin, Ayas, Adalia, Tlemcen, Palatia [ancient Miletus], Turkey and the Mediterranean.) These are areas of religious warfare (Christian against pagan) covering a period of more than forty years. The natural assumption is made that the Knight has just returned to England. The otherworldly impression of his "lord," however, can leave the Knight/Mars unattached—to England or to the Continent. The "Great Sea," in the travels of a planet, would, of course, correspond to that area of the heavens called "the Sea."

The narrator declares,

> He was a verray parfit, *gentil* knyght.
>
> (A 72)

(He was a very, a truly perfect, gentle/gentile knight.)

He's perfect. Baldwin calls him "the abstraction of an ideal." His battles are "a great rollcall of crusades against the infidels."[470] How strange that no *political* battles are involved. Each battle involves *infidels*. I wonder why we assume he was *against* the infidels. After all, he was a "gentil" knight, the adjective expressing *gentile*—pagan—as well as *gentle*—noble.

Chaucer makes two claims of the Knight's worthiness that hold an ambiguity about his position. He was found "Ful worthy.../.../As wel in cristendom as in hethenesse (the heathen world)" (A 47–49). We have encountered this crossover many times, where the image of Mars is transformed into a Christian role. A few lines later a reference is made to "No Cristen man...of his degree" (A 55). (The obvious astrological sense—degree—is not our concern here.) The poet does not say, "No *other* Christian man," but "No *Christian* man" has performed as the Knight has, which puts him outside the Christian community.

The poet was able to present clincher clues with the notable stars in a constellation, but the visual embodiment of a planet lacks complexity; it is not as versatile. We will have to watch closely as each introduction approaches its end. Here the lines turn to a few details of the Knight's appearance. It is important to note that there is *no* physical description: no height, no strength, no age, no details of eyes, hair, facial attitude. Instead, we learn about his horse:

> His hors were goode, but he was nat gay.
>
> (A 74)

(His horse was good, but he was not noble, strong.)

This knight, the most prestigious individual in the Canterbury company, has a horse found to be only "good." What a mediocre impression! The Canterbury story of Sir Thopas finds a foolhardy knight riding a *dextrer*, a war-horse. Why doesn't the ideal knight have an ideal horse? The disparity in the picture is a signal. The mount was not "gay," that is, it was not noble, strong, gallant. I take this chosen horse as an allusion to a sacrificed animal central to that important ritual associated with Mars.

Then we're given a penultimate detail.

> Of fustian her wered a gypoun
> Al bismotered with his habergeoun.
>
> (A 75–76)

> (He wore a tunic made of coarse fabric
> All besmattered along with his coat of mail.)

His tunic is stained as a parallel to Mars' image with a "bloody cope." (The planet, too, is "stained" red, no doubt an inspiration for a *bloody* garment.) When the Knight is seen "still in the battle clothes" of his most recent war, I see a signal. This is not a reasonable expectation. True, the fourteenth century didn't shower frequently, nor did it demand pristine cleanliness in clothing. But, his "battles" were across the European continent from this road to Canterbury. Military action was days, weeks away in time. (The son, we will find, is beautifully attired.) The image of a battle-besmirched man of war wearing a protective garment of the battlefield is the necessary image for our mind's eye. The fact that he has come to do *his pilgrimage*, the ultimate word Chaucer uses to describe him, is because it identifies him as an essential *pilgrim*—a *planet*.

The story he tells is in keeping with his Mars identity, "the pagan past at its most noble and dignified."[471] It is a tale Mars knows as one of his own experiences because the deity is an influence in the outcome of the story.

And what of his son?

THE SQUIRE

In spite of differing itinerary,

> With hym ther was his sone, a yong Squier.
>
> (A 79)

> (With him there was his son, a young Squire.)

We recall that twenty-nine pilgrims arrived en masse at sunset; we understand the allegorical intent. But, here again, is a surface detail

that ought to be thought-provoking. As William Witherle Lawrence has pointed out, "the Squire's military excursions are dissociated from those of his father."[472] And yet, in this medieval world sans telephone, sans e-mail, etc., the father and son manage to coordinate their simultaneous arrival from different points of the world. Yes, this is a fantasy.

We should establish who, as son of Mars, this Squire is. If we choose Cupid/Eros (from many progeny), the poet does his best to construct a corresponding portrait.

> A lovyere and a lusty bacheler,
> With lokkes crulle as they were leyd in presse.
> Of twenty yeer of age he was, *I gesse.*
> Of his stature he was of evene lengthe,
> And wonderly *delyvere*, and of greet *strengthe.*
>
> (A 80–84)

> (A lover and a lusty bachelor,
> With curly locks as if they were laid in a press.
> Twenty years of age he was, I guess.
> Of his stature he was average height,
> And had wonderful delivery, and great strength.)

There is that curly-haired boy (or young man) so familiar in cartoons and Valentines, as well as formal works of art. Then, too, there is that vague ending regarding his age—"I guess." In appearance the mythological figure is twenty, but in actual existence, century upon century. "I guess" is Chaucer's way of being informative on one plane, while being evasive on another. His *strength* and *delivery* are associated with skillful release of arrows that accurately hit their mark.

He's had considerable practice.

> And he hadde been somtyme in chyvachie
> In Flaunders, in Artoys, and Pycardie,
> And born hym weel, as of so litel space,
> In hope to stonden in his lady grace.
>
> (A 85–88)

(And he had been some time in a riding expedition
In Flanders, in Artois, and Picardy,
And bore him well, in so little space,
In hope to stand in his lady's grace.)

F. N. Robinson's note records that "it is possible, as several scholars have suggested, that in making the portrait Chaucer had in mind his own youth.... He had even taken part himself, in 1369, in a campaign in Artois and Picardy."[473] There is no doubt he was thoroughly familiar with the three locations in this area of France. (His familiarity is well noted in his personal tale of Sir Thopas.) The horse riding expedition (chyvachie) fits the picture nicely, too. We can see an autobiographical impression of Chaucer as a victim of Cupid's arrows.

Clothing celebrates the season.

> Embrouded was he, as it were a meede
> Al ful of fresshe floures, whyte and reede.
>
> . . .
>
> He was as fressh as is the monthe of May.
> Short was his gowne, with sleves longe and wyde.
>
> (A 89–93)

> (Embroidered was he, as if it were a meadow
> All full of fresh flowers, white and red.
>
> . . .
>
> He was as fresh as is the month of May.
> Short was his gown, with sleeves long and wide.)

What colorfully elegant attire! Especially when compared with his father's outfitting. Rosemond Tuve, in describing medieval Books of Hours, draws particular attention to the "Chaucerian figure" of the Squire. His curly hair, decorated garment, wide sleeves and associated flowers are common to several manuscript illustrations of the personified "monthe of May." I often wonder whether Chaucer had a visual pattern for the physical characteristics of his pilgrims. Tuve similarly speculates, "Perhaps Chaucer's squire was 'as fresh'

as a very particular 'month of May.'"[474]

The lines A 95–98 continue to delineate a passionate and accomplished young romantic. (We'll look at the final two lines and then return for some word play.) We've already established that his father, the Knight, sits at the head table (A 52), which is completely appropriate for Mars. Those with him at table would be other powerful gods: Jupiter, Apollo, and Pluto, for example. Then the end of the Squire's portrait tells us,

> Curteis he was, *lowely*, and *servysable*,
> And *carf* biforn his fader at the table.
>
> (A 99–100)

> (Courteous he was, lowly and serviceable,
> And cut/pierced before his father at the table.)

We can find traces of Eros/Cupid as a shorter figure, or of a lesser rank, than the other gods (*lowely*). He also serves *willingly*, in his own particular fashion, or is *useful* (*servysable*). And if we understand the "carf" to mean *pierce* with a pointed weapon, then incidents involving Cupid are recalled as he pierced both Pluto and Apollo with his pointed weapons (arrows) and had to run to his mother (Venus) for protection.[475]

Now let's look at two of Chaucer's double-duty words.

> Juste and eek daunce, and weel *purtreye* and write.
>
> (A 96)

> (Joust and also dance, and well "purtreye" and write.)

There is a good chance that the Squire's ability to "weel purtreye" (besides alluding to portraiture) is concealing a glimpse of *putti* (cupids) which were popular in fifteenth-century Italy, and I wager were developing that popularity when Chaucer made his visits there. (Italians enjoyed the image of Cupid so much that they multiplied it as *putti* or *cupidines*.)

I wouldn't hesitate to see a second play on "purtreye" as *putrie* (lechery, adultery). When wounded by Cupid's arrow, one is help-

less to resist romance, no matter how immoral, irresponsible or id-
iotic the object of affection may appear to others. (For example,
Venus was wounded accidentally and fell in love with a baby boy.)
Then there is the poet's choice of "floytynge" in

> Syngynge he was, or *floytynge*, al the day.
>
> (A 91)

> (Singing he was, or "floytynge," all the day.)

Baugh's note says *floytynge* means "playing the flute or (possibly)
whistling." (*Flute* is "floute." MED) This is a reasonable explication
for the surface. But the word has a special interest when you know
you are dealing with an image of Cupid. Because fourteenth-cen-
tury English was uninhibited by spelling rules, the MED can lead
you on a merry chase to catch the proper meaning. (This time it
was a short chase.) Starting with "floy" (the root of Chaucer's
word), it points the searcher toward "flien" (not toward "flout")
which gives you "flying with wings, passing through the atmo-
sphere or the sky." The alternate image of the Squire is hovering,
looking for his next victim. A double meaning for Cupid (both as
love and the spirit of *fornication*) has an ancient tradition going
back to Plato. Such allegory developed a Christian interpretation,
as well.[476]

THE YEOMAN

The Yeoman, the servant, is the central figure between the father
(the Knight), and the son (the Squire), but only for a short time.
His is one of the briefest introductions, a mere seventeen lines.

> A Yeman hadde *he* and servantz namo
> At that tyme, for hym liste ride so,
> And he was clad in cote and hood of grene.
>
> (A 101–03)

> (A Yeoman had he and not servants more
> At that time, for he wished to ride so
> And he was clad in a coat and hood of green.)

The "he" of A 101 is ambiguous. Editors generally direct that the Knight is indicated, but "he" just as easily could refer to the Squire. Leaving the connection indefinite may have a purpose we'll get to later.

Color continues to be celebrated.

> A sheef of pecok arwes, bright and kene,
> Under his belt he bar ful thriftily—
> Wel koude he dresse his takel yemanly.
>
> (A 104–06)

> (A sheaf of peacock arrows, bright and keen,
> Under his belt he bore very properly, skillfully—
> Well could he dress his tackle professionally.)

Peacock feathers are attention-getters. They are a natural conversation piece. Aerodynamically, however, it is questionable whether such feathers would make proper fletching for arrows. A toxophilist (lover of archery) from the time of Henry VIII was outspoken in his opinion: "Peacock feathers seldom keep up the shaft either right or level, it is so rough and heavy, so that many men which have taken them up for gayness [*display* or *distinction*, OED], hath laid them down again for profit."[477]

After much internal deliberation, I've decided that the only thing to do is go out on a limb with this character—and take you with me. The Yeoman doesn't tell a story. After he is introduced, he is never seen or heard from again. We have no mythology, no astrology, just these seventeen lines.

Here, then, is my much-labored-over impression. This is a *peacock* playing the part of a Yeoman. I think Chaucer's word-choices will prove it. I have a fairly good idea as to why this is a bird, and we'll talk about that after a bit.

For now let's look at the details the poet provides. To begin, that *sheef* of arrows can be a *bunch* of arrows rather than a container for them. These peacock arrows (we're talking about the feathers, of course) he bears under his belt. Below the waist of a peacock is the proper location for this bunch of showy feathers. In addition,

the Yeoman's expert ability to *dress* (adjust, arrange) his equipment is an important analogy when considering the capabilities of presenting the spectacle of the tail feathers, and then neatly packing away this "equipment" once again.

> His arwes drouped noght with fetheres lowe—
> And in his hand he baar a myghty bowe.
>
> (A 107–08)

> (His arrows drooped not with feathers low—
> And in his hand he bore a mighty bow.)

If we were actually talking about arrows, why would feathers of such poor quality (that they *droop*) even be thought about? If, instead, it's the carriage of the peacock, the management of his splendid attribute, *that* is worth commenting upon. The vocabulary serves the concealed image as well or better than the primary image. Then A 108 tells of his mighty *bow*. The word in Middle English could be understood as *rainbow*. Not only is the contour of the peacock's tail *bow*-shaped, but the bird's display creates a rainbow par excellence.

The head and face are properly crafted.

> A not-heed hadde he, with a broun visage.
>
> (A 109)

> (A close-cropped head had he, with a brown visage.)

With closely cropped hair, and brown at the center of his face, we can see the smooth feathers of a bird's head and his facial features, his "eyes, nose and mouth."

Dominant habits are noted.

> Of *wodecraft* wel koude he al the usage.
>
> (A 110)

> (He knew all about the ways of the forest.)

The Yeoman knew the life of the woods, and so did peacocks. The birds were both domesticated and wild. They made up part of the medieval diet. In the wild they would roost in tall trees and enjoy the sylvan existence as long as they survived the hunter's arrow. A second and different kind of image is hidden within the usage of *wodecraft*. (This is a Chaucer one-time-only word.) *Wode*, that we now spell "woad," was a source of blue dye. A "movement among meanings" finds the line to say that this Yeoman/peacock knew the craft, the skill, of using blue coloring. A peacock's use of blue is an extravaganza.

And now for the weaponry.

> Upon his arm he *baar* a gay bracer,
> And by his syde a swerd and a bokeler,
> And on that oother syde a gay daggere
> Harneised wel and sharp as point of spere.
>
> <div align="right">(A 111–14)</div>

> (Upon his arm he bore an elegant protective covering,
> And by his side a sword and buckler,
> And on that other side an elegant dagger
> Harnessed well and sharp as the point of a spear.)

Have you noticed the repeated use of *bar/baar* throughout his depiction? It's such a modest word; we pay it little attention. But repeated words are a signal. In twelve lines Chaucer uses *bar* four times: The Yeoman *bar* arrows, *baar* a mighty bow, *baar* a bracer and soon he'll *bar* a horn. This is the verb "to bear" (*beren*). The Yeoman *bore* all these things. Why didn't he *wear, hold, have, use*? Why not incorporate variety? Because *bar* can mean "to have [something] as part of one's body" (MED). Examples given are: a ram *bar* fleece of gold; a beast that *bar* horn; a cock *bereth* a comb. Chaucer's unchanging verb tells us that each of these "things" the Yeoman *bore* are, for the peacock, parts of his body: tail feathers, understandably noted twice; the texture above his claw; the sound of his voice. Recalling the figures of the ram, goat and bull we've already deciphered and the means the poet used to depict the use of their horns as their defense system, the pattern is similar for this

bird with talons. A weapon well-harnessed is a particularly apt portrayal of the aggressive equipment being securely attached; it's part of the body structure. (Pliny, centuries before, said of birds with talons that they have "weapons [that] grow upon their legs."[478])

The next line appears to have two purposes. We'll deal with one of them now.

A Cristophre on his brest of silver sheene.

(A 115)

(A Christopher emblem on his breast of silver shone/sheen.)

The Middle English word order leaves the reader with the question, "Is it the Christopher emblem that glistens—or the feathers?" Modern usage speaks of brilliant "metallic" greens and blues to describe the peacock. A fourteenth-century suggestion of silver could intend that metallic quality. Speaking of the same bird family, Lydgate obliges with the descriptive used by Chaucer: "The peacock...with his feathers *schene*."[479] The *Christopher* seems a play on the Latin *cristatem*, which denotes a peacock's crest. *Pavo cristatus* is a peacock. We'll review this Christopher again.

He comes bearing color once again.

An horn he bar, the bawdryk was of grene.

(A 116)

(A horn he bore, the shoulder strap was green.)

The Yeoman's horn provides the ugly, raucous sound made by the peacock. The means of securing "the horn," as we would expect, is the same color as his coat and hood.

Here we are at the last line.

A forster was he, soothly, as *I gesse*.

(A 117)

(A forester was he, truly, as I guess.)

As is Chaucer's habit, the "I guess" tells us that—as far as the covert level is concerned—a forester is what he is *not*.

Now, how to begin to explain what I see in my head, and why the Yeoman must be a peacock? It will get complicated, but I think it will all work out.

We have before us a group of three figures. The father, the son and the peacock. It recalls for me an exasperated reply I once heard given by a theologian. In response to a question about the role of the Holy Spirit, he responded, "That damned *bird!*" The third *person* of the Trinity is not a bird, not a dove. That's just a mental picture we are attached to. I think Chaucer, with pagan personifications, is replicating that picture of the Trinity. That's why a bird needs to be part of this group.

We've said quite a bit about Christianizing pagan figures, and that we would return to do so here. First we have Mars, as god of war, a parallel to the *Old Testament* proclamation, "The Lord is a man of war" (Exod. 15:3). Wyclif, for example, sees "knighthood representing the might and the power of the father." Then there is the Squire with his loving attributes and Eros identity. In the time of the New Testament, 1 John 4:8 says, in contrast to Exodus, "God is love." Mythology of Eros had been recast with Christian identities. And Christ himself was, for Augustine, the archer of love: "You had pierced our hearts with the arrow of Your love."[480]

Three related figures—poetically, philosophically—are not a rarity. Some philosophers found "manifestation of the mythological 'trinity'" aligning Jupiter, Minerva, and Juno, while others created philosophical figures who were subsequently defined as they "whom Scripture identifies as Father, Son and Holy Spirit."[481]

For philosophers and theologians, the concept of the Trinity takes up much of their thinking. Chaucer was well-read on the subject, we can assume. The Arian heresy (touched upon with the Wife of Bath) saw the Holy Spirit as "a mere creature," one of the "ministering spirits, who differs only in degree from the angels."[482] This statement gives us two points of comparison. First, the peacock is clearly a mere *creature*, and immersed in pagan mythology. (See "Argus.") Secondly, angel wings, in medieval illustration, were made of peacock feathers. Chaucer's portrayal presents the Yeo-

man/peacock in a pagan light and creates an angelic aura, as well. Viewed through an Arian veil, we see the potential of a poetic variation of the third person of the Trinity.

Augustine, the ever-present source, "made of the Trinity a key both to the nature of God and to the nature of man and the world."[483] It should be no surprise, then, to find a three-element pattern in the thoughts of a poet so surely influenced by Augustine. Who the Yeoman serves, we said earlier, is ambiguously stated. Does he serve the father or the son? Perhaps the ambiguity is necessary because the relationship between the Father and Son in regard to the Spirit was a question of debate. There was (and is) no universal agreement.

The Canterbury father and the son both tell stories. (We'll forego them because of their complexities.) The Yeoman tells none. I can't help but wonder whether it was intended that he tell no story because of the concept of the thoroughly intangible Christian Spirit. For example, in John 20:22 the Holy Spirit is manifested as the *breath* of Christ.

Now, to review, take another look at, the *Christopher* on the Yeoman/peacock's breast. It serves as a clue: There is a Christian analogy concealed here. The object is small. It is not a portrait of Christ, but mainly a depiction of a large man carrying Christ as a little child. In essence, it is applied to the surface, not an integral part of the Yeoman. When I found a thirteenth-century reflection about a peacock based on St. Isidore (Isidore is quoted by Chaucer's Parson), it echoed thoughts I've already expressed. Those "beautiful blue breast feathers" that provide background for the poet's *Christopher* inspired an exemplum, a moral teaching: "These feathers signify the various and most deceptive vanities of the devil and his ministers, who transfigure themselves into angels of light and apostles of Christ."[484] This Yeoman/peacock has an external Christian image, but the remainder of his portrait and his presence in the triad testifies that he is not Christian.

We'll reflect briefly here on something avoided earlier, avoided until we had the background to deal with it. Recognizing the Knight as a likeness of the God of the Old Testament, let's return to the very repulsive Pardoner and a troublesome scene where the Pardoner insults the Host, and tempers flare. The Knight steps for-

ward. His directive for resolution of the problem is agreed to by the Host and the Pardoner without protest; just that easily, the situation is resolved. My feeling is that the Knight is demonstrated to have this capability because of his "god the father" image.

Thoughts about the Knight/Mars and his companions are at an end, except to say that his choice as the first to tell a tale, as we said during the "Plan," "is as it should be." Mars was patron of the first month of the Roman calendar, and fittingly inaugurates the "year's" stories. And for the Knight, as Mars (in whose month the first movement of the cosmos occurred), to begin the progress, which will conclude as time runs out, is also as it should be. We will have more to say about time running out.

Now, on to Venus, patroness of the second month of the Roman calendar and our final look at the planets.

THE PRIORESS

With a slight bow and a swish of his hand—as if doffing a cap—Chaucer salutes the last of the planets as an invitation to come forward. A vision of brilliance, a celestial wonder appears. Often playing the role of "morning star," we see Venus (Aphrodite). She is the Pilgrim Prioress. *Prioress* in the ancient world designated the leader of the Vestal Virgins; in the Middle Ages it was the title of the head of a house of a religious order.[485] Chaucer's knowledge of Latin understands the title he has given her as *higher in importance* (*prior*). As she glides toward the front of the stage, something is odd; an oversized shadow trails behind her. Checking my program gives the answer. Though they don't make themselves visible, she has two traveling companions. A note briefly informs us, "she had another nun with her and a priest" (A 163–64). The two are mystery pilgrims for now. The *General Prologue* says nothing about them. So, for the present, neither will we.

In trying to discern Chaucer's plan, the beginning of the *General Prologue* can be seen to follow the Roman calendar: Mars (the Knight and his entourage) juxtaposed with Venus (the Prioress and her companions). Explained by Ovid, "the month of Mars was the first, and that of Venus the second; she was the author of the race, and he [its] sire."[486]

If it seems outlandish to propose this head of a convent is Ve-

nus, recall that in the "Plan" (p. 47) we said that Ovid's stories of gods and goddesses was moralized in the fourteenth century for women in religion, and the goddesses were illustrated as nuns.

As a planet, Venus (like Mercury) is very near the sun. Because of this proximity, it is often regarded as a splendid evening or morning "star." As morning star, it is called *Lucifer*, the name that also refers to the devil. Chaucer makes use of both intentions:

> O Lucifer, the brightest of angels all,
> Now art thou Satan,
>
> (B 3194–95)

and,

> Lucifer, the day's messenger,
> Began to rise.
>
> (*TC* 3:1417–18)

We'll touch on the diabolical alter ego after a while.

The planet changes position rapidly, as does Mercury, but its beauty and radiance keep it from being mistaken for Mercury. It is bright enough, as a matter of fact, that it can be seen during the day. With its "zigzag" movement, Venus is sometimes found preceding the sun, sometimes following, but it is never more than two signs away. As you scrutinize for a daylight viewing, be more flexible than just following the ecliptic, because Venus journeys to several constellations outside the zodiac.[487]

The beauty of the "star" was first associated with the Babylonian Ishtar and then with Aphrodite. The planet's astrological influence is even more beneficent than Jupiter's, bringing fame, honor, fortune and good relationships. It blesses the earth with warmth and moisture and is a median force between extremes of heat and of humidity. Venus "inspires the renewal of all creatures by her generative impulses.... Astrologers believe that whatever incites the human longing for pleasure becomes vehement through the influence of Venus' star."[488]

Venus' (Aphrodite's) mythology is rather endless. Let's sample a few stories related to the portrait of the Prioress. The goddess

had a unique beginning. Do you remember the god who was emasculated by his son? The severed members were thrown into the Mediterranean Sea. Resulting foam produced the goddess; she arose full-grown. (Her Greek name means "foam of the sea.") As Chaucer tells it, Saturn "engendered her by his life— / But not upon his wedded wife!" (*RR* 5955–56). Botticelli (about 75 years after Chaucer's death) was inspired to record the beauty of Venus rising from the water in his famous "The Birth of Venus." With all her bodily perfection, naturally someone (such as Euripedes) would claim her to be "human passion" personified. Rome honored her as an ancestress of Julius Caesar and Nero.[489]

Another of her famous accomplishments involves winning a spur-of-the-moment contest to choose the most beautiful among Juno, Minerva, and Venus (in their Greek identities). A handsome young shepherd named Paris was selected as judge. Each goddess offered a bribe—greatness, success in war, or the most beautiful woman in the world for his wife. He chose the wife—Venus' bribe, of course. The woman awarded was Helen of Troy, whose existing marriage to Menelaus was disregarded. The goddess aided the lovers' getaway and that precipitated the Trojan War.

Venus is the mother of Harmonia, the harmony primarily related to singing or music making.[490] The goddess is "universally" associated with music by her constant participation in the music of the spheres, of the heavenly bodies. A twelfth-century poem glowingly reports:

> The sphere of Lucifer is light of movement; its breeze is fresher. Producing sound as it moves, it sports with a treble voice; nor is the Muse of Venus' harp considered common but rightly deserves the ear's attention.[491]

Another basic myth tells of her affection for Adonis, a beautiful youth. We pick up the action where Venus is accidentally wounded by one of Cupid's arrows as she holds him in her motherly embrace. It was inevitable, then, that Venus would fall hopelessly in love. It was the beginning of the fabled Venus and Adonis relationship. She witnessed the birth of her inamorato as he emerged from the trunk of a tree. (How his mother got to be a tree is another

story.) It was love at first sight, and though his life's end was tragic, it was not as revolting as the mutilation of Attis. In his prime Adonis was wounded by the tusk of a boar and died. His devotees, in preparation for the festival of his rebirth, would commemorate his tragedy by planting seeds in shallow containers. As soon as the seeds sprouted, because of lack of soil, they withered and died. Besides being a vegetative metaphor for the short life of Adonis, it's a humane remembrance, and much to be preferred to the practices of the Galli, the castrated pagan priests.

Roses were symbolic and held sacred to both Venus and Aphrodite before their identities united.

We learned, with the Wife, that criticizing multiple goddesses with only one personality was one of Augustine's constant polemical topics. Venus, therefore, rates his attention. His words bring immediate complications. The goddess Venus is a star, he complains, but she is "the moon as well."[492] If Venus is the moon, what happens to Diana, who is called "Luna," the moon? (That's a hint of what's ahead.)

More than one element is present in the construction of this pilgrim's image. Her doubleness frequently captivates scholars. One example notes "a delicately poised ambiguity. Two definitions [natural and supernatural] appear as two faces of one coin."[493] Here, again, is a perception of the poet's image behind the image. The Prioress' "otherworldliness" seen by Ruggiers may project the pagan *world*. Even before the reader acknowledges a second (or third?) level, there is a sense of "something going on here." Now, because the attributes of Venus and Diana often blended for early poets or philosophers, we will briefly look into Diana.

A good place to start would be to remember that Diana is the twin sister of Apollo; the two are another version of the sun and moon. She is a virgin huntress skilled with bow and arrows. One of the Homeric Hymns sings her praises: "Over the shadowy hills and windy peaks she draws her golden bow, rejoicing in the chase...destroying the race of wild beasts."[494] Cicero, who peered into multiple identities, sees Diana as the moon and also calls her "Lucifera." Venus and Diana merge again as the acclaimed mother of Cupid. The point of all this is that the Prioress, I believe, represents a compounded "Venus" personality: Venus and Diana are one.

Looking a little deeper into Diana, Chaucer pictures her in the *Knight's Tale.*

> With smale houndes al aboute hir feet;
> And undernethe hir feet she hadde a moone,—
> Wexynge it was and sholde wanye soone.
>
> . . .
>
> With bowe in honde, and arwes in a cas.
> Hir eyen caste she ful lowe adoun.
>
> (A 2076–81)

> (With small hounds all about her feet;
> And underneath her feet she had a moon,—
> Waxing it was and should wane soon.
>
> . . .
>
> With bow in hand, and arrows in a case.
> Her eyes cast down very low.)

Diana's presence adds complexity. Her powers influence tides and destiny over affairs of men. Her divinity manifests itself "now as *Lucina* in her radiance, now as the *Huntress* with her quiver, and now as Hecate."[495] (Hecate is usually called the guardian of crossroads, a task assigned to Diana by Augustine.)

This additional personality has her own fascination. Ovid describes Hecate as having three faces turned in three directions to properly guard the crossroads. Augustine indicates her darker image, and calls her a lying, cheating demon. An introduction to a collection of ancient poems prepares the reader with the information that "the composite" of Diana-Hecate-Selene "is the power of mortal life here below, and as such is occult, ambiguous and dread." Ovid has a suppliant call upon "thou three-formed Hecate, who knowest our undertakings and comest to the aid of the spells and arts of magicians."[496] Dreaded features of the goddess(es) are cast in the silhouette of *Lucifer.*

It's time to look into Chaucer's design for this group; it is unique in several ways. First, I believe the Prioress, because of her name, is *the first* and therefore qualifies as Venus. Then, of necessity, her companion, the Second Nun, must be the moon—along

with the personalities that share that identity. Lastly, to give a firm cohesion to this complex triad, the priest who travels with them will prove to be a proper attendant. It's time now to let the poet have his say.

What does Chaucer tell us of our Prioress/Venus?

> Ther was also a Nonne, a Prioresse
> That of hir smylyng was ful symple and *coy.*
>
> (A 118–19)

> (There was also a Nun, a Prioress
> That of her smiling was very simple and coy.)

Prioress as "the first in rank" has been explained. Her coy smile immediately puts us at a loss. Arthur Hoffman ponders, "'simple and coy' is a romance formula, but she *is* a nun."[497] (Her smile, as smiles go, can be a deception.)

A little story may set the tone for subsequent considerations. It tells how Venus became one of Julius Caesar's foremothers, and has to do with her seduction of Anchises. (Their son is Aeneas of the *Aeneid.*) She appeared to Anchises as "a pure maiden in height and mien, that he should not be frightened." She played the part well. The "laughter-loving" deity "with face turned away and lovely eyes downcast" had her way with him. After accomplishing her goal, she donned her robes and jewels, but now "her head reached to the well-hewn roof-tree." Moral: Coy maidens are not necessarily coy maidens.[498]

Returning to our focus on the Prioress, Chaucer surprises us: this pilgrim has a name.

> And she was cleped madame *Eglentyne.*
>
> (A 121)

> (And she was called [named] Madame Eglantine.)

Appropriately, *Eglantine* is a rose, like those associated with Venus and Aphrodite.[499] Hoffman, sensing a special aura to the Prioress' portrait, directs our attention again. "The name, Eglentyne, is

romance," and yet the poet seems to be describing a nun. Her name is for effect only, a momentary mental picture, a meaningful "ornament."

> Ful weel she soong the *service dyvyne*,[500]
> Entuned in hir nose ful semely.
>
> <div align="right">(A 122–23)</div>

> (Full well she sang the divine service,
> Intoned from her nose very attractively.)

The surface meaning is a nun participating in liturgical chant. Numerous medieval musical connections are made to Venus (mother of Harmony, etc.). Chaucer's allusion, "thow mayst maken melodie," appears to refer to the celestial harmonies, another level of "divine service" (*TC* 3:187). And then, while telling of the birth of Venus, he puts a musical instrument in her hand, although tradition sees her holding a sea shell (A 1959).

> And Frenssh she spak ful faire and fetisly,
> After the scole of Stratford atte *Bowe*,
> For *Frenssh of Parys* was to hire unknowe.
>
> <div align="right">(A 124–26)</div>

> (And French she spoke very nicely and properly,
> After the school of Stratford at Bow,
> For French of Paris was to her unknown.)

These three lines are a prime example of the poet's collage technique. The town named allows the use of "bow" as a glimpse of Diana, but she is surrounded by Venus. The French of Paris was unknown to her because the Paris she knew came from Troy! With just a little suspicion about the poet's intentions, a very different outline can be seen below the surface. The statement about her French also appeared suspect to a contributor to *Gentleman's Magazine*: "It is evident that the Prioress' French was none of the purest; but there is some reason for supposing that Chaucer really meant that the Prioress could not speak any French at all."[501]

Lowes details a connection between the *Romance of the Rose*

and the next group of lines, where "delicate behavior at the table" is presented as a romantic strategy.[502]

> At mete wel ytaught was she with-alle:
> She leet no morsel from hir lippes falle,
> Ne wette hir fyngres in hir *sauce* depe;
> Wel koude she carie a morsel and wel kepe
> That no drope ne fille upon *hire brest.*
> In *curteisie* was set ful muchel hir *lest.*
> Hir over-lippe wyped she so clene
> That in hir coppe ther was no ferthyng sene
> Of *grece*, whan she dronken hadde hir draughte.
> Ful semely after hir mete she raughte.
>
> (A 127–36)

(Besides, at meat [at meals] she was well taught:
She let no morsel fall from her lips,
Nor did she wet her fingers in her deep sauce;
Well could she carry a morsel and hold it well
So that no drop fell upon her breast.
In benevolence was set her very great pleasure, desire.
Her upper lip she wiped so clean
That in her cup there was no particle seen
Of grease, when she had drunk her draft.
Very properly after her meat [her food], she reached.)

An outstanding amount of space is dedicated to table manners. It attracts attention. What thoughts are masked by the vocabulary? The fact that no "grece" was associated with her—directs her existence to *Rome*, not *Greece*. She is Venus (the name of the planet) rather than Aphrodite (who has no planet). A homely bit of the picture finds that she doesn't *wet* her fingers in the *sauce*. Why *wet*? *Soiled* would be more accurate; the word *soil* could replace *wet* without a problem. But *wet* brings the impression of *water*. The attention-getting negative statement—what she doesn't do—can beget the positive—what she does do. Both *French* and *wetness* serve in the same way. It's one of Chaucer's standard modes of—we could say—reverse communication.

Word-choice about her neatness does not mention preserving a *garment* from being soiled. Instead, crumbs do not drop on *her breast*—a problem the goddess would want to avoid in her classic state of undress.

As a deity, the *courtesy* shown is an instance of mercy, of beneficence. Many of these "instances" are found in the mythology. A 132 tells of the high degree of her *lest*: her desire, wish, pleasure. (Just as an aside, the line can be read as a statement of the astrological influence of the planet Venus: "In benevolence was set her very great pleasure.") Venus exhibited her *curteisie* (benevolence) in her romantic entrapment of Anchises. He was fearful because "he who lies with a deathless goddess is no hale man afterwards." But her *lest*, her pleasure was to assure him, "You need fear no harm from me."[503]

We come now to a "Diana" segment. John Speirs notes "the gradually evolved ambiguity in this presentation of the Prioresse." She is "sufficiently a lady of the world, and a sentimentalist."[504] The following lines turn from delicate concerns of the lady of the world toward sport, and animal life.

> And sikerly she was of greet *desport*,
> And ful plesaunt, and amyable[505] of port,
> And peyned hire to *countrefete* cheere
> Of court, and to been *estatlich of manere*,
> And to ben holden *digne of reverence*.
> But, for to speken of hire conscience,
> She was so charitable and so pitous
> She wold wepe, if that she saugh a mous
> Kaught in a trappe, if it were deed or bledde.
> Of *smale houndes* hadde she that she fedde
> With rosted flessh, or milk and wastel-breed.
> But soore wepte she if oon of hem were deed,
> Or if men smoot it with a yerde smerte;
> And al was conscience and tendre herte.
>
> (A 137–50)

> (And surely she was of great sport, recreation,
> And very pleasant, and affable in behavior,

And it pained her to counterfeit a mood
Of court, and to be stately of manner,
And to observe suitable dignity.
But, to speak of her attitude of mind,
She was so charitable and so full of pity
She would weep, if she saw a mouse
Caught in a trap, if it were dead or bleeding.
Small hounds had she that she fed
With roasted meat, or milk and special bread.
Sorely she wept if one of them were dead,
Or if men smote one harshly with a stick;
And was all sensitive and tender of heart.)

What a contrast! The "lady" with the lovely table manners, the one who sang so elegantly, now finds great pleasure in physical activity, in sports. And, more than that, she dislikes the pretense of court, to behave in a stately fashion, to observe suitable dignity. It makes us wonder if we are talking about the same person.

From her desire for a less formal way of life, we learn of her interest in animals, little animals she nurtured. Chaucer's description of Diana (above) uses the same words, "smale houndes"; many were gathered at her feet. (Wild animals of the chase are not mentioned; her enjoyment of hunting would throw light on the hidden meaning.)

Ful *semyly* hir wympul *pynched* was,
Hir nose *tretys*, hir eyen *greye* as glas,
Hir mouth ful smal, and therto softe and reed.

(A 151–53)

(Very properly her wimple was pleated,
Her nose "tretys," her eyes grey as glass,
Her mouth very small, and soft and red besides.)

The first word that demands attention is *tretys*; it's the only word without a similar modern equivalent. It means *slender*. The poet, in fact, could have used *slendre*. Why would he choose *tretys* instead? Because it contains *tre*, three, as a hint of the goddess (Diana or

Hecate) who faces three ways to guard the crossroads, and, therefore, must have three noses. She—the guardian of crossroads—is often pictured with three faces and sometimes with three heads. Very unattractive.

Grey eyes can define capability rather than color. For guarding, they can be *bright, gleaming.*[506] Then, if we consider this a woman with three faces, her head covering would have to be pleated in a *semely* fashion, in a proper manner, in order to allow three-way visibility. Chaucer uses *semely* three times in this portrait, to say that her nose, her reach and her wimple were suitable for her. This holds the possibility (as with her French, or lack of it) that—with a planet in mind—they are properly imaginary, and only figurative.

Another incongruity in the following lines is recorded by both Speirs and Hoffman.

> But sikerly she hadde a fair *forheed,*—
> It was almoost a *spanne* brood, I *trowe,*—
> For, hardily, she was nat *undergrowe.*
>
> (A 154–56)

> (But surely she had a fair forehead,—
> It was almost a hand's span broad, I trust,—
> For hardly was she undergrown.)

We learn that "social historians make the point…that nuns were forbidden to expose the forehead." Despite laxity in restrictions, "the costume *is* a nun's habit."[507] The breadth of her forehead is remarkable. Let's think back to Venus' rendezvous with Anchises. First, her *stature* and demeanor were that of a normal young woman, as a deception. Her purpose achieved, she attained a greater height. With that "normal" godly presence in mind, her forehead could surely (*sikerly*) be as broad as the distance stretched from thumb tip to little finger tip. "I trowe" (I trust) makes it likely that the expanse was even greater. The impression continues in the next line which denies she was less than normal size. Once more, there is an alternate reading. If a planet is what is being described, facial features are only imaginary approximations, and specifying her actual size is avoided.

To this point (as with the introduction of the other planets) minimal physical detail is given. No bodily parts are pictured—arms, legs, feet—and only a wimple (a head covering) has been provided for clothing. But now the lady is supplied with an all-purpose endowment.

> Ful *fetys* was hir *cloke*, as I was war.
> Of smal coral aboute hire arm she bar
> A *peire* of bedes, gauded al with grene.
>
> (A 157–59)

> (Very ingenious was her cloak, as I was aware.
> Of small coral, about her arm she bore
> A "pair" of beads, all gauded, ornamented with green.)

Fetis is one of Chaucer's trick words; perhaps signal words is better. It is "ingenious," and so is the way Chaucer uses it. The "boots" of the Centaur were clasped "faire and fetisly" (A 273). The "hair" of little Perkyn, the bee, was combed "ful fetisly." (See Appendix, A 4369.) It can indicate that a deeper meaning is concealed by the surface. In this case, the all-enveloping "garment" I see as Venus' well-proportioned vestment of her birth from the sea. Coral and the green enhance the picture. When I first read about the coral and green, I saw Venus emerging from the Mediterranean, bits of coral encircling her arm—perhaps her wrist—with shreds of seaweed clinging to (ornamenting) the coral, a figure a la Botticelli. (In the *Knight's Tale*, Chaucer directly describes an image of Venus aborning, which reads like a "before" to Botticelli's "after.")[508]

Hoffman, continuing to study the ambiguity of the Prioress, directs attention to "the coral beads and the green gauds, but they *are* a rosary."[509] A prayerful use for the beads is a surface assumption, although Chaucer preserves the image as ambiguous. The poet refers to a string of beads. (A pair of beads could be understood as a set of more than two in number.) Being sparse with precise details is a technique the poet employs repeatedly to gain flexibility for more than one meaning.

We've arrived at the final detail of the Prioress/Venus portrait.

It takes three lines for Chaucer to say, adequately, what he wants to give as the final—telltale—clue.

> And theron heng a brooch of gold ful sheene,
> On which ther was first write a crowned A,
> And after *Amor vincit omnia.*
>
> <div align="right">(A 160–62)</div>

> (And thereon hung a brooch of gold very brilliant,
> On which there was first engraved a crowned "A,"
> And after "Love conquers all.")

It seems that every scholar who writes about the Prioress' introduction applies considerable verbiage to the subject of her brooch. Lowes reflects, "Now is it earthly love that conquers all, now heavenly; the phrase plays back and forth between the two. And it is precisely that happy ambiguity of the convention…that makes Chaucer's use of it here…a master stroke." Precisely. It suits the background of the convent, if we ignore the monetary value of the brooch. It suits the background of goddess of love as well or better. The crowned "A" can be seen as a symbol of love for *Adonis. Love conquers all* is a phrase from Virgil, from a song that recalls "fair Adonis," and considers the problems of men with maids. The completion of Virgil's thought is, "let us too yield to Love."[510] Spoken like a devotee of Venus. The Prioress at the surface may direct her *amor* to God, but the sensual reading is dear to the heart of the concealed goddess.

Two lines remain. They contain the entire introduction of the Prioress' companions.

> Another Nonne with hire hadde she,
> That was hir chapeleyne, and preestes thre.[511]
>
> <div align="right">(A 163–64)</div>

> (Another Nun with her had she
> That was her chaplain, and priest [made] three.)

Minimal, minuscule, for a reason, no doubt.

We will deal with them in the order of their presentation.

THE SECOND NUN

The female companion is generally referred to as the Second Nun. I didn't call attention to it as the Prioress came forward with her companions, but if she is the planet Venus, and we said "the last of the planets" was coming on stage, we're one planet short. There has to be a *moon*. By allegorical "rules," we must find a moon. The Second Nun is the only remaining woman; by elimination—she *is* the moon. I've written of her in detail elsewhere, but not of her lunar manifestations. The only fact from astronomy that seems to apply is that five nights out of a month are moonless.[512] Perhaps that is the basis of Chaucer's joke, presenting her as invisible.

As a pilgrim, she has *no* identity. Searching through the snatches of conversation among the travelers, she is never spoken to or about. And yet she among the non-participants (such as the Guildsmen or the Parson's brother) tells a story. This makes her unique. It is *necessary*, however, for her to tell her tale. A group portraying a sign of the zodiac can have some silent members and still display their presence. Without her story, a member of the planets would fail to be represented.

She is not called upon by the Host, as is the usual routine. Her story is not commented on when she finishes. There is one quirk worth noting, however. A "mistake" occurs in the introduction to the *Second Nun's Tale*. She refers to herself as an "unworthy *son* of Eve" (G 62). As the Moon, there is a well-known answer to that problem. Though Luna is pictured as feminine, there is a *man* in the moon. Chaucer warns, take care "lest the churl may fall out of the moon!" (*TC* 1:1024).

Word selection in the *Second Nun's Prologue* could be seen to produce visions of the moon. When the principal character of her story is likened to "heaven's lily," a sense of chastity pervades the image. Both the moon and the lily are symbols of chastity—and, therefore, sterility, infertility. Chaucer's words continue to mirror the moon with this character as *swift, round, white* and a *great light* (G 87–117).

The moon is "goddess of the night"[513] and in that capacity endowed with associations of the occult, the dead, as well as of spells and arts of magicians. This adds a dark aura to the Prioress' group. With the gentility and refinement (evident in some aspects of

pagan deities) evidence of cruelty and vengefulness coexists. We won't analyze the stories of the Prioress and the Second Nun, but we'll get the gist of the action. Both pilgrims contain elements of the moon—the Prioress mainly from being compounded with Diana. Their pagan images serve pagan purposes and aid "dread" causes.

Their stories have appropriately dreadful plots. The crux of the Prioress' story is a Lucifer/Satan-inspired murder of a child. The Second Nun recounts pagan persecution and the martyrdom of Christians, including a cruel death of her main character. Chaucer indicates before the pilgrimage begins that each traveler is to tell of his or her own experiences (A 795). The tales are an aid to identifying the covert images. These two "women," then, play a part in their stories, as participants in the action, or as observers.

A closing anecdote characterizes Diana's inclinations as perceived by the British Middle Ages and exemplifies that paganism did not go quietly. In the sculptured decor of an early English church, "the carver has shown the goddess Diana, disguised as a *nun*" tricking pilgrims into assisting to burn down a church that once was her temple.[514] She no longer had her ancient prominence, but she was still trying to be a force in the world.

THE NUNS' PRIEST

And now we come to the "priest" who accompanies the two nuns. No more is said of him in the *General Prologue* than the word indicating his office. Chaucer, however, generously describes him, and has the Host chat with him before his story, and speak to him afterward. The *Nuns' Priest's Tale* is a favorite and frequently anthologized.

The Nuns' Priest, even today, is much talked about as a storyteller. The direction our pursuit of clues will take becomes clear immediately. One reviewer finds the star of the Priest's story a "more than half human rooster." Another says, "we can hardly decide which is the personification and which the actuality."[515] Chaucer's skill in presenting double images is evident; the duplicity only needs to be recognized. The companion priest, you've no doubt guessed, is a rooster.

This is probably the most humorous demonstration of the

"horse" being part of the pilgrim—not so much transportation as characterization. As Roger Sherman Loomis sees him,

> his mount was a lean jade, but...the Priest himself was a brawny, large-chested masculine type, with the eyes of a hawk and ruddy skin.[516]

With the "mount" portraying an aspect of the Pilgrim, we have a very good picture of a well-built *bird*. (I couldn't help but chuckle.) The story he will tell of a rooster is part of his actual bird-experience.

Why is this priest a rooster? We'll take that up soon. First, let's eavesdrop on his conversation with the Host.

> Thanne spak oure Hoost with *rude* speche and boold,
> And seyde unto the Nonnes Preest anon,
> "Com neer, thou preest, com hyder, thou sir John!"
> <div align="right">(B 3998–4000)</div>

> (Then spoke our Host with rude speech and bold,
> And said unto the Nun's Priest at once,
> "Come near, thou priest, come hither, thou sir John!")

It's often remarked that the Host is anything but courteous to this *clergyman on pilgrimage*. It's quite understandable, however, that the guide of the pilgrims might use a lower level of politeness when speaking to a rooster, even an attractive rooster. It may also be that his words have no offensive connotation at the second level of meaning. For example, *rude* can communicate *simple*, *inelegant*, which seems the proper tone for addressing a bird.

> "Telle us swich thyng as may oure hertes glade.
> Be blithe, though thou ryde upon a jade.
> What though thyn hors be bothe *foul* and lene?"
> <div align="right">(B 4001–03)</div>

> ("Tell us such a thing as may our hearts gladden.
> Be joyful, though thou ride upon a mediocre horse.
> Why is thine horse both foul/fowl and lean?")

What fun the poet must have had! The riddling words are there for all to see—if the *Tales* are recognized as a riddle, an allegory to be interpreted. The Host doesn't wait for a reply, of course. The question elicits a mental image; no reply is necessary or expected.

Our Host goes on about the "horse" almost apologetically, after being outspoken.

> "If he wol serve thee, rekke nat a bene.
> Looke that thyn herte be murie everemo."
>
> (B 4004–05)

> ("If he will serve thee, don't worry about a bean.
> Look that thine heart be merry evermore.")

As long as his lean legs carry him, the priest need not worry about a bean or any other daily food.

The "priest" replies.

> "Yis, sire," quod he, "yis, Hoost, *so moot I go*,
> But I be myrie, ywis I wol be blamed."
>
> (B 4006–07)

> ("Yes, sir," said he, "yes, Host, *so may I go*,
> Unless I be merry, certainly I will be blamed.")

"So may I go" has a second and more important interpretation for roosters: "As sure as I hope to live." Roosters can't be too careful, if they hope to live. Their loudness or earliness may prove objectionable, which could make them the preferred entree for Sunday dinner. There will be more to say about concerns of the Priest/rooster.

> And right anon his tale he hath *attamed*,
> And thus he seyde unto us everichon,
> This sweete preest, this goodly man sir John.
>
> (B 4008–10)

> (And very shortly his tale he had "attamed,"

And thus he said unto us everyone,
This sweet priest, this goodly man sir John.)

There is word-play involving a tale/tail as *attamed* (ventured upon, commenced) and *atamed* (trained, controlled). As soon as his tail feathers were under control, he spoke to all the travelers. (Pliny describes a rooster "rearing its curved tail aloft."[517]) I can almost hear Chaucer laughing about the joke. A few lines earlier (B 3979) the Monk (the lion) was told his "*tale* annoyed everyone." With a double intent, the Monk's sad *tale* bothered the group, while the swishing of the lion's *tail* was annoying. That worked so well that the poet couldn't pass up a second opportunity. Using the same pattern less than thirty lines later, the poet works his imagination on the rooster's tail/tale. Once the tail is tamed (controlled), the tale (the story) is begun.

Many readers, who know nothing else about the *Canterbury Tales*, know the story of Chaunticleer and his lovely wife, Pertelote. Chaunticleer is in great distress, fearful over bad dreams. His wife offers the cure-all with her memorable line: "Taak som laxatyf" (B 4133). That actually *will* do the job. Later we'll learn why, and how.

When the Priest's story is finished, the Host is appreciative.

> "Sire Nonnes Preest," oure Hooste seide anoon,
> "I-blessed be thy *breche*, and every *stoon*!
> This was a murie tale of *Chauntecleer*."
>
> > (B 4637–39)

> ("Sir Nun's Priest," our Host said immediately,
> "Blessed be thy breech, and every stone!
> This was a merry tale of Chaunticleer.")

The blessing directed toward masculinity allows for a special barnyard double meaning for a pecking rooster's "every stone." The breech, in an animal, can be its hindquarters. I imagine rooster thighs were found to be tasty then as they are now. Chaunticleer, the main character in the story, is said to be named "sing-out-loud." In addition, because "cler" can be *light*, or *dawn*, a second intention becomes "sing-at-

dawn" or "sing-at-early-light," a rooster's instinctive vocation.

> "But by my trouthe, if thou were *seculer*,
> Thou woldest ben a *trede-foule* aright."
>
> (B 4640–41)

> ("But by my truth, if thou wert secular,
> Thou wouldst be a "trede-foule" all right.")

"Trede-foul" refers to a sexually active bird; it was used jokingly about men. Although making fun of a priest is the traditional interpretation, recall that allegory can express contrasting ideas at different levels. At the rooster-level, the Host is simply being complimentary. If the rooster he is speaking to were allowed to roam the world (be secular), instead of living in a confined area, he would be a very productive specimen, an actual "trede-foule." Chaunticleer of the story, for example, "feathered (made a courting display) to Pertelote twenty times and *tread* as often e'er it was prime," that is, 9 A.M. (B 4368).

> "For if thou have *corage* as thou hast *myght*,
> Thee were nede of hennes, as I wene,
> Ya, moo than seven tymes seventene."
>
> (B 4642–44)

> ("For if thou hast 'corage' as thou hast might
> Thee were in need of hens, as I suppose,
> Yea, more that seven times seventeen.")

The Priest/rooster continues to be recommended for his capability. If his vigor (*myght*) matches his sexual desires (*corage*), instead of having seven hens (as the story relates), this "Priest" will need seventeen times that seven.

> "See, which *braunes* hath this gentil preest,
> So gret a *nekke*, and swich a large *breest*!
> He loketh as a *sperhauk* with his yën."
>
> (B 4645–47)

("See, what brawn hath this gentle priest,
So great a neck, and such a large breast!
He looks like a sparrowhawk with his eyes.")

Here are his large breast and sharp eyes that were mentioned at the beginning. He also has remarkable brawn, a term which refers to *meat as food*. (It is difficult to admire a rooster without seeing it as a possible food source.) His neck resembles the notably long neck of one of the roosters in the story (B 4498, 4522).

"Him nedeth nat his *colour* for to *dyen*
With brasile, ne with greyn of Portyngale.
Now, sire, faire falle yow for youre tale!"
(B 4648–50)

("He need not his color to dye
With brazilwood, nor with grain of Portugal.
Now, sir, good befall you for your tale/tail!")

The dye produced, from brazilwood or the special grain from Portugal, is *red*. Reference to his color amounts to an allusion to his face, his "complexion." This fine specimen of a rooster surely would need no red dye to enhance his comb and wattle. As his closing thought, the Host grants a blessing for both the Priest's tale and his tail!

(A chronological aside: Medieval brazilwood, as a source of red dye, originally came from India. At a later date, the country of Brazil [*tierra de brasil*] was named for its brazilwood trees. *Brazil* is Portuguese for the Spanish *brasil*.)

We've heard all the poet has to say about the Nun's Priest. Now there are questions that need answers. To prepare for the answers, we'll gather some facts about augury.

The term *augures* means *information gained from the observation of birds*—alive or dead. (The original word was *auspices*; a believer would be guided in decisions by the *auspices*.) Birds were seen as "created for the purpose of giving omens."[518] Their vocal display was believed significant. There was a basic use-it-anywhere ceremony where grain was thrown to specially kept birds and careful note taken of how it was eaten.

Augury, the job of augurs, was an occupation "of high dignity," especially in early Rome. Ovid tells that the gods feel that birds reveal their thoughts, the reason being that birds were able to transport themselves close to the gods. Pliny gives an unexpected view of the overriding power of cocks: "These birds daily control our officers of state...these hold supreme empire over the empire of the world, being as acceptable to the gods with even their inward parts and vitals as are the costliest victims."[519]

Cicero tells the following story of a Roman officer who failed to "comply with the auspices" in a war against Carthage. When caged chickens were released and grain was scattered for them, they refused to eat. The officer ordered them thrown into the water; he jokingly said perhaps they would rather drink than eat. The birds' refusal to eat, of course, was a serious sign which he failed to honor. Because of his foolishness, the Roman forces suffered a defeat.[520]

A more elaborate ritual conducted by augurs included the sacrifice of the bird and examination of its entrails. The chickens that refused to eat must have had digestive problems, and, as a result, the message their entrails held was an ignored warning. It's a short leap, then, to understand why—when Chaunticleer felt serious misgivings—his wife's suggestion of a laxative was efficacious. His homey compliance could change the course of history. This is related to the reason the Priest/rooster said he would be blamed if he were not merry (B 4006–07). The content of the covert meaning can be seen as quite respectful of an instrument of augury, even if the primary reading appears to show disrespect for a priest.

It's amusing to find a rooster cast as a pilgrim, but the reason for his playing the part holds more than amusement. The reviewer who spoke about personification, as we began our look at the Nun's Priest, continues by wondering "whether birds are being personified, as man and wife, or humanity *galli*nized as cock and hen."[521] (My emphasis.) In the structure of the *Tales*, the poet works an enigmatic triple-play with *galli*: first by introducing the potential pagan priest (*gallus, galli*), next with religious tendencies of the French (*Gallus, Galli*) and finally with the inclusion of a rooster (*gallus, galli*). The Latin root is the same for all three words. A clue to the priestly connection is concealed in B 4645, when the Host refers to the pilgrim as a "gentil priest." "Gentil" gives a *kind, gener-*

ous priest for the surface reading, but it introduces the *pagan* (gentile) priest beneath the surface.

Here again Chaucer is playing a symbolic game (as with the Knight's threesome as a trinity). Where Christian poetry builds on the biblical book of Hebrews (2:17, 9:26) to portray Christ as "our Victim, and our Priest," Chaucer provides a pagan victim (a sacrificial bird) and overlays its image with that of a priest. Ovid makes a direct connection for us: "To Goddess Night the crested fowl is slain."[522] As was claimed when we first learned of the accompanying priest, he *is* the appropriate pagan attendant for Venus, Diana, Hecate (the moon).

The highly respected Roman augurs ritually sacrificing a bird to examine its entrails were actually fortunetellers, predictors of the future. While it may seem that such beliefs involving magic, the moon and sacrifice of birds were ancient and disappeared with the Greek and Roman civilizations, such was not the case. The Middle Ages inherited a legend from the sixth century of Theophilus and the sorcerer at the crossroads; a chronicle from the tenth century containing "one of the earliest direct linkings of witchcraft to heresy"; and an authoritative document used by canon lawyers that presents details of sorcery at crossroads, flights of witches, and a leader who was "Diana, the goddess of pagans." Medieval *grimoires* were manuals of magic, containing incantations and instructions for rituals. One might be directed to take a hen to a crossroad "at the stroke of midnight," and inscribe a magic circle on the ground. Then, standing within the circle, sacrifice the bird while uttering words of invocation.[523] Elements of witchcraft (often identified with heresy) were a dark side of fourteenth-century life.

We are at the end of our speculation about the Prioress and her companions. With the Knight and his group also in mind, Brooks offers that Chaucer's "aim may be to provide another knot of pilgrims like the preceding household group."[524] That seems just right. Because Mars and Venus inaugurate the calendar and are claimed as the source of the glory of Rome, it is fitting that they both have special and similar treatment.

With the Prioress, once again, the trio is made up of two "human" figures and a bird. The pattern could be a challenging starting point, but there is no need to take up the challenge here.

Having finished with Venus and the Moon, there are no more medieval "planets" to introduce. We have met Jupiter (the Franklin), Mercury (the Man of Law), Saturn (the Doctor of Physic), the Sun (Our Host), Mars (the Knight), Venus (the Prioress), and finally the Moon (the Second Nun). What is different about the planets, different from the zodiac introductions? Minimal physical description was noted; the planets have no underlying animal traits, for example, to blend with human qualities and no individual stars to provide ornamental clues.

Let's say a few words about common elements of the planet's stories. Taken all together, the subjects are serious, often philosophical, at times grim. The Knight's tale of love and death is the longest; the Prioress tells of a murdered child; the Second Nun, of persecution and martyrdom; the Franklin, a story with strong possibilities of a philosophical debate; the Doctor, an account of a child sacrifice. Nothing is risqué. Nothing seems trivial. Nothing is unfinished. As a group, the atmosphere is sombre compared to those of the zodiac.

A thought from John Livingston Lowes, regarding man's perception of the heavens when Chaucer lived, seems appropriate as we close this section.

> Earth and stars were far closer then than now, and the planets and the constellations, endowed with human qualities, were baleful or friendly, as the case might be, but never quite alien or aloof.[525]

With the twelve signs and the seven planets already introduced, you might think the performance would be over. Chaucer doesn't make things that simple. There is still some muttering and motion going on behind the curtain.

*The story is widely regarded as a good one, a good piece of realism
and not much more.... Its materials are so solid as to seem to
defy further "interpretation." If there is a philosophical
pattern to the* Canterbury Tales, *this seems to be its
one unassimilable lump.*

—*Charles Muscatine,* Chaucer and the French Tradition *(1957)*

VI. A Duo:
The Canon and His Yeoman

AS THE poet motions for the next participant to come forward,
two approach in a sudden flurry of activity. This appears to be a
variation on the Cook and Guildsmen, or the Parson and his
brother. One of the new arrivals, the more reserved of the two, will
remain to tell a tale. His frenetic companion, on the other hand,
will create a stir and then be off to lurk in a distant corner, con-
cealed in the folds of the velvet. This agitated character is the com-
et referred to at the end of the riddling game we played in the
opening pages.

When I started working on this prologue and tale, I gathered a
good deal of information about comets to give detailed pictures to
readers who had never seen one in action. The 1990s, however, have
provided firsthand knowledge previously lacking for most of us.

A little historical background, nevertheless, is worthwhile. The
appearance of a comet (Latin, *cometa*, long-haired star) held great
portents, usually assumed to be disastrous. Ptolemy taught that the
tails indicated regions to be affected; the shape of the heads indi-
cated the kind of misfortunes expected; their position in relation to
the sun and their visible duration told how quickly misfortunes
would occur and how long they would last. Supposedly affecting
earthly weather, the greater the size of a comet's head, the greater
were the winds, floods, etc. anticipated.[526]

Fear of what were seen as cosmic messengers continued for centuries. Venerable Bede, the author of *The Ecclesiastical History of the English People*, told of two comets appearing at the same time in 729 A.D., "striking great terror into all beholders. One of them preceded the sun as it rose in the morning and the other followed it as it set at night...to indicate that mankind was threatened by calamities both by day and by night."[527]

In the century while Chaucer lived, three of these fiery apparitions were recorded. In 1315, belief among astronomers was "unanimous that a comet is a prognostic of future events.... Comets are not made from inferior matter by the virtue of the stars but are new creations solely due to the divine will as a sign of future marvels." Two other fourteenth-century hairy stars were seen, one in 1337, the other in 1368. Their appearance might be spoken of as "fiery torch-like trains...poised to start a fire," or the comet itself like a "belfry completely enveloped in flames." Michael Scot held that comets cause sudden death, political changes, wars, barren earth, general afflictions.[528] Foretelling of the Black Plague was attributed, in retrospect of course, to one of these heralds of destiny.

(Do you remember the first time you got a good clear view of a comet? My first sighting, under perfect conditions, was Hayakutake.[529] I was transfixed. What a thrill! I'd waited a long time for the experience. Of course, it was not a fearful discovery as it would have been in the fourteenth century.)

The comet worked into the design of the Bayeux tapestry is believed to be an early orbiting of what would later be called Halley's comet. In 1680, a red-tinted example, bright enough to be seen during the day, displayed a tail of seventy degrees. (Halfway from horizon to horizon is ninety degrees.) The nineteenth century had a superabundance of fiery stars, three hundred in all. In 1811–12 the lengthiest in duration was recorded—seventeen months. These mavericks have even been observed to split in two. As part of God's universe, a comet was commemorated in the sculpture of the Piacenza Cathedral, portrayed as having multiple tails; such a figure in the real world is not uncommon.[530]

Chaucer could have read historic and scientific discussions regarding these intruders of the orderliness of the heavens. He also had the opportunity to see one firsthand. In spite of this, the term

is not found in his writings. We know, however, that he had the knowledge necessary to include one in this cast of players.

As we take up the action, the narrator draws attention to the meeting about to take place.

> Er we hadde riden fully fyve mile,
> At *Boghtoun* under *Blee* us gan atake
> A man that clothed was in clothes blake,
> And under-nethe he hadde a whyt surplys.
> His hakeney, that was al pomely grys,
> So *swatte* that it wonder was to see.
>
> (G 555–60)

> (Before we had ridden fully five miles,
> At Boghtoun under Blee we began to be overtaken
> By a man clothed in black clothes,
> And underneath he had a white surplice.
> His hackney, that was all dappled grey,
> So sweat that it was a wonder to see.)

The narrator is captivated by the amount of sweat produced by the figure advancing on the group. Seven times in twenty lines he comments on the marvel of the sweat and froth pouring from horse and rider (G 560–80). Some take this sudden encounter with the pilgrims to be an unforeseen stroke of creativity in the mind of the poet. Charles Muscatine, however, recommends that "the head-long entry of the Canon and Yeoman cannot be read as Chaucer's afterthought. It seems thoroughly, artistically, premeditated." This scholar also draws attention to the Canon's "hot gallop and the high temperature," a unique characteristic of the intruder, and a necessary aspect of a comet.[531]

The town name is significant. *Boghtoun* can mean a *curve*, and *blee* means, among other things, *luster*. *Blee* is used in a poem of 1325 to describe the glowing moon.[532] The two words together play on *lustrous bend*, one way of viewing a comet.

Before the poet delves into ominous elements, he entertains the whole company (and his audience) with spirited and playful vocabulary.

> The hors eek that his yeman rood upon
> So *swatte* that unnethe myghte it gon.
> Aboute the peytrel stood the *foom ful hye*;
> He was of *foom* al *flekked as a pye.*
>
> (G 562–65)

> (The horse also that his yeoman rode upon
> So sweat that it scarcely might go.
> About the breastplate the foam stood very high;
> He was all flecked with foam and looked like a magpie.)

Froth is heaped on the harness and spatters the rest of the horse's body, looking like characteristic white splotches on a bird. (The simile appropriately compares a moving celestial object to a creature of flight.) "But it was joye for to seen hym swete (sweat)!" (G 579). How incongruous! How astonishingly creative![533]

The character anticipated a vigorous ride, taking proper precautions for the super-heated atmosphere.

> A clote-leef he hadde under his hood
> For swoot, and for to kepe his heed from heete.
>
> . . .
>
> His forheed dropped as a stillatorie,
> Were ful of plantayne and of paritorie.
>
> (G 577–81)

> (A large burdock leaf, or a bit of cloth, he had under his hood
> For the sweat, and to keep his head from the heat.
>
> . . .
>
> His forehead dripped like part of a distillery,
> As if full of plantain and herbs.)

The effect of all this perspiring is that the spray coming off of him is extremely noticeable. It isn't absorbed by his clothing; it creates an aura surrounding the rider—a very workable depiction of a comet.

Besides the sweat, the Canon's "garments" become part of this trailing image.

And in myn herte wondren I bigan
What that he was, til that I understood
How that *his cloke was sowed* to his hood;
For which, whan I hadde longe avysed me,
I demed hym *som chanoun* for to be.

<div align="right">(G 569–73)</div>

(In my heart I began to wonder
What he was, until I understood
How his cloak was sewed to his hood;
For which, when I had thought a while,
I judged him to be some sort of canon.)

The narrator's *heartfelt* questioning is too meditative for the considering of strangers approaching. Such a feeling, however, would suit the discovery of a comet. Wonderment ceases when he understands how the cloak and hood *were joined.* How peculiar. Why would a bit of sewing be any kind of assurance? That's not a reasonable solution to understanding "*what* he was," but it fits the comet game we're playing. In the narrator's judgment the advancing rider is "some sort of canon." Just *what* sort of canon will be of *signal* importance.

Repeated references made to the Canon's outerwear, now includes a hat for good measure.

His hat heeng at his bak doun by a laas.

<div align="right">(G 574)</div>

(His hat hung by a cord down his back.)

It is joined to his silhouette in a very tenuous fashion. The narrator describes how it's possible for cloak, hood and hat to stay together in spite of the pace at which the Canon travels. The harried outline is alluded to for the final time some lines later (G 620–37).

Speed of a comet, compared to the movement of the rest of the heavens, is the topic when,

It semed as he had priked miles three.

<div align="right">(G 561)</div>

(It seemed he had pricked, spurred for three miles.)

He's prodding his mount to close the gap between the pilgrims and himself. Chaucer's "it seemed," as usual, gives a clue for thinking "but not really," the distance noted being an imaginative approximation.

> For he hadde riden moore than trot or paas;
> He hadde ay priked lik as he were wood.
>
> (G 575–76)

(For he had ridden at more than a trot or pace;
He had spurred, sped as if he were a madman.)

As he approaches, the Canon/comet has a message for all, but no one among the pilgrims responds. He will be in their presence for a little over one hundred lines. Then, as comets will, he will draw nearer to the Sun—the Host—and then he "fled away," gone forever (G 690, 702, 706).

Chaucer, so far, has pictured the insubstantial train of the comet and has endowed it with necessary speed. Illumination is also part of its spectacle. Here, using word-play with *light/little* ("lite"), the game continues.

> *It semed* that he caried *lite* array.
> Al *light for somer* rood this worthy man.
>
> (G 567–68)

(It seemed he carried "lite" array, little clothing.
All light for the summer rode this worthy man.)

"It seemed" signals—calls for—skepticism. He carried *little clothing* for the usual reading. But, as our comet, the words tell of his luminous quality, his *lighted array*.

According to the early lines of the poem, the pilgrims set off one April morning. It seems conflicting information to speak of the Canon's preparation for *summer*. The words "lite array" for the "somer," however, are a surface compromise allowing the covert

level to tell of the celestial display. "Light for all of the summer" would be a comet's reasonable time span.

When the Host comments on the tattered condition of the clergyman's clothing (the better to trail haphazardly behind him) the term "lite" is worked in once again (G 632). *Light*, for the last time, accompanies the circumstances of his departure (G 699), but that will take a little explanation after we meet the Canon's servant and hear what he has to say.

Let's return to the narrator's first noting the Canon. The poet uses the ploy we saw in the *Prologue to the Parson's Tale*, where the Host asks that a *male* (in Middle English, either a "male human being" or "a bag, pouch") be unbuckled (X 26), the implication being that more was contained in this figure than was admitted. Here, the wording is a little different—but a little more straightforward.

A *male tweyfoold* upon his croper lay.

(G 566)

(A *double-folded bag* upon his [horse's] hind-quarters lay.)

Part of the poet's plan, I'm sure, is that all description until now has been of assorted things flapping behind, all anchored to the Canon's *head*. The bag—the "male"—of this line is assigned to the *hind-quarters* of a horse, a horse we take to be an aspect of the person described. *Tweyfoold* gives a strong impression of *two parts*: two elements, two aspects, or two in number. The Canon is a double image. "Of course, there are two together," you may say. "His Yeoman (his servant) is with him." *Two* was not emphasized with the Parson; that *male* was more a point of curiosity. The subject of this *male* is separate from details of the Yeoman. Why? We'll need some working space to tackle that problem. First we'll finish with the Canon and send him off to continue his mad dash.

In proper chronology, "a man" was seen trying to overtake the pilgrims. His flapping clothing, his light array, his speed all came into the picture. He makes an ostentatious entrance, shouting,

"God save," quod he, "this joly compaignye!
Faste have I priked," quod he, "for youre sake,
By cause that I wolde yow atake,
To riden in this myrie compaignye."

(G 583–86)

("God save," quote he, "this jolly company!
Fast have I spurred," quote he, "for your sake,
Because I would overtake you
To ride in this merry company.")

After this resounding greeting, his servant, who has arrived without notice, explains:

…"Sires, now in the morwe-tyde
Out of youre hostelrie I saugh yow ryde,
And *warned* heer my lord and my soverayn,
Which that to ryden with yow is ful fayn
For his desport; he loveth daliaunce."

(G 588–92)

(…"Sirs, during the morning hours
Out of your hostelry I saw you ride
And 'warned' my lord and sovereign here
Who is very eager to ride with you
For his amusement; he loves conversation.")

The servant uses the word "warned." A reply, following the speech, is punctuated so that it apparently comes from the Host, although it works very well as a further greeting of the Canon.

"Freend, for thy *warnyng* God yeve thee good chaunce!"

(G 593)

Host: Friend, for a *warning* from you, God give you god fortune.
Canon: "Friend, for a *warning* to you, God give you good fortune!"

Whichever way it's read, the operative word, again, is *warning*. That's the Canon's medieval destiny—a comet's prophetic intent.

For all his desire to join this band of pilgrims, he remains detached, aloof. He does not converse with them, nor do they with him. We learn about his habits and lifestyle through questions the Host asks the servant and through additional information the servant seems eager to volunteer—the poet's means of incorporating knowledge and beliefs about comets so as to show the animated character's hidden identity.

The Host asks,

> "Can he oght telle a myrie tale or tweye,
> With which he glade may this compaignye?"
>
> (G 597–98)

> ("Can he tell a merry tale or two,
> With which he may glad this company?")

("Tale *or two*" could jokingly refer to a comet with more than one tail.) The servant replies in a remarkably conversational manner.

> "Who, sire? my lord? ye, ye, withouten lye,
> . . .
> And ye hym knewe as wel as do I,
> Ye wolde wondre how wel and craftily
> He koude werke, and that in sondry wise.
> He hath take on hym many a greet emprise,
> Which were ful hard for any that is heere
> To brynge aboute, but they of hym it leere.
>
> (G 599–607)

> ("Who, sir? my lord? yes, yes, without a lie,
> . . .
> If you knew him as well as I do,
> You would wonder how well and craftily
> He could work and in how may ways.
> He has taken on many great enterprises,

Which would be very hard for anyone that is here
To bring about, unless they learn it from him.)

Astrologically, the lines confide that the power and skill of a comet are beyond the capabilities of the average sign of the zodiac or planet working on its own, without his help.

The servant concludes his stream of information with,

> "He is a man of *heigh* discrecioun;
> I *warne* yow wel, he is a *passyng* man."
> (G 613–14)

> ("He is a man of high discretion
> I warn you, he is a passing man.")

There is the word *warn*, again. That's the message of this scene. In addition, to distinguish him ambiguously, both *high* and *passing* are part of the poet's fun. While *passing* is usually taken to be a term of great approval, the added sense of *movement high overhead* is clear.

The Host makes another inquiry:

> "Wel," quod oure Hoost, "I pray thee, tel me than,
> Is he a clerk, or noon? telle what he is."
> (G 615–16)

> ("Well," said our Host, "pray tell me then,
> Is he a cleric, or not? tell what he is.")

The question posed is constructed to ask *what* he is, rather than *who* he is—a subtle difference. The servant's reply, again, gives more information than expected.

> "Nay, he is gretter than a clerk, ywis,"
> Seyde this Yeman, "and in wordes fewe,
> Hoost, of his craft somwhat I wol yow shewe.
> . . .
> That al this *ground* on which we been ridyng,
> Til that we come to Caunterbury toun,

He koude al clene turne it up so doun,
And pave it al of silver and of gold."

<div align="right">(G 617–26)</div>

("Nay, he is greater than a cleric, for sure,"
Said this Yeoman, "and in words few,
Host, of his craft somewhat I will show you.

. . .

That all this ground on which we are riding,
Until we come to Canterbury town,
He could clean turn it upside down
And pave it all with silver and gold.")

In the covert reading, there is no *ground* beneath their feet; they are travelers in the firmament. On that level of communication, a comet would have little difficulty spreading its glowing tail to cover the expanse of miles to the pilgrims' destination.[534]

The Host's inquisitiveness expands. How can this personality be as it has been described?

"Syn that thy lord is of so heigh prudence,
By cause of which men sholde hym reverence,
That of his worshipe rekketh he so lite.

. . .

Why is thy lord so sluttissh, I the preye,
And is of power bettre clooth to beye,
If that his dede accorde with thy speche?
Telle me that, and that I thee biseche."

<div align="right">(G 630–39)</div>

("Since thy lord is of such high prudence, foresight,
Because of which men should reverence him,
That of his dignity he cares so little.

. . .

Why is thy lord to slovenly, I pray thee,
And he has the power better clothes to buy,
If his deeds accord with thy speech?
Tell me that, and that I thee beseech.")

This degree of curiosity is quite unexpected in the Host. The penetrating inquiry surprises this servant.

> "Why?" quod this Yeman, "wherto axe ye me?
> God help me so, for he shal nevere thee!
> (But I wol nat avowe that I seye,
> And therfore keep it secree, I yow preye.)
> He is to wys, in feith, as I bileeve.
> That that is overdoon, it wol nat preeve
> Aright, as clerkes seyn; it is a vice.
> Wherfore in that I holde hym lewed and nyce."
>
> (G 640–47)

> ("Why?" said this Yeoman, "why do you ask me?
> God help me so, for he shall never thrive!
> [But I will not avow what I say,
> And therefore keep it secret, I pray you.]
> He is wise, in faith, as I believe.
> That that is overdone, it will not prove
> Correct, as clerks say; it is a flaw.
> Therefore in that I hold him misguided and strange.")

In spite of the servant's attitude of finality, the Host persists.

> "Where dwelle ye, if it to telle be?"
>
> (G 656)

> ("Where do you dwell, if it can be told?")

Seeming unable to resist queries, the servant replies:

> "In the suburbes of a toun," quod he,
> "Lurkynge in hernes and in lanes blynde,
> Whereas thise robbours and thise theves by kynde
> Holden hir pryvee fereful residence,
> As they that dar nat shewen hir presence;
> So faren we, *if I shal seye the sothe*."
>
> (G 657–62)

("Outside the walls of a town," said he,
"Lurking in secret places and dark, hidden lanes
Where robbers and thieves by their nature
Keep their private fearful residence,
Like they that dare not show their faces;
So we fare, if I say the truth.")

Here Chaucer sketches the medieval conception of comets. We are told where they exist when we can't see them and what ideas are associated with them. At the close of information there is a vaguery, "If I say the truth." Reexamination, reevaluation is called for. The Canon's covert dwelling is not the habitat of *humans* but a figurative description of where evil astrological forces reside.

As the conversation continues, the Canon draws near (nearer to the Host, the Sun).

> This Chanoun drough hym neer, and herde al thyng
> Which that this Yeman spak, for suspecioun
> Of mennes spech ever hadde this Chanoun.
> . . .
> And thus he seyde unto his Yeman tho:
> "Hoold thou thy pees, and spek no wordes mo,
> For if thou do, thou shalt it deere abye.
> Thou sclaundrest me heere in this compaignye,
> And eek discoverest that thou sholdest hyde."
>
> (G 685–96)

> (This Canon drew near and heard everything
> That this Yeoman spoke, for suspicion
> Of men's speech this Canon always had.
> . . .
> And thus he said to his Yeoman:
> "Hold thou thy peace, and speak no words more,
> For if you do, you shall pay dearly for it.
> You slander me here in this company,
> And reveal what thou shouldst hide.")

After hearing the Canon's warnings, the Host offers words of en-

couragement (G 697–98) to the servant: "Don't be concerned over threats of a comet."[535] Chaucer follows this with a dual-purpose, one-line response. This line can serve two purposes because the source of the remark is not absolutely certain.

> "In feith," quod he, "namoore I do but *lyte*."
>
> (G 699)

> ("In faith," said he, "I do no more than 'lyte.'")

Who is "he" that is speaking? If we assume it is the servant, then we read it as minimizing his disclosures:

> "In faith, I do no more than a little."

But if we read "lyte" as a play on *light*, once again, it can be the Canon's plaintive final statement of exasperation, resignation and a claim of innocence of wrongdoing:

> "In faith, I do no more than light."

Rather than associating evils with a comet, he—the Canon/comet—protests he is only an object of illumination. Chaucer's careful construction allows two readings (as in G 593).

The Canon, because of secret disclosures, says he is unable to remain with these pilgrims. He takes leave as suddenly as he came.

> And whan this Chanon saugh it wolde nat bee,
> But his Yeman wolde telle his pryvetee,
> He fledde awey for verray sorwe and shame.
>
> (G 700–02)

> (And when this Canon saw it would not be,
> But that his Yeoman would tell his private matters,
> He fled away for sorrow and shame.)

The poet creates a clever excuse for the Canon's departure. With the nature of allegory, however, once we identify the Canon as a

comet, he *must* "leave as suddenly as he came." That's a given for the role he plays. The Canon's existence for us, now, is only a memory. Cloaked by the velvet folds, he can no longer be seen. He is not a part of the glistening display of the celestial Pilgrims that surround us.

THE ABANDONED YEOMAN

The Canon/comet has left the stage. His Yeoman stands before us all alone. We were told many things about the Canon; details constructed a recognizable portrait of a comet—the flowing contour, the "light array," the accelerated movement which overtook and then suddenly departed from this company of heavenly pilgrims. But, now that the Yeoman is alone, how do we identify him? I don't know a more difficult question in this allegory of the *Tales.*

We've been given little physical knowledge as a help to construct a mental image of him. Nevertheless, he is privileged to tell two stories. Though I've not tried to explain the tales (only to visualize the tellers of the tales), this case is different. Clues to his allegorical identity must be contained in his disclosures. From the pattern of all that has gone before, we should anticipate a double image and expect it to have a celestial meaning.

Having confidence that patience and thoroughness would reveal the sought-after answer, I began to examine information attached directly to this character. There isn't much. We've been told,

1. The narrator observes that the Yeoman's mount is stressed (G 562–63).
2. The Host notes the first direct detail: the Yeoman's face is discolored (G 664).
3. The Yeoman himself admits having no interest in looking into mirrors (G 668).

In a little while we will be told that he covers his head with a stocking ("hose," G 726) and his eyes are bleary (G 730). Because the discoloration of his face was the first observation about his person, I assumed it would have a major influence. (Compare the initial statement about the Wife—her deafness—and how pivotal the circumstances of that "injury" proved to be.) I expected that the

loss of color was a signal, a specially telling clue. These meager details are his entire "portrait." Once again, there is no height, no age, no quality of voice—no physical attributes except those concerned with his face. The only other thing that distinguishes him is he talks a lot.

Methodically, I began to examine the vocabulary. The Yeoman's two offerings are very different from each other. The first is crammed with *things*: chemicals, utensils, vegetable and animal products. Here's an example:

> As boole armonyak, verdegrees, boras,
> And sondry vessels maad of erthe and glas,
> Oure urynals and oure descensories,
> Violes, crosletz, and sublymatories,
> Cucurbites and alambikes eek,
> And othere swich, deere ynough a leek.
> Nat nedeth it for to reherce hem alle,—
> Watres rubifiying, and boles galle,
> Arsenyk, sal armonyak, and brymstoon;
> And herbes koude I telle eek many oon,
> As egremoyne, valerian, and lunarie.
>
> (G 790–800)

These words, mainly unfamiliar whether in Middle or Modern English, have definitions related to alchemy (that's the accepted subject of the Yeoman's tale), but I was surprised to find many alternate meanings that deal with pigment, book-binding, waterproofing, etc. The challenge of allegory is to identify the *second* meaning—using the *same* words, but discovering a *different* message.[536]

Mulling over the lines heavy with *stuff* that produced ink, pigment, fixatives and more, the image of a *book* took shape in my mind. If this servant *is* a book (and what is a book if not a servant?), it's no wonder he has so much information to give! The Yeoman's great willingness to inform, even in confidential matters, reminds me of Richard de Bury's fourteenth-century sentiment in praise of books:

We must consider what pleasantness of teaching there is in books, how easy, how secret! How safely we lay bare the poverty of human ignorance to books without feeling any shame! They are masters who instruct us without rod or ferule, without angry words, without clothes or money. If you come to them they are not asleep; if you ask and inquire of them, they do not withdraw themselves; they do not chide if you make mistakes; they do not laugh at you if you are ignorant.[537]

His first story, then, I understood to be the early memories of a book being constructed, details of things necessary for the manufacture of paper, vellum, inks, and other manuscript-producing items.[538] When the presentation suddenly changes from a first person narration to a second person report (regarding a procedure gone awry), it appears to be notations now being made *in* the book. When Muscatine likens these "poetic" lines to an *inventory* from someone ready to "tell all that he can," or Spargo projects an image of a parrot recalling "by rote," it is Chaucer's intention unwittingly recognized, once again.[539]

The Yeoman's subsequent story is that of a false canon as a deceptive influence. It is clearly stated that the canon spoken of now is *not* the Canon that was the original companion to this Yeoman/book (G 1090). Why tell a story of a second canon and need to explain the difference from the first? Why not cast a doctor, or a musician, or a bishop in the main role? Why? Because *canon* is ambiguous—and so are many other words the Yeoman (Chaucer) selects.

The main reason for the *ambiguity* is that it lends itself so readily to more than one level of understanding. (A *book* provides a means of talking about *canon* on two levels: the physical presence and the intellectual content.) The reason for Chaucer's *explanation*—a response made by the Yeoman to a question *never asked* by the Host (G 1088–90)—is the poet's holding out a verbal hand to his audience. When we grasp his assist, it keeps us from the futile effort of trying to understand how a *comet* can function in ways to be revealed. Allegories are supposed to be difficult, but not impossible.

A canon is obviously a kind of clergyman, but the word also refers to subjects such as scientific documentation: codifying of

information, and principles of calculation, are just two examples. *Canon* is also the name given to volumes that hold this knowledge. Although his departed companion was formerly touted as without peer, now we learn that the canon of this narration "knows an hundred fold (as in pages of a book) more subtlety" (G 1091). The "hundred folds" are the clue that this "*canon* of religion" is a *book*.[540]

A *false canon* having a deceptive influence (aside from seeing this as human behavior) can be *faulty information* which causes errors in judgment or outcome. In dealing with an instructive *canon* (that is, dealing with *words*), when "he" asserts that "he" never meant falsehood *in his heart* (G 1051), there is no reason to doubt his sincerity; we should only doubt the usefulness of the *words* which make up his identity.

Much of the poet's vocabulary, here, serves at cross purposes. The patron saint called upon, "Seint Gile" (G 1185), is a wonder. If not personified, the two words—seint gile—say *holy fraud*. *Coles* that can feed a fire, in book construction communicate *glue or sizing*, and in a deception indicate *trickery*. *Fire*, scattered throughout the entire narration, could speak of *energy* (or *passion*) for tasks undertaken. *Time*, introduced as the French *temps*, plays a complicated role sometimes merging with *tempren* (to mix), which adds an interesting subtlety.[541] *Time* also functions in determining the vocation of the gulled priest: he is an *annueller*, one who commemorates *yearly* anniversaries of deaths.

Let's take a longer look at the word *canon*. A canon can be a book, a book of information collected and coordinated to assist a special task. For example, such a volume could aid determining the position of stars or calculating dates of celestial happenings.[542] It is reasonable to see the Yeoman as a medieval star-gazer's almanac. Such a limitation was anticipated at the outset of our search for his identity: By his early admission, he "contains" observations about stars, planets and comet activity. In addition, his laboring at, and lamenting over multiplication (G 669, 731, 835, 849, 1391, 1401, 1417) implies the effort of recording these tables (often in Roman numerals) as one of the "services" he provides.

A pocket-sized book of Chaucer's day that held a quantity of information on a particular subject (similar to a modern day handbook) was a common personal possession, easily carried from place

to place. Because it was so transportable it was called a *vade mecum* ("goes with me").[543] This is precisely the role played by the Yeoman; he went with the Canon.

Now we'll think back to that "male tweyfoold" of the Canon/ comet. It is a double-folded carrying case, an attention-getter, an allegorical identifier. I believe we are to see that the two parts contain two canons (similar imagery to Gemini, the Twins). One of these canons is the *comet*, the second a *vade mecum*, the idea playing on the fold-over (two-fold) *male*.

A *vade mecum* was generally used a great deal, which would cause deterioration of its binding (and fading of the printed matter, making it difficult to read—as if one's eyes were *bleary*). An originally red cover would show wear of the applied pigment. It could lose its vibrancy and pale to grey—just as the Yeoman's *face* turned from "red to leaden hue" (G 727–28). To minimize wear on this much-used book, it was provided with a protective sheath. *Sheath* can be synonymous with *hose*.[544] The *hose* the Yeoman wears on his head could be the poet's playful way of indicating the sheath of a *vade mecum*.

As the narration goes on, hints of a religious meaning appear. The first comes at the close of the introductory story.

> He that semeth the wiseste, by Jhesus!
> Is moost fool, whan it cometh to the preef:
> And he that semeth trewest is a theef.
>
> (G 967–69)

> (He that seems the wisest, by Jesus!
> Is most a fool, when it comes to the proof:
> And he that seems truest is a thief.)

I see the three crosses on Good Friday. One man "by Jesus," who seems the wisest, turns out to be a fool; the other one "by Jesus," even though he is a thief (the Good Thief), is the one who is truest. Associations with "Jesus" are a link to the second narrative.

A second hint of religion is the Christianizing of the featured utensil. The book-construction story uses a *pot* as the functioning container. The second narrative, of a different mood, fills a *crosslet*.

This new word, we are told, can mean *crucible*, and is treated so in the surface plot. But this story is the only source of quotations for that definition in the MED, and this narrative is Chaucer's only use of a "crosselet," which makes the choice suspect, better said, intriguing. Its parallel definition, *little crosses*, stimulates a mental picture.[545] For a book, these crosses serve as internal and/or external ornamentation.

The matter of changing base metal to gold is a predominant goal in alchemy. The deception narrative—the influence of the false canon—touches upon gold, briefly, but the activities center on silver. This seemed very strange to me. Why would manipulating *silver* be the main action of the tale?

To give that some serious thought, let's collect a few facts about alchemy.[546] It is reputedly confusing, and was intended to be. Only those in the know were expected to understand. Confusion is often based on using mythology or astrology to express ideas about chemicals or metals. For example, Chaucer allegedly quotes a process using *quicksilver*, but states it alchemically: *Mercury* (another name for quicksilver) cannot be killed without the knowledge of his brother (G 1431–40). Alchemists could also say that something happened to Sol and Luna while actually referring to gold and silver. (Chaucer notes the correspondence of these metals with the sun and moon at G 826. The fact that the poet uses "Sol" and "Luna" *only* in this account has significance.) What if Chaucer is turning the alchemy game upside down? What if the false canon (erroneous information) was leading the priest and others astray in matters of the *sun and moon* (code words for *gold and silver*)?[547]

This, too, touches religion—along with being "by Jesus," with a priest as one of the characters, and with the crosses. These ideas blend when a *canon* is used to calculate the church calendar. (*Ecclesiale*, written by Alexander of Villa Dei, is such a book, such a *canon*.[548]) The principal calculation in the church calendar was (and is) the correct date for Easter; other feast days are then determined as so many days before or after Easter.[549] The complicated process involves the solar (gold) and lunar (silver) calendars. Information about *time* from both sources must be merged. (This merging is where *tempren* as *time* and *mix* functions. In G 926 either can be read; a process is not properly *mixed*, or not properly *timed*.[550]) An

essential, at the outset, is knowing the *Golden Number*, the unique numeric designation of each lunar year in the solar cycle of nineteen years.

Though multiplication, often mentioned by the Yeoman, is assumed to illustrate alchemy in its attempts to increase gold, it is a major process in fixing dates in the religious calendar, as well.[551] (And, to illustrate that *multiplication* also touches the making of books, it is a factor in recorded fourteenth-century recipes for pigment.[552])

Today we take Easter's date for granted. Just look at your calendar. In the Middle Ages, however, many debates, controversies, even excommunications were involved with celebrating Easter on the wrong, the "unlawful," date.[553] When I think back to moments in the *Tales* where Chaucer appears to question if the Church's way is Christ's way,[554] the malfunctioning canon seems to indicate another questioning moment.

The *fire* that we understood as the *energy* for a project is finally interpreted by the poet. The Yeoman's voice takes on a new tone of authority as he nears the end of his message:

> Withdraweth the fir, lest it to faste brenne;
> Medleth namoore with that art, *I mene.*
>
> (G 1423–24)

> (Withdraw the fire, lest it burn too fast;
> Meddle no more with that art, I mean.)

He recommends ceasing to expend energy. I understand this to say, stop all your efforts; don't waste your time on this matter.

Chaucer (and many others, including the Pope) understood that the vernal equinox, a necessary in determining the Paschal date, was no longer aligned. The calendar needed adjustment, but it would be almost two centuries before corrective measures were taken. With a progressive discrepancy (amounting to more than a week in Chaucer's day), labor as they would, "true" dates would not be certain.[555] Calendar inaccuracies left the clergy, including *annuellers*, unsure of the proper date for commemorating the yearly anniversary of the "Death to end all death"—Good Friday.

The Yeoman's lengthy message closes with a final thought about doing God's will. The narrator "concludes" that men may strive for more than a lifetime, but the secret is to live in God's will, and that's the storyteller's *point* (G 1479–80).[556] This says to me that Chaucer is stating (as he has elsewhere) that one should strive to follow Christ's basic message, in this case, the *meaning* of Easter, rather than worry about conformity of universally celebrating on one particular day.

Though the Canon/comet's actions and idiosyncrasies seemed to be the moving force as this duo arrived, the Yeoman remained as the figure of substance, the abiding message-giver. (What an appropriate assignment for a *book* to deliver a writer's thoughts!) The content and organization of the Yeoman's narrative is problematic; its sources, for John Webster Spargo, are "extraordinary confusion."[557]

Would a more thorough knowledge of medieval alchemy add clarity? Edgar H. Duncan, aided by a National Science Foundation grant, determined that alchemical manuscripts are enigmatic, "thus advancing ignorance rather than knowledge."[558] He found the scientific language of Arnold of Newtown (one of Chaucer's—the Yeoman's—final references), "parabolic" and well-nigh impossible to decipher.

When Duncan turned to the *Yeoman's Tale* itself, a peculiar situation came to light. The poet has rearranged statements gleaned from Arnold's writings. Evidence becomes even *more* peculiar, more provocative. Some statements are from the treatise identified by the poet, but most are from another treatise altogether.[559] Duncan muses:

> What is happening is, I think, pretty obvious. Both of the treatises and the yeoman are being managed from behind the scenes. Chaucer, the dramatic artist, is so arranging the quotations from the treatises as to make them say what, for the dramatic presentation of the yeoman, he wants them to say.[560]

The poet's "subtle changes in emphasis…enforce the opposite conclusion" than that proposed by Arnold.[561] (We were confronted by

a similar situation when the Pilgrim/Doctor took the stage. We noted, then, that allegory, "as it says two things…can actually deliver messages of *opposite* mood or content.")

Duncan, intrigued by the possibilities of his discoveries, wonders,

> Has Chaucer so managed affairs in this tale that while the yeoman speaks one message to the *ignorantes, fatui,* and *sophisti* (ignorant, foolish, and self-serving philosophers), which groups would, I suspect, include most of us, Chaucer speaks at the same time quite another message to the true sons of doctrine?[562]

I share this closing question. It is not the first time Chaucer has been seen to be devious.

As the Yeoman retires now to a place reserved for him, the poet smiles enigmatically. His performance is almost completed.

[Petrarch inquires of pagan Virgil,] "Dost thou dwell in that quiet
region of heaven which receives the blessed, where the stars smile
benignly upon the peaceful shades of the illustrious? ...
Wert thou received thither after...the Highest
King...beat down the unyielding bars
of hell with His pierced Hands?"

—Petrarch, Letters to Classical Authors *(ca. 1360)*

VII. The Final Solo: The Clerk

WE'VE SEEN *all* the signs of the zodiac and the planets, and a
comet for good measure. It seems about time for the house lights to
come up, but, oddly enough, our poet/director/producer has turned
his back to us and appears to be making some stage adjustments.

I'm going to take this opportunity to fill in a promised bit of
information. A while back I said, "There is one more empower-
ment the stars possess, in addition to their personalities, but that
must wait until later." There has been no need to know about it be-
fore now. I also wanted to wait to talk about it because it involves a
couple of unusual words: *Euhemerism* and *castasterism*.[563]

Euhemerism (u-*he*-mer-ism) was the idea of Euhemerus, a
Greek philosopher who lived about 300 B.C. He taught that pagan
gods were really just heroic mortals who had been deified by subse-
quent generations.

The second word, *castasterism*, according to Franz Cumont,
tells of being rewarded by being set in the sky as a group of stars.
(*Aster* means star. That's why an *aster*isk is star-shaped.) The pro-
cess is generally expressed as "translation to the stars." Ancient
writers found it a convenient way to end a myth, projecting "fabu-
lous heroes and even members of human society as living on high
in the form of glittering constellations."[564] It's much like the end-
ing we love—"They lived happily ever after."

Benefactors to humanity and founders of a race of people were seen as gods. Recalling that Julius Caesar had descended from Venus, here is Ovid's account of Venus' action following Caesar's death at the hands of assassins:

> Venus took her place within the senate-house, unseen of all, caught up the passing soul of her Caesar from his body, and not suffering it to vanish into air, she bore it towards the stars of heaven. And as she bore it she felt it glow and burn, and released it from her bosom. Higher than the moon it mounted up and, leaving behind it a fiery train, gleamed as a star.[565]

The belief was that kings' souls "came from a higher place than those of other men"; immediately at death "their souls once again rose to the stars, who welcomed them as their equals."[566]

Cosmographia portrays the Milky Way as a "highway" that emitted "radiance which its mass of stars produces through sheer multiplicity." But all is not glorious: "A numberless throng of souls clustered about the abode of Cancer." Sad and weeping, they "were destined to descend...from splendor into shadow...[into] fleshy habitation."[567] It appears that (poetically, at least) souls descended from heaven and would return there. At some point a person would remember his heavenly beginning, "it remembereth me wel, here was I born...here wol I duelle (dwell)." The brilliance of the Milky Way was "the meeting place in heaven for deserving souls."[568]

Thinking back to the account of the Assumption of the Virgin Mary, *Ecclesiale's* words were "the Holy Mother of Christ is taken up *to the stars*." The same star-laden expression is used repeatedly by the author: Agatha ascends to the stars, as does Samson; Nicomedes climbs to the stars, Lambert passes, Cosmos and Damian are lifted, and Maurice leads a legion of martyrs to the stars. It was the terminology used as long ago as Plato, "he who lived well throughout his allotted time should be conveyed once more to a habitation in his kindred star, and there should enjoy a blissful and congenial life." Ovid says of Romulus' death, "The king [Romulus]...soared to the stars."[569]

Chaucer's contemporaries thought in the same pattern. They immortalized King Arthur's ascension to the star Arcturus as a Christian alternative to his final voyage to Avalon. Lydgate speaks of "Arthur's translation to 'the rich, starry, bright castle which Astronomers call Arthur's Constellation', where he lives in Christian glory." The basic image was a "widespread and enduring tradition."[570]

In the *House of Fame*, Chaucer dreams he is soaring with the eagle, and ponders:

> Shal I noon other weyes dye?
> Wher Joves wol me stellyfye,
> Or what thing may this sygnifye?
>
> <div align="right">(585–87)</div>

> (Shall I no other way die?
> Where Jove will me stellify,
> Or what thing may this signify?)

The eagle, knowing the poet's thoughts, assures him,

> For Joves ys not theraboute—
> I dar wel put the out of doute—
> To make of the as yet a sterre.
>
> <div align="right">(597–99)</div>

> (Jove is not here about—
> I dare well put you out of doubt—
> To make of thee as yet a star.)

The poet could still have hope for the future.

In the *Parlement of Foules*, the African guide calms the poet's doubts with,

> And rightful folk shul gon, after they dye,
> To hevene; and shewede hym the Galaxye.
>
> <div align="right">(55–56)</div>
> (And rightful folk shall go, after they die,
> To heaven; and showed him the galaxy.)

When Troilus died, his spirit happily "went up to the eighth sphere" (5:1808–09). Chaucer is no stranger to the convention of the stars being a worthy man's ultimate destination.

Here in his theatre, we are getting a little restless, but the poet ignores the stir in the audience. He has opened the curtains wide, and it appears we will have an encore—but there is no one on stage. A door at the back, unseen until now, opens. A fragrant breeze moves the curtains. We glimpse a sunny forest glade. Bird-calls and the sound of rushing water can be heard. When our eyes adjust to the brightness of the aperture, a slender figure is visible. Chaucer beckons and, after some hesitation, the figure enters the stage area, closing the door as he does so. Chaucer is ready to have us meet the very last pilgrim, the Clerk.

In trying to fit clues together this way and that, my final answer to this part of the Canterbury riddle is—the Pilgrim Clerk is *Petrarch*, an Italian poet, letter writer, cleric in minor orders (a man of the church below the training of an ordained priest), and—most important of all—"the first humanist." His humanist philosophy is almost always the first thing noted about him.

As a young man he achieved the signal honor of being crowned with a Roman laurel wreath, which he then laid at the feet of a statue of St. Peter. He is renowned for his love of studying, solitude, classic literature, the Latin language, and books. It was his wish that his personal volumes be given to the city of Venice as the nucleus of a library he hoped would grow. He had no patience with Scholastic philosophy and questioned scientific "knowledge" based on "tradition" devoid of observation. Classic works of the ancient Greek and Roman period were his dedication. His contemporaries, he complained, "permitted the fruit of other minds and the writings that their ancestors had produced by toil and application, to perish through insufferable neglect."[571]

Living through, and losing loved ones during, more than one onslaught of the plague, he was left with a deep sense of the transitory nature of life. Urged, when he was ill and old, to give up working and prepare for death, he said he would die all the sooner if he didn't work. In a letter to a friend, he confided, "I desire that death find me reading and writing." His desire was fulfilled on the morning of July 19, 1374; he "was found leaning over a book as if

sleeping, so that his death was not at first suspected by his household."[572]

This final pilgrim introduction will no doubt be unlike the others. None of the other travelers had a hidden identity as a human being. Now to begin.

> A Clerk ther was of Oxenford also,
> That unto logyk hadde longe ygo.
>
> (A 285–86)

> (A Clerk there was of Oxford also,
> That according to[573] logic had long gone.)

His reputation during his lifetime was such that the *Britannica* (with a slight qualification) delivers kudos: "Never before, perhaps, has a writer had so rapid, so decisive and so far-reaching an influence."[574] Associating the Clerk with Oxford would be a way of expressing the presence of Petrarch's ideas, his spirit, as part of the university curriculum in England. With a double meaning, A 286 covertly says that because he is dead, it is logical that he had long gone. This is followed by his fascinating "horse."

> As leene was his hors as is a rake,
> And he nas nat right fat, I undertake,
> But looked holwe, and therto sobrely.
>
> (A 287–89)

> (And lean was his horse as is a rake,
> And he was not very fat, I declare.
> But looked hollow, and thereto solemn.)

The "animal" is thin as a stick, a rake handle, and the pilgrim himself is anything but fat. As a matter of fact, he looked hollow and appropriately solemn. Do the words conjure up a strange image for you? They do for me. One other pilgrim thin as sticks was the scorpion. This depiction sees the figure thin as sticks and hollow, besides. Chaucer uses "hollow" another time just to describe a figure's eyes as hollow "and grisly to behold" (A 1363). If hollow

eyes are *grisly*, what does that say for a hollow person? The pilgrim, for me, is a skeleton; this is the dead Petrarch. "Undertake" (A 288), according to the MED entry, was not yet used in regard to funerals, but the mood is so right that it makes me wonder if it had just not been recorded in the sources that make up the dictionary.

> Ful thredbare was his overeste courtepy;
> For he hadde geten hym yet no benefice,
> Ne was so worldly for to have office.
>
> (A 290–92)

> (Completely threadbare was his outer garment;
> For he had got himself no ecclesiastical position,
> Nor was he as worldly as to have other employment.)

His threadbare garment and his not being "worldly" continues to give cues to our mind's eye to see one who is no longer in this world.

> For hym was levere have at his beddes heed
> Twenty bookes, clad in blak or reed,
> Of Aristotle and his philosophie,
> Than robes riche, or fithele, or gay sautrie.
>
> (A 293–96)

> (For he would rather have at the head of his bed
> Twenty books clad in black or red,
> Of Aristotle and his philosophy,
> Than rich robes, or fiddle, or gay psaltery.)

A declaration of love of books is to be expected. Petrarch is noted for his "prodigious achievement as the discoverer of so many of the treasures of classical learning and beauty, both in those texts which he actually found and in those which he re-established by his sensitive and accurate interpretation." This may be the only time Chaucer ever took time (space?) to describe the physical appearance of books. This chosen "ornament" signals the personality of the man. The number of volumes is, I'm sure, meant to be impres-

sive. Naming Aristotle defines the period of literature Petrarch loved. Books being more essential to the pilgrim than finery can be understood in the way the Italian scholar spent time in the company of princes: "When everyone else sought the palace, I hied me to the woods, or spent my time quietly in my room, among my books."[575]

> But al be that he was a philosophre,
> Yet hadde he but litel gold in cofre.[576]
>
> (A 297–98)
>
> (But even though he was a philosopher,
> Yet he had but little gold in his coffer/coffin.)

Identification as philosopher almost seems redundant, but repetition as a clue is the point. *Cofre* of the second line, a Middle English word with varying connotations, conceals an ambiguity: He was not concerned with riches for his *coffer*; and/or he had no need for gold in his *coffin*.

> But al that he myghte of his freendes hente,
> On bookes and on lernynge he it spente,
> And bisily gan for the soules preye
> Of hem that yaf hym wherwith to scoleye.
> Of studie took he moost cure and moost heede.
>
> (A 299–303)
>
> (But all that he might of his friends receive,
> On books and on learning he spent,
> And busily he began for their souls to pray
> Of them who gave him wherewithal for schooling.
> Of study took he most care and most heed.)

The portrait could not be more packed with assurances of his studious inclination. In his own words, when Petrarch accepted an invitation to spend time with the nobility, "I should never have submitted to any conditions which would, in any degree, have interfered with my liberty or my studies." "Study," he said, "provides us

with the fellowship of [the] most illustrious men."[577] It was his aim to be the best writer he could be. In candor, with humility, he wrote, "If I were really great...I should strive...to become greater."

He was a man of serious conscience, a man with many devoted friends, a man dedicated to learning.

> Noght o word spak he moore than was neede.
>
> (A 304)

(Not one word spoke he more than was needed.)

He tells us that it was his habit at times to "remain silent" while others around him conversed. He enjoyed solitude and wrote at length on the subject. During his life, Petrarch passed extended periods of tranquillity at two quiet retreats, not isolated from friends, but detached from "the world." The first was at Vaucluse, in the rustic Sorgue River valley near Avignon. It was his home at several periods, including a sojourn of more than two years, as it provided a special haven for his spiritual and literary development. His work *The Life of Solitude* is addressed to a dear friend, a bishop. At the closing he admits, "I intended to write a letter and I have written a book."[578]

In 1367, determined to live out his last days in his native Italy, he found the necessary solitude in the hills south of Padua, where he lived almost continuously until his death in 1374. (There are some who believe Chaucer and Petrarch met in Padua.) These idyllic settings were his "Helicon," the Greek mountain said to be the home of the Muses.

He said of poets, being a poet himself, "They raise themselves aloft on the wings of their genius, for they must needs be carried away with more than human rapture."[579] (For a fleeting moment I see Chaucer, the dreamer, raised aloft by the philosophizing eagle in his long poem, *House of Fame*.)

We've reached the end of the Clerk's portrait. The very last line is one of Chaucer's oft-quoted gems.

> And that was seyd in forme and reverence,
> And short and quyk and ful of hy sentence.

Sownynge in moral vertu was his speche,
And gladly wolde he lerne and gladly teche.

(A 305–08)

(And that was said properly and reverently,
And short and quick and full of deep significance.
Resounding in moral virtue was his speech
And gladly would he learn and gladly teach.)

These, the final lines of this pilgrim's introduction, hold a reverence for Petrarch. And the use of *quick*, which can mean *alive*, imprints the idea that although the man is dead, his words are still alive—an achievement greatly desired in the fourteenth century.[580] A letter written to Boccaccio paints a detailed portrait of our scholar and his love for his friends in the year before his death.

> I should prefer to die while you are all still alive, and leave those behind in whose memory and conversation I should still live, who would aid me by their prayers, and by whom I should continue to be loved and cherished. Except a pure conscience, I believe there is no solace so grateful to the dying as this.[581]

As a teacher, his beliefs at times shocked the tradition-bound Middle Ages. For example, when he was urged by his confessor to give up working (after he had had a stroke) and prepare for death, the medieval practice noted above, his response was, "If you have anything better to urge, pray produce it." He went on to record his "audacious and historically remarkable statement of the Humanists' creed."[582]

> There is a certain justification for my plan of life. It may be only glory that we seek here, but I persuade myself that, so long as we remain here, that is right. Another glory awaits us in heaven and he who reaches there will not wish even to think of earthly fame. So this is the natural order, that among mortals the care of things mortal should come first; to the transitory will then succeed the eternal; from the first to the second is the natural progression.[583]

Let's move now to the *Prologue to the Clerk's Tale* where the Host addresses the Clerk for twenty lines, referring to "everything has its time" and a hope that he will not choose the topics friars use during Lent to make folks weep for their sins (E 6–13). These lines capture the humanism just reviewed—taking things in their proper order followed by a rejection of dwelling upon death. Also asking him to reserve high style for letters addressed to kings, the Host implies that the pilgrim *has* a high style; mention of kings alludes to his many diplomatic activities and his "veritable passion" for letter-writing.[584]

The Clerk's quietness is remarked upon, but he dutifully responds,

> "Hooste," quod he, "I am under youre yerde;
> Ye han of us as now the governance,
> And therfore wol I do yow obeisance,
> As fer as resoun axeth, hardily.
> I wol yow telle a tale which that I
> Lerned at Padowe of a worthy clerk,
> As preved by his wordes and his werk."
>
> (E 22–28)

> ("Host," said he, "I am under your direction;
> You have of us now the governing,
> And therefore I will obey you,
> As far as reason asks, readily.
> I will tell a tale that I
> Learned at Padua from a worthy clerk,
> As proved by his words and his work.")

He goes on to say that the worthy clerk is Petrarch and speaks of his being poet laureate and of his death. In spite of references in the third person, this does not preclude the possibility that this pilgrim *is* Petrarch.[585] He is referring to himself in his earthly life. (Perhaps Chaucer wants this character to have a double identity just as the rest of the travelers. As the only concealed "human," his doubleness is unprecedented.) The story he will tell, as we have stated many times before, should be a clue to his identity and relate

an experience that is part of the pilgrim's life. Narrating a story written by Petrarch fits the requirements. To indicate the source of his chosen story as a "clerk" (as is he) is an element of identification, as well. (Mercury's telling a tale heard from a merchant is equally fitting.)

At the end of the *Tale* there is a special section, Chaucer's addition. It is headed "Lenvoy de Chaucer." A "lenvoy" (or envoy) can be a postscript to a letter; to add a postscript to a work written by a man famous for his letter-writing, who "allowed scarcely a day to pass without writing one or more letters,"[586] seems a clever touch. The tone of this postscript, however, is a contrast to the message of the story. Where Griselda, the main character, is patient and passive in the face of malice, the added lines give counsel to wives not to be foolishly naive. They are prompted to devise strategy which will gain their needs and their rights.

Considering Chaucer's plan, the decision to include a second writer among his companion pilgrims (Chaucer himself is one of the pilgrims) follows an imaginative scheme spoken of in Petrarch's letters. On a trip to his favorite retreat, Vaucluse, he tells of his arrival with an author-companion: "Cicero, who was greatly astonished at the beauty of these new regions...seems to rejoice and to be eager to remain in my company. We have now passed ten quiet and restful days together here." In a letter to Virgil, he inquires whether Homer "roam[s] about in thy company." The Italian philosopher later explains that through constant wondering, "Such thoughts as these, O Vergil, bring thee vividly before my eyes." In his work on solitude, he tells of recalling those "you can converse [with] only in the imagination."[587] I'm not saying that Chaucer is using Petrarch's ideas. I believe Chaucer's genius had a parallel inspiration which manifested itself in dramatic form.

The Clerk is not an afterthought, a tag-along. The Italian humanist arrived at sunset that night at the Tabard. He *is* one of the company. *Company* implies a group associated by a common element—profession, religious faith, etc. By including Petrarch among the celestial figures on this pilgrimage, Chaucer is castasterizing him, honoring him as worthy to be among the stars, declaring him to be a new generation of the heroic mortals deserving of translation to the stars.[588] It is his tribute, as Daniel 12:3 says,

They that are learned shall shine as the brightness of the firmament: and they that instruct many to justice, as stars for all eternity. (Douay)

This poetic commonplace for a journey to the afterlife, I believe, is the basis of Chaucer's journey. Traveling with pilgrim-companions who have a second identity in the cosmos is even more meaningful. The poet's Retraction clearly expresses the longing for a heavenly reward.

Consider *Cosmographia's* portrayal of worthy souls reaching their destination:

Man...will go forth at the dissolution of his earthly life: "He will ascend the heavens, *no longer an unacknowledged guest*, to assume the place assigned him among the stars."[589]

As Chaucer himself proclaimed, he had joined the pilgrims in fellowship immediately. The only problem facing him was the confession he had to make, the disclosure of the deeds of his life. I see the overall heavens-oriented plan of the *Tales* as Chaucer's ardent desire to be "one of them," one of the accepted lights of the firmament, a truly *acknowledged guest*.

It's time to excuse Petrarch/the Clerk. Exiting through the door and back into his wooded retreat, he'll be there to spend time (or eternity) as Chaucer's companion.

The poet turns toward his audience once again and comes forward, I assume, to take a final bow. I'm surprised to hear a voice ask, "Sir, may we address some questions to you?"

The poet appears intrigued, and nods encouragingly.

Someone begins, "As you traveled through Europe, which was your favorite city?"

Lost in thought for a moment, he sighs. His cheeks show a hint of red.

Another voice asks, "Why, after all this time, do we still read your stories?"

Folding his arms, a satisfied smile comes over his face.

A third questioner, anxious to participate, wonders, "Did you accomplish all you set out to do in the *Tales*?"

Looking directly at the source of the question, his expression almost grave, Chaucer cups his chin in his hand.

The seriousness of the moment is broken as someone begins to laugh. Others, realizing the poet's craftiness, join in the laughter. He wanted to know what our questions would be; he never intended to answer them. Laughter soon gives way to applause. The creator of the entertainment gestures toward the velvet draperies, acknowledging the contribution of his brilliant performers who surround us; each one truly a star. He is visibly pleased with our heightened ovation for his players—the Cook, the Wife, the Doctor, and all the others. The poet/director/producer, his energy spent, bows deeply as the curtains close. His performance is finally over.

"Full comprehension" of any allegory seems to be the consequence of the reader's sensing how many levels are involved. Even if there are ten levels and they are at odds with each other sometimes, this calculation can still theoretically be made and the allegory worked out. The process of explication, a gradual unfolding, is sequential in form. There is normally a gradual increase of comprehension, as the reader pursues the fable, and yet most allegories of major importance have ultimately very obscure images, and these are a source of their greatness.

—*Angus Fletcher,* Allegory: A Symbolic Mode *(1964)*

VIII. Reflections

THIS GRAND allegory has had many things to say. In a most fascinating way, many of them were said through "a movement among meanings"—a line would communicate with us, but if we glanced away momentarily and then returned our attention to it— we found a meaning that was not there just a moment before! There is a mutability within the concept of creative allegory; its flexibility, its kaleidoscopic potential, needs to be recognized and embraced. When Baldwin decides that Chaucer's metaphor of the Canterbury journey "never *hardens* into allegory," the descriptive, for me, doesn't even apply.[590]

In viewing Dante, it is seen that believability of traveling through hell is accomplished because the author "purposely refrains from furnishing particulars that might destroy the illusion." It is the same with Chaucer. Wolfgang Clemen speaks of Chaucer's "new art of silence." Lack of specifics, uncluttered imagery, allow us to peer "through the surface [as] we read the true interior design."[591]

A fourteenth-century author speaks of allegory as "mistied"; that is, covered with mist, obscure. Resolution of the obscurity has a purpose. "Mistied" is "illumined for to see the works of God in holy church." Chaucer's knowledge of classic pagan literature and (with the blessing of Augustine) its adaptability to Christian themes give witness to aspects of the Church, when the inner

meaning is brought to light, "illumined." The movement to synthesize a continuous outpouring of truth and wisdom from both pagan and biblical writings had many advocates (not the least of whom was Petrarch). Neoplatonism, a new look at Plato, "provided a means of coordinating the insights of other authors, translating their imagery into cosmological…terms."[592] The strength of Neoplatonism was second only to that of Augustine.

In the late fourteenth century, material from myths became standard literary content. The gods, having become stars or planets, opened the way linguistically for Chaucer to introduce them as pilgrims. As Legouis has said, Chaucer's "astrological sky is *peopled* with stars."[593]

To venture into the cosmos was not a flash of Chaucer's originality. *The Wedding of Mercury and Philology* and the *Anticlaudian* (both known to Chaucer) are adventures involving travelers through the cosmos. Chaucer, as usual, doesn't use a pattern he already knows, but, instead, allows his creativity to enlarge and enliven a familiar form. Rather than send a main character on a celestial errand, he ventures forth himself to become of equal importance with the cast of participants.

When Donald Howard says, "a literary work was experienced differently in the fourteenth and fifteenth centuries from the way one is experienced now," he is right, of course.[594] Part of that difference, when applied to the *Tales*, is our generally limited knowledge and understanding of the sky. Kolve draws attention to the fact that Chaucer "most characteristically sought to exercise the *visual imagination* of his audience."[595] This is bound to be true for the Canterbury story, because our vision is the means of experiencing the wonders of the heavens. That predominant characteristic is what allows the images to remain clarified, transparent; there are no complications of smells, sounds, responses to textures—unless his well-chosen words serve in a *visual* capacity, as well, for another level of meaning.

When Manilius marvels at the design of the heavens "and the obedience of all," I think back to the "problem" that many have with the pilgrims—back at the Tabard, before the pilgrimage begins—unquestioningly agreeing to do as the Host will direct. At the level of astronomy, this is the "design and the obedience of all

to immutable law" of the Creator's universe.[596] The "problem"—the unquestioning agreement—becomes, instead, a confirmation of stellar identities in their "immutable" roles.

What the poet has to say is laced with "evasive ambiguity," with "a new art of silence," with "self-concealing art."[597] An almost invisible method of concealment is his frequent use of a dash at the end of a line: the Prioress has a "fair forehead—"; the Doctor and the apothecaries "made each other win—"; the Wife was "without company in her youth—." This ellipsis (—) has been understood (or misunderstood) to represent a figurative *eclipse*, an obscurity or concealment. It really says, "I could tell you more about the event, or the image, but let's talk about something else instead." The inherent implication is generally overlooked.

Considering Chaucer's Church-related thoughts, the fourteenth century was fraught with conflicts "between [religious] ideals and reality." His *recognition* of the situation needs to be assumed. He was no fool; philosophical and ecclesiastical translations were his foundation. It is clear that he had no desire to be as outspoken as Wyclif; nevertheless, he could not have been blind to abuses. His Retraction, and the *Parson's Tale*, as the conclusion of the pilgrimage, serve "as a reminder to his readers of the necessity to read the *Tales* for its sentence (inner meaning)."[598]

His inner meaning is not generally given as a direct gift, but all needed information is provided. Using obvious details and images, a mental process is necessary to penetrate to the covert level. There is no straightforward communication with his audience as we see with characters named Wicked-Tongue, Shame, and Idleness in the *Romance of the Rose*, or Lust-of-Eyes, Hunger, and Robert-the-Robber in *Piers Plowman*.

A perfect example of my point is the identity of Sir Elephant in the *Tale of Thopas*.[599] All the clues are present. Are they examined for their significance? or passed over as odd but of no importance? Only if you *expect* a double meaning will understanding become an essential goal, a prize to cherish. The sentence, the valued hidden meaning, of this grand enigma may offer communication on many topics just waiting to be grasped.

For example, along with his necessary awareness of distressing practices of the Church, there was, developing throughout Chaucer's

adult life, a sense of anxiety all across Europe and England. Predictions abounded regarding the advent of the Antichrist. The idea itself created unrest: because some (but only some) believed conjecture on the subject was permissible; others believed no prior knowledge of the fateful time was possible; and still others believed one could gain certainty, and that this certainty was "the mark of the true Christian."[600]

Laymen were active participants in a "new science" that was developing: "computation of the end of the world."[601] Some theology changed its emphasis from concern over the end of man's *life* to serious inquiry related to the end of *time*.

While laymen had a part to play, serious theologians were making predictions based on inspired prophecies. One line of thinking felt the Church was about to be replaced; a new age was dawning. (I have wondered whether the Wife of Bath's remark is related to this conviction. We never hear that husband 5—we identified with the early Church—is dead, and yet she speculates that she'll be ready for husband 6 *whenever* he comes along [D 45].)

Catastrophic events, such as the devastation of the Black Plague, fed the growing apprehension. If I had to identify Chaucer's position in all this forecasting, I'd put him with the "no-prior-knowledge-is-possibles." That's partly because he seems kindly toward his comet; not as an indication of disaster, but only a light. And it's partly because of the Wife's speculation rather than an *announced* wedding date—or even her confiding of the *death* of husband 5. It is also partly because of an additional way of looking at the *Canon's Yeoman's Tale*.

[What I'm going to say now will interrupt the flow from end of performance to end of book, but I want you to get the feeling of how it happened.]

I was sorting out note cards, categorized "conclusion," from many sources over an extended period of time. A notation said, "2s and 3s." Odd. (It was as unexpected as finding "neck" as an index entry regarding the history of Marian doctrine. See pp. 177–78 above.) A few notes later, I saw "Arnold of Villanova," the name of the author referred to by the Yeoman/book. It was time to take the *oddity* seriously as I thought of the enigma where multiplying seems concerned with salvation.

There is no problem with an allegory suddenly gaining a new

level of meaning (the headnote makes that clear)—that is, if you find support for the additional interpretation. We spoke of the Knight/Mars having three patterns of functions; the new thought is related to the third function. The Knight, as a traveler with the group, is standard interpretation. At the second level, Mars as the first month of the Roman calendar is associated with the journey as the passage of a year. At the third level, both primarily and ultimately, the Knight's/Mars' position is at the leading edge of the cosmos—the beginning of Time and its conclusion. When all the stars and planets coordinate in their original positions, that will accomplish the fulfillment of the Great Year, *the end of Time*. (See p. 43 above.) That belief is one of the deep storylines being portrayed within the *Tales*. Now, let's find out how the distressed Yeoman's words fit the new picture.

It seemed that every author I checked had something to say about Arnold. According to Thorndike, Arnold had a secret "for making azure" (an unexpected recollection of book production). Bloomfield, whose book has to do with *Piers Plowman* (the only great non-Chaucer poem in English for the fourteenth century), told of "major prophetical figures" of Chaucer's lifetime; Arnold of Villanova was one of them. Rand cited him as "a great medical scholar." Reeves called him "the mysterious Arnold of Villanova." Finally, when Oberman, a source I've used many times, told of how the Chancellor of Oxford had declared Arnold's ideas "sheer fantasy," using words like "*experientia* temp*orum*" and "*experimento* temp*oris*," it was time (no pun intended) to break into this closing chapter and do some digging.[602] Arnold was a greater presence than his mention in this Yeoman's tale would indicate.

Spurred by prophecies from one of the first of the inspired theologians, Joachim of Flora, Arnold pressed Popes Boniface VIII and Benedict XI to prepare for tribulation, which he believed was soon to come. Experiencing no positive response, he solicited the aid of his friend, King Frederick of Aragon. He wrote a good deal, including *De* Temp*ore Adventus Antichristi* (there's *temp* again), and a Commentary on a pseudo-Joachim work. In the Commentary he announced "the end of the world was foretold for 1400, and thus this work naturally became one of particular interest for fourteenth-century readers."[603]

To believe that Chaucer could have known about these proph-
ecies, both Bloomfield and Reeves, my main sources of informa-
tion, cite considerable evidence of Joachim's prophecies being well-
known in fourteenth-century England.[604] With Joachim's ideas as
his basis, Arnold's writings created a great stir at the University of
Paris (about 1300). An Oxford scholar condemned Arnold's work;
surprisingly, Joachim's work, Arnold's source, was shown more re-
spect. (It is fairly accurate to say information from Joachim was re-
cycled by Arnold.) Refutation that claimed the end date "could not
be determined by the human mind…[was not] of much avail." The
espoused doctrine was held to be "pernicious" and "*pestiferi.*" Tho-
mas Aquinas, no less, "declared himself unequivocally against" the
Joachimist way of thinking; he termed it a "menace to orthodoxy."
The Bishop of Majorca (in 1342) believed the teachings "engen-
dered" a "deadly poison."[605]

What was so in need of condemnation? An idea of the basics
will have to suffice at this point. The prophecies are (like the alche-
my manuscripts) "bewildering," laden with a profusion of letters
and numbers. Joachim's original inspiration (based on a gift of sud-
den insight) sees history as two "parallel streams" destined for con-
summation. His "mind is playing almost equally on the 'twos' and
'threes,'" finding numerical correspondences that were mainly bib-
lical. A doctrine of the Trinity, condemned by the Lateran Council
of 1215, was prominent. His problematic ideas were perpetuated
and reinterpreted by his disciples (the Florensian Order, who held
considerable property in England), thereby developing and extend-
ing his influence for centuries.[606]

"Continuing fascination" is Reeves' description of Chaucer's
milieu regarding prophecies of the end times. A new fourteenth-
century anthology of predictions was produced for St. Paul's in
London and another for the Vatican. English libraries contained "a
large number of prophetic manuscripts"; the mid-1300s may have
been "a high mark in the history of prophecy." As the dates of pre-
dictions passed without the calculated event occurring, dates were
recalculated and modified accordingly. As an English chronicler
comments, "He failed foule and erred in his counting."[607] When
new dates indicated the 1360s—the decade that brought the
plague to Europe and the devastation of war to France—belief in

the predictions grew stronger. The Schism in the Church which began in 1378 added confidence that the prophecy of the end of time might also come to pass.

How does all this show up in the Yeoman's tale? We are looking at a third level of meaning. First was alchemy. Second, we recognized the Yeoman as a book, the multiplication tables, etc. which were found in handbooks to aid with the difficult discernment of the date of Easter. Third, we will associate clues that speak of the new prophetic practices.

To begin, when the poet Anglicizes Arnold's last name to Newtown (instead of Villanova), it is forecast in the first two lines of the second narrative. "A canon of religion would infect a town," where *town* and *infect* come together with a religious canon; that is, a directive. If Arnold is a new "town," he *has* been "infected" by the religious canons of Joachim, which were *pernicious* and *pestilential*. All the multiplying reflects Joachim's multiple series of 2s and 3s central to the doctrine. When the Yeoman complains that no matter how carefully they work, they fail, that is the necessity of recalculating new dates in the future. Duncan has described the tricks Chaucer plays regarding the work the poet specifies; when Arnold is finally referred to, as an author, the title indicated ("his Rosarie," G 1429) has a properly religious connection.[608] In addition, the poet counsels, through the Yeoman, to cease meddling with this art—all this calculating and recalculating. God does not wish the answer known. The closing gist is, try to do God's will and leave it in His hands. This, for me, puts Chaucer among those who believe the time cannot be discovered by the mind of man; it's a waste of effort to try.

And that's what came of sorting out the notes I'd gathered.

Why did Chaucer write the *Tales*? Better said, why did he create this complex allegorical structure? Certainly, to entertain. And then, as Augustine directs, it should also instruct. For those who work to gain the hidden meaning, the *Tales* would provide much food for thought. It also seems quite fitting that Chaucer would— as Petrarch recommended—try to be the best he could possibly be so as to assure that his name would live on.[609]

We'll close our adventure with Chaucer's cosmos by looking at

the poet's way with words in the *Prologue to the Parson's Tale*, the last commentary from his narrator.

> The sun from the south line was descended
> So low that he was not, to my sight
> *Degrees* nine and twenty in height.
> Four of the clock it was though, as I guess.
>
> . . .
>
> Therewith the moon's exaltation,
> I mean Libra, had begun ascending,
>
> . . .
>
> For which our Host...
>
> . . .
>
> Said in this way: Lordings, everyone,
> Now lack we no tales more than one.
> Fulfilled is my *sentence* and my decree;
> I trust that we have heard from each *degree*;
> Almost fulfilled is my ordinance, plan.[610]
>
> (X 2–19)

Rodney Delasanta has demonstrated how the "theme of Judgment" is present in the *Tales*: "The sign of Libra is the scales; and we have already seen that a traditional detail of thirteenth-century tympanums was the figure of the angel weighing the virtues and vices of the defendant in his apocalyptic scales. The ascending Libra of the Parson's prologue thus betokens for the Canterbury pilgrims approaching Judgment."[611] We might term it that the Pilgrims are in *the 11th hour*, but Chaucer is inclined to speak, instead, of *degrees*. Twice in the lines printed just above he uses the word; and in the beginning of the *General Prologue*, he alludes to the "degree" of the pilgrims (A 40). The explanation of "rank" or "class" of the individuals applies to the surface story, but let's consider the readily applicable celestial intent of the word.

Saying that the time he refers to (for the primary reading) is four o'clock in the afternoon, he adds "*I guess*," which constitutes the signal of a covert meaning. Nine and twenty degrees is almost 30°; thirty is neater, a simple round figure. There must be a significance to twenty-nine. In referring to the degrees (of the Pilgrims)

we have heard from, we know that they also number nine and twenty. I studied these matching numbers long and hard. Twenty-nine communicates, for example, (like the 11th hour) that there is only one degree left to complete the passage through a sign. I'd read a prophecy about Pisces; I knew that Aries starts the year, but Chaucer is talking about Libra and the moon. What does that have to do with it? Nothing—and everything.

Delasanta comments on the presence of Libra: "It is the ascendancy of the scales of Libra which will bring justice and judgment." That fits the setting nicely, but still doesn't clarify that nagging number—29. With more cogitating and considerable rotating of the bits of information—like trying to fit odd pieces of a puzzle together—I realized these "pieces" had images on the reverse side also. With the "reverse" sides connected, I could finally see how (in Delasanta's words), "Chaucer has written straight with crooked lines."[612] It's not what the poet says, but what he doesn't say, that holds the meaning to be discovered.

If Libra is rising *at sundown*, it is Aries that will be the sign at *sunrise*, sunrise being the time that determines the designated sign. This says, in the secondary meaning, that we have almost returned to the starting point of the zodiac once again, the start of another year. The Ram (Aries) is present in the opening of the *General Prologue* (A 8). "Tomorrow" morning will bring us to the Ram (Aries) once again. Deeper significance, the third level, is that the end of Time is at hand, the end of the Great Year. If the morning brings Aries, we are now in the *last degree* of Pisces—that's the importance of 29—and the celebrated astrology of Albumasar "foretold the destruction of the world...should be...in the last degree of Pisces."[613] Libra rising at *evening* anticipates Aries in the morning, but there will be no morning. We are *in* the last degree of Pisces; Judgment—the world's end—is imminent.

Now we have only the moon to consider. When Chaucer speaks of the moon's exaltation, the time when it "exerts its greatest influence,"[614] there is something *wrong*. This is a major *non sequitur*; Libra is *not* the moon's exaltation, astrologically speaking. Chaucer knew that. Rather than think of the statement as a mistake (on Chaucer's part or that of a scribe, which is what editors suggest), let's look at what is implied if the statement is meant to

be valid. How better to attract attention than with a clearly errone-ous statement—if the attention of his audience is what he wants?[615]

If we picture the moon's exaltation as a *full moon*, the period of its "greatest influence," we are dealing with Easter once again. The proper date is concerned with the appearance of the first full moon which follows the vernal equinox. The Scales, then, actually play a double role—first to demonstrate Judgment, and then as the sym-bol of equal day and night.[616] The poet's equinox adjoins the full moon. To see Easter coinciding with Judgment is found in the me-dieval prediction recorded in *Mandeville's Travels* where the author directly states: "The doom (Judgment) shall be on Easter Day."[617] For pilgrimage to be closely associated with thoughts of Easter (as Salvation) seems almost necessary.

I have nothing more to explain or identify about the journey. I've enjoyed Chaucer's pilgrimage (and my own) more than I can say. Road signs to look for, accommodations to be arranged, strangers to get along with, mishaps, surprises, and delays to handle. The ex-perience has been grander and more all-encompassing than I ever could have dreamed.

When the *Tales* are thought about, there is often an accepted way of dealing with the content seen or understood from the face value of Chaucer's lines, his *obvious* images. I can't say strongly enough that, with all that is new in the world of medieval scholar-ship, it's time to reevaluate, to begin to examine his words as if they have never been read before. Oberman (dealing with four-teenth-century religious thought) and Bloomfield (writing about Langland's fourteenth-century *Piers Plowman*) make the same point in regard to assumptions about material we've read: "We have only just begun to discover...assessment at this point is perforce premature and provisional"; and, "The time is not yet ripe...much more needs to be known about the intellectual life of fourteenth-century England."[618]

We owe that same degree of respect, of dedication, to the as-sessment of our first great English writer. Without thorough knowledge of daily life in the fourteenth century (not just its liter-ary tastes), we cannot really know what is concealed within this al-legory of "major importance" from a master of the genre.

The body of literature, with its limits and edges, exists outside some people and inside others. Only after the writer lets literature shape her can she perhaps shape literature.

—*Annie Dillard,* The Writing Life (1989)

IX. Closure

WHO COULD have known how amazing and far-reaching the pilgrim adventure would be when it started.

Chaucer's Host: Up-So-Doun had strength added to its basic assumption by the publication of Miri Rubin's *Corpus Christi: The Eucharist in Late Medieval Culture* in 1991.

Pilgrim Chaucer: Center Stage gained one more clue to the overall riddle when new legal evidence about Chaucer's court case was found by Christopher Cannon, and published in *Speculum* in 1993.

Chaucer's Pilgrims: The Allegory, this volume, was given a timely aid to understanding in at least one area when Hyakutake and Hale-Bopp burst on the scene—as did Chaucer's Canon.

I've found the answers to my original questions—and much more. I've traveled so many by-ways, followed so many of the poet's clues in search of treasure. Some clues continue to elude sleuthing. But many turned out to be pure gold. How exciting! I hope you've shared some of the excitement.

Those with greater depth of medieval knowledge would have conducted the search differently, I know. But they wouldn't have had more passion for the task.

There is much more to be done, but—about *the Pilgrims*—this is my closing word.

Thank you, Geoffrey Chaucer.

Appendix: Chaucer's "Litel Jape"

This is a story of the Cook's personal experience because it involves his acquaintance with a Beehive, an alternate name for the Manger, a formation in the constellation of Cancer.

TO AMUSE his fellow Canterbury Pilgrims, Chaucer's Cook tells a "litel Jape" that occasions little laughter among modern readers. It may be assumed that the humor fails because the tale is incomplete. Ten Brink speculated, about one hundred years ago, that the "jape" was headed in a bawdy direction and Chaucer broke off writing the story because the poet realized "three stories of the same [vulgar] stamp following each other" would be "too much for the reader." But what if the "licentious…apprentice" (155) that ten Brink perceived is only a façade?

To evoke smiles, this humble jest does not require a conclusion. Enjoyment of the Cook's humor relies on the mode of narration, and the pleasure of a beast fable, correspondences between the behavior of animals and the behavior of men, that was common knowledge in the fourteenth century.

The Cook speaks not of an apprentice *cook* but of a *victualler, a gatherer of foodstuffs*. Signals of hidden identity abound. Brown as a berry, a proper short fellow (A 4368), he is like a hive full of honey (A 4373) and merry as a bird in the woods (A 4367). I'm claiming

this little character is an English brown bee. (They were called "Brownie" in rhymes [Ransome, 220–21].) But he's not just any bee—he's a good-for-nothing drone.

This handsome little fellow is called Perkyn Revelour *because* he danced "so wel and jolily" (A 4370–71). The name implies he enjoyed reveling with his *kin*; the story bears this out. Only one bit of his image, aside from his color, is visual: he has *neatly* combed black hair. His name Re*velour* (velour being medieval French for velvet) adds his fuzzy surface. (A nineteenth-century beekeeper, with a similar view, said bees wore a "round velvet cap" [Langstroth, 224–25].)

The allegory plays with correspondences between bee lore and Perkyn's lifestyle. Our first clue was the "hive full of honey" (A 4372–73). His depiction omits facial features, clothing, feet, and hands. We are told, instead, of his daily goings on. Perkyn hopped and sang at weddings, played stringed instruments, and preferred the tavern to the shop. If a group in his vicinity went riding out, he'd be sure to join them to play at "dys."

If this claimed identity seems to stretch possibilities, let's look at tactics used in old riddles. They can be ingenious "in adapting the details of human form and activity" (Taylor, 5), but may "force an ambiguity beyond the limits of fair play" (Baum, x). Taylor gives examples where a bee is a *short little gentleman* (753), where a hive is a *convent of nuns* (330) or a *mistress in a barn* (457), and a swarm is a *heap of people on London Bridge* (332). These characterizations are similar to the strategy used by Chaucer.

How appropriate for a cook to joke about a bee! Honey was a coveted cooking ingredient in Chaucer's day. The industrious worker bee, the worthless drone, the normal—or sometimes temperamental—movements of swarms were all common knowledge. There were laws to compel beekeepers to announce "the issue of a swarm" so that it could be followed and reestablished in a hive (Ransome, 196–97). Other laws systematized who had the rights to these migrating swarms (Fraser, 23–24). The poet knew about honey and he knew about bees—everybody did. And because of his connection with foreign incoming shipments, Chaucer, no doubt, also knew about the honey shortage that occurred in the 1380s (Ransome, 199). Perhaps the Cook's "litel jape" is an amusing at-

tempt to explain the shortage to his audience. What a delicious trick for the cook to play!

Chaucer depicts many traits common to Perkyn and bees. Although proverbially hard-working, not all bees are industrious and responsible. There are lazy drones and robber-bees that consume disproportionate amounts of honey and spend their days in carefree living and thievery. The existence of these "rotten apples" (A 4406) has been known since Aristotle's day. At the end of the honey-making season (which parallels the end of apprenticeship), misfits are driven from the hive and perish.

How do we find the jape within this tiny tale? First of all, Perkyn's presence at weddings and in taverns notes a bee's attraction to sweets and wine or mead. There used to be many "honey" terms to describe nuptials, but today the only memento left of these associations is *honeymoon*. An old tradition pictures bees as singers and musicians (Ransome, 190). He hops and sings at weddings. A wench who met him was blessed (A 4374) because a drone does not sting. But she is actually twice blessed because an old superstition says if a bee failed to sting a young woman it was evidence of her virginity (Ransome, 237).

In the tavern he'd find mead, a honey-based libation, sweet wines, spiced beverages. Such temptation, for this less than laudable youngster, was irresistible.

On the surface we see men, who love *dice* (A 4384, 4386, 4420), but in their covert image as bees, they love the *colors* (dyes) of flowers. Ambiguity exists because medieval dyes (colors) were derived *only* from plants and other natural substances. Perkyn and his friends would instinctively seek out colorful flowers because they held a great attraction for bees.

This attraction in a "king bee" is spoken of in *Mum and the Sothsegger*: "The king covets the colours to be-hold / Of the fressh floures that on the feeldes grow" (1038–39). That may explain "dys," but how does a bee "cast a paire of dys" (A 4386)? The answer is, *by swarming on a branch of colorful flowers!*

When birds were *cast*, it meant they were sent in pursuit of quarry. Chaucer, in his *Parlement of Foules*, called bees "small fowls that make honey of flowers fresh of hue" (353–54). More to the point for this reading is a term found in many British dialects. A

cast is an after-swarm of bees—the bane of all beekeepers. For bees to cast bright flowers would mean to leave an established hive, fly off to engulf a blooming branch, and probably never be enticed to return to producing honey in their abandoned hive—the kind of disruptive activity one would expect Perkyn to enjoy. And the *pair* of dice he was so skillful with is no longer a problem when we understand that *paire* could mean a group, "not limited to two" (OED).

The "riding" he joined mentions no horses for Perkyn nor anyone else. Missing details are part of the jape. Bees have their self-contained means of locomotion.

Their revels sometimes led to Newegate (A 4402), a likely place for a swarm to settle. Though the usual reading assumes Newgate *Prison*, Chaucer doesn't mention a building. He is clever at choosing place names that are also simple words. A *new gate* is a structure reminiscent of the riddler's London "bridge."

Besides vocal ability displayed at weddings, Perkyn was also proficient with stringed instruments (A 4396). This proficiency with "strings" allows the ears of our mind to respond to his humming sound. (A constant string note would come to be called a "drone.")

For those who have never seen bees swarming, here's an account of their flight:

> The order comes. The captains echo it. With a furious roar the hordes are released, and a living stream of bees pours forth. Like flood water they emerge in a brown mass…The air becomes misty, then clouded with bees. A booming, organ-like note rises and swells over the fields.
>
> You may witness now for anything from five minutes to a quarter of an hour the complete abandon of an insect holiday. You may watch forty thousand bees indulging in aerial gymnastics and singing as they perform…but [soon] there is hardly a bee in the air, while from [a] branch hangs a great pear-shaped cluster (Crompton, 46–47).

I can see Perkyn and his friends in the midst of that "riding," and then being attracted to the colors of a flowering branch.

After-swarms have always been a serious problem for beekeepers; the problem still exists. Their outing concluded, drones return to the hive and "gorge themselves" on honey (Langstroth, 69). Compare Perkyn's activity, following his meeting to cast "dys." He was "free / Of his dispense, in place of pryvetee. / ... / For often tyme [the master] foond his box ful bare" (A 4387–90). There went the honey!

Perkyn compounds his irresponsibility by freely dispensing his master's property. Though currency is generally assumed, the poet makes no mention of *money*. This is no oversight. Loss of *honey* is the alternate, ambiguous intent.

What does all this foolishness have to do with learning the trade? We assume Perkyn's master to be the beekeeper. He would surely be unhappy with an "apprentice" who spent his time gadding about and who caused the box to be bare. Though Perkyn's reputation with his own sort was one of liveliness and generosity, his master finally saw him as too detrimental an influence. No longer could he abide the drone's behavior, so he looked for "his *papir*" (A 4404). Although it is assumed that the paper certifies that Perkyn had completed his apprenticeship satisfactorily (see Baugh text), there is no internal indication that the apprentice profits from a certification. Rather than planning to be the master of his own workers, Perkyn joined a *lowke*, an accomplice of his thefts (A 4415). Perkyn ejected from his dwelling parallels the natural fate of all drones at the end of the season. Some drones may find temporary shelter in another hive; that is a fact (Langstroth, 203). Such hospitality for the time being was little Perkyn's good fortune.

If the hive, the skep (OE sceop), is indicated by "shop," Chaucer is consistent in moving Perkyn from one *shop* to another *shop* (OE sceoppa). Chaucer uses straightforward bee terminology to say the two rascals, Perkyn and his *lowke*, would *sowke* (suck) what they could steal or borrow (A 4416–17).

Our final consideration is the denouement. Does the *Tale* have an appropriate bee-ending? We look first at the spurious conclusions because they were created by medieval thinking. When Chaucer stopped writing, Perkyn and his companion were well and happy. But those who tried to "complete" the story reversed their fate. With inevitable drone-like destiny, both revelers were impris-

oned for life (caught in a drone-trap, an ancient device) or executed. The two companions were judged harshly and dispatched.

Bee life, often sermon material, was the perfect example of a well-run kingdom—the rulers, the workers, the swarms, and the ne'er-do-wells. Each held a lesson. There are outstanding recorded examples of moral "bee" stories from the 1200s to Shakespeare. (See Thomas Cantimpre, *Boni universalis de Apibus*; Richard Rolle of Hampole, "Natura Apis"; *Mum and the Sothsegger*; Shakespeare, *Henry V*, I:2.)

Now to examine Chaucer's ending. Unfortunately we have no link to characterize the tale, to give the pilgrims' opinion of the material. Instead, the story ends abruptly with the introduction of the companion's wife "that heeld for contenance / A shoppe, and swyved for hir sustenance" (A 4421–22). Her "swyving" immediately identified her as a prostitute—alternate fourteenth-century word, *quene*—which is a very strong clue for a "queen" bee. Though Chaucer's contemporaries did not understand the workings of the hive as we do, they *did* believe that royalty ruled. (See *Mum* above and Chaucer's *Parson's Tale*, X 465–70.)

With the identification of a quean/quene, no more need be said! The point of the tale had been revealed. The trick had been exposed. I can picture one of the Cook's companions seeing through the jape, laughing, and saying something equivalent to, "That's a good one, Roger. You certainly had me fooled."

WORKS CITED

Baugh, Albert C., ed., *Chaucer's Major Poetry*. New York: Appleton-Century-Crofts, 1963.

Baum, Paull F., *Anglo-Saxon Riddles of the Exeter Book*. Durham, NC: Duke Univ. Press, 1963.

Crompton, John [John Battersby Crompton Lamburn], *The Hive*. London: Blackwood, [1947].

Fraser, Henry M., *The History of Beekeeping in Britain*. London: Bee Research Association, 1958.

Langstroth, L. L., *A Practical Treatise on the Hive and Honey-bee*. 4th ed. Philadelphia: Lippincott, 1876.

Mum and the Sothsegger. Eds. M. Day and R. Steel. EETS, o.s. 199, London: Oxford Univ. Press, 1936.

Ransome, Hilda M., *The Sacred Bee.* New York: Houghton Mifflin, 1937.

Taylor, Archer, *English Riddles from Oral Tradition.* Berkeley: Univ. of California Press, 1951.

Ten Brink, Bernhard, *History of English Literature.* New York: Henry Holt, 1893.

NOTES

For Chaucer's works cited in the text and in the notes, the following abbreviations are used:

Astrolabe is *Treatise on the Astrolabe.*
Boethius is the translation of Boethius' *Consolation of Philosophy.*
B of D is the *Book of the Duchess.**
H of F is the *House of Fame.**
LGW is the *Legend of Good Women.*
"Mars" is "The Complaint of Mars."
P of F is the *Parlement of Foules.**
RR is the translation of *Romance of the Rose.*
TC is *Troilus and Criseyde.**

All of the above may be found in the F. N. Robinson text. Those with an asterisk (*) are included in the Albert C. Baugh text.

I. INTRODUCTION

1. *Canterbury Cathedral,* a souvenir booklet. Pitkin Pictorials (London: Britannia Books, 1969), p. 30.

2. Of sondry folk, by *aventure yfalle* (A 25). All citations to Chaucer's poetry, unless otherwise identified, to *Chaucer's Major Poetry,* ed. Albert C. Baugh (New York: Appleton-Century-Crofts, 1963).
 MED, ss.v. "aventure": 1. Fate, chance, destiny; 5. a marvelous thing; "fallen" 28a. to become engaged in an activity; to start to do something. *Middle English Dictionary,* eds. Hans Kurath and Sherman M. Kuhn (Ann Arbor: U. of Michigan Press, in progress, 1956–). Many clues can be tracked down using the MED in tandem with the *Concordance to the Complete Works of Geoffrey Chaucer,* John S. P. Tatlock and Arthur G. Kennedy, eds. (1927; rprt. Gloucester, MA: Peter Smith, 1963).

3. G. Wayne Hearne, not understanding why such a fuss was made over the pilgrim poet's acceptance into the company in such a short time, sensed that the "obvious" answer is, "He had already met them at some earlier time."
 This is probably the earliest instance, in the *Tales,* of Chaucer's

vocabulary functioning more clearly, more productively at the covert level than in the surface understanding.

II. Just a Taste: The Cook (and the Five Guildsmen)

4. Gregory K. Jember, *The Old English Riddles* (Denver, CO: Society for New Language Study, 1976), Preface.

5. *Chaucer's Poetry: An Anthology for the Modern Reader*, ed. E. T. Donaldson (New York: Ronald, 1958), 891.

6. *Curye on Inglysch: English Culinary Manuscripts of the Fourteenth Century*, eds. Constance B. Hieatt and Sharon Butler, EETS, s.s. 8 (London: Oxford U. Press, 1985). Lengthy glossary.
 Tarts were made with fish as well as other fillings (p. 138, #178; p. 78, #84). Because seafood pies and tarts are a possibility, it is fitting to assume that that is what the poet intended. Poudremarchant is a mixture of prepared spices. No recipe was found by the editors (s.v. "powdour"). Galingale resembles ginger in flavor (s.v. "galynga(le"). Mortreux means ground in a mortar (s.v. "mortrellus").
 Many fish and seafood recipes, such as thick soups, were often thickened with bread crumbs (p. 76, #73 oysters; #74 eels). Bread and ale are added to both #73 and #74.

7. MED, s.v. "mor-mal(e."

8. "Beste" is *beast*, that is, figures of the zodiac.

9. This is not similar to *blancmange*, the modern dessert.

10. Hieatt and Butler, p. 75, #66.

11. Richard Hinckley Allen, *Star Names: Their Lore and Meaning* (*Star-Names and Their Meanings*, Stechert, 1899; New York: Dover, 1963), 107.

12. *The* Cosmographia *of Bernardus Silvestris*, trans. Winthrop Wetherbee (New York: Columbia U. Press, 1973), 77; Ptolemy, *Tetrabiblos*, trans. F. E. Robbins, Loeb Series (Cambridge: Harvard U. Press, 1940; rprt. 1980), 49. Loeb Series volumes are cited wherever possible, because they are easily found in libraries. In these volumes, it is the *page number* which is noted.

13. Hieatt and Butler, "Blankmanger," #30: perch or luce, rice, almond milk, sugar, and fried chopped almonds (pp. 89–90).

14. The English Pope, Adrian IV, retells the fable in 1100s. Joseph Jacobs, *The Fables of Aesop* (1889; rprt. New York: Burt Franklin, 1970), 183–84. The story appears in *Caxton's Aesop*, ed. R. T. Lenaghan (Cambridge: Harvard U. Press, 1967), 117.

15. MED, s.v. "cok"; "Confessio Amantis" in *The English Works of John Gower*, EETS, e.s. 82 (London: Oxford U. Press, 1901: rprt. 1979), 7.478-82.
 The preacher is the stomach digesting and distributing nourishment in Gerald R. Owst, *Preaching in Medieval England* (Cambridge: Cambridge U. Press, 1926), 7.
 MED, s.v. "norice" 2b. "Trev. Barth. 59b/b: As þe norice of þe body, it [the stomach] fongiþ & seþiþ mete & drinke to fede alle þe membres of þe body."

16. Fletcher quotes Northrup Frye, 304–05; Elder Olson, 307. Angus Fletcher, *Allegory: The Theory of a Symbolic Mode* (1964; rprt. Ithaca, NY: Cornell Paperbacks, 1970).

17. Disguisings were popular. Animal heads were worn as costumes at New Year's celebrations in Chaucer's day. Glynne Wickham, *A History of the Theatre* (Cambridge: Cambridge U. Press, 1985), 62–65.

18. *The Receyt of the Ladie Kateryne*. ed. Gordon Kipling, EETS, o.s. 296 (Oxford: Oxford U. Press, 1990), lxvii.

19. *Receyt*, 56, 64.
 In medieval France processions were "enlivened" by monsters and evil creatures. "Dragons" animated internally by several people belonged to the category of fancy dress. Françoise Piponnier and Perrine Mane, *Dress in the Middle Ages*, trans. Caroline Beamish (*Se vêtir au Moyen Age*, 1995; New Haven: Yale U. Press, 1997), 143, 149.

20. The image is out of place (not between Gemini and Leo). Allan Temko, *Notre-Dame of Paris* (New York: Viking Press, 1952; Viking Compass, 1959), 196.

21. Latin played an important part in alternate understandings in *Pilgrim Chaucer*, and will also prove so here. Dolores L. Cullen, *Pilgrim Chaucer: Center Stage* (Santa Barbara, CA: Fithian Press, 1999).

22. MED, s.v. "clothen."

23. Baugh, n. A 362.

24. Emile Legouis "sees," but assumes "the poet did not think it *necessary* to make a portrait of each" (163, italics added). It is *not* making a portrait of each that *fulfills the necessity*. *Geoffrey Chaucer,* trans. L. Lailavoix (New York: Dutton, 1913).
 Ralph Baldwin refers to the guildsmen as "presented in aggregate." "The Unity of the Canterbury Tales," Anglistica 5 (Copenhagen: Rosenkilde and Bagger, 1955): 45; Harold F. Brooks finds them "so little individualized." *Chaucer's Pilgrims* (London: Methuen, 1962), 26.

25. MED, ss.v. "piked," "pik(e."

26. Aristotle, *Historia Animalium*, vol. II, A. L. Peck, trans. Loeb Series (Cambridge: Harvard U. Press, 1970; rprt. 1984), 21.

27. MED, s.v. "crabbed."
 In speaking to emperors, a woman "daunted ther corage / With hir femynyn crabbid elloquence." John Lydgate, *Lydgate's Fall of Princes*, ed. Henry Bergen (Washington, D.C.; Carnegie Institute, 1923), 7.590–91.

28. The OED explains the connection of "scratch or claw" to *crab* in Low German, a doubly fitting choice of word. *The Compact Edition of the Oxford English Dictionary*: Complete Text Reproduced Micrographically. 2 vols. (Oxford: Oxford U. Press, 1971).

29. Odd or different words chosen mainly for their function in the covert meaning was proposed at the end of *Pilgrim Chaucer.*

30. Crabs are likened to "horses." Aristotle, *Historia Animalium*, vol. II:17; MED, s.v. "rau(e."

III. THE PLAN
Understanding Allegory

31. Matthew 13:3–8; Mark 4:3–20; Luke 8:5–15; Fletcher, 311.

32. Fletcher, 220–1.

33. W. T. H. Jackson, *The Literature of the Middle Ages* (New York: Columbia U. Press, 1960), 354.

34. Fletcher, 70.

35. William Paton Ker, *English Literature: Medieval* (New York: Henry Holt, [1912]), 186–87. Italics added.

36. Fletcher, 23.

37. Gordon Kipling, *The Triumph of Honour* (Leiden, the Netherlands: Leiden U. Press, 1977), 103, n. 17.

38. Fletcher, 2.
 It is assumed that Chaucer knew "the later allegorical school, which was then in the height of its fashion in Paris." *Five Hundred Years of Chaucer Criticism and Allusion 1357–1900*, ed. Caroline F. E. Spurgeon, 3 vols. (Cambridge: Cambridge U. Press, 1925; rprt. New York: Russell and Russell, 1960), vol. II, Part 3, p. 24.

39. Fletcher, 4.

40. John Champlin Gardner, *The Construction of Christian Poetry in Old English* (Carbondale, IL: Southern Illinois U. Press, 1975), 11–15. Italics added.

41. First used in *Chaucer's Host*, 39–40. Dolores L. Cullen, *Chaucer's Host: Up-So-Doun* (Santa Barbara, CA: Fithian Press, 1998). Gardner's admiration for Chaucer's skill is shown in an example taken from the *Book of the Duchess* (13).

42. Fletcher, 108 n. 59. A term borrowed from Harry Berger's *The Allegorical Temper* (New Haven: Yale U. Press, 1957).

43. Bernard F. Huppé, *A Reading of the* Canterbury Tales (Albany, NY: State U. Press, 1964), 8. Also recommended by Dionysius the Areopagite, "Symbolism…is most seemly for mystic discourse to hide holy truth…inaccessible to the masses." Leonard Barkan, *The Gods Made Flesh* (New Haven: Yale U. Press, 1986), 112.

44. Bernard F. Huppé, *Doctrine and Poetry: Augustine's Influence on Old English Poetry* (New York: State U. Press, 1959), 10, 24.

45. Huppé, *Doctrine and Poetry*, 16.

46. Fletcher, 310.

47. Fletcher, 245, n. 39.

48. Jember, Preface.

49. Jember, Preface.

50. Fletcher, 7.

51. Jember, Preface.

52. Emile Mâle, *The Gothic Image*, Dora Nussey, trans. (Dutton, 1913; rprt. New York: Harper Torchbooks, 1958), 136.

53. V. A. Kolve, *Chaucer and the Imagery of Narrative: The First Five Canterbury Tales* (Stanford: Stanford U. Press, 1984), 71.

54. Fletcher, 317.

55. Fletcher, 304–5.

56. Fletcher, 307. In Fletcher's own words, "Allegory is structured according to ritualistic necessity, as opposed to probability" (150).

57. Richard D. Altick, *The Art of Literary Research* (New York: W. W. Norton, 1963), 120.

Understanding Fourteenth-century Astronomy

58. The earth stands still. John Matthews Manly, ed. *Canterbury Tales by Geoffrey Chaucer* (New York: Henry Holt, [1928]), 133; Cicero, *De Natura Deorum*, H. Rackham, trans. Loeb Series (Cambridge: Harvard U. Press, 1933; rprt. 1979), 173.

59. Samuel G. Barton and William H. Barton, *A Guide to the Constellations*, 3d ed. (New York: McGraw-Hill, 1928; rprt., 1943), 6.

60. Chauncey Wood, *Chaucer and the Country of the Stars* (Princeton, NJ: Princeton U. Press, 1970), 303.

61. Manly, *CT*, 134. The scientific explanation in Manly is simple and quite readily understood even with the many details incorporated (132–37).

62. I've never seen a claim that they really made the trip in one day.

63. An explanation of the time element from a different point of view can be found in *Chaucer's Host*, 131–35.

64. This has been a lively topic of explication. Noting a time of day or a town's name does not add clarity; instead, inherent ambiguity fuels debate.

65. When the drawing of lots results in the Knight as first storyteller, some see this as trickery. For a strong opinion to the contrary, see *Chaucer's Host*, n. 8.

66. Choice of the Knight proves the poet "a conservative [and] explicitly mediaeval" (Baldwin, 64).

67. The Appendix in *Fasti* speaks of the eight-day Roman week and ten-month year. Ovid, *Fasti*, trans. Sir James George Frazer, Loeb Series (Cambridge: Harvard U. Press, 1931; rprt. 1967), 131–33, 385–86.

68. *Wimbledon's Sermon*, ed. Ione Kemp Knight (Pittsburgh, PA: Duquesne U. Press, 1967), 113, 116. The "Black Plague" usually means the first attack, but it's used here as a recognizable term for all such ravaging.

69. The tradition of Judgment *Day* expected it to be accomplished in one day. (Doomsday and Judgment are dealt with in Cullen, *Chaucer's Host*, 130–36.)
 Heiko A. Oberman, "Fourteenth-Century Religious Thought: A Premature Profile," *Speculum* 53 (Jan. 1978), 90–1.

70. A medieval mystery: Chaucer uses the expression, "4 o'clock," but there were no *clocks* as we know them. See OED, "clock."

71. This concept is discussed by Rodney Delasanta in "The Theme of Judgment in *The Canterbury Tales*," *MLQ* 31 (Sept. 1970): 302–03.

72. Lydgate, a contemporary of Chaucer's, calls this "time long." *Pilgrimage of the Life of Man*, F. J. Furnivall and K. B. Locock, eds. EETS, e.s. 77, 83, 92 (London: Paul, Trench, Trübner, 1899–1904).

> By processe of tymë long,
> Thow shalt retourne ageyn by grace
> Vn-to thyn ownë duë place,
> Reste in god, and ther abyde.
>
> (12406–09)

73. *The Timaeus of Plato*, R. D. Archer-Hind (1888; rprt. New York: Arno Press, 1973), 129, 131; *Cursor Mundi*, ed. Richard Morris, EETS, o.s. 57 (1874; rprt. London: Oxford U. Press, 1961), 1547–52; Cicero, 173.
 It was estimated that it would take the zodiac 36,000 years to return to this all-important point of departure. Bartholomæus Anglicus, *On the Properties of Things*, John Trevisa, trans. (Oxford: Clarendon, 1975), 501.

74. Plato, 127; Barkan, 89.

75. Cicero, 165; Plato, 130, n. 2.

76. Jean Seznec, *The Survival of the Pagan Gods*, trans. Barbara F. Sessions (Princeton, NJ: Princeton U. Press, 1953; rprt. Bollingen paperback, 1972), 38–42; Augustine, *The City of God Against the Pagans*, William M. Green, trans. Loeb Series (1963; rprt. Cambridge: Harvard U. Press, 1978), vol. II:426 note.

77. J. A. W. Bennett, *The Parlement of Foules* (1957; rprt. Oxford: Clarendon, 1965), 56; John Lydgate, *Assembly of Gods*, ed. Oscar Lovell Triggs, EETS, e.s. 69 (London: Paul, Trench, Trübner, 1896), st. 243: "By nature thus as the seuyn planettys / Haue her propre names by astronomers, / But goddys were they called by oold poetys."

78. Cicero, 81; Augustine, *City of God*, vol. II:431, 379, 84–85; Cicero, 325.

79. Augustine, *On Christian Doctrine*, trans. Professor J. F. Shaw (Edinburgh: T. & T. Clark, 1892), 75–76; Seznec, 4; Barkan, 109.

80. Wickham, *History of the Theatre*, 60–61.

81. Barkan, 102.

82. Seznec, 91. Salisbury quoted in Seznec.

83. Seznec, 93, 90 n. 33, 172.

84. Barkan, 104. See also Bromyard in Owst, *Preaching*, 304–05.

85. Hawes, "Pastime of Pleasure," 2724–30, quoted in *Receyt*, 130–31.

86. Rosemond Tuve, *Seasons and Months* (Paris: Librairie Universitaire S. A., 1933), 148, 150, 143.

87. Owst, *Preaching*, 260; *Origen: the Song of Songs*, trans. R. P. Lawson (London: Longmans, Green, 1957), 16.

88. Erwin Panofsky and Fritz Saxl, "Classical Mythology in Mediaeval Art," *Metropolitan Museum Studies*, vol. IV, pt. 2 (New York: Metropolitan Museum of Art, 1933), 238.
 Erwin Panofsky explains, "The artists who used the motif of a Hercules for an image of Christ...acted under the impression of visual models which they had before their eyes, whether they di-

rectly copied a classical monument or imitated a more recent work derived from a classical prototype through a series of intermediary transformations." *Studies in Iconology* (New York: Oxford U. Press, 1939), 20–21, 213.

Before we think too critically of medieval artists using images that elicit a conditioned emotional response, let's remember that art and drama, even today, emulate arrangements of figures of the Crucifixion or the Pietá to assure a certain response from an audience.

89. Seznec, 212–13.

90. Seznec, 105, n. 98.

91. Seznec, 107, 206; 157, fig. 61.

Seznec offers a perceptive analysis: "Nurtured upon ancient letters, the most scrupulous among [men of the church] cannot rid themselves of their classical memories and ways of thinking...when [sixteenth-century Roman prelates] delight in composing a Ciceronian parallel between Diana and the Virgin Mary...they are, in the last analysis, merely being true to their education" (265–66).

92. Seznec, 127.

93. Seznec, fig. 63.

94. Seznec, 92–94.

95. Cicero, 177.

96. Fletcher, 96–97.

97. Fletcher, 97.

Chaucer's Proposal in the General Prologue

98. Cullen, *Pilgrim Chaucer*, 14.

99. MED, s.v. "condicioun"; Gower, 7.938–39.

100. Thomas Wright, *The Canterbury Tales of Geoffrey Chaucer*, Percy Society (London: T. Richards, 1847), xvi.

Baldwin points out that "every one of the pilgrims is introduced, uniformly, in the past tense" although the presentation is of a *"story as it is being written"* (55).

101. MED, s.v. "clause."

102. MED, s.v. "estat" 6, 8.

103. MED, s.v. "nombren." See quotes under 1. (d).

104. Gower, 7.683; MED, s.v. "causen."

105. MED, ss.v. "assemblen," "assemble." Boethius III:pr. 12.

106. MED, ss.v. "compaignie," "compaignabli."

Chaucer's Words and the Games He Plays

107. David Wright, trans. *Geoffrey Chaucer*: The Canterbury Tales (1985; rprt. Oxford: World's Classics, 1991), 169.

108. John Livingston Lowes, *Geoffrey Chaucer* ([1934]; rprt. Bloomington: Indiana U. Press, Midland, 1958), 3.

109. A Baugh text is easier on the eyes, but covers only Chaucer's poetry. The Robinson text is single-space, but includes the prose works. All citations to Chaucer's prose are to this edition. F. N. Robinson, ed., *The Works of Geoffrey Chaucer*, 2d ed. (Boston: Houghton Mifflin, 1957).

110. Kolve, *Chaucer*, 2. Italics added. This visual "characteristic" lends itself to a *visual* covert meaning. Sounds and odors would need to correspond figuratively to relate to the *celestial* (visible).

111. Baldwin, 42.
 What we learn about the pilgrims from their stories is not necessarily straightforward, as Howard explains in regard to all "tidings": "As part of such a thing, every tiding is true in one way or another. You have to *look* for the truth of a tiding, and not all tidings are true in the same way, but every tiding is authentic: either it has a real event behind it or else [it's like something that could have happened]. It tells us something but the burden is on us to know what that something is."
 He sees Chaucer's idea as an offering for the reader to interpret: "If you tell a tale, true or false, your choice of the tale and your motive and manner in telling it tells a truth about you. There is a truth somewhere, but it is relative, various—and partial." Donald R. Howard, "Chaucer's Idea of an Idea," in *Essays and Studies*, vol. 29 (London: John Murray, 1976), 48–50.

112. Baldwin, 38–9.

113. Baldwin, 51.

114. Howard, *Essays and Studies*, 51.

115. Baldwin, 57.

116. F. N. Robinson, 763–64. See Rickert in *TLS*, 1932, 761.

117. Bertrand H. Bronson, *In Search of Chaucer* (Toronto: U. of Toronto Press, 1960), 32.

118. Bronson, 32.

119. Huppé, *Doctrine and Poetry*, 55.

120. Huppé, *Doctrine and Poetry*, 62, n. 57. Italics added.

121. Jackson, 61; Fletcher, 107; John Speirs, *Chaucer the Maker* (London: Faber and Faber, 1951), 104.

122. Fletcher, 107.

123. Dorothy Everett, *Essays on Middle English Literature* (Oxford: Clarendon, 1955), 106.

124. Baugh, p. 540.

125. Though "stere" is glossed as "rudder" (Baugh) or "ruler" (MED, "stere" n. [3]), I've chosen "guiding star" because the first line of the stanza refers to "this day, or hyt be nyght" (8), and line 10 refers to "the sonne bryght." From day and night to sun and star seems fitting.

126. St. Gregory (often referred to by the poet) termed life a *journey* to a home hereafter. F. C. Gardiner, *The Pilgrimage of Desire* (Leiden, the Netherlands: E. J. Brill, 1971), 15.

127. F. N. Robinson, 549.
 Quite some time ago I found an article by William Spencer, called "Are Chaucer's Pilgrims Keyed to the Zodiac?" I thought the job had already been done, the hidden meaning revealed. The content of the article, however, did not relieve me of this happy task. *Chaucer Review* 4 (1970):147–70.

128. The pilgrims and beasts of the little poem are told to "hold the *high* way," an ambiguity which can intend the airy regions as well as a road. The Canterbury travelers are directed (three times in twenty-five lines) to "the *way*." And then, as the Knight prepares to tell the first tale, the narrator repeats "we ryden forth oure *weye*" (A 856).

129. The African's actions are suspiciously Augustinian.

130. MED, s.v. "don" 2. (b).: "Þou art elde man and neiʒ ydo: Þi werlde is sone ydon."

131. Boethius "was one of the hundred best books—one of those books that no educated man left unread. That was still the case in the eighteenth century, and had been so since the Middle Ages, in which period his influence was sovereign." Edward Kennard Rand, *Founders of the Middle Ages* (Cambridge: Harvard U. Press, 1929), 136.

132. Fletcher, 130.

133. *Boethius*, IV:m. 4: "Deth ne taryeth nat his swifte hors"; Beryl Rowland, *Animals with Human Faces* (Knoxville: U. of Tennessee Press, 1973), 109.

 In classic theatre, an actor would ride another actor costumed as a horse, with horse's head and tail. Wickham, *History*, 38; Lydgate, *Assembly*, lxxii; Langland, *Piers Ploughman*, trans. J. F. Goodridge, rev. ed. (1959; rprt. Baltimore: Penguin, 1974), 42; MED, s.v. "riden"; OED, s.v. "ridden."

134. Ovid, *Metamorphoses*, trans. Frank Justus Miller, Loeb Series (1916; Cambridge: Harvard U. Press, 1984), vol. I:69, 61, 15.

135. Arthur W. Hoffman, "Chaucer's Prologue to Pilgrimage: The Two Voices," *Chaucer: Modern Essays in Criticism*, ed. Edward Wagenknecht (New York: Oxford U. Press, Galaxy, 1959), 31; Donald Howard, *The Idea of the Canterbury Tales* (1976; rprt. Berkeley: U. of California Press, 1978), 79.

136. J. S. P. Tatlock, speaking of Chaucer's humanized birds in *Parlement of Foules. The Mind and Art of Chaucer* (New York: Gordian Press, 1966), 68–69.

137. Perhaps it would be better said that the statement is made without its author being aware of all that it can imply. For example, Delasanta identified the Scriptural role of *Servant-Master* (a Christ image) with the Host (299).

 Baldwin delineated the Host as the judge who will not tolerate dissent, threatens penalties, and is "given *carte blanche*" in making arrangements for the group without seeing the God-like role in the combining of those functions (63).

138. Baldwin, 31.

 Matthew Arnold (d. 1888) said of Chaucer that "something is wanting." Arnold sensed a lack of "high seriousness." Chaucer's "seriousness" is not easily recognizable; it was intended to be revealed only through effort and concentration. Chaucer's Host clearly displays the poet's "high seriousness," and Pilgrim Chaucer demonstrates a different kind of seriousness in self-revelatory earthiness and humility.

139. Fletcher, 154–55, italics added.

Summary

140. This hints at augury.

141. Wolfgang Clemen, *Chaucer's Early Poetry*, trans. C. A. M. Sym (London: Methuen, 1963), 128.

IV. THE FIRST DOZEN OR SO
The Parson and the Plowman

142. Zeus was the father of the immortal Helen.

143. *Britannica*, s.v. "St. Elmo's fire." The Christian St. Elmo was addressed as guardian of sailors.

 Seneca also describes "so-called stars" believed to be Pollux and Castor. *Natural Questions*, Thomas H. Corcoran, trans. Loeb Series (Cambridge: Harvard U. Press, 1971), I:21; Pliny, *Natural History*, H. Rackham, trans., Loeb Series (Cambridge: Harvard U. Press, 1938), I:245.

144. See "Dioscuri," George Howe and G. A. Harrer, *A Handbook of Classical Mythology* (Detroit: Gale Research, 1970).

 In Homeric Hymn No. 33, Hesiod commemorates Gemini protection: "[Leda bore] these children as saviors of men on this earth and of swift-sailing ships, whenever wintry storms sweep along the pitiless sea. Then men go to the edge of the stern and with offers of white lambs they pray and call upon the sons of great Zeus." *The Homeric Hymns*, Apostolos N. Athanassakis, trans. (Baltimore: Johns Hopkins U. Press, 1976).

 Roman devotion to the Gemini has come down to us in the expression "By Jiminy." Allen, 228; OED, obs. for Gemini.

145. Steven L. Beyer, *The Star Guide* (Boston: Little, Brown, 1986), 336–37, 360–61.

146. MED, ss.v. "dichen," "delven."

147. MED, ss.v. "chatel," "catel."

148. Lane Cooper, *Aristotelian Papers*, rev. rprt. (Ithaca, NY: Cornell U. Press, 1939), 109. MED, s.v. "vicari(e."

149. *Wyclif: Select English Writings*, ed., Herbert E. Winn (London: Oxford U. Press, 1929), 3.

150. Brooks, 36. Many references are made to sheep and actions of a good shepherd: A 496, A 504, A 506, A 508, A 512–14.

151. Winthrop Wetherbee, *Platonism and Poetry in the Twelfth Century* (Princeton: Princeton U. Press, 1972), 114–15.

152. Germaine Dempster, "The Parson's Tale" in *Sources and Analogues of Chaucer's Canterbury Tales*, edited by W. F. Bryan and Germaine Dempster (1941; rprt. New York: Humanities Press, 1958), 723; Baldwin, 90.

153. Baldwin, 104.
 Ruggiers also sees the *Parson's Tale* as commenting on the pilgrims and their stories. Paul G. Ruggiers, *The Art of the Canterbury Tales* (Madison: U. of Wisconsin Press, 1965), 251–52.

154. Fletcher uses Curtius' idea of a "summation schema." Ernst Robert Curtius, *European Literature and the Latin Middle Ages*, Willard R. Trask, trans. (1953; New York: Harper Paperback, 1963), 289; Fletcher, 175, n. 40; *Divine Comedy* and *Faerie Queene*, by Dante and Spenser, respectively; Fletcher, 176.

155. Baugh, n. X 43.

The Monk

156. Its sire and dam—Typhon and Echidna—were both monsters.

157. Chaucer also tells that Hercules slew the lion and bereft him of his skin. *Boethius*, IV:m. 7.

158. Sir Christopher Lynch-Robinson and Adrian Lynch-Robinson, *Intelligible Heraldry* (London: Macdonald, 1948), 54.

159. Rowland, 120.

160. Beyer, 95.

161. Beyer, 114, 89.

162. Viewing is best between midnight and 3 A.M., however, the manifestation varies; if you see it in a good year you will probably never forget the sight.

163. *Britannica*, s.v. "Meteor"; Roberta J. M. Olson, *Fire and Ice*, Smithsonian (New York: Walker, 1985), 6.

164. Allen, 256, 255, 259.

165. Manilius, *Astronomica*, G. P. Goold, trans., Loeb Series (Cambridge: Harvard U. Press, 1977), 101.

166. Ptolemy, 203.

167. Saturn's claim:

> My cours, that hath so wyde for to turne,
> Hath moore power than woot any man.
> Myn is the drenchyng in the see so wan;
> Myn is the prison in the derke cote;
> Myn is the stranglyng and hangyng by the throte,
> The murmure and the cherles rebellyng,
> The groynynge, and the pryvee empoysonyng;
> I do vengeance and pleyn correccioun,
> Whil I dwelle in the signe of the leoun.
> Myn is the ruyne of the hye halles,
> The fallynge of the toures and of the walles
> Upon the mynour or the carpenter.
> I slow Sampsoun, shakynge the piler;
> And myne be the maladyes colde,
> The derke tresons, and the castes olde;
> My lookyng is the fader of pestilence.
>
> (A 2454–69)

168. Allen, 252.

169. *The Catholic Encyclopedia*, 1910 edition, s.v. "rochet"; Piponnier and Mane, glossary: "rochet—loose garment made of linen, worn over normal clothing.... A protective garment worn also by the clergy from the thirteenth century."

170. MED, ss.v. "leten," "pas(e n.(1)," "elde," "space."

171. In the course of these thoughts between stories, there is an important soliloquy by the Host which is explicated in detail in *Chaucer's Host* (143–45).

172. Perhaps the "joke" can also be read seriously. Nero's life is one of the "tragedies" the Monk will recite. He may be included because he might "first [have] brought lions into religion" against the Christians.

173. MED, ss.v. "gret": adj., adv., n.

174. MED, s.v. "grei," adj. & n. 2. (a), (c).

175. "Stepe" is discussed in *Chaucer's Host*, 104–05.

176. Such ornamental bells are both visible and audible.

The Merchant

177. A constellation called "Centaurus" is not part of the zodiac, and not to be confused with Sagittarius.

178. Howe and Harrer, 144.

179. Ovid, *Fasti*, 289–91; *Bulfinch's Mythology* (Garden City, NY: International Collectors Library, 1968), 132.

180. Beyer, 262; *Cosmographia*, 78; Ptolemy, 51, n. 3.

181. *Receyt of the Ladie Kateryne*, 129; Allen, 356.

182. *Petrarch's Africa*, trans. Thomas G. Bergin and Alice S. Wilson, (New Haven: Yale U. Press, 1977), 46.

183. Ovid, *Fasti*, 289 (L. "flavi").

184. MED, s.v. "fetisly."

185. Chaucer's Reeve: "And whan the hors was laus, he gynneth gon / Toward the fen, ther wilde mares renne, / And forth with 'wehee,' thurgh thikke and thurgh thenne" (A 4064–66).
 Piers: "As wilde bestis with wehe." William Langland, *The Vision of Piers the Plowman II Text B*, ed. Walter W. Skeat, EETS, o.s. 38 (London: Trübner, 1869), Passus VII:91.
 This "we-hee" is the imitation of horses whinnying. Our word "whinny" is not to be found in Chaucer's recorded vocabulary, but Skeat doesn't hesitate to give the word as a possiblity for the line in the Wife's narration. She boasts that, as a *horse* does, she can "byte and whyne" (D 386); "whinny" as the dynamic expression of

the sexual urge is a fitting interpretation. (See *Pilgrim Chaucer*, 87–89.)

The MED has not yet published the *WH-* fascicle, but some useful information can be found under "neighen," v. (2): In 1336 steeds "nyen and togider *whine.*" (Probable pronunciation *whee'-neh.*) In 1450 "neyed" is a variant of "whenyd." And in 1500 instructions are given so horses shall not "ney or whynye."

It seems quite natural to find a second reading in Chaucer's line about the Merchant—who is, after all, part horse—to be a play on *winning* and *whinnying.*

186. Ovid, *Fasti*, 289 (L. "semivir").

The Friar

187. Ovid, *Fasti*, 185.

188. Howe and Harrer, 221; Seznec, 50–1.

189. Allen, 77, 76.

190. Allen, 79, 415–16; Beyer, 285.

191. Rowland, 135.

192. MED, s.v. "horned," 2. (c), the horned of hell is the devil. Lydgate, *Pilgrimage*, 1750: the horned beast which lieth in hell; *Britannica*, ss.v. "Devil," "Costume Design." Illustrations portray the devil with horns, a tail, and, often, with cloven hooves. See also E. K. Chambers, *The Mediaeval Stage*, 2 vols. (1903; rprt. London: Oxford U. Press, 1967), II:91, 148; V. A. Kolve, *The Play Called Corpus Christi* (Stanford: Stanford U. Press, 1966), 26.

193. The term was used to refer to a black cat (and other animal) familiars during witch trials, but no such recorded instances from Chaucer's day are shown in the dictionaries I've used. (MED, s.v. "familier.")

194. MED, s.v. "licence." "Licenciat," the word used, comes from "licence," permission, formal authorization. One can, however, have a "wicked purpose" and "with licence...worchen wickedlye."

195. Skeat explains the tippet as "a loose hood, which seems to have been used as a pocket." Walter W. Skeat, *The Complete Works of Geoffrey Chaucer* (1894; rprt. Oxford: Clarendon, 1924), V:26.

Elizabethan tippets, it is true, were wider and appear pocket-like, but costume histories dealing with Chaucer's time do not

confirm the hood-as-pocket idea. MED, "tippet," for example, describes a "piece of cloth, usu. long and narrow," said to "hangeþ on as a kalues taille."

The Bradfield Glossary describes, "A long streamer, usually of white material, which was worn round the arm above the elbow, with the long end hanging to the knee or the ground." (Illus., 39) Nancy Bradfield, *Historical Costumes of England from the Eleventh to the Twentieth Century* (New York: Barnes and Noble, 1958).

196. OED, s.v. "yed"; *New English Dictionary on Historical Principles* (Oxford: Clarendon, 1928); *Scottish National Dictionary* (Edinburgh: Scottish National Dictionary Association, 1976).

197. OED, s.v. "whelp." The MED has not yet reached "Wh."

198. Kolve, *Corpus Christi*, 228, 140; *Cursor Mundi*, ed. Richard Morris, EETS, o.s. 59 (1875; rprt. London: Oxford U. Press, 1966), 11759–60.

199. *Castle of Perseverance* in *The Macro Plays*, ed. Mark Eccles, EETS, o.s. 262 (London: Oxford U. Press, 1969), stage directions and lines 3128, 2198, 3086; *The Chester Plays*, ed. Dr. Hermann Deimling, EETS, e.s. 62 (1892; rprt. London: Oxford U. Press, 1926), 223; *Ludus Coventriæ*, ed. K. S. Block, EETS, e.s. 120 (London: Oxford U. Press, 1922), pp. 27, 19; *The Towneley Plays*, ed. George England, EETS, e.s. 71 (London: Paul, Trench, and Trübner, 1897), p. 297; MED, ss.v. "freke," "frek."

200. Celebrated at the New Year.

201. Kolve, *Corpus Christi*, 135–36; Chambers, I:277.

202. Kolve, *Corpus Christi*, 141–42.

203. Allegories are *supposed* to deal with history on some level. It may be (I often think this) that there is a level in the *Tales* that involves happenings in English history. A "Hubert" that would bear investigation is Walter Hubert, who was once Archbishop of Canterbury. He is called by the *Britannica* an "administrative genius." Many of the descriptions of the Friar's negotiations could see him also as an administrative genius. The historic thread of Chaucer's story is not what is being pursued here so I'll drop the subject.

204. Ovid, *Fasti*, 255.

205. I've also seen illustrations with a goat front projecting from a spiral-type sea shell.

206. Ovid, *Metamorphoses*, vol. I:167ff.

207. *The New Golden Bough*, Sir James George Frazer, abridged, ed. Dr. Theodor H. Gaster (New Jersey: S. G. Phillips, 1959), 355; Ovid, *Fasti*, 27.

 Matt. 9:17; Mark 2:22; Luke 5:37. Old skins harden and lose elasticity. The bottle would burst with gasses of the development of fermentation. Both wine and bottle would be lost.

208. Allen, 140

209. Manilius, xxv.

210. *Britannica*, s.v. "Calendar." *The Equatorie of the Planetis*, ed. Derek J. Price (Cambridge: Cambridge U. Press, 1955), 104–07.

 The equinoxes were about nine days out of place in the 1300s. Roger Bacon and others had suggested revisions but no action was taken then.

211. Ptolemy, 85; Allen, 136–38.

212. Augustine, *City of God*, vol. V:411.

213. *Gesta Romanorum*, ed. Sidney J. H. Herrtage, EETS, e.s. 33 (1879; rprt. London: Oxford U. Press, 1962), 4.

214. Goats and sheep have such similar body structure that in a mixed flock you pick out the goats because they hold their tails in the air; sheep tails hang down.

215. Ptolemy, 85.

216. Baugh, n. A 404.

217. Baugh, n. A 408.

218. *Receyt*, xx; Kipling describes a ship that "sailed" into a palatial hall and served a cargo of fish at a banquet (104).

219. Glynne Wickham, *Early English Stages* (New York: Columbia U. Press, 1959), 73, 132; Chambers, II:136; *The Wakefield Mystery Plays*, ed. Martial Rose (New York: W. W. Norton, 1961), 39; Kolve *Corpus Christi*, 212–13; *Golden Legend*, xvi, italics added. See *Chaucer's Host* for one possibility (133).

220. *Catholic Encyclopedia*, s.v. "Indulgences."

The Manciple

221. Allen, 270–71; Ptolemy, 51, n. 2.; Beyer, 174.

222. Ptolemy, 51, 205, 69, 89.

223. John Matthews Manly, *Some New Light on Chaucer* (1926; rprt. Gloucester, MA: Peter Smith, 1959), 257; Brooks, 44, 42.

224. Brooks, 43.

225. F. N. Robinson, xxi.

226. MED, s.v. "stat."

227. MED, s.v. "passen," 11a.

228. Ronald Edward Zupko, *British Weights and Measures: A History from Antiquity to the Seventeenth Century* (Madison: U. of Wisconsin Press, 1977), 49–50.

229. MED, s.v. "laue"; Zupko, 62–64.

230. Zupko, 62, 59.

231. Zupko, 68.

232. MED, s.v. "taille."

233. Zupko, 38.

234. Bruno Kisch, *Scales and Weights: A Historical Outline* (New Haven: Yale U. Press, 1965), 69, 134, 137.

235. Baugh, n. A 586. Chaucer uses a variation at A 3143, but never again. *Cap* seems to hold a special purpose (a coded meaning). What does it stand for? Is it the astrological *caput* of caput and cauda?

236. Baugh notes.

237. *Chaucer's Host* elaborates on the importance of Judgment in the *Canterbury Tales*. See especially 100, 111–12. See also a coordinating interpretation of the *number* of the stories called for (as this is to be understood at the covert level) found in *Chaucer's Host*, 135–36.

238. Wyclif Bible (Matt 21:12; Mark 11:15; John 2:15) in *The Gospels: Gothic, Anglo-Saxon, Wycliffe and Tyndale Versions* (London: Gibbings, 1907).

The Miller

239. Donaldson, 896; Howard, *Idea of C T*, 239; Brooks, 42–43. Italics added.

240. Ovid, *Metamorphoses*, vol. I:119, 121; *Fasti*, 243.

241. Allen, 386; Ptolemy, 47.

242. Howe and Harrer, 223–24.

243. Barton, 50; Allen, 379; Beyer, 312–13, 309; Allen, 392–94.

244. Ovid, *Fasti*, 273; Allen, 387–88.

245. MED, s.v. "sword." "Owt of ther balys come iiij and xxte oxon playng at the sword and bokelar."

246. MED, s.v. "furnais(e," 5; Gerald R. Owst, *Literature and Pulpit in Medieval England*, 2d rev. (1926; rprt. New York: Barnes and Noble, 1961), 113; Donaldson, 896.

247. MED, ss.v. "janglere," "harlotri(e," "goliardeis."

248. MED, s.v. "stelen," to entice away.

249. Edward A. Block, "Chaucer's Millers and Their Bagpipes," *Speculum* 29 (1954), 239–40.

250. Block, 242. Italics added.

251. *Castle of Perseverance* has pipers playing as part of the devil's forces (p. 68). See Thomas Wright's illustrations. *A History of Caricature and Grotesque* (London: Virtue Bros., 1865), 71, 140.

The Reeve

252. Hesiod, *Homeric Hymns*, Hugh G. Evelyn-White, trans. Loeb Series (Cambridge: Harvard U. Press, 1936), 71–73; Allen 305.

253. Beyer, 199, 218–22.

254. Ptolemy, 205; To save the earth, Zeus slew him with a thunderbolt. Ovid, *Metamorphoses*, vol. I:81, 83.
Baugh line numbers. This reference is specially cited by

Chauncey Wood because it has been considered to be unusual for Chaucer to speak of a celestial figure in conjunction with its myth, rather than its astrological influences (279).

255. Scot, called a genius by Pope Honorius III, laid the ground work for the scientific method improved upon by Roger Bacon and others. Lynn Thorndike, *Michael Scot* (London: Thomas Nelson and Sons, 1965), 1, 58.

256. Manilius, 101; MED, s.v. "scorpioun"; Thorndike, *Michael Scot,* 58.

257. General information from *Britannica,* s.v. "Scorpion."

258. Brooks, 44–45.

259. MED, s.v. "kepen."

260. MED, s.v. "governing(e," 3. (a).

261. Something is concealed in the lord's "twenty years of age"—it attracts attention. The only idea that has come to mind is that this sign has a beginning *date* by the authority of Julius Caesar. Information I find, however, does not easily mesh with Chaucer's words. Perhaps Chaucer knew another chronological explanation—or perhaps the answer is something else entirely.

262. MED, ss.v. "priveli(e," "sotilli."

263. *Astrolabe,* p. 552; Ptolemy, 75; *Cosmographia,* 78. In allegorical thinking, it's likely (perhaps *expected* is better) that Chaucer would use an astrological guide for actions, and incidents between his characters.

264. Kolve, *Chaucer,* 225.

265. George T. Flom, *Introductory Old English Grammar and Reader* (New York: D. C. Heath, 1930), Glossary; MED, s.v. "ossen"; Wimbledon, Glossary. Details about King Osewold might be worth pursuing at an historical level.

266. Boccaccio also mentions Michael Scot. Recalling the "horse" being named *Scot* is worth dwelling on. Michael Scot is depicted by Dante, in the *Divine Comedy,* as having his head facing toward the back; that's a variation of *hindermost.* Could Chaucer have known Dante's description? Or, could both writers have described some trait of the genius in two similar ways?

267. Chaucer talks of Ganymede in *House of Fame*, 589–92.

268. "Walter" could involve an historical level.

269. See a Latin dictionary.

270. A poem from the 1200s tells of three corpses addressing three young men in order to give a warning: "none can disregard his *summons*." Such depictions are found on old church walls. See M. D. Anderson, *Drama and Imagery in English Medieval Churches* (Cambridge: Cambridge U. Press, 1963), 73–74.

271. Glynne Wickham, *The Medieval Theatre*, 3d ed. (1974; rprt. Cambridge: Cambridge U. Press, 1987), 169; Owst, *Literature and Pulpit*, 531; Wimbledon, 99; notes p. 133.

272. *Britannica*, s.v. "Black Death."

273. *Oxford Illustrated History of Medieval England*, ed. Nigel Saul (Oxford: Oxford U. Press, 1997), 163.

274. Boccaccio, *Decameron*, [Anonymous trans., 1620.] (London: David Nutt, 1909), cii-ciii.

275. *Cambridge World History of Human Disease*, ed. Kenneth F. Kiple (Cambridge: Cambridge U. Press, 1993), 276; Boccaccio, 26.

276. Guy de Chauliac, *The Cyrurgie of Guy de Chauliac*, ed. Margaret S. Ogden, EETS, o.s. 265 (London: Oxford U. Press, 1971), 157.

277. *Oxford Illustrated History of Medieval Europe*, ed. George Holmes (Oxford: Oxford U. Press paperback, 1990), 265. An account from Siena concludes, "so many died that everyone thought that the end of the world had come" (264).

278. Chauliac, 156. Thirty Latin copies of the work exist. (Preface, v.)

279. Baugh, n. 624; Anderson, 167; Thorndike, *Michael Scot*, 3.

280. MED, ss.v. "cherubin," "somnour," "messager."

281. "Bite" refers to the effect of lye contained in ointments which were used to cure infections, etc. Chauliac, 96, 110.

282. An excerpt from a Body and Soul poem: "There is now no prostitute, however cheap, who would wish to touch [your hair], let alone comb it." Rosemary Woolf, *The English Religious Lyric in the Middle Ages* (Oxford: Clarendon, 1968), 100, n. 3.

283. Numbers 11:5–33 (Douay). See also R. E. Kaske, "The Summoner's Garleek, Oynons, and eek Lekes," *MLN*, vol. 74, no. 6 (June 1959).

284. MED, s.v. "tong(e," clapper of bell. "Death's Warning," by John Lydgate in *The Minor Poems of John Lydgate* Pt. II, Henry Noble MacCracken, ed., EETS, o.s. 192 (London: Oxford U. Press, 1934), 655:

> Howe my custome and mortall vsage
> Ys for to spare nether olde ne yonge of age,
> But that ye nowe in thys world leuyng,
> Afore be redy or I my belle rynge.
>
> (4–7)

285. MED, s.v. "gropen."

286. The *Early English Carols*, ed. Richard Leighton Greene, 2d ed. (Oxford: Clarendon, 1977), #83, #139, #180.

287. MED, ss.v. "gentil," "harlot," "kind(e," "kinde"; Bartholomæus, 293.

288. Baugh, n. A 623.

289. Baugh, n. A 652.

 George Lyman Kittredge, "Chauceriana," MP, vol. VII (July 1909) quotes Tyrwhitt: "'to pull a finch' signified 'to strip a man, by fraud, of his money,' and in this erroneous gloss he has been followed by all the editors and by the *Oxford Dictionary*. But, in the passage which includes this verse, Chaucer is not speaking of fraud: he is describing the Summoner's method in cases of fornication" (475–76). While the sexual intent works at the surface, the attempt to bribe may fit covert dealings with death.

290. MED, s.v. "daunger."

291. "Death and the Maiden" ("Der Tod und das Mädchen") can be understood to say:

> Pass by, O pass by! go, fierce bony man!
> I am still young, go Dear!*
> And do not move toward me,
> And do not move toward me.

Give me your hand, you lovely and delicate thing!
I am your friend and come not to punish.
Be of good cheer! I am not fierce.
You shall sleep peacefully in my arms!

*The German word is *Lieber* and implies some degree of fondness.

The story behind Sibelius' "Valse Triste" is of a similar mood: A young man is startled to see his beloved dancing with another man—Death.

292. MED, s.v. "gerlond." "Make a garlond of a kerchefe, and bynde þe seke hed." Medieval images of sickness and old age are shown with cloths about their heads. See Kolve, *Chaucer*, 232 and *Bibliographica*, vol. 2 (London: Paul, Trench, Trübner, 1896), 329.

293. George A. Renn, "Chaucer's *Canterbury Tales*," *Explicator* 43 (Winter 1985), 8–9.

The Pardoner

294. Ovid, *Fasti*, 91; Allen, 339.

295. Allen, 340, 344–45; Beyer, 322. The four Royal stars mark the four seasons.

296. Manilius, 97.

297. Hoffman takes a serious look at the Summoner and Pardoner (based on the personalities), but stops short of allegory (45).

298. For those who know book one of this trilogy, the image of the Church presented here does not conflict with what was said there. Book I (*Chaucer's Host*) noted the poet's charges of cruelty and arrogance. Book III, this volume, finds hypocrisy and fraud. Both are complaints of the lack of Christ's spirit in the Church. It is obvious that such accusations could only be made covertly, allegorically.

299. *Song of Roland*, trans. C. H. Sisson (Manchester, Eng.: Carcanet Press, 1983), Introduction: 7, 9.

300. *Ideas That Have Influenced Civilization*, ed. Oliver J. Thatcher, vol. IV, *The Middle Ages* (Chicago: Roberts-Manchester, 1902), 345–46.

301. Eugenius (1145–53) was "pope of the lamentable second crusade." Ss.v. "Crusades," "Papacy" in *The Middle Ages: a Concise Encyclopædia*, ed. H. R. Loyn (1989; rprt. London: Thames and Hudson paperback, 1991).

302. Gardner, 12. Gardner finds another of Chaucer's poems a "tour de force" of rhythmic encoding (13).

303. The Pardoner is actually *not* said to be *wearing* a cap. Its presence is noted, not more. Chaucer uses "cap" several times in the *Canterbury Tales* and generally in a line that needs clarification—or interpretation. It has odd possibilities; I wonder if he doesn't use it as a "code word."

304. OED, s.v. "ware," sb[5]; MED, s.v. "ware" n. (4).

305. I must credit Lisa Warner for suggesting "bare" when I was headed in a different. She saw the solution before I did.

306. Compare *Chaucer's Host*, 127.

307. Two other entries use the spelling, but refer to the Book of Ecclesiastes, B 4519, D 651.

308. I think *song* has a covert meaning; it's used in such a special way. Perhaps it is a simple and direct complaint that the beautiful music (and it was) masks spiritual deficiencies.

309. Hilda Graef, *Mary: A History of Doctrine and Devotion* (New York: Sheed and Ward, 1963), 231, 317, 146–147.

310. Graef, *Mary: A History*, 234, 337. Italics added.

311. Graef, *Mary: A History*, 313–14.

312. Cullen, *Chaucer's Host*, 136–38.

313. The need to communicate secretly is covered in Cullen, *Chaucer's Host*, 27–36.
 It would be worthwhile to reexamine the idea that "in spite of many references to its failings, Chaucer accepted the religion of his day, without question, as far as we can tell…" H. S. Bennett, *Chaucer and the Fifteenth Century* (Oxford: Clarendon, 1947), 26.
 With all of today's burgeoning research, it may be possible to understand more now. Reexamination needs to be based on a search for truth, however, not on a crusade to prove or disprove his Catholicism.
 In *Writers and Pilgrims*, Donald Howard states: "It is not hard

to realize that [Chaucer] *anticipated* here the rejection of medieval religion, the whole complex of Crusades, relics, indulgences, saints, miracles, that was to pass away a century later. He embodied that complex not just in the pilgrimage frame but in the body of the work, in the pilgrims themselves and in their tales." (Berkeley: U. of California Press, 1980), 98. Italics added.

Why is it assumed that it was Chaucer's "anticipation"? The term sets him apart, makes of his work a coincidence. What seems to me a firm possibility, instead, is that the poet had the courage to record what may already have been common attitudes among the knowledgeable.

The Incomparable Wife

314. Robert P. Miller, "Allegory in *The Canterbury Tales*," in *Companion to Chaucer Studies*, ed. Beryl Rowland (Toronto: Oxford U. Press, 1968), 286.

315. Allen, 460–63.

316. Beyer, 17, 150–51. Corn, in a broad sense, means *grain*.

317. Ovid, *Fasti*, 201–05.

318. Augustine, *City of God*, vol. I:155; vol. II:328–29.

319. Augustine, *City of God*, vol. II:467–69, 435.

320. Ovid, *Fasti*, 181–83; Ovid, *Metamorphoses*, vol. I:289–99.

321. Augustine, *City of God*, vol. II:39.

322. Ovid, *Fasti*, 199; Pausanius, *Guide to Greece*, trans. Peter Levi (1971; rprt. New York: Penguin, 1985), I:222.

323. *Britannica*, ss.v. "Bath" (England), "Britain."

324. Apuleius, *The Metamorphoses or Golden Ass of Apuleius of Madaura*, trans. H. E. Butler (Oxford: Clarendon, 1910), 129–30.

325. *Britannica*, s.v. "Great Mother of the Gods."

326. Ovid, *Fasti*, 207.

327. Augustine, *City of God*, vol. I:165; vol. II:329, 463.

328. Maarten J. Vermaseren, *Cybele and Attis: The Myth and Cult* (London: Thames and Hudson, 1977), 138.

329. Frazer, *New Golden Bough*, 315.

330. MED, s.v. "scath(e."

Even though the words are apparently equivalent, I find it difficult to say "weaving" when Chaucer says "cloth-making." I also wonder at the appearance of "Gaunt," a name so important in the poet's life.

331. Howe and Harrer, s.v. "Hera."

332. MED, s.v. "ground."

333. MED, s.v. "hose." See Cullen, *Pilgrim Chaucer*, 78–79.

334. Frazer, *New Golden Bough*, 313; *Boethius*, II:m. 6.

335. *Britannica*, s.v. "terra cotta."

336. Brooks, 32.

337. I. A. Richards, *The Philosophy of Rhetoric* (London: Oxford U. Press, 1936), 48.

338. Baugh, n. A 468.

339. MED, s.v. "esili."

340. OED, s.v. "wimple," v., *fig.* can mean to veil or conceal.

341. MED, s.v. "spore" n. (2).

342. Macrobius, *The Saturnalia*, trans. Percival Vaughan Davies (New York: Columbia U. Press, 1969), 142.

343. MED, s.v. "parchaunce."

344. Franz Cumont, *Oriental Religions in Roman Paganism* [authorized translation] (London: Paul, Trench, Trübner, 1911), 208. Italics added, and author's italics.

345. Lowes, *Chaucer*, 187.

346. MED, s.v. "sel(e."

347. The value of personal experience gained in importance as indicated by Oberman.

> Fourteenth-century thought can no longer be described only in terms of philosophy and academic theology, as we have been inclined to do. Lay thought and lay piety now begin to occupy the center of the stage.
> The warning against...academic speculation gave

weight and new authority to *experientia*—the experience of man and nature, of history and society, of daily life—which would soon put the validity of tradition to the test. Something new was afoot (93).

Brooks, in speaking of the wife's "uninhibited appetite for experience" notes that the very first word in her narrative is, in fact, "experience" (32).

348. Cumont, *Oriental Religions*, 208.

349. MED, s.v. "bigon."

350. MED, s.v. "pith(e."

351. Lowes, *Chaucer*, 186.

352. Ovid, *Fasti*, 214, n. *b*.: "This feast [of Cybele] was a great time for hospitality."

353. Ovid, *Fasti*, 215.

354. Augustine, *City of God*, vol. I:155–57.

355. Curtius, 123.

356. MED, ss.v. "pine" n. (1); "pin(e" n. (2).

357. MED, s.v. "burel" n. (1); n. (2).

358. Vermaseren, 11.

359. Ovid, *Fasti*, 215 and note b.

360. MED, s.v. "statut(e" n. 5. (a) and (b). The Latin is *statuo* and *statua*.

361. *Third Pythian Ode:*

> To the Mother…the maidens
> often sing before my door at night,
> for she is a venerable goddess.
>
> (77–79)

Pindar, *Olympian and Pythian Odes*, trans. William H. Race, Loeb Series (Cambridge: Harvard U. Press, 1997).

362. MED, s.v. "bien," 8. "to suffer."

363. MED, s.v. "abroche"; "abroching."

364. Vermaseren, 99–100; 115.

365. Vermaseren, 102–03. Frazer describes it as "hot reeking blood." *New Golden Bough*, 313.

366. MED, s.v. "practik(e."

367. Vermaseren, 80–82, 119.

368. Cumont, *Oriental Religions*, 205.
 Owst, in the mid-twentieth century, lodges a complaint against this endless medieval verbiage, alluding to "the wearisome logic of the schools"; that is, of scholastic thinking (*Preaching*, 112).

369. MED, s.v. "daungerous."

370. MED, s.v. "lor(e" n. (2).

371. MED, s.v. "hend(e."

372. MED, s.v. "fe" n. (2).

373. Beyer, 124–25.

374. Ptolemy, 51. Italics added.
 Middle English "venerien" is more clearly associated with sexuality than the modern "Venusian."

375. Curtius, 215.

376. Godfrey of Admont (d. 1165) uses exaggerated erotic terminology. The idea "gave rise to some ribald and blasphemous jokes in the vernacular literature of the time." Understandably, Graef gives no source (*Mary: A History*, 248).
 There is something to be discovered in Chaucer's four-line jingle following the Arius anecdote:

> "Whoso that buyldeth his hous al of salwes,
> And priketh his blynde hors over the falwes,
> And suffreth his wyf to go seken halwes,
> Is worthy to been hanged on the galwes!'
>
> (D 655–58)

It makes me wonder if the jingle isn't a blasphemous example. Christ's Cross was poetically referred to as His "gallows." MED, s.v. "galwe" 1. (b): "hys owne galewys for to be hangyd."

377. Cullen, *Chaucer's Host*, 33–36.

378. S.v. "Nicene Creed."
 The Arian heresy "reflects the paradox inherent in the notion of a god who is both three and one." Council of Nicaea (325 A.D.) produced the Nicene Creed. "The orthodox position was quite simple. If one had to choose between logical consistency and the salvation through faith in Jesus...it was far better to be saved than to be logical."
 "Thus the Arian controversy points up important differences... between the Greek and Christian mentalities." W. T. Jones, *The Medieval Mind*, 2d ed. (1952; rprt. New York: Harcourt, Brace and World, 1969), 63–65.

379. I must acknowledge my son Ted's insight about the absence of prayers.

380. There is much evidence of Cybele's Cult in North Africa. (Vermaseren, 128–30).

381. *Britannica*, ss.v. "Constantine," "Roman history"; *The Golden Legend of Jacobus de Voragine*, trans. Granger Ryan and Helmut Ripperger (1941; rprt. Salem, NH: Ayer, 1987), 642; Seznec, 212–13. See also Owst, *Preaching*, 245.

382. Howard, *Essays and Studies*, 53–54.

383. George Lyman Kittredge, *Chaucer and His Poetry* (1915; rprt. Cambridge: Harvard U. Press, 1946), 186–89. Italics added.

384. Graef, *Mary: A History*, 35.
 A very popular German-language *Life of Mary* (1172 A.D.) portrayed her as a young girl in a medieval palace. The story ends with Mary being "venerated as a goddess" in Egypt (*Mary: A History*, 262–63).

385. Sir James George Frazer, *The Golden Bough*, 12 vols., 3d ed. (1911; rprt. London: Macmillan, 1913), I:12–15 and notes.
 Ephesus, in Greece, is where Paul was confronted by Diana's cult. It is also where Mary was officially designated "Theotokos," Mother of God. Hilda Graef, *The Devotion to Our Lady* (New York: Hawthorn, 1963), 27–28, 32–33.

386. Alexander de Villa Dei, *Ecclesiale*, trans. L. R. Lind (Lawrence: U. of Kansas Press, 1958), 85–86. Italics added.

387. Charles Mills Gayley, *Plays of Our Forefathers* (New York: Duffield, 1907), 75; Temko, 123.

388. Graef, *Mary: A History*, 269, 270, 147.

389. Temko, 123.

390. Temko, 184 and plate XXI. At Notre-Dame in Paris, "Her Son, except in the central Last Judgment, is scarcely more than her equal, and usually only her child" (182).

391. Graef, *Devotion to Our Lady*, 33–5. In tracing the history of devotion to Mary, Graef confirms the feast of her Assumption (into heaven) was celebrated in Palestine on Aug. 15 before 600 A.D.

392. An apropos article came into my hands many years ago (*Maryknoll Magazine*, April 1973). It is so perfectly attuned to what we are saying here that I include excerpts.

The title is "Our Lady and the earth goddess." It tells of a grand festival on December 8, not coincidentally, I am sure, the Feast of the Immaculate Conception (Mary's soul preserved from Original Sin).

Two quotes will tell the whole story of Mary's position in what used to be a pagan culture. Her image, with potatoes attached, is carried in procession as part of the festivities.

> For more than 400 years the Aymara people in Juli [their city] have combined their belief in *Pacha Mamma*, their traditional goddess of earth and fertility, with religious devotion to the Mother of God which the first missioners to Peru preached. (31)

> [The bishop] is not certain what exact meaning the fiesta of Our Lady has for the Aymaras. Is it one culture's expression of belief in the Mother of God? Or does it have more to do with the earth goddess and a hope for fertile fields? (32)

Graef seems to anticipate the Maryknoll thoughts in speaking of Diana of Ephesus and the later Council of Ephesus, where shouts acclaiming Theotokos might be heard as "a Christian echo of 'the Great Diana....'" The "veneration of a mother-figure is a deep-rooted human instinct, and so it is not improbable that, in the hearts of many simple people, the Theotokos should have taken the place of the ancient Diana. For the safeguards of Christian theology are not always generally understood by the crowds and the 'Mother of God' may sometimes seem closer and more acces-

sible to the hearts of the people than the incomprehensible God-head or even the mysterious God-man" (*Mary: a History*, 109).

393. Allen, 463; "Ave Maris Stella," the most popular hymn in the Middle Ages. Graef, *Devotion to Our Lady*, 40–41.

V. Almost Everyone Else

394. Manly, *CT*, 133–34; Ptolemy, 35–45.

395. Seznec, 52.

396. Pliny, vol. I:227–29, 177.

397. The prestige of astrology, and the belief that planets influence life on earth, developed great interest in predictions of the future. It was believed that it would be "scientifically" possible to determine "the destiny of individuals with the same precision as the date of an eclipse." Franz Cumont, *Astrology and Religion Among the Greeks and Romans* (New York: G. P. Putnam's Sons, 1912), 137.

398. F. N. Robinson, 521.

399. Robert Armstrong Pratt, "The Knight's Tale," in *Sources and Analogues of Chaucer's Canterbury Tales*, ed. W. F. Bryan and Germaine Dempster (1941; rprt. New York: Humanities Press, 1958), 89. Italics added.

Lydgate also describes the actions of Venus and Mars as planetary conjunction and departure (*Pilgrimage*, 20249–260). It may be a common element of the fourteenth-century imagination.

The Franklin

400. Cicero, 185; Ovid, *Metamorphoses*, vol. II:81; vol. I:11; Ovid, *Fasti*, 255.

401. Pliny, vol. I:191; Barton and Barton, 18.

402. Pliny, vol. I:227; *Britannica*, s.v. "Jupiter" (the planet).

403. Ptolemy, 183.

404. *Anticlaudianus of Alan of Lille*, James J. Sheridan, trans. (Toronto: Pontifical Institute of Mediaeval Studies, 1973), 134; Bartholomæus, 480; *Cosmographia*, 109.

405. Seznec, 156–57; Thorndike, *Michael Scot*, 100–01. Symbolic intent of clothing explained. *Cosmographia*, 100–01.

406. Barkan, 133; Huppé, *Doctrine and Poetry*, 69–70; Lynn Thorndike, *A History of Magic and Experimental Science*, 8 vols. (New York: Columbia U. Press, 1923), II:333; Seznec, 161 illustration.

407. Owst, *Preaching*, 260; Seznec, 99 n. 72. The recommendation is that of "Mutianus Rufus" (Conrad Muth, d. 1526).

408. Complexion has to do with both skin color and humors (personality).

409. Gower, 7.909–19.

410. Ovid, *Fasti*, 345–49.

411. Bartholomæus, 480; 471.

412. Speculation about the Franklin's tale: I see possibilities of a philosophical debate. Three characters *Dorigen* portraying ideas of (d') Origen; *Aurelius* representing thoughts of Augustine, whose name was also Aurelius (the *most noteworthy* Aurelius); *Arveragus*, perhaps as Averroes. A problem with the removal of *rocks*, seems to involve a *foundation*, or an *impediment* (possible Church matters, thinking of St. Peter, the *rock*).

 Who plays the role of the Magician? Ovid has been termed a Magician. Is it christianizing Ovid? Aquinas' methods blended different philosophies. Three controversial systems of the time were—Scholasticism, Nominalism, Realism. (What is more real than rocks?) The basis seems philosophic, but working it out is beyond this project.

The Man of Law

413. Seznec, 22; *Britannica*, s.v. "Hermes Trismegistos."

414. Augustine, *City of God*, vol. II:471.

415. Ovid, *Fasti*, 311.

416. Augustine, *City of God*, vol. II:425–29.

417. Ovid, *Fasti*, 233.

418. *Cosmographia*, 78; H. Percy Wilkins, *A Guide to the Heavens* (London: Frederick Muller, 1956), 89; Pliny, *Natural History*, vol. I:193.

419. Ptolemy, 39; Seznec, 17; Cumont, *Astrology and Religion*, 119; Bartholomæus, 475.

420. William Harris Stahl, *Martianus Capella and the Seven Liberal Arts* (New York: Columbia U. Press, 1971), 231; Temko, 201.

"Montmartre never meant Mount of Martyrs, in honor of Saint Denis and his companions, as is sometimes supposed, but Mons Mercore, Mount of Mercury, where the Traveler ruled for centuries as god of the Hill" (Temko, 36).

421. Seznec, 156–60; *Cosmographia*, 103.

422. MED, ss.v. "quik-silver," "Mercurie."

423. Baugh, n. A 318; *Britannica*, s.v. "Mercury" (the god).

424. Howe and Harrer, 128.

425. A great deal of astronomical information had been gathered before the fourteenth century. *Equatorie,* for example, tells of a collection of data on stellar movement, tables of annual motion of the mean motus of Venus and Mercury, etc. for "the Era of Christ." One example specifies a date as early as 17 May, 15 A.D. (76–77, 107). For Chaucer to *limit* records to the time since King William is a distraction, a false lead.

426. MED, s.v. "terme," 3. *"Astrol.* A division of the zodiac defining a period within which the influence of a planet is heightened; *astr.* an appointed course of a planet or star."

MED, ss.v. "cas," "fallen." Chaucer employs *fall* astrologically elsewhere in the Tales:

> Infortunat ascendent tortuous,
> Of which the lord is helplees fall, allas,
> Out of his angle into the derkeste hous!
>
> (B 302–04)

Fell is used in the *Astrolabe* to speak of the sun (168–70) and of a planet (156–61).

An opinion expressed about the OED by Derek Price fits the MED as well. These very fine reference works are not "intended to be at all exhaustive or definitive. The first quotation for a given word merely indicates that this is the earliest text read for the dictionary in which that word is to be found, but it can certainly not be taken for granted that it represents the first appearance of

the word in English" (*Equatorie*, 147). Some of the astrological terms, he confides, can be found in other astrological manuscripts as yet unprinted.

If Chaucer's use of a word is not documented with additional connotations, it does not mean that he could not have intended a meaning beyond those listed as possible in the dictionary. Finding the word there is a confirmation; not finding it is not conclusive.

427. MED, s.v. "enditen." There must be something to be discovered in *pinch*—it's too noticeable.

428. Ovid, *Fasti*, 267.

429. MED, s.v. "homli," adv.

430. MED, s.v. "quik-silver."

431. Baugh, n. A 329.

432. *Equatorie*, 123.

433. Chaucer and *Equatorie of the Planetis*: "Ascription to Chaucer must remain tentative." If Chaucer is disregarded it is not easy to come up with "an alternative explanation...to fit the facts and indications" contained in the manuscript (149). The work would function as an appropriate companion to Chaucer's *Treatise on the Astrolabe*. Instructions about the "silk thred" and metal "barres" may be found in *Equatorie* (24–26).

434. Charts of the anomalies of the planets show that Saturn, Jupiter, Mars have none. Venus had five in eight years. Mercury had 145 observed anomalies in 46 years (*Equatorie*, 123).

The Doctor of Physic

435. Huppé, *Doctrine and Poetry*, 23. "Figurative words have one meaning in one context but may have a different, even an opposite, meaning in another context."

The Augustine source explains that there are "things that are contrary, or things that are only different. They signify contraries, for example, when they are used metaphorically at one time in a good sense, at another in a bad" (*On Christian Doctrine*, 101).

436. Cicero, 185.

437. Ovid, *Fasti*, 203.

438. *Cosmographia*, 99–100.

439. *Britannica*, s.v. "Cronus."

440. Pliny, vol. I:189; Barton, 18; *Britannica*, s.v. "Saturn" (the planet).

441. Seznec, 160, 156; Gower, 7.939; Petrarch, *Africa*, 3:173–77.

442. Wood, 71.

443. *Astrolabe*, 156–61. The story is really of "Clytemnestra," but that's not Chaucer's spelling in the legend.

444. MED, s.v. "magik(e."

445. MED, s.v. "practik(e."

446. An interesting note: "old Aesculapius" at the top of the list, I take to be the "person" worshiped "at the time of a great pestilence" in 293 B.C. He had received his medical training from Chiron, the centaur, who went on to become the sign of Sagittarius. (Howe and Harrer, ss.v. "Aesculapius" and "Asclepius.")

447. MED, s.v. "norishing(e."

448. The Wife, D 9–13; the Franklin, F 721–22.

449. There is the feeling of a special picture of Saturn used as the pattern. "Clad" can be *conceal, envelope, disguise.*

450. MED, s.v. "cendal" 2.
 The MED quotes another poem, "Iesu þat wolde" which uses the same pair of fabrics. I have not been able to locate the poem to compare the purpose (s.v. "taffata").

451. OED, s.v. "wan." *Wan-* is also a prefix indicating deprivation, pejoration. MED, s.v. "wan."

452. Baugh's introductory note to the "Physician's" tale, p. 485.

453. R. M. Lumiansky, "The Meaning of Chaucer's Prologue to 'Sir Thopas,'" *PQ*, No. 26 (Oct. 1947), 316.

The Host

454. Pliny, vol. I:179; Homer, *Iliad*, trans. William Cullen Bryant (Boston: Houghton, Mifflin, 1870), 3. 347; Cumont, *Astrology and Religion*, 104–05.

455. *Cosmographia*, 101–02.

456. Bartholomaeus, 486; Macrobius, 149.

457. Augustine's Christmas sermon, No. 190. *The Works of Saint Augustine*, trans. Edmund Hill, O.P. (New Rochelle, NY: New City, 1993), 38.

458. Bartholomæus, 484–85.

459. Baldwin, 25.

460. "Through him a collection of tales becomes a unified work of art. Chaucer did not find such a character ready-made. The host is Chaucer's own creation, a figure of fiction, not a portrait of the actual innkeeper of Southwark." Kemp Malone, *Chapters on Chaucer* (Baltimore: Johns Hopkins Press, 1951), 196.

461. *Astrolabe*, 236–40.

462. Cullen, *Chaucer's Host*.

The Knight

463. *Britannica*, s.v. "Mars" (the planet); Pliny, vol. I:191.

464. *Cosmographia*, 79, 101.

465. Ovid, *Fasti*, 397–99, 414.

466. Ovid, *Fasti*, 125.

467. Augustine, *City of God*, vol. II:427; *Africa*, 48.

468. A 1747; *TC*, 3.724, 5.306; "Mars," 75; *CT*, A 2431–33.

469. Huppé, *Reading of CT*, 31; Donaldson, 882.

470. Baldwin, 40–41; Huppé, *Reading of CT*, 31.

471. Kolve, *Chaucer*, 86.

The Squire

472. William Witherle Lawrence, *Chaucer and the Canterbury Tales* (New York: Columbia U. Press, 1950), 46.

473. F. N. Robinson notes, p. 653; Cullen, *Pilgrim Chaucer*, 32–34.

474. Tuve, 186–87; Lydgate depicts Cupid as a fresh gallant with costly array, jewels and rings asparkle. A kerchief of pleasure is over his "helme" (*Assembly*, st. 43).

475. MED, ss.v. "louli," "servisable," "kerven."

476. Ovid's *Metamorphoses* was "exploited as a mine of sacred truth." Seznec, 91; Miller, 276.

Centuries of pagan images preceded a flowering of such adaptations in the 1500s when "Cupid yields his bow and arrows to the Infant Jesus, who in his turn uses them to pierce human hearts" (Seznec, 103). The image seems a variation of Augustine's Christ the Divine Archer.

In a poem by Theocritus, Eros is addressed as "tormenting Eros! Why have you clamped on my veins / like a marsh leech, and drained the dark blood out?" (lines 56–7). A few lines later he is described "with his wicked ravings he hounds virgins, even, / from their chambers—even brides to leave their husbands' beds / still warm" (lines 136–38). *The Poems of Theocritus*, trans. Anna Rist (Chapel Hill: U. of North Carolina Press, 1978), 41, 44.

The Yeoman

477. "Pecock fether doth seldome kepe vp ye shaft eyther ryght or leuel, it is so roughe and heuy, so that many me[n] which haue taken them vp for gayenesse, hathe layde them downe agayne for profyte." Ascham's *Toxophilus*, in *English Works*, ed. William Aldis Wright (Cambridge: Cambridge U. Press, 1904), 88–89. Ascham invented the archery term.

478. MED, s.v. "beren," 6.(b); Pliny, vol. III:323.

479. MED, s.v. "shene," adj. 2. (c); "shenen," v. (2). Lydgate is quoted under "shene."

480. "Knyȝthod representing þe myȝt & þe powere of þe fadir." John Wyclif, *The Lanterne of Liȝt*, ed. Lilian M. Swinburn, EETS, o.s. 151 (London: Paul, Trench, Trübner, 1917), 34; Augustine, *The Confessions of St. Augustine*, trans. F. J. Sheed (New York: Sheed and Ward, 1942), 152.

481. *Cosmographia*, 23. Martianus Capellanus and Bernardus Silvestris each have their own terms for figures that correspond to the Trinity.

482. *Britannica*, s.v. "Holy Spirit."

Dorothy L. Sayers (sometime mystery writer, sometime essayist on theology) presents a "bewildered...Japanese gentleman" who complains, "Honourable Father, very good; Honourable son,

very good; but Honourable Bird I do not understand at all." (*The Mind of the Maker*, New York: Harcourt, Brace, 1941), 123.

483. "Most Christian language about the Trinity remained in the molds that had been cast 15 or more centuries earlier." *Britannica*, s.v. "Trinity."

The Feast of the Trinity was made "universal" by John XXII (d. 1334). Miri Rubin, *Corpus Christi* (Cambridge: Cambridge U. Press, 1991), 178.

484. John F. Friedman, "Peacocks and Preachers," in *Beasts and Birds of the Middle Ages*, eds. Willene B. Clark and Meradith T. McMunn (Philadelphia: U. of Pennsylvania Press, 1989), 188.

The Prioress

485. MED, ss.v. "priour," "priores(se."

486. Ovid, *Fasti*, 5.

487. Barton and Barton, 16; Cicero, 175; Barton and Barton, 57.

488. Ptolemy, 185, 37; *Cosmographia*, 103.

489. Ovid, *Fasti* 192–93; *Britannica*, s.v. "Aphrodite"; *Oxford Companion to Classical Literature*, ed. M. C. Howatson, 2d. ed. (1937; rprt. Oxford: Oxford U. Press, 1991), s.v. "Venus."

490. MED, s.v. "armonie." Also intends harmonious relationships.

491. *Anticlaudianus*, 132.

492. Augustine, *City of God*, vol. II:427; vol. II:431–33.

493. Hoffman, 36; Ruggiers, 9.

Lowes alludes to "the impression of the hovering of the worthy lady's spirit between two worlds" (60). His pursuit of her double nature (60–67) is a delight. John Livingston Lowes, *Convention and Revolt in Poetry* (New York: Houghton Mifflin, 1919).

494. Hesiod, Loeb, 453; Cicero, 189–91, 341–43; Pliny calls the planet Venus "a deputy for the moon" (vol. I:191–193).

495. *Cosmographia*, 104. Italics added; Augustine, *City of God*, vol. II:431.

496. Ovid, *Fasti*, 13; Augustine, *City of God*, vol. VI:223; Theocritus, 35; *Metamorphoses*, vol. I:357.

The triple faces are also associated with having power over

heaven, earth, and hades. Jeffrey Burton Russell, *Witchcraft in the Middle Ages* (Ithaca, NY: Cornell U. Press, 1972), 48.

A spell, in Theocritus, is addressed to the goddess of the moon:

> I'll bind him fast with my fire-sorcery.
> Shine clear, Moon: low, in your hushed ears,
> shall my spells be sung, goddess, and to her, the earthbound
> Hecate, before whom the dog-pack cowers
> when she comes among the tombs for the black blood of
> corpses.
> Hail, dread, Hecate!
>
> (p. 39)

I have not located an actual description of Hecate's rituals, as with the taurobolium. Perhaps it's just as well. I find secondary sources referring to her rites as "terrifying" and "dreaded." See Vermaseren, 119; "Julian [the Apostate]," in *Cambridge Medieval History*, H. M. Gwatkin and J. P. Whitney, eds., 2d ed. (1911; rprt. Cambridge: Cambridge U. Press, 1957), 93.

497. Hoffman, 37.

498. Hesiod, Loeb, 409–21; MED, s.v. "coi."

Lydgate portrays a deceiving female character confide: "And vnder colour, by deceyt, / I lygge euermor in awayt, / Simple and coy, off port ful lowe, / That men my tresoun may nat knowe" (*Pilgrimage*, 15165–68).

"Coy" is rhymed with "St. Loy" who is identified by Lowes as "a one-time artist, and courtier, and lover of beautiful attire, the French Saint Eloi" (*Convention*, 62).

I'm not sure how high the "well-hewn roof-tree" is, but the description of another goddess (Hecate) records her height as "half a furlong"—more than 100 yards! Montague Summers quotes Lucian's *Philopseudes*, in *The Geography of Witchcraft* (New York: University Books, 1958), 7.

499. MED, s.v. "eglentin," a briar rose; Hoffman, 37.

500. MED, ss.v. "divin(e," adj 2. (a): "Partaking of the nature of a god"; divin(e, n. 2. (a): "One who predicts future events" by astrology, augury, etc. or the activity itself—astrology, augury, prophecy.

501. *The Gentleman's Magazine* (July 1841), 154.

502. Lowes, *Convention*, 63.

503. MED, s.v. "courteisie," n. 4; Hesiod, Loeb, 419.

504. Speirs, 106–07.

505. MED, s.v. "amiable," 1. (b). Regarding a planet, the term means *favorable*.

506. MED, s.v. "grei," 2. (b).

507. Speirs, 106; Hoffman, 37.

508. The poet offers two portraits of Venus: *P of F*, 260–73 and the following from the *Canterbury Tales*.

> The statue of Venus, glorious for to se,
> Was naked, fletynge in the large see,
> And fro the navele doun al covered was
> With wawes grene, and brighte as any glas.
> (A 1955–58)

509. Hoffman, 37. (See n. 608 below for pertinent information about the rosary.)

510. Lowes, *Convention*, 66; *Virgil's Works*, trans. J. W. Mackail (New York: Modern Library, 1950), 291.

 Hoffman explains, "The motto itself has, in the course of history, gone its own double pilgrimage to the shrine of Saint Venus and to sacred shrines; the original province of the motto was profane, but it was drawn over to a sacred meaning and soon became complexly involved with and compactly significant of both" (38).

511. The priest is assumed to be a *singular* presence; I won't get into the debate about the possibility of three of them.

The Second Nun

512. Cullen, *Pilgrim Chaucer*, 42–46; Barton and Barton, 15.

513. Ovid, *Metamorphoses*, vol. II:379.

514. Anderson, 194. Italics added.

 An illustration of a witch plying her craft is carved into the stone of the Lyons Cathedral, built between the twelfth and fourteenth centuries. Emile Grillot De Givry, *Picture Museum of Sor-*

cery, Magic and Alchemy, trans. J. Courtenay Locke (New Hyde Park, NY: University Books, 1963), 51.

The Nuns' Priest

515. Edgar H. Duncan, "The Literature of Alchemy and Chaucer's Canon's Yeoman's Tale," *Speculum* 43 (1968): 633; Bronson, 58.

516. Roger Sherman Loomis, *A Mirror of Chaucer's World* (Princeton: Princeton U. Press, 1965), #84.

517. MED, s.v. "moten," 11.(c); Pliny, vol. III:323.
Chaucer's addressing one level and then the other alternately, or addressing both levels simultaneously, gives a complex, even puzzling, aura to his narration. He can joke with himself about the multilevel character that only he completely recognizes. And his audience, trying to understand on one level alone, attempts to follow two levels at once, as if the narration was "flat"; tries to understand in moment-to-moment time in a certain geographic setting a story which is undefined by time and space.

518. Cicero, 277.

519. Cicero, 135; Ovid, *Fasti*, 33; Pliny, vol. III:323.

520. Cicero, 129–31. This was serious business. The officer who "fail[ed] to comply with the auspices...was tried and condemned for high treason." A fellow officer committed suicide.

521. Bronson, 58; MED, s.v. "gentil," adj. 3. (d); 4.
Frazer tells of an "urn in the Lateran Museum" where a "cock bears the punning reference to the Latin word *gallus*, which means both 'cock' and 'priest of Attis'" (New Golden Bough, 377, n. 234.3). A picture of such a funeral urn is found in Vermaseren, fig. 64.

522. Ovid, *Fasti*, 33.

523. Dennis Wheatley, *The Devil and All His Works* (New York: American Heritage, 1971), 80; Richard Cavendish, *The Black Arts* (New York: Capricorn, 1968), 304–06; Russell, *Witchcraft*, 79; Cavendish, 248.
Russell's expertise covers both witchcraft and heresy: *Religious Dissent in the Middle Ages*, ed. Jeffrey B. Russell (New York: John Wiley and Sons, 1971).
John of Salisbury (d. 1180) expresses scepticism regarding the

then common idea of a witch queen. *Witchcraft in Europe 1100–1700*, Alan Kors and Edward Peters, eds. (Philadelphia: U. of Pennsylvania Press, 1972), 37.

524. Brooks, 16.

525. Lowes, *Chaucer*, 21.

VI. A Duo: The Canon and His Yeoman

526. Ptolemy, 193–95, 217.

527. Bede, *Bede's Ecclesiastical History of the English People*, eds. Bertram Colgrave and R. A. B. Mynors (1969; rprt. Oxford: Clarendon, 1992), 557.

528. Thorndike, *History of Magic*, III:285, 286, 592; Bede, 557; *The Chronicle of Jean de Venette*, trans. Jean Birdsall, ed. Richard A. Newhall (New York: Columbia U. Press, 1953), 141; Thorndike, *Michael Scot*, 70.

529. The "perfect" opportunity was the black night sky of the California desert.

530. Olson's book and the *Britannica* (s.v. "Comet") hold a wealth of fascinating information.

531. Charles Muscatine, *Chaucer and the French Tradition* (Berkeley: U. of California Press, 1957), 220.

532. MED, ss.v. "bogh→boue; bouen"; "boue," n. (1) 6; "bouen," v. (1) 4a. A chronicle records, "In this same ȝere...appered a sterre...with a hie bem, whech bem bowed into the north." The noun "boughtnes" means *curve*.

 MED, s.v. "ble": "Þe mone mandeþ (sends forth) hire bleo."

 "The tail may be nearly straight...or it may be moderately or highly curved and form a large angle with the antisolar direction" (*Britannica*, s.v. "Comet").

533. Chaucer was not the first nor the last to personify a comet. A thirteenth-century cathedral sculpture is the earliest I've seen. The nineteenth century, with its plethora of comets, inspired painters, sculptors, and cartoonists to communicate a great variety of messages of politics, current events, or simply esthetic enjoyment. See Olson figs. 7, 84, 87, 91, 93. (Fig. 78 depicts shooting stars as lovers in an erotic embrace.)

534. MED, s.v. "ground," 5. A basis for doctrine, opinion; fundamental principle, assumption.

The ground spoken of can be the basis of the action, the beliefs that prompted the poet to construct this grand "lie" that conceals the truth.

535. Lisa Warner deserves thanks for that bit of insight.

The Abandoned Yeoman

536. As an example, using just the names of materials listed in the excerpt, *boole armonyak*, *verdegrees*, *arsenyk*, and *brymstoon* aided production of pigments. *Boras* was a fixative for gold leaf. *Sondry vessels maad of erthe and glas* are utilitarian. *Urynals* would appropriately contain urine used as a pigment-enhancer. *Descensories, sublymatories, cucurbites,* and *alambikes* function as processing equipment. *Crosletz* (plural of *crosselet*) may be watermarks in the paper, or illustrated symbols. *Watres rubifiying* (reddened) and *boles galle* lend color to ink. *Sal armonyak*, which exists in several colors, could provide a source of pigment. The three herbs (*egremoyne, valerian,* and *lunarie*) would be processed for their color; many herbs were. *Violes* has not been directly accounted for, but could intend a vial (container); it might also be a watermark or illustration because of its position listed next to the *crosletz*.

As a comparison, the "arming" scene in Thopas presents a complex collection of images when understood as medical procedures disguised as a knight's preparation for battle. See Cullen, *Pilgrim Chaucer*, 117–26

537. Richard de Bury, *Philobiblon* (1960; rprt. Oxford: Basil Blackwell, 1970), 21.

538. Repugnant odors of brimstone, goats, and rams would reflect crafting of parchment, leather, and more as a book's components develop (G 884–90). As with the Cook being an *ingredient* in the recipes associated with him—the prominence of an *inventory* of materials is the intimate knowledge of the embryonic development of the *book*.

539. Muscatine, 219; Spargo, 689.

540. In England, the title "canon" is still used for clergymen.
MED, s.v. "folden" v. (2) : 4. (a); 7. (a). To close a book, to fold over a letter or parchment.

541. MED, s.v. "gile," n. (3). Chaucer's fondness for assigning the proper saint goes back (at least) to "St. John" in the *B of D*, line 1319; MED, ss.v. "col," n. (2); "cole," n.; Baugh recommends that we read this *temps* (G 875) as *time*; that is, *expectation*; F. N. Robinson recommends *temps* as (future) *tense*.

Many unexpected terminations and sudden new beginnings, of things "I forgot to mention" (G 852), make his ramblings and interruptions reminiscent of the Wife of Bath's prologue.

542. The following examples are medieval uses of *canon*. From Lynn Thorndike's *History of Magic and Experimental Science*: John of Saxony (mid-1300s) protested, "Whereas many astronomers have composed various books which they call *Canons* concerning the use of tables, some did not cover all possible operations, while others wrote in a difficult and obscure way." This same John dedicates himself to produce a work which will "give examples of all the operations which are commonly performed with tables so that there may be no one henceforth who will shrink from the use and employment of tables of stars because of the difficulty of working with them" (III:258–59).

From Chaucer's *Treatise on the Astrolabe*: "The whiche fourthe partie in speciall shal shewen a table of the verrey moeving of the mone from houre to houre every day and in every signe after thyn almenak. Upon which table there folewith a canoun suffisant to teche as wel the manere of the worchynge of the same conclusioun as to knowe in oure orizonte with which degre of the zodiak that the mone arisith in any latitude, and the arisyng of any planete" (p. 546).

Another brief quote from Chaucer demonstrates the use of *canon* associated with the calendar: "Loke hou many houres …shewith by the canon of thy kalender" (p. 558, #32).

543. Michelle P. Brown, *Understanding Illuminated Manuscripts* (Malibu, CA: J. Paul Getty Museum, 1994), s.v. "vade mecum."

544. "The red lead often used for rubrics frequently fades and turns silver-black through oxidation." Handling the pages could spread "silver-black" to the cover of the book (as with newsprint), and dull the outer color. (Brown, s.v. "pigment.")

MED, s.v. "hose," n. 3. This "hose" can have two purposes. First, as a slip-on protector. But, secondly, because the Yeoman is companion to a "hairy star" (comet), covering his hair keeps him from being mistaken for another one, from being a duplicate image.

545. MED, s.v. "crosselet," n. (1), a small cross; n. (2), a crucible.

546. Chaucer uses the term *alchemist* ("alkamystre") only once (G 1204). It puts in a tardy appearance when the action of the deception story is more than half over. (There are no other such entries in the Chaucer *Concordance*.) His referent is mainly *philosopher*, a serviceable term in many areas.

 To understand *philosopher* only as an alternate referent for *alchemist* ignores other connotations. *Ecclesiale*, for example, recognized philosophers as watchers of the sky (99). The closing of this tale alludes to the philosopher Plato. And an example closer to our pursuits finds *philosophers* of the Middle Ages interested in the production of illuminated manuscripts. The medieval *Secrets of the Philosophers* has a section where "instructions are given for making colors employed in illuminating, ink, white tablets, and glues" (Thorndike, *History of Magic*, II:788).

 Though the comment seems rather out of place, the façade of the primary reading is supported by the maxim, "Everything that shines as gold / Is not gold, as I've heard it told" (G 962–63). That, and the single use of *alchemist* (where any epithet would have served, as long as it implied *charlatan*) insinuate an alchemical milieu for the surface story.

547. *Equatorie of the Planetis* disapproves of some of its content, with "this canon is false" (34, 38).

548. *Ecclesiale*, called "a priest's handbook" is "a book on 'the art of reckoning church festivals'" and more (4). We may term it a "canon of religion." *Sol* and *Luna* are the Latin forms used to express solar and lunar entries in works such as this "handbook."

 Alexander of Villa Dei, author of *Ecclesiale*, chastises a "pestiferous chair of learning" for supporting "a deadly doctrine" that "spreads contagion among many" (65). This thought is echoed (intentionally or otherwise) in Chaucer's opening lines about a canon of religion that "would infect a whole town."

549. Significant bits of imagery, in the deception story, create an Easter pastiche. (See *Ecclesiale*, 102, 132–33.) A *key* (*clavis Paschae*) is needed; Chaucer works in a *key* (G 1219). A limiting factor, the Feast of St. Mark, is the last date (*ultimum Pascha*) on which Easter may fall; a fleeting glimpse of "Mark" is the denomination of money chosen by Chaucer, the *mark* (G 1026, 1030). The poet, here, exhibits his special talent for matching the coin to the occasion. ("Jane," a coin from Genoa, plays a special part in the *Tale of*

Thopas. See Cullen, *Pilgrim Chaucer*, 80–81.)

550. *Time* and *mix* (that is, *temps* and *tempren*) become similar when mixing solar time and lunar time to arrive at a conclusion that coordinates both.

551. The most cryptic use of *multiplication* precedes the lines about being "by Jesus." The words are understandable; the potentially salvific message is not.

> For bothe two, by my savacioun,
> Concluden in multiplicacioun
> Ylike wel, whan they han al ydo;
> This is to seyn, they faillen bothe two.
>
> (G 848–51)

It almost seems that salvation, when all is said and done, is dependent upon multiplication. Paschal consideration of the nebulous "two" could be the two calendars. Despite attempts at multiplication to achieve a correct outcome, the "two" may both fail (G 851).

To gain a proper date, accuracy of a *canon* is indispensable. Cycles of both the sun and the moon were consulted: (6x19x29)+(6x19x30) is the number of moon cycles that equal nineteen years; that is, nineteen cycles of the sun.

552. For example, see Thomas Wright in *The Journal of the British Archaeological Association*, (1844) 155.

553. Pope Victor (late second century) excommunicated all of Asia because their computation was erroneous. Closer to the English environment was a dispute over the proper date of Easter between the Celtic faithful and Roman missionaries. It took a decree from the Archbishop of Canterbury to settle the matter following the Synod of Whitby. Some believers stubbornly chose to *fix* the date at March 21—or March 25—no matter the day of the week. Because the lunar calendar can vary by several days, the Eastern Orthodox celebration may differ from the West by 4–5 weeks (*Britannica*, s.v. "Easter").

554. See the conclusion of *Chaucer's Host* and this volume 176–79, for example.

555. Chaucer was aware that "the equinoctial point had slipped back nine days" (Manly, *CT*, 135).

The problem even today can be recognized with two questions: Why doesn't Passover always coincide with Easter? Why does the Eastern Church celebrate Easter on a different date from the West? See "Paschal Controversies."

556. A philosophical interlude filled with mythological images and shrouded terminology intervenes (G 1428–71), until we reach the prayerful ending.

> For whoso maketh God his adversarie,
> As for to werken any thyng in contrarie
> Of his wil, certes, never shal he thryve.
>
> (G 1476–78)

The final words of the Tale are: "God sende every trewe man boote of his bale!" (G 1481). The Good Thief (proposed as being "by Jesus") was, at the end of his life, a true man.

557. Spargo, 685.

558. Duncan, 637, 650.

559. Duncan, 652.

560. Duncan, 653.

561. Duncan, 654–55.

562. Duncan, 656.

VII. THE FINAL SOLO: THE CLERK

563. Franz Cumont, *After Life in Roman Paganism* (1922; New York: Dover, 1959), 104.

564. Cumont, *Astrology and Religion*, 117.

565. Ovid, *Metamorphoses*, vol. II:425.

566. Cumont, *After Life*, 112–13.

567. *Cosmographia*, 95–96.

568. *Boethius*, IV:m. 1; Stahl, 179, n. 22.

569. *Ecclesiale*, 85, 75, 87, italics added; Plato, 145; Ovid, *Fasti*, 93.

570. *Fall of Princes* (3102–08) nicely quoted in *Receyt of the Lady Kateryne*, xvii.

Seznec refers to a question by the early theologian Tertullian (d. ?230) as to why someone as great as Socrates had never been deified by the ancients. In contrast, "medieval man was ready to venerate sages whom antiquity itself had not placed among the immortals" (17). Peter Comestor (ca. 1160) developed a "codified form" of euhemerism, which gained "tremendous authority" (16).

571. James Harvey Robinson, *Petrarch, the First Modern Scholar and Man of Letters*, collab. Henry Winchester Rolfe, 2d ed., rev. and enlarged (1914; New York: Greenwood, 1969), 29, 32–33, 25.

Because Venice was not on good terms, politically, with the area where Petrarch died, the library was never delivered to the city. Some volumes have been recovered through the centuries, but with wars, neglect, and other calamities fewer than thirty-five have been located.

572. J. H. Robinson, 466–68 and note.

Howard explains the medieval dedication to "the art of dying" (*De arte moriendi*) as urging that one come to a state of mind (or soul) where one "might embrace and *choose* his death with equanimity." (*Idea of the CT*, 172. Author's italics.)

573. MED, s.v. "unto" 12. "according to"; 19. "with respect to, regarding." Chaucer uses "unto" in *TC* (1.968) to express "according to."

574. *Britannica*, s.v. "Petrarch."

575. *Britannica*, s.v. "Petrarch"; J. H. Robinson, 460.

576. MED, s.v. "cofre" n. 2. (a); 3. (a).

577. J. H. Robinson, 459–60, 467; *Petrarch's Letters to Classical Authors*, trans. Mario Emilio Cosenza (Chicago: U. of Chicago Press, 1910), 40.

578. J. H. Robinson, 39; *The Life of Solitude by Francis Petrarch*, trans. Jacob Zeitlin (Urbana: U. of Illinois Press, 1924; rprt. Hyperion, 1978), 315.

579. Petrarch, *Life of Solitude*, 158.

580. Oberman, 93.

581. J. H. Robinson, 464–65.

582. J. H. Robinson, 451–52.

583. J. H. Robinson, 452.

584. J. H. Robinson, 128.

585. Third person references, for example, are used by the Host. See Cullen, *Chaucer's Host*, 85–86.

586. J. H. Robinson, 128.

587. *Petrarch's Letters*, 39–40, 136, 139; *Life of Solitude*, 293.

588. Seventy years ago, in explaining how Euhemerism affected the Middle Ages, John Daniel Cooke took examples from Lydgate, Gower, and others. Chaucer was not mentioned—until the final sentence: "It is worthy of note that Chaucer nowhere subscribes to the euhemeristic interpretation." "Euhemerism: A Mediaeval Interpretation of Classical Paganism," *Speculum* 2 (1927): 409.

Scholarship along with deeper understanding over these many decades allows a clearer vision of Chaucer's creativity.

589. *Cosmographia*, 28. Italics added.

Barkan tells of Dante's meeting with classical authors in limbo. Dante's words compare to Chaucer's as he tells of meeting the pilgrims for the first time. Dante's translator relates the meeting in limbo as, "They made me one of their company" (139). Chaucer, with the pilgrims, was "of their fellowship immediately" (A 32).

VIII. Reflections

590. Baldwin, 96. Italics added.

Interpretive allegory, the twisting and distorting of a story to establish comparisons, has nothing to do with the *Tales*. Chaucer created interwoven story lines as his plan.

591. Lawrence, 44; Clemen, 10; Fletcher, 119, n. 80.

592. MED, ss.v. "mistied"; "misti" adj. (1); *Cosmographia*, 13.

In the *Timaeus*, "Plato's cosmos was understood as providing the essential context of the writings of the great *auctores*, and in relation to this model the study of literature in general assumed a new importance" (*Cosmographia*, 13–14).

Bradwardine (Archbishop of Canterbury, d. 1349) "respects" Ovid not as "a source of delight...but as a source of *truth*." (Oberman, 87. Italics added.)

593. D. W. Robertson, Jr. *A Preface to Chaucer: Studies in Medieval Perspectives* (1962; rprt. Princeton: Princeton U. Press, 1969), 370;

Emile Legouis, *Geoffrey Chaucer*, trans. L. Lailavoix. (New York: Dutton, 1913), 204. Italics added.

594. Howard, *Idea of CT*, 60.

595. Kolve, *Chaucer*, 2. Italics added.

I have long wondered if there might be a "lost" literary convention which uses church buildings as outlines for stories, or, perhaps, a particular manuscript with illustrations that correspond to plots or settings. The possibility has been mentioned by others.

W. A. Pantin says about *Pricke of Conscience*, "Its description of the Last Judgment is represented in a stained-glass window in All Saints' Church, North Street, York. It is a very rare, almost unique distinction to find a contemporary literary work directly represented in wall-painting or stained-glass." *The English Church in the Fourteenth Century* (Notre Dame: U. of Notre Dame Press, 1962), 230.

In a vivid depiction of judgment and hell, "Myrc indeed seems to be actually reading off to us from the walls of some ancient Shropshire Church, where he is preaching" (Owst, *Preaching*, 338).

J. A. W. Bennett has a similar thought: "The earliest known representations of the paradise on any large scale is in the mosaics at S. Vitale in Ravenna. If, as is thought probable, Dante wrote part of the *Comedia* there, these may well have stirred his imagination" (75, n. 2).

Mâle explains a particular find: "We have dwelt at length on the doorway of Laon because the real meaning of that great ordered whole had not been elucidated, and because the close connection between mediæval art and literature is clearly shown in this example" (150).

"It is precisely in terms of such a framework [of liturgy] that mediaeval drama could stand comparison with the breath-taking splendour of Gothic cathedrals." Wickham, *Early Stages*, 315.

596. Manilius, 43.

597. Clemen, 18, 10; Edward Kennard Rand, *Ovid and His Influence* (Boston: Marshall Jones, 1925), 147.

Lydgate refers to truth "clipsed" by deceit and the "eclypse" of a woman's truth. (MED, s.v. "eclipsen.")

598. Morton W. Bloomfield, *Piers Plowman as a Fourteenth-Century Apocalypse* (New Brunswick, NJ: Rutgers U. Press, 1961), 42; Huppé, *A Reading of CT*, 237.

599. Cullen, *Pilgrim Chaucer*, 106–12.

600. Oberman, 91.

A medieval preacher asks "that grace god graunt us specialy of his gret mercy *in thees last days*." (Owst, *Preaching*, 137. Italics added.)

"The last end shall come, and when it shall be, only he knows that is the maker of time" (Bartholomæus, 501).

601. Oberman, 93, 91.

Legnano, referred to by Chaucer in the *Prologue to the Clerk's Tale*, was a celebrated jurist who was also knowledgeable in astrology. He predicted the year "1365 as a crucial date" for the appearance of Antichrist (Bloomfield, 204, n. 79).

602. Thorndike, *History of Magic*, III, 210; Bloomfield, 94; Rand, *Ovid*, 137; Marjorie Reeves, *The Influence of Prophecy in the Later Middle Ages* (Oxford: Clarendon, 1969), 314; Oberman, 90–91.

603. Reeves, 314–17, 58.

604. Reeves, 93–94 and n.1; Bloomfield, 157.

605. Reeves, 316; Bloomfield, 91; Reeves, 61, 64, 69.

606. Bloomfield, 91; Reeves, 5–6, 136–37; Bloomfield, 158; Reeves, 59; Bloomfield, 158.

607. Reeves, 324, 92–93; Bloomfield, 91; Reeves, 59.

608. Although the OED lists the origin of today's Rosary as later than Chaucer's life, and the MED does not have a religious connotation for the word, Hilda Graef, the Marian authority, has more to say. "According to the research of Meersseman the rosary is connected with the so-called 'Greeting Psalters', an extra-liturgical use of the psalms which replaced the ordinary antiphons by verses applicable to the blessed Virgin...the antiphons were left out, the *Gloria Patri* was interspersed and the one hundred and fifty Hail Mary's were divided into groups of fifty. These were called *rosarium* after Mary's title of *rosa mystica*. There was no meditation attached to them; but early in the twelfth century they were already counted on beads" (*Devotion to Our Lady*, 57).

609. Oberman tells of "the effort to prolong life by establishing one's fame and achieving a name which will survive." The idea was particularly Italian, but was also "derived from Suso (a pupil of Meister Eckhart [d. 1366]) in the North" (92–3).

610. "*Sentence*" in this case can function as *doctrine, teaching, judgment*, or *prophecy*. *Ordinance* ("ordinaunce") can intend *Divine plan* (MED).

611. Delasanta, 304.

Donaldson also notes Libra in its ascendancy as the symbol of God's justice (948).

612. Delasanta, 306.

613. Thorndike (in *History of Magic*, II:19–21) discusses Albumasar's reputation in England. He was known to the English Adelard of Bath (early 1100s). Adelard made an "extensive intellectual pilgrimage even to lands Mohammedan."

Bernardus Silvestris (mid-1100s) "persistently associated" with Arabic works, and was probably the author of a volume on astrology written so that "one may avoid the perils of which the stars give warning by penitence and prayers and vows to God who, as the astrologer Albumasar admits, controls the stars" (vol. II:110–11).

We can recognize a demand and interest in Albumasar's astrological work by the fact that it was in print less than 100 years after Chaucer's death (Allen, 77, n.).

614. Baugh, n. X 10.

615. Statements that appear to be mistakes are a pattern of Chaucer's creativity. This pattern is used many times to conceal the identity of Christ, while signaling a second reading, in the Host.

616. Libra, at *sunrise* in autumn, symbolizes equal day and night.

617. John Mandeville, *Mandeville's Travels*, trans. Jean d'Outremeuse, ed. P. Hamelius (London: Paul, Trench, Trübner, 1919), 76–77. See *Chaucer's Host*, 134–35.

618. Oberman, 82; Bloomfield, 157.

BIBLIOGRAPHY

Allen, Richard Hinckley. *Star Names: Their Lore and Meaning.* 1899. Reprint. New York: Dover, 1963.

Altick, Richard D. *The Art of Literary Research.* New York: W. W. Norton, 1963.

Anderson, M. D. *Drama and Imagery in English Medieval Churches.* Cambridge: Cambridge Univ. Press, 1963.

Anticlaudianus of Alan of Lille. Translated by James J. Sheridan. Toronto: Pontifical Institute of Mediaeval Studies, 1973.

Apuleius. *The Metamorphoses or Golden Ass of Apuleius of Madaura,* Translated by H. E. Butler. Oxford: Clarendon, 1910.

Aristotle. *Historia Animalium.* Loeb Classical Library. Reprint. 1984.

Ascham, Roger. *Toxophilus.* In *English Works.* William Aldis Wright, ed. Cambridge: Cambridge Univ. Press, 1904.

Augustine. *The City of God Against the Pagans.* Loeb Classical Library. 1978.

——. *The Confessions of St. Augustine.* Translated by F. J. Sheed. New York: Sheed and Ward, 1942.

——. *On Christian Doctrine.* Translated by Professor J. F. Shaw. Edinburgh: T. & T. Clark, 1892.

——. *The Works of Saint Augustine.* Translated by Edmund Hill, O.P. New Rochelle, NY: New City, 1993.

Baldwin, Ralph. "The Unity of the *Canterbury Tales.*" *Anglistica* 5 (Copenhagen: Rosenkilde and Bagger, 1955): 11–110.

Barkan, Leonard. *The Gods Made Flesh.* New Haven: Yale Univ. Press, 1986.

Bartholomæus Anglicus. *On the Properties of Things.* Translated by John Trevisa. Oxford: Clarendon, 1975.

Barton, Samuel G. and William H. Barton. *A Guide to the Constellations.* 3d ed. 1928. Reprint. New York: McGraw-Hill, 1943.

Baugh, Albert C., ed. *Chaucer's Major Poetry.* New York: Appleton-Century-Crofts, 1963.

Bede. *Bede's Ecclesiastical History of the English People.* Bertram Colgrave and R. A. B. Mynors, eds. 1969. Reprint. Oxford: Clarendon, 1992.

Bennett, H. S. *Chaucer and the Fifteenth Century.* Oxford: Clarendon, 1947.

Bennett, J. A. W. *The Parlement of Foules.* 1957. Reprint. Oxford: Clarendon, 1965.

Berger, Harry, Jr. *The Allegorical Temper.* New Haven: Yale Univ. Press, 1957.

Beyer, Steven L. *The Star Guide.* Boston: Little, Brown, 1986.

Bibliographica, vol. 2. London: Paul, Trench, Trübner, 1896.

Block, Edward A. "Chaucer's Millers and Their Bagpipes." *Speculum* 29 (1954): 239–43.

Bloomfield, Morton W. *Piers Plowman as a Fourteenth-Century Apocalypse.* New Brunswick, NJ: Rutgers Univ. Press, 1961.

Boccaccio. *Decameron.* [Anonymous translator, 1620]. London: David Nutt, 1909.

Bradfield, Nancy. *Historical Costumes of England from the Eleventh to the Twentieth Century.* New York: Barnes and Noble, 1958.

Bronson, Bertrand H. *In Search of Chaucer.* Toronto: Univ. of Toronto Press, 1960.

Brooks, Harold F. *Chaucer's Pilgrims.* London: Methuen, 1962.

Brown, Michelle P. *Understanding Illuminated Manuscripts.* Malibu, CA: J. Paul Getty Museum, 1994.

Bulfinch's Mythology. Garden City, NY: International Collectors Library, 1968.

Bury, Richard de. *Philobiblon.* 1960. Reprint. Oxford: Basil Blackwell, 1970.

Cambridge Medieval History. H. M. Gwatkin and J. P. Whitney, eds. 2d ed. Reprint. Cambridge: Cambridge Univ. Press, 1957.

Cambridge World History of Human Disease. Kenneth F. Kiple, ed. Cambridge: Cambridge Univ. Press, 1993.

Canterbury Cathedral. (Pitkin Pictorials) London: Britannia Books, 1969.

Casey, Donald J., M. M. "Our Lady and the earth goddess." *Maryknoll Magazine* vol. 67, no. 4 (April 1973): 30–33.

Castle of Perseverance. In *The Macro Plays.* Mark Eccles, ed. EETS, o.s. 262. London: Oxford Univ. Press, 1969.

Catholic Encyclopedia. 1910 edition.

Cavendish, Richard. *The Black Arts.* New York: Capricorn, 1968.

Caxton's Aesop. R. T. Lenaghan, ed. Cambridge: Harvard Univ. Press, 1967.

Chambers, E. K. *The Mediaeval Stage.* 2 vols. 1903. Reprint. London: Oxford Univ. Press, 1967.

Chauliac, Guy de. *The Cyrurgie of Guy de Chauliac.* Margaret S. Ogden, ed. EETS, o.s. 265. London: Oxford Univ. Press, 1971.

Chester Plays. Dr. Hermann Deimling, ed. EETS, e.s. 62. 1892. Reprint. London: Oxford Univ. Press, 1926.

Cicero. *De Natura Deorum.* Loeb Classical Library. Reprint. 1979.

Clemen, Wolfgang. *Chaucer's Early Poetry.* Translated by C. A. M. Sym. London: Methuen, 1963.

Compact Edition of the Oxford English Dictionary: Complete Text Reproduced Micrographically. 2 vols. Oxford: Oxford Univ. Press, 1971.

Concordance to the Complete Works of Geoffrey Chaucer. John S. P. Tatlock and Arthur G. Kennedy, eds. 1927. Reprint. Gloucester, MA: Peter Smith, 1963.

Cooke, John Daniel. "Euhemerism: A Mediaeval Interpretation of Classical Paganism." *Speculum* 2 (1927): 396–410.

Cooper, Lane. *Aristotelian Papers.* rev. ed. Ithaca, NY: Cornell Univ. Press, 1939.

Cosmographia of Bernardus Silvestris. Translated by Winthrop Wetherbee. New York: Columbia Univ. Press, 1973.

Cullen, Dolores L. *Chaucer's Host: Up-So-Doun.* Santa Barbara, CA: Fithian Press, 1998.

——. *Pilgrim Chaucer: Center Stage*. Santa Barbara, CA: Fithian Press, 1999.

Cumont, Franz. *After Life in Roman Paganism*. 1922. Reprint. New York: Dover, 1959.

——. *Astrology and Religion Among the Greeks and Romans*. New York: G. P. Putnam's Sons, 1912.

——. *Oriental Religions in Roman Paganism*. [Authorized translation.] London: Paul, Trench, Trübner, 1911.

Cursor Mundi. Richard Morris, ed. EETS, o.s. 57, 59. 1874. Reprint. London: Oxford Univ. Press, 1961.

Curtius, Ernst Robert. *European Literature and the Latin Middle Ages*. Translated by Willard R. Trask. 1948. Reprint. Harper Paperback, 1963.

Curye on Inglysche: English Culinary Manuscripts of the Fourteenth Century. Constance B. Hieatt and Sharon Butler, eds. EETS, s.s. 8. London: Oxford Univ. Press, 1985.

De Givry, Emile Grillot. *Picture Museum of Sorcery Magic and Alchemy*. Translated by J. Courtenay Locke. New Hyde Park, NY: University Books, 1963.

Delasanta, Rodney. "The Theme of Judgment in *The Canterbury Tales*." *Modern Language Quarterly* 31 (Sept. 1970): 298–307.

Dempster, Germaine. "The Parson's Tale." In *Sources and Analogues of Chaucer's Canterbury Tales*, edited by W. F. Bryan and Germaine Dempster. 1941. Reprint. New York: Humanities Press, 1958.

Dillard, Annie. *The Writing Life*. 1989. Reprint. New York: HarperPerennial, 1990.

Donaldson, E. T., ed. *Chaucer's Poetry: An Anthology for the Modern Reader*. New York: Ronald, 1958.

Duncan, Edgar H. "The Literature of Alchemy and Chaucer's Canon's Yeoman's Tale: Framework, Theme, and Characters." *Speculum* 43 (1968): 633–56.

Ecclesiale of Alexander de Villa Dei. Translated by L. R. Lind. Lawrence: Univ. of Kansas Press, 1958.

Encyclopædia Britannica. 1968 edition.

The Equatorie of the Planetis. Derek J. Price, ed. Cambridge: Cambridge Univ. Press, 1955.

Everett, Dorothy. *Essays on Middle English Literature.* Oxford: Clarendon, 1955.

Fletcher, Angus. *Allegory: The Theory of a Symbolic Mode.* 1964. Reprint. Ithaca, NY: Cornell Paperbacks, 1970.

Flom, George T. *Introductory Old English Grammar and Reader.* New York: D. C. Heath, 1930.

Frazer, Sir James George. *The Golden Bough.* 12 vols. 3d ed. 1911. Reprint. London: Macmillan, 1913.

——. *The New Golden Bough.* Dr. Theodor H. Gaster, ed. Abridged. Great Meadows, NJ: S. G. Phillips, 1959.

Friedman, John F. "Peacocks and Preachers." In *Beasts and Birds of the Middle Ages.* Willene B. Clark and Meradith T. McMunn, eds. Philadelphia: Univ. of Pennsylvania Press, 1989.

Gardiner, F. C. *The Pilgrimage of Desire.* Leiden, the Netherlands: E. J. Brill, 1971.

Gardner, John Champlin. *The Construction of Christian Poetry in Old English.* Carbondale, IL: Southern Illinois Univ. Press, 1975.

Gayley, Charles Mills. *Plays of Our Forefathers.* New York: Duffield, 1907.

The Gentleman's Magazine (July 1841).

Gesta Romanorum. Sidney J. H. Herrtage, ed. EETS, e.s. 33. 1879. Reprint. London: Oxford Univ. Press, 1962.

The Golden Legend of Jacobus de Voragine. Translated by Granger Ryan and Helmut Ripperger. 1941. Reprint. Salem, NH: Ayer, 1987.

Gower, John. *The English Works of John Gower.* G. C. Macaulay, ed. EETS, e.s. 82. 1901. Reprint. London: Oxford Univ. Press, 1979.

Graef, Hilda. *The Devotion to Our Lady.* New York: Hawthorn, 1963.

——. *Mary: A History of Doctrine and Devotion.* New York: Sheed and Ward, 1963.

Greene, Richard Leighton, ed. *The Early English Carols.* 2d ed. Oxford: Clarendon, 1977.

Hesiod. *The Homeric Hymns*. Translated by Apostolos N. Athanassakis. Baltimore: Johns Hopkins Univ. Press, 1976.

——. *The Homeric Hymns*. Translated by Hugh G. Evelyn-White. Loeb Classical Library. 1936.

Hoffman, Arthur W. "Chaucer's Prologue to Pilgrimage: The Two Voices." In *Chaucer: Modern Essays in Criticism*. Edward Wagenknecht, ed. New York: Oxford Univ. Press, Galaxy, 1959.

Homer. *Iliad*. Translated by William Cullen Bryant. Boston: Houghton, Mifflin, 1870.

Howard, Donald R. "Chaucer the Man." *Publications of the Modern Language Association* 80 (Sept. 1965): 337–43.

——. "Chaucer's Idea of an Idea." In *Essays and Studies* vol. 29. London: John Murray, 1976.

——. *The Idea of the Canterbury Tales*. 1976. Reprint. Berkeley: Univ. of California Press, 1978.

——. *Writers and Pilgrims: Medieval Pilgrimage Narratives and Their Posterity*. Berkeley: Univ. of California Press, 1980.

Howe, George and G. A. Harrer. *A Handbook of Classical Mythology*. Detroit: Gale Research, 1970.

Huppé, Bernard F. *A Reading of the* Canterbury Tales. rev. ed. Albany: State Univ. of New York, 1967.

——. *Doctrine and Poetry*. [Albany]: State Univ. of New York, 1959.

Ideas That Have Influenced Civilization. Oliver J. Thatcher, ed. Chicago: Roberts-Manchester, 1902.

Ingraham, Andrew, ed. *Geoffrey Chaucer's the Prologue to the Book of the Tales of Canterbury*. New York: Macmillan, 1922.

Jackson, W. T. H. *The Literature of the Middle Ages*. New York: Columbia Univ. Press, 1960.

Jacobs, Joseph. *The Fables of Aesop*. 1889. Reprint. New York: Burt Franklin, 1970.

Jember, Gregory K. *The Old English Riddles*. Denver, CO: Society for New Language Study, 1976.

Jones, W. T. *The Medieval Mind*. 2d ed. New York: Harcourt, Brace and World, 1969.

Kaske, R. E. "The Summoner's Garleek, Oynons, and eek Lekes." *Modern Language Notes* 74 (June 1959): 481–84.

Ker, William Paton. *English Literature: Medieval.* New York: Henry Holt, [1912].

Kipling, Gordon. *The Triumph of Honour.* Leiden, the Netherlands: Leiden Univ. Press, 1977.

Kisch, Bruno. *Scales and Weights: A Historical Outline.* New Haven: Yale Univ. Press, 1965.

Kittredge, George Lyman. *Chaucer and His Poetry.* 1915. Reprint. Cambridge: Harvard Univ. Press, 1946.

——. "Chauceriana." *Modern Philology* 7 (July 1909): 465–84.

Kolve, V. A. *Chaucer and the Imagery of Narrative: the First Five Canterbury Tales.* Stanford: Stanford Univ. Press, 1984.

——. *The Play Called Corpus Christi.* Stanford: Stanford Univ. Press, 1966.

Langland, William. *Piers Ploughman.* Translated by J. F. Goodridge. 1959. Rev. ed. Reprint. Baltimore: Penguin, 1974.

——. *The Vision of Piers Plowman II Text B.* Walter W. Skeat, ed. EETS, o.s. 38. London: Trübner, 1869.

Lawrence, William Witherle. *Chaucer and the Canterbury Tales.* New York: Columbia Univ. Press, 1950.

Legouis, Emile. *Geoffrey Chaucer.* Translated by L. Lailavoix. New York: Dutton, 1913.

Loomis, Roger Sherman. *A Mirror of Chaucer's World.* Princeton: Princeton Univ. Press, 1965.

Lowes, John Livingston. *Convention and Revolt in Poetry.* New York: Houghton Mifflin, 1919.

——. *Geoffrey Chaucer.* [1934]. Reprint. Bloomington: Indiana Univ. Press, Midland, 1958.

Ludus Coventriæ. K. S. Block, ed. EETS, e.s. 120. London: Oxford Univ. Press, 1922.

Lumiansky, R. M. "The Meaning of Chaucer's Prologue to 'Sir Thopas.'" *Philological Quarterly* 26 (Oct. 1947): 313–320.

Lydgate, John. *Assembly of Gods*. Oscar Lovell Triggs, ed. EETS, e.s. 69. London: Paul, Trench, Trübner, 1896.

——. *Lydgate's Fall of Princes*. Henry Bergen, ed. Washington, D.C.: Carnegie Institute, 1923.

——. *The Minor Poems of John Lydgate*. Pt. II. Henry Noble MacCracken, ed. EETS, o.s. 192. London: Oxford Univ. Press, 1934.

——. *Pilgrimage of the Life of Man*. F. J. Furnivall and K. B. Locock, eds. EETS, e.s. 77, 83, 92. London: Paul, Trench, Trübner, 1899–1904.

Lynch-Robinson, Sir Christopher and Adrian Lynch-Robinson. *Intelligible Heraldry*. London: Macdonald, 1948.

Macrobius. *The Saturnalia*. Translated by Percival Vaughan Davies. New York: Columbia Univ. Press, 1969.

Mâle, Emile. *The Gothic Image*. Translated by Dora Nussey. 1913. Reprint. New York: Harper Torchbooks, 1958.

Malone, Kemp. *Chapters on Chaucer*. Baltimore: Johns Hopkins Press, 1951.

Mandeville, John. *Mandeville's Travels*. Translated by Jean d'Outremeuse. P. Hamelius, ed. EETS, o.s. 153. London: Paul, Trench, Trübner, 1919.

Manilius. *Astronomica*. Loeb Classical Library. 1977.

Manly, John Matthews, ed. *Canterbury Tales by Geoffrey Chaucer*. New York: Henry Holt, 1928.

——. *Some New Light on Chaucer*. 1926. Reprint. Gloucester, MA: Peter Smith, 1959.

Middle Ages: A Concise Encyclopædia. H. R. Loyn, ed. 1989. Reprint. New York: Thames and Hudson, 1991.

Middle English Dictionary. Hans Kurath and Sherman M. Kuhn, eds. Ann Arbor: Univ. of Michigan Press, in progress, 1956– .

Miller, Robert P. "Allegory in *The Canterbury Tales*." In *Companion to Chaucer Studies*. Beryl Rowland, ed. Toronto: Oxford Univ. Press, 1968.

Muscatine, Charles. *Chaucer and the French Tradition*. Berkeley: Univ. of California Press, 1957.

New English Dictionary on Historical Principles. Oxford: Clarendon, 1928.

Oberman, Heiko A. "Fourteenth-Century Religious Thought: A Premature Profile." *Speculum* 53 (Jan. 1978): 80–93.

Olson, Roberta J. M. *Fire and Ice*. Smithsonian. New York: Walker, 1985.

Origen. *Origen: The Song of Songs*. Translated by R. P. Lawson. London: Longmans, Green, 1957.

Ovid. *Fasti*. Loeb Classical Library. 1931. Reprint. 1967.

—. *Metamorphoses*. Loeb Classical Library. 1916. Reprint. 1984.

Owst, Gerald R. *Literature and Pulpit in Medieval England*. 2d ed. Oxford: Basil Blackwell, 1961.

—. *Preaching in Medieval England*. Cambridge: Cambridge Univ. Press, 1926.

Oxford Companion to Classical Literature. M. C. Howatson, ed. 2d ed. 1937. Reprint. Oxford: Oxford Univ. Press, 1991.

Oxford Illustrated History of Medieval England. Nigel Saul, ed. Oxford: Oxford Univ. Press, 1997.

Oxford Illustrated History of Medieval Europe. George Holmes, ed. Oxford: Oxford Univ. Press paperback, 1990.

Panofsky, Erwin. *Studies in Iconology*. New York: Oxford Univ. Press, 1939.

— and Fritz Saxl. "Classical Mythology in Mediaeval Art." *Metropolitan Museum Studies*. vol. 4, pt. 2 (New York: Metropolitan Museum of Art, 1933): 228–80.

Pantin, W. A. *The English Church in the Fourteenth Century*. Notre Dame: Univ. of Notre Dame Press, 1962.

Pausanius. *Guide to Greece*. Translated by Peter Levi. 1971. Reprint. New York: Penguin, 1985.

Petrarch, Francesco. *Africa*. Translated by Thomas G. Bergin and Alice S. Wilson. New Haven: Yale Univ. Press, 1977.

—. *Letters to Classical Authors*. Translated by Mario Emilio Cosenza. Chicago: Univ. of Chicago Press, 1910.

——. *The Life of Solitude by Francis Petrarch*. Translated by Jacob Zeitlin. Urbana: Univ. of Illinois Press, 1924. Reprint. Hyperion, 1978.

Pindar. *Olympian and Pythian Odes*. Loeb Classical Library. 1997.

Piponnier, Françoise and Perrine Mane. *Dress in the Middle Ages*. Translated by Caroline Beamish. *Se vêtir au Moyen Age*. 1995. New Haven: Yale Univ. Press, 1997.

Plato. *Timaeus of Plato*. Translated by R. D. Archer-Hind. 1888. Reprint. New York: Arno Press, 1973.

Pliny. *Natural History*. Loeb Classical Library. 1938.

Pratt, Robert Armstrong. "The Knight's Tale." In *Sources and Analogues of Chaucer's Canterbury Tales*, edited by W. F. Bryan and Germaine Dempster. 1941. Reprint. New York: Humanities Press, 1958.

Ptolemy. *Tetrabiblos*. Loeb Classical Library. Reprint. 1980.

Rand, Edward Kennard. *Founders of the Middle Ages*. Cambridge: Harvard Univ. Press, 1929.

——. *Ovid and His Influence*. Boston: Marshall Jones, 1925.

Receyt of the Ladie Kateryne. Gordon Kipling, ed. EETS, o.s. 296. Oxford: Oxford Univ. Press, 1990.

Reeves, Marjorie. *The Influence of Prophecy in the Later Middle Ages*. Oxford: Clarendon, 1969.

Renn, George A. "Chaucer's *Canterbury Tales*." *Explicator* 43 (Winter 1985).

Richards, I. A. *The Philosophy of Rhetoric*. London: Oxford Univ. Press, 1936.

Robertson, D. W., Jr. *A Preface to Chaucer: Studies in Medieval Perspectives*. 1962. Reprint. Princeton: Princeton Univ. Press, 1969.

Robinson, F. N., ed. *The Works of Geoffrey Chaucer*. 2d ed. Boston: Houghton Mifflin, 1957.

Robinson, James Harvey. *Petrarch, the First Modern Scholar and Man of Letters*. 2d ed. New York: Greenwood, 1969.

Rowland, Beryl. *Animals with Human Faces: A Guide to Animal Symbolism*. Knoxville: Univ. of Tennessee Press, 1973.

Rubin, Miri. *Corpus Christi: The Eucharist in Late Medieval Culture*. 1991. Reprint. Cambridge: Cambridge Univ. Press, 1993.

Ruggiers, Paul G. *The Art of the Canterbury Tales*. Madison: Univ. of Wisconsin Press, 1965.

Russell, Jeffrey Burton, ed. *Religious Dissent in the Middle Ages*. New York: John Wiley and Sons, 1971.

——. *Witchcraft in the Middle Ages*. Ithaca, NY: Cornell Univ. Press, 1972.

Sayers, Dorothy L. *The Mind of the Maker*. New York: Harcourt, Brace, 1941.

Scottish National Dictionary. Edinburgh: Scottish National Dictionary Association, 1976.

Seneca. *Natural Questions*. Loeb Classical Library. 1971.

Seznec, Jean. *The Survival of the Pagan Gods*. Translated by Barbara F. Sessions. 1953. Reprint. Bollingen paperback, 1972.

Skeat, Walter W., ed. *The Complete Works of Geoffrey Chaucer*. 2d ed. 7 vols. Oxford: Clarendon, 1924.

Song of Roland. Translated by C. H. Sisson. Manchester, Eng.: Carcanet Press, 1983.

Spargo, John W. "The Canon's Yeoman's Prologue and Tale." In *Sources and Analogues of Chaucer's Canterbury Tales*, edited by W. F. Bryan and Germaine Dempster. 1941. Reprint. New York: Humanities Press, 1958.

Speirs, John. *Chaucer the Maker*. London: Faber and Faber, 1951.

Spencer, William. "Are Chaucer's Pilgrims Keyed to the Zodiac?" *Chaucer Review* 4 (1970): 147–70.

Spurgeon, Caroline F. E., ed. *Five Hundred Years of Chaucer Criticism and Allusion 1357–1900*. 3 vols. 1925. Reprint. New York: Russell and Russell, 1960.

Stahl, William Harris. *Martianus Capella and the Seven Liberal Arts*. New York: Columbia Univ. Press, 1971.

Summers, Montague. *The Geography of Witchcraft*. New York: University Books, 1958.

Tatlock, J. S. P. *The Mind and Art of Chaucer*. New York: Gordian Press, 1966.

Temko, Allan. *Notre-Dame of Paris*. 1952. New York: Viking Compass, 1959.

Theocritus. *The Poems of Theocritus*. Translated by Anna Rist. Chapel Hill: Univ. of North Carolina Press, 1978.

Thorndike, Lynn. *A History of Magic and Experimental Science*. 8 vols. New York: Columbia Univ. Press, 1923–58.

——. *Michael Scot*. London: Thomas Nelson and Sons, 1965.

Towneley Plays. George England, ed. EETS, e.s. 71. London: Paul, Trench, Trübner, 1897.

Tuve, Rosemond. *Seasons and Months*. Paris: Librairie Universitaire S. A., 1933.

Venette, Jean de. *Chronicle of Jean de Venette*. Translated by Jean Birdsall. Richard A. Newhall, ed. New York: Columbia Univ. Press, 1953.

Vermaseren, Maarten J. *Cybele and Attis: The Myth and Cult*. London: Thames and Hudson, 1977.

Virgil. *Virgil's Works*. Translated by J. W. Mackail. New York: Modern Library, 1950.

Wakefield Mystery Plays. Martial Rose, ed. New York: W. W. Norton, 1961.

Wetherbee, Winthrop. *Platonism and Poetry in the Twelfth Century*. Princeton: Princeton Univ. Press, 1972.

Wheatley, Dennis. *The Devil and All His Works*. New York: American Heritage, 1971.

Wickham, Glynne. *Early English Stages*. New York: Columbia Univ. Press, 1959.

——. *A History of the Theatre*. Cambridge: Cambridge Univ. Press, 1985.

——. The Medieval Theatre. 3d. ed. 1974. Reprint. Cambridge: Cambridge Univ. Press, 1987.

Wilkins, H. Percy. *A Guide to the Heavens*. London: Frederick Muller, 1956.

Wimbledon, Thomas. *Wimbledon's Sermon.* Ione Kemp Knight, ed. Pittsburgh, PA: Duquesne Univ. Press, 1967.

Witchcraft in Europe 1100–1700. Alan Kors and Edward Peters, eds. Philadelphia: Univ. of Pennsylvania Press, 1972.

Wood, Chauncey. *Chaucer and the Country of the Stars.* Princeton, NJ: Princeton Univ. Press, 1970.

Woolf, Rosemary. *The English Religious Lyric in the Middle Ages.* Oxford: Clarendon, 1968.

Wright, David, trans. *Geoffrey Chaucer: The Canterbury Tales.* 1985. Reprint. Oxford: World's Classics, 1991.

Wright, Thomas. *The Canterbury Tales of Geoffrey Chaucer.* Percy Society. London: T. Richards, 1847.

—. "Early English Artistical Receipts." In the *Journal of the British Archaeological Association.* 1844.

—. "Early English Receipts for Painting, Gilding, &c." In the *Journal of the British Archaeological Association.* 1844.

—. *A History of Caricature and Grotesque.* London: Virtue Bros., 1865.

Wyclif, John. [Wyclif Gospels] *The Gospels: Gothic, Anglo-Saxon, Wycliffe and Tyndale Versions.* Joseph Bosworth and George Waring, eds. London: Gibbings, 1907.

—. *The Lanterne of Liȝt.* Lilian M. Swinburn, ed. EETS, o.s. 151. London: Paul, Trench, Trübner, 1917.

—. *Wyclif: Select English Writings.* Herbert E. Winn, ed. London: Oxford Univ. Press, 1929.

Zupko, Ronald Edward. *British Weights and Measures: A History from Antiquity to the Seventeenth Century.* Madison: Univ. of Wisconsin Press, 1977.